OUR AMERICA

OUR AMERICA

A Photographic History

KEN BURNS

with Susanna Steisel, Brian Lee, and David Blistein

 ALFRED A. KNOPF | NEW YORK | 2022

THIS IS A BORZOI BOOK
PUBLISHED BY ALFRED A. KNOPF

Published in the United States by Alfred A. Knopf, a division of Penguin Random House LLC, New York,
and distributed in Canada by Penguin Random House Canada Limited, Toronto.

www.aaknopf.com

Photo credits: ; (page vi) Chief Justice Melville W. Fuller administering the oath of office to Benjamin Harrison on the east portico of the U.S. Capitol, March 4, 1889.
Library of Congress Prints and Photographs, LC-USZ62-63418. (pages 3 and 4); Ken Burns; (page 11): Spread from *Walker Evans: American Photographs.* 75th Anniversary Edition.
Published by The Museum of Modern Art, New York. © Modern Art, New York; (page 12) Spread from *Walker Evans: American Photographs.* 75th Anniversary Edition.
Published by The Museum of Modern Art, New York. © Modern Art, New York / Photograph © Walker Evans Archive, The Metropolitan Museum of Art.

Library of Congress Cataloging-in-Publication Data
Names: Burns, Ken, [date] author.
Title: Our America : a photographic history / Ken Burns.
Description: First edition. | New York : Alfred A. Knopf, 2022.
Identifiers: LCCN 2021057411 | ISBN 9780385353014 (hardcover)
Subjects: LCSH: Photography—United States. | United States—History. |
United States—Social life and customs.
Classification: LCC E178.5 .B88 2022 | DDC 973 –dc23/eng/20220309
LC record available at https://lccn.loc.gov/2021057411

Jacket photograph by Jerome Liebling
Jacket design by John Gall

Manufactured in Germany
Published November 1, 2022
Second Printing, December 2022

This book is dedicated to my mentor, teacher, friend, and inspiration,

Jerome Liebling,

who instilled in me a love and respect for the still image
and the great power it has to convey the most complex information about us.

And

Robert K. Burns, Jr.,

my father, who introduced to me the magic of the photographic process,
gave me my first camera, and also gave to me my love of films.

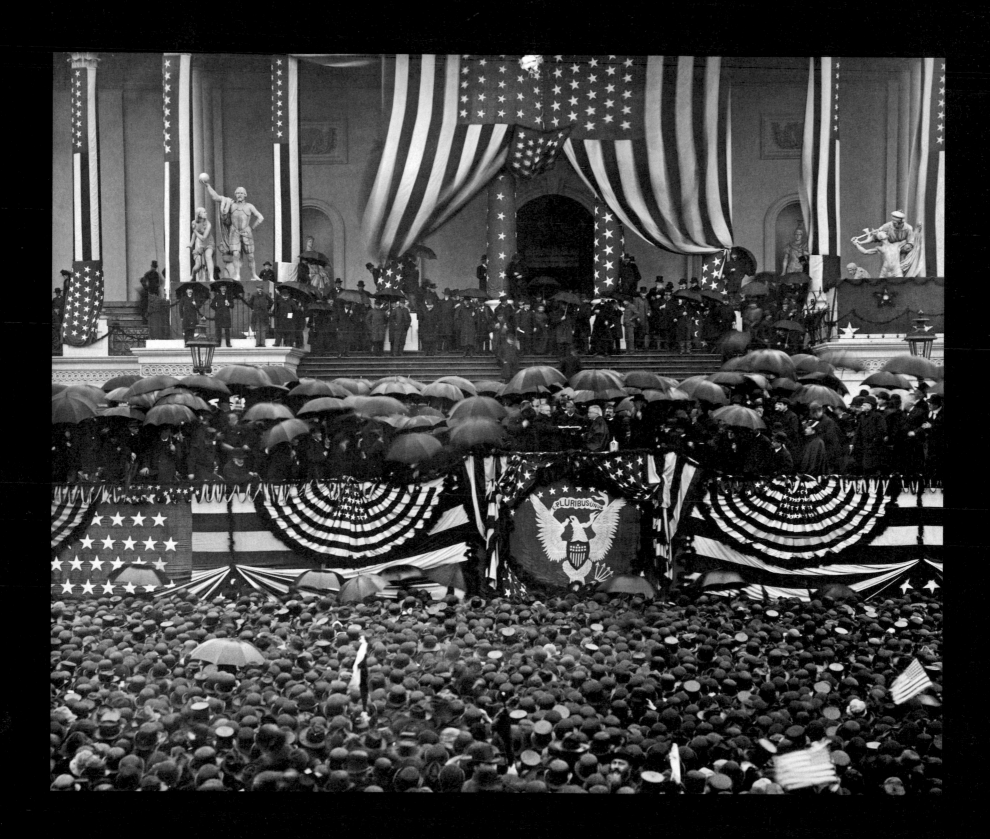

CONTENTS

OPPOSITE
Washington D.C. 1889.
Inauguration of
Benjamin Harrison

OUR AMERICA

INTRODUCTION

All life is interrelated. All people are caught in an inescapable network of mutuality, tied in a single garment of destiny. Whatever affects one directly, affects all indirectly. I can never be what I ought to be until you are what you ought to be, and you can never be what you ought to be until I am what I ought to be.

—MARTIN LUTHER KING JR.

My father, Robert K. Burns Jr., was a cultural anthropologist—and a serious amateur photographer. I am the older of his two sons. My first memory—it's just a fleeting mental movie clip that still has a kind of fragile clarity to it—is of my dad building a darkroom in the basement of our mid-1950s tract house in a development called Binns, at 827 Lehigh Road, in Newark, Delaware. I can remember playing while he measured and sawed, snaking myself back and forth between the two-by-fours of the stud walls before it was all sheathed in Masonite. My second memory, which crowds the first, is of being held in my father's strong left arm, watching a wonderful alchemy take place, as an image began to slowly emerge from a blank piece of photographic paper immersed in a tray of strange-smelling chemicals under a dim, eerie red lamp, my father's right hand agitating the newborn print with metal tongs. To a three-year-old it seemed like magic. Without my knowing it, my father was introducing me—perhaps unwittingly guiding me—to what would be my life's calling: trying to tell complicated stories about history, particularly the visual his-

One night, while my dad and I were watching a film called *Odd Man Out*—directed by Sir Carol Reed, starring James Mason, about the Irish Troubles—I saw my father cry for the first time. He had not cried during my mother's long, excruciating illness, nor at her death, nor at her sad funeral, a fact not lost on disapproving friends in the neighborhood. But as the fugitive hero and his lover die at the end of the film, my father began to weep. I understood instantly the power of film and the safe harbor it permitted him to have, allowing him to express emotions his own fraught life would always force him to suppress, emotions I would have to confront, as well.

I vowed to myself, right then and there, that I would become a filmmaker. That meant, in 1966, that I would go to Hollywood and try to become another John Ford or Alfred Hitchcock or Howard Hawks. After I started at Hampshire College in the late summer of 1971, I fell under the influence of two superb social documentary still photographers, Elaine Mayes and my beloved mentor, Jerome Liebling. My interests and inclinations changed, and I gravitated away from the fiction of feature films to the world of documentary film and true stories. Jerry and Elaine reminded me, indeed *insisted*, that there is as much drama in what is, and what was, as anything the human imagination can dream up.

Soon the "what was"—our at times glorious, at times tortured American past—overtook all of my other interests and I began a nearly fifty-year journey of exploration into the deceptively simple question "Who are we?"—that is to say, who are these strange and complicated people who like to call themselves Americans? What can an investigation of the past tell us not only about that past moment, but also about where we are today, and, perhaps most important, where we might be going? It was an emotional archeology I would attempt, not just excavating the dry dates and facts and events of the past, but also searching for some higher emotional meaning that makes the shards of all that cold data somehow cohere. Two decades into my professional life, my late father-in-law, an eminent psychologist, said to me that what I did for a living was "wake the dead," knowing full well that there was only one person I really wished to wake—my mother. He was right; like my father, I had buried my grief, always unable to be present—mindful—on the anniversary of her death, superstitiously blowing out the candles on my birthday cakes, secretly wishing she would come back.

tory of our even more complicated country. Photographs remain magical to me.

Many years later, after my mother, Lyla Tupper Burns, had succumbed to a nearly decade-long struggle with cancer, a trauma that would influence every aspect of my being every day of my life, my father, who had a strict curfew for my younger brother, Ric, and me, now twelve, still let me stay up well past midnight—even on school nights—to watch movies on our small black-and-white TV. We had by then moved to Ann Arbor, Michigan, and sometimes my father and I would go together to an evening screening at the University's Cinema Guild, or at the Campus Theater on South University Street, places where a silent classic by Buster Keaton, or a western by Howard Hawks, or a French New Wave masterpiece by François Truffaut or Jean-Luc Godard was being shown. I was spellbound, not just at the great films I was seeing, but also at the new worlds of imagination and history and culture he was allowing me to enter.

. . .

To this day I still practice the mystifying and intricate task of trying to will our shared past to life. At the heart of everything I do professionally, at the heart of waking the dead, this effort of resurrection, the DNA of my life's work has been the still photograph, the same seemingly simple artifact that had so captivated me as a young boy held in the crook of my father's arm in that darkroom. In an echo of the Hollywood that once beckoned me, I started my historical documentaries by treating an old photograph the way a feature filmmaker would a master shot, that included within its "borders" a long shot, medium, close, a pan, a tilt, a pullout or telling detail. (God, so many told me, was in the details.) With an energetic and exploring camera eye, I try to continue to enter into the world of that photographic moment.

I don't just look at the photograph and imagine the compositional possibilities, I *listen* to it, as well. Are the troops tramping, the cannons firing, the leaves rustling? Is the bat cracking, the crowd cheering? Each photograph represents for me an arrested moment, but a moment that once had a past and would certainly have a future, and it has been my essential responsibility in every film I've made to try to animate that moment, to will it alive. What the seemingly static still photograph lacked in kinesthetic motion could be offset by a combination of this camera movement and a style of storytelling that accentuated the emotional archeology I sought. These photographs could then have a new life—one with motion and emotion restored.

Jerry Liebling, whose remarkable photograph graces the cover of this book, taught me not just for the four years I was at Hampshire College but for the next thirty-six, until his death in 2011. I simply do not know who or where I would be without his insight, stories, and love. He could transform an ordinary trip to town into an eye-opening experience. He used to command all of us who sought out his wisdom with a kind of mantra: Go. See. Do. Be. He wanted us all to actively go out and engage in life, to pay attention to everything, to really see how light struck the cornice of a building, how a woman's hand moved as she spoke to a companion, where the fleeting organization of the universe periodically revealed itself. He urged us to create something, to *do* something, and to experience this world, to be present and responsible as photographers to our obligations as human beings. There was an inherent reciprocity involved in taking a photograph that we could not shirk. It could not be—as Susan Sontag suggests—merely about appropriation. A camera wasn't something we could hide behind, Jerry said; we were required to engage . . . to *be*. It was for me lifelong learning in the realest sense, a true pursuit of happiness. And his influence is felt in everything I've done, even in the difficult decade that he's been gone.

This book is a tribute to Jerome Liebling and all that he tried to pass on to me. His campus office and home were filled with hundreds of photography books, which he would sometimes silently hand to me. My education also happened inside these books—the hours I spent, with him looking over my shoulder, or alone, "waking up" to the photographs of Lewis Hine, Walker Evans, Paul Strand, Helen Levitt, André Kertész, Berenice Abbott—but also delving into books of historical photographs detailing every aspect of our American past. He knew—and fed—my latent appetite for history, lighting up the path I would follow my whole life.

The best books to me were the Aperture monographs, where there was only one image per page, with minimal captions, the full expressive power of each image undiluted by explanation, description, words. It permitted the photograph to speak for itself—opening up emotions and associations deep inside me—liberated temporarily from a rational world where one and one always equaled two. Here, the old alchemy returned: one and one often equaled three, and the photographs became portals, not just to a different time and space but also to dimensions and possibilities within myself. It is almost impossible to articulate, but the last of Jerry's dicta—"Be!"—now had an emphatic urgency to it that began to suggest, book after book, class after class, year after year, how I would pursue my professional aspirations, how I would tell the stories I felt compelled to share, even what kind of human being I could become. And in these questions and revelations the seed for this book was born. It would take decades to gestate.

. . .

I've needed forty-five years of telling stories in American history, of diving deep into lives and moments, places and huge events, to accrue the visual vocabulary to embark on this book. I knew it would need to reflect all the films I had made; it would need to touch every corner of this country

(indeed, every state of our union is represented here); and it would need to engage all of the big themes and small quotidian moments that characterized first Jerry's approach to taking and looking at photographs, and now the arc of the collective narratives of my films. It would need to insistently acknowledge in its pages the history of the U.S., but also the story of "us," the two-letter, lowercase plural pronoun that in its intimacy often balances out the majesty, the complexity, the contradictions, and the controversy of its larger counterpart. I have had the great privilege and responsibility of operating in that special space between the U.S. and "us" for decades—and if I have learned one thing, it is that there is only "us," no "them." The photographs in the book would need to try to reconcile these disparate energies.

As Susanna Steisel, and later Brian Lee, and I worked to select and match the images in this book, we were amazed at all the emotions and ideas about our larger national story that were inspired by each of the photographs you are about to experience. Here is our genius, our carelessness, our sensuality, our hypocrisy, our symmetry, our folly, our courage, our absurdity, our faith, our ugliness, our wonder, our irony, our ingenuity, and our cruelty. Here is our authenticity, our sacrifice, our playfulness, our curiosity, and our grief. Here is our beauty, fragility, grandeur, and cool. Here is reflection and perseverance, industry and Nature. Our harmony and our dissonance. Our forgetfulness and our memory.

Accumulated memory at its most intimate level is that deeply personal affirmation of self, that which calibrates and triangulates our sense of who we are. And yet memory is also an ambassador of our own individual "foreign policy"—the agency that helps cement friendships, associations, and ambitions. In a larger sense, memory permits us all to have an authentic relationship to our national narrative. These discrete stories and moments, anecdotes and memories, become the building blocks of our collective experience alongside our individual identities. Out of these connections we find the material, the stuff, the glue, to make our obviously still fragile experiment stick, permanent; "a machine," someone once said of our constitutional undertaking, "that would go of itself."

. . .

Memory is imperfect. But its inherent instability allows our past, which we usually see as fixed, to remain as it *actually* is: malleable, changing not just as new information emerges but as our own interests, emotions, and inclinations change. I believe that the study of history—particularly a complex and nuanced view of it populated with visual artifacts, like these photographs—can be a table around which all of us can have a personal stake in these past events, the simple moments and grand episodes, where we can have human engagement and try to evoke what Abraham Lincoln called "the better angels of our nature." My own work, including this book of photographs, has been an attempt to summon those angels without neglecting the difficult aspects of our national existence. It is our intention, without cloying nostalgia or unforgiving revisionism, to gather up in these images the generous and the greedy, the prurient and the puritan, the sordid and sensational, the hideous and the humorous, the miserable and the miraculous.

In our films—as in this book—we come across the myriad tensions of our story. Since freedom is at the heart of the American mythology, we straight away encounter an immediate and abiding tension between our personal freedom—what I want—and collective freedom—what we need. Our country was founded on the belief that all "men" are created equal, yet the man who wrote those words, indeed too many of our exalted Founders, owned other human beings and never saw that glaring contradiction and its attendant hypocrisy. And so race has played a huge, outsize role in our story. There are among us people who have had the peculiar experience of being unfree in a free land, whose history has sadly been relegated to February, our coldest and shortest month, as if it were some politically correct addendum to our national narrative and not, as it is, at the burning center of that narrative. The Black experience in the United States underscores, in ways particular and all-encompassing, our great promise and our great failing. Any attempt to sugarcoat or to bury this central fact of our history is dangerous and un-American. The stark reality of this drama permcates this book.

Other tensions manifest, as well. We, as Americans, acquired through the ruthless dispossession of Indigenous peoples' lands an extraordinarily beautiful continent, then proceeded to dam as many rivers as we could, clear-cut as many forests as we could, and mine even the most magnificent of our canyons. And yet we also, for the first time in human history, created national parks, set aside not just for the enjoyment of the rich but for *everyone* for all time. We have boasted to the world about our love of liberty—and yet we failed for 144 years of our national existence to

extend those basic rights to a majority of our citizens. We have created flying machines and probed the heavens, but have failed to protect the most vulnerable among us. We have, of course, constantly criticized these very failings, overlooking the blessings before us and the natural and human beauty right before our eyes. These photographs attempt to embrace these contradictions. I take exception to an automatic assumption of American exceptionalism, but we do find much that is exceptional in these images, much to celebrate, even smile at, glimmers of light amid the dark and perilous divisions that threaten still to overtake us.

We are fond of saying that history repeats itself. It never does, of course. No event has ever happened twice. Mark Twain is supposed to have suggested that "history doesn't repeat itself, but it rhymes." If he did in fact say that, he was right. The Book of Ecclesiastes, from the Old Testament, says this: "What has been will be again, what has been done will be done again; there is nothing new under the sun." However disappointing or reassuring these words may be, human nature doesn't change; it superimposes itself on the seemingly random chaos of events. In this way, we see recurring issues, motifs, echoes, resonances—rhymes, Twain would say—in our present moment that seem to mirror the themes of our historical investigations. There is selfishness and generosity, scandal and rectitude, altruism and animosity. Rhymes of race, freedom, innovation, politics, war, leadership, prejudice, art, and scandal recur vividly and insistently. The scholar will interpret these manifestations dispassionately; the artist will extract the poetic. The collection of photographs presented here listens to and amplifies these rhymes within specific images, between them, and in their totality. They begin with the advent of photography itself in 1839 and end, more impressionistically, in the historical "no man's land" of our recent past—all history needs the perspective the passage of time permits—approaching but not quite touching our present moment.

This book is entitled *Our America*, and it was conceived and created in the spirit that assembling photographic evidence of our collective past might help heal our divisions. Of course, this book is really "my" America. We all understand our country differently. There's no right way to view it, no uniform focal length or perspective. One size cannot, by the very nature of us, fit all. But the poet and painter William Blake thought you could "see the world in a grain of sand." Our religious teachings suggest "as above, so below." The architecture of the atom and the solar system share a similar profound design. So too does this book try to find the specific in panorama and the universal in myriad telling details, a few hundred images to stand in for the billions and billions of photographs that have been taken in our America.

It is beyond clichéd to say that a picture is worth a thousand words, but perhaps today—with their ever-increasing number and lack of attention at the time of their taking—the value of a photograph has been diminished. Maybe it's worth only five hundred words, or two hundred and fifty, or maybe not even one hundred. We have tried here to return something like full value to these images. We hope you will look at each one of them a good long time, read the wonderful essay by the scholar and curator Sarah Meister, then turn to the back of the book, where each photograph's backstory is told. You may then find yourself going back and forth between an image that has "spoken" to you and then to the lengthy caption that might invest your appreciation of that photograph with even more meaning. We hope so. That is *our* intention.

—Ken Burns

A POWERFUL MONUMENT
TO OUR MOMENT

One might argue that the best-known and most compelling group of photographs made in (and of) the United States was published by the Museum of Modern Art in 1938. It was called, simply, *American Photographs*, and it included eighty-seven photographs by Walker Evans made between 1929 and 1937. Someday, the volume you hold in your hands might assume comparable status, but that is for future generations to determine. Soon—in this essay, even—we will consider a number of titles that compete for this distinction. Specific rankings are surely beside the point, yet *American Photographs* is undoubtedly foundational in constructing a picture of America within our popular imagination. In his essay that accompanied Evans's photographs in the bound volume in 1938, the critic, collector, and influencer Lincoln Kirstein wrote,

> After looking at these pictures with all their clear, hideous and beautiful detail, their open insanity and pitiful grandeur, compare this vision of a continent as it is, not as it might be or as it was, with any other coherent vision that we have had since the war. What poet has said as much? What painter has shown as much? Only newspapers, the writers of popular music, the technicians of advertising and radio have in their blind energy accidentally, fortuitously, evoked for future historians such a powerful monument to our moment.

Kirstein wrote this at a time when the status of photography among the fine arts was hardly secure. His favorable comparisons with poetry and painting carry with them a hint of this insecurity: his contemporary audience was inclined to look to the written word or the painted image as a model for a "coherent vision." Kirstein then pivoted to an astute, if less conventional, claim, pointing to other popular forms (journalism, advertising) as comparably noteworthy and historically significant. After positioning *American Photographs* between these "high" and "low" achievements, Kirstein concluded, "Evans' work has, in addition, intention, logic, continuity, climax, sense and perfection." It is difficult to imagine higher praise.

Kirstein and Evans shared a confidence that photography, the most democratic of media, was well suited to construct a picture of America. Even a passing familiarity with Ken Burns's documentary films would lead one to conclude that he agrees with this assessment. They believed not only that a group of photographs, thoughtfully chosen and sequenced, could do this more effectively than a haphazard assortment, but also that the group as a whole could transcend its component parts and become even more powerful as an indivisible statement. One might say *American Photographs* proved that potential. *Our America* is a variation on this concept, reinforcing the principle while differing in a few notable ways. Each book offers the story of a nation told through photographs. Each is guided by a singular sensibility, authored by an individual with an attentiveness to (and an affection for) the particular pleasures of the medium. Some obvious distinctions scarcely need mention: all of the photographs in *American Photographs* were made by Walker Evans, within an eight-year period. The photographs in *Our America* were made by scores of individuals, both known and nameless, over nearly two centuries.

Photography has always been in the hands of many. It was not a practice learned in an academy that discouraged (or forbade) the full participation of women. Technical and financial barriers to entry were relatively low, and decreased as the nineteenth century progressed. From its infancy, photography served many different functions for many different people: scientists used it to capture significant detail and facilitate comparison, photojournalists deployed it to expand or complicate the public's understanding of newsworthy events, artists wrangled with its mechanical limits in pursuit of aesthetic pleasures, and perhaps most important, people everywhere (sometimes with the help of entrepreneurial professionals) used it to capture likenesses of their loved ones and details of their lives. Evans appreciated this breadth and adopted the plainspoken visual language of functional photographs for much of his career, although the fact that *American Photographs* was published by MoMA points to the core audience for these works: those interested in art, and specifically in art made with a camera. Evans's signature style may have evoked the unassuming charm of photographs made at a local commercial studio, but his concerns were anything but pedestrian. Generations of art historians (including Kirstein), often in dialogue with Evans, have sought to define the nuances of his ambition: that elusiveness is at the heart of what distinguishes his achievement from the one in your hands. The first-person plural implied by the title of *Our America* is meant to include anyone interested in photographs of America, a plurality that also extends to the multiplicity of purposes for which these photographs originally were made. In this it differs from most other books of photographs that concern themselves with a similar topic, both before 1938 and since.

· · ·

One of the most radical, and enduring, aspects of Evans's achievement was that a photograph didn't have to emulate other media to merit serious artistic attention.* Photographers with artistic ambition in the late nineteenth and early twentieth centuries (often referred to as "pictorialists") often adopted soft-focus, dramatic perspectives, and painstak-

ing processes to align themselves, visually, with printmaking or drawing. They saw this as necessary to distinguish their achievements from hordes of professionals and amateurs who were churning out thousands upon thousands of photographs every day. Examples of what the pictorialists found so threatening abound in *Our America*: images filled with previously unimaginable detail (some fascinating, some horrifying, some both); scenes of gatherings and events that provided a sense of *being there* beyond a standard written report; photographs of friends and family intended for the album page or home display. Evans approached his subjects directly, with an unembellished, functional aesthetic that harkened back to these humble cornerstones of photographic history, even while he focused his attention on bringing these images into the more rarefied atmosphere of the art world. *Our America* is similarly positioned to connect the wildly disparate corners of the photographic medium, with the notable distinction that these images were rarely considered in artistic contexts. Evans adopted photography's plainspoken local dialect—often referred to as its "vernacular traditions"—but the goal was to give them due consideration as Art.

The vast majority of the photographs that appear in *Our America*, while attentive to aesthetic considerations, weren't made for museums. Even considering the first few images reproduced on these pages one grasps the ways in which the photographic medium echoes the democratic pluralism of the country in which they were made. The earliest image here was made in 1839, the same year Louis-Jacques-Mandé Daguerre announced his discovery for fixing photographic images to astounded audiences in Paris.[†] It didn't take long for news to cross the Atlantic, where legions of curious individuals attempted to make their own "mirror with a memory" (as these daguerreotypes, made on highly polished, specially sensitized copper plates were described). Robert Cornelius was working for his family business when he took what is believed to be the first photographic self-portrait in the United States: the result is decidedly more of an experiment than an exercise in narcissism. Cornelius's wary gaze reveals a skepticism regarding the process (was it really technologically possible to capture one's own likeness?), not the carefully cultivated OOTD look

* He was not the only one: in the United States, Paul Strand deserves special mention here, as well as Alfred Stieglitz, although Stieglitz had previously played a leading role on the opposite side, championing photographs that masked their photographic origins.

† Malcolm Daniel wrote a succinct history of this discovery, accessible online in the Heilbrunn Timeline of Art History. See "Daguerre (1787–1851) and the Invention of Photography" (New York: Metropolitan Museum of Art, 2000).

we have come to expect in the era of camera phone self-ies. The sense of curiosity and wonder has evolved with each technological advance: as Garry Winogrand later quipped, "I photograph to find out what something will look like photographed."

The same daguerreotype process, with a few improvements that shortened the time needed to cap-ture an image, deserves credit for the specificity in the plates that follow. But these are no longer novel experi-ments: they are deploying photography's capacity for record keeping in service of goals we can only now sur-mise. We hope the photograph of Isaac Jefferson can be understood as a declaration of personhood after decades of enslavement. We hope the branded hand of an abolitionist helped inspire others to the cause. Daguerreotypes were unique original images (unlike technologies that easily facilitated multiple prints from

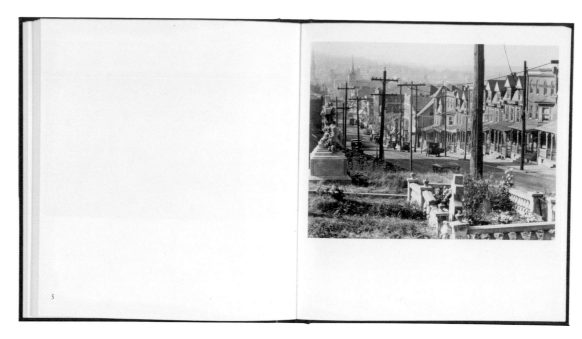

Bethlehem, Pennsylvania 1935, from *Walker Evans: American Photographs*

a single matrix). The octagonal brass windows reproduced here secured them within a handheld case, so while they may have been passed along, their immediate audience would have been a small one. To circulate more widely they would have been translated into an ink-on-paper reproduction (such as a lithograph or engraving). The image of the U.S. Capitol on the following spread was surely reproduced through these methods to reach as broad an audience as possible, whether as a souvenir or in the illustrated press.

Almost since its invention, photography has served the dual interests of the personal and the popular. Decades before Kodak introduced its No. 1 camera in 1888 (its memorable advertising slogan, "You Push the Button, We Do the Rest," pointed to the fact that untrained amateurs could capture their own lives on film), Americans were keen to collect family portraits. Whether made by an itinerant photographer or in a local commercial studio, these were available for a fraction of the cost and at a fraction of the time than it would have taken to have commissioned a painted portrait. Our visual record of the populace across the continent began to align with the actual population. The delicate details of cloth-ing and expression and the tender connections conveyed through gesture and pose give us a window into the lives of Iowa tribe members in Mis-souri as well as a nursemaid and her charge in Louisiana. Once seen, these

people and these relationships cannot be forgotten, nor their concerns overlooked. For generations these specific photographs were likely held by those pictured in them, or their descendants, but their presence here is a symbolic representation of tens of thousands of others.

The next image is the first in this volume that might be characterized as newsworthy, a proto-photojournalist's record of a momentous gather-ing. As with many news photographs, the caption assumes a particular significance, allowing us to identify that it is Frederick Douglass seated just left of the table. This raises an important feature of this book and the audience it serves: the contrast with Walker Evans's *American Photographs* is telling. Each of Evans's photographs appears on the right side of its own spread with no text other than an unobtrusive sequential number on the opposite page. These numbers allow an attentive reader, at the back of each of the book's two parts, to associate a brief title (often just a place name) and date with a particular image. Evans's audience is thus asked to grapple with the evidence of the images themselves, and the sequence in which they appear, long before the minimal contextual information is offered. The text that appears alongside the images in this volume is akin to Evans's terse titles—only a location and a date—yet even these bare details serve to guide the reader. That they are complemented by extensively researched fuller captions at the back of the book is a generous gesture to those of

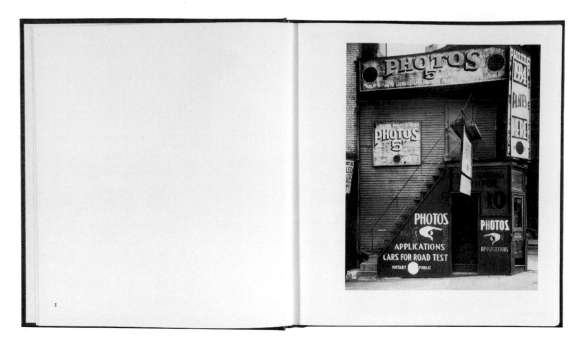

License Photo Studio, New York City 1934, from *Walker Evans: American Photographs*

expand and complicate our understanding of what we see. Evans's dispassionate approach to a similar moment in our history seems clinical in comparison. Although other marvelous photo books appeared in the ensuing decades,* the ambition and impact of these two publications was (again, arguably) not matched until Robert Frank released *The Americans* to an unsuspecting audience in 1959.[†] In eighty-three images, placed one to a spread (nodding to Evans), the Swiss-born Frank deflated the myth of American prosperity in the middle of the twentieth century and pointed to a much more complex and racially charged nation—an image in which some Americans refused to see themselves (see page 208). It was not simply the subject matter but also the seemingly offhanded way in which Frank deployed his camera that created such a stir. With rough grain and informal, often asymmetric framing, Frank asserted

us who would prefer to enjoy these photographs without requiring the internet to learn more of the context of their creation. This is a book for the curious: an interest in photography's artistic traditions is welcome, but not necessary.

. . .

Our America and *American Photographs* are arguably the youngest and the oldest of the epic photographic portraits of America, but they are hardly the only ones. After *American Photographs* in 1938, the photo book came to assume a singular significance within photography's rich traditions, but also a central role in how we picture ourselves. Only a year later, the photographer Dorothea Lange and her husband, the agricultural economist Paul Taylor, collaborated on *An American Exodus*, subtitled, pointedly, *A Record of Human Erosion*. Here a cacophony of voices, often transcribed from interviews with the individuals photographed, are deployed to

a cool indifference to the precise focus and delicate tonal range then associated with serious photographic efforts. One of the curious things about photographs is the way even the most incendiary ones, in time, can assume new meaning or be deployed in new ways. Frank's image of a segregated trolley in New Orleans assumes a historical air on these pages, a regrettable fact. When it appeared on the cover of *The Americans*, the Supreme Court had only recently banned segregation on public transportation and it would be five years before the Civil Rights Act would further assert protection of these rights. The offhanded style of the photographs themselves was similarly normalized as it was adopted by subsequent generations prowling busy sidewalks with a camera.

By the mid-1970s, artists such as Robert Adams and Lee Friedlander were proving and reinforcing the vitality of photo books made in and of the United States with continued creativity and increasing frequency.[‡] Color had been expensive, often fugitive (think faded family snapshots), and regularly derided as antithetical to serious artistic intent, at least until

* A few personal favorites include Berenice Abbott, *Changing New York* (1939, with Elizabeth McCausland); Wright Morris, *The Home Place* (1948); Roy DeCarava, *The Sweet Flypaper of Life* (1955, with Langston Hughes); and William Klein, *Life is Good & Good for You in New York: Trance Witness Revels* (1956). These are each anchored in a specific place without the broad geographic reach represented here or in Evans's book.

[†] Frank was initially unable to find an American publisher for this work; it appeared first in France as *Les Américaines* in 1958.

[‡] Each of these photographers has produced many notable books, but the first to look at the American landscape were Adams's *The New West* (1974) and Friedlander's *The American Monument* (1976).

about this moment. Photographers such as William Eggleston, Stephen Shore, Janet Delaney, Richard Misrach, Tina Barney, and Joel Sternfeld persuasively demonstrated that cameras containing color film held equal potential as art.* As the audiences for these books and the number of publishers increased, opportunities began to emerge for explorations of smaller corners of the American landscape: from Jeanne Moutoussamy-Ashe's *Daufuskie Island* (1982) to Sam Contis's *Deep Springs* (2017). For individual artists, the impulse to capture this vast continent with a camera may have waned, but it has been more than counterbalanced by an attentiveness to its constituent parts.

The need to reflect on our history through photography is one that seems ever more urgent. We are consistently reminded that neither history nor photography is ever neutral, and the strength of the photo books discussed here, including this one, is that they acknowledge the priorities of a particular individual. The best stories are those told through a distinctive lens, and that acknowledge the ways in which that lens is shaped by a personal history. On these pages, photographs from the Civil War outnumber images from the past three decades: this selection is guided by a visual historian, not an inventory that draws equally from each year in our nation's history. While there are a handful of well-known or widely reproduced images here, most will be unfamiliar, and their presence points to the research that we share a responsibility to do, and the stories that remain to be told. *Our America* is an intentionally idiosyncratic, deeply personal collection of photographs that have shaped our understanding of ourselves and our history. It is, too, a powerful monument to our moment.

—Sarah Hermanson Meister

* Some specific titles include *William Eggleston's Guide* (1976); Stephen Shore, *Uncommon Places* (1982); Janet Delaney, *South of Market* (2013; photographs made between 1978 and 1986); Richard Misrach, *Desert Cantos* (1987); Tina Barney, *Theater of Manners* (1997; photographs made beginning in 1982); and Joel Sternfeld, *American Prospects* (1987). The gap between the dates of the negatives and the dates of the publications is particularly notable with women artists.

O would some Power

the gift to give us

to see ourselves

as others see us.

—ROBERT BURNS

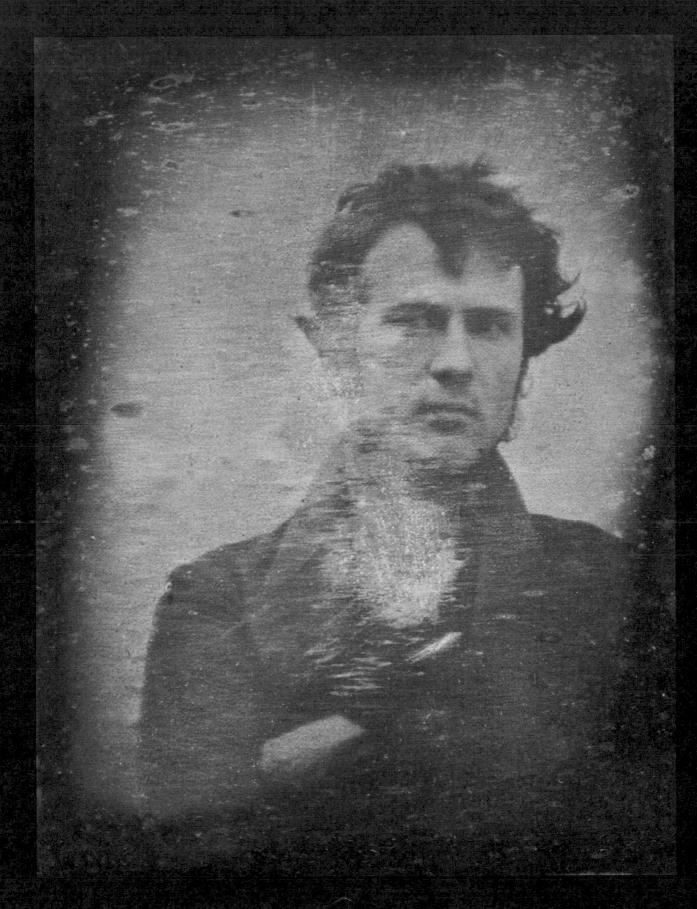

PHILADELPHIA, PENNSYLVANIA 1839

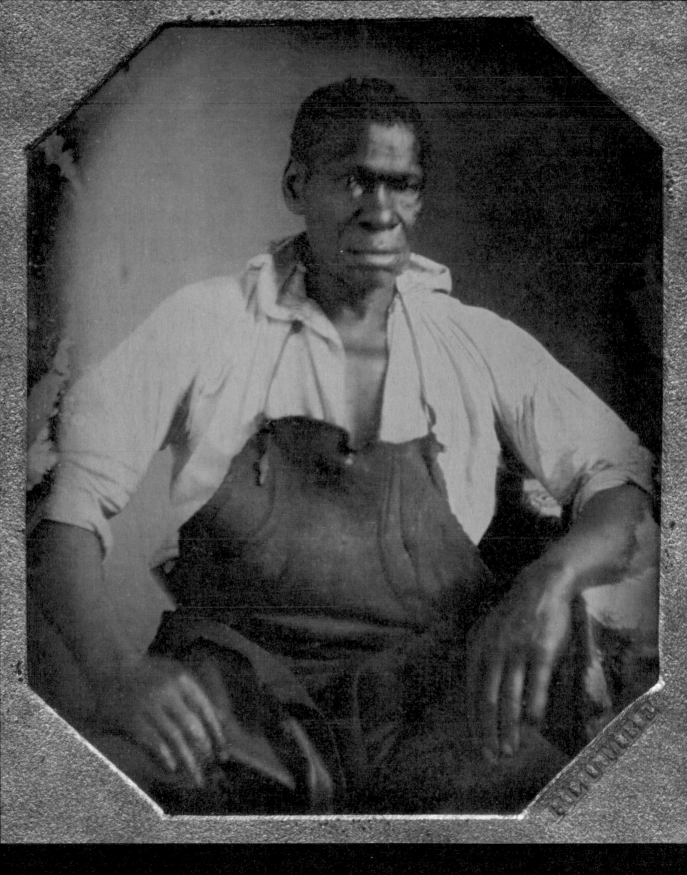

PETERSBURG, VIRGINIA C. 1845

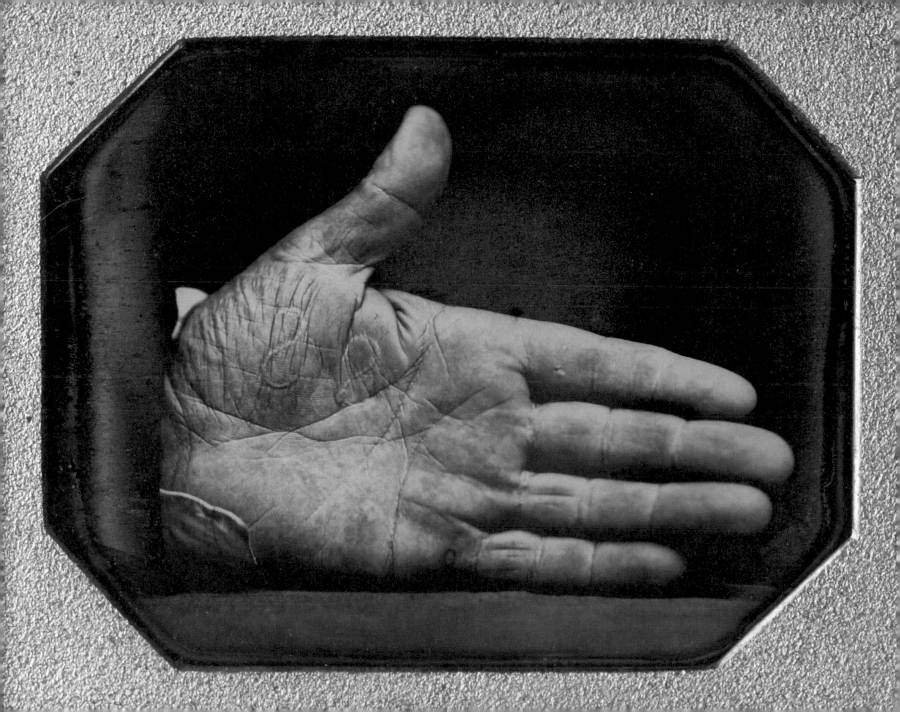

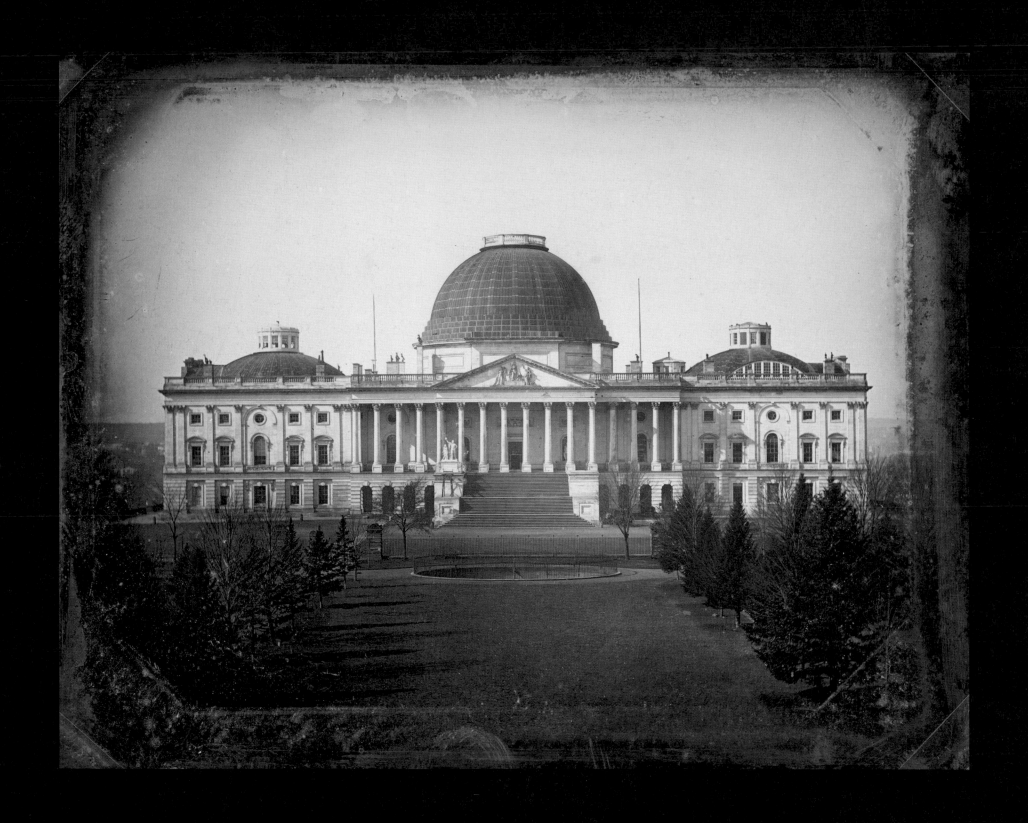

WASHINGTON, D.C. 1846

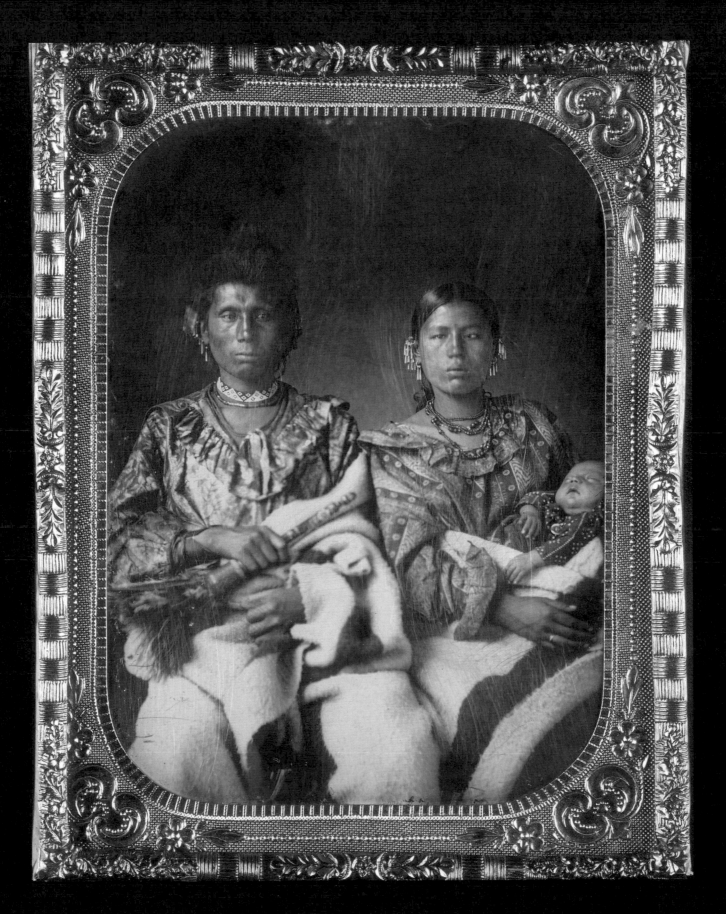

MISSOURI 1849

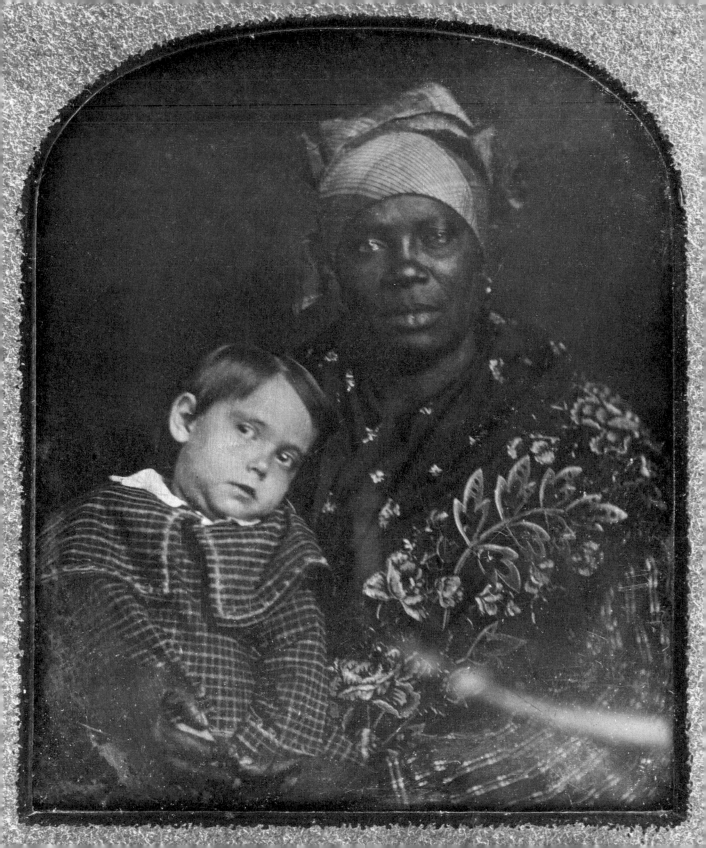

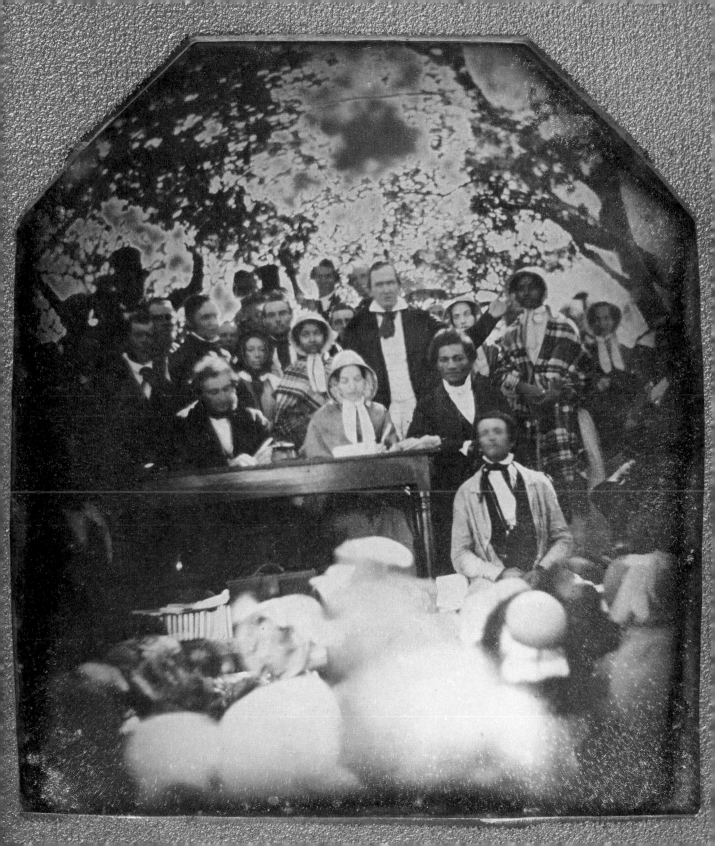

FROM CAMBRIDGE, MASSACHUSETTS 1851

BOSTON, MASSACHUSETTS 1855

WORCESTER, MASSACHUSETTS 1856

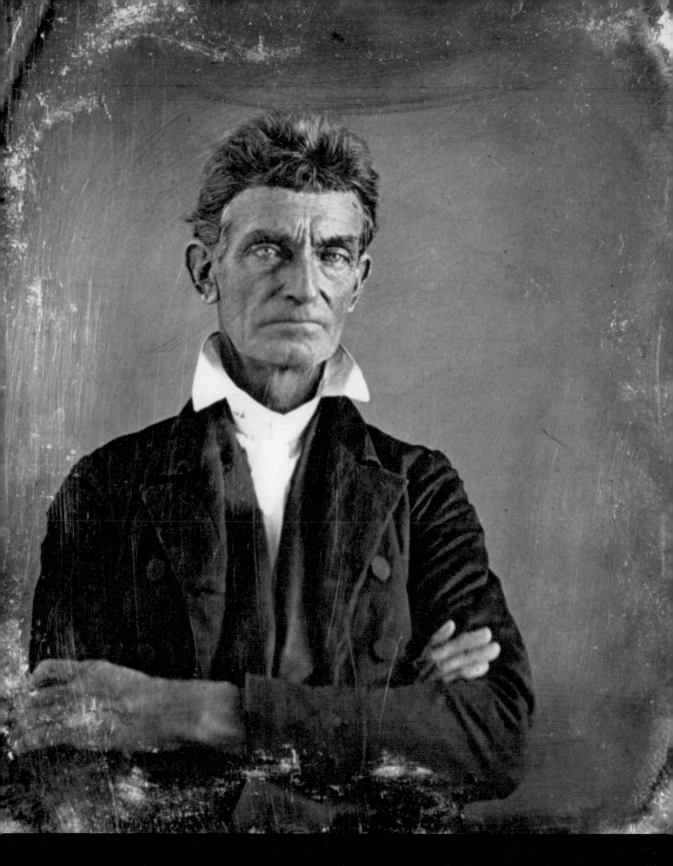

BELIEVED TO BE KANSAS C. 1856

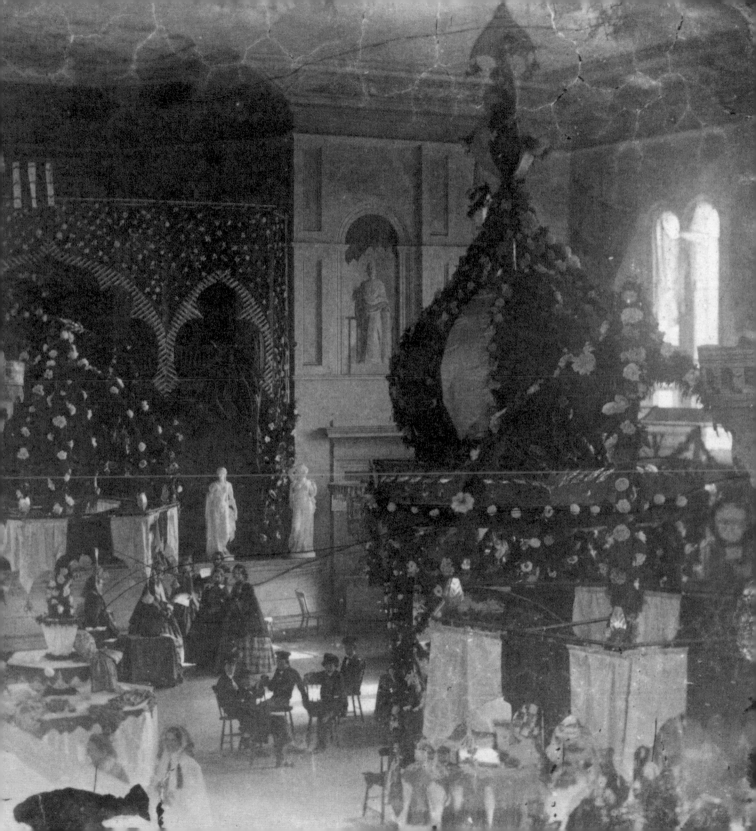

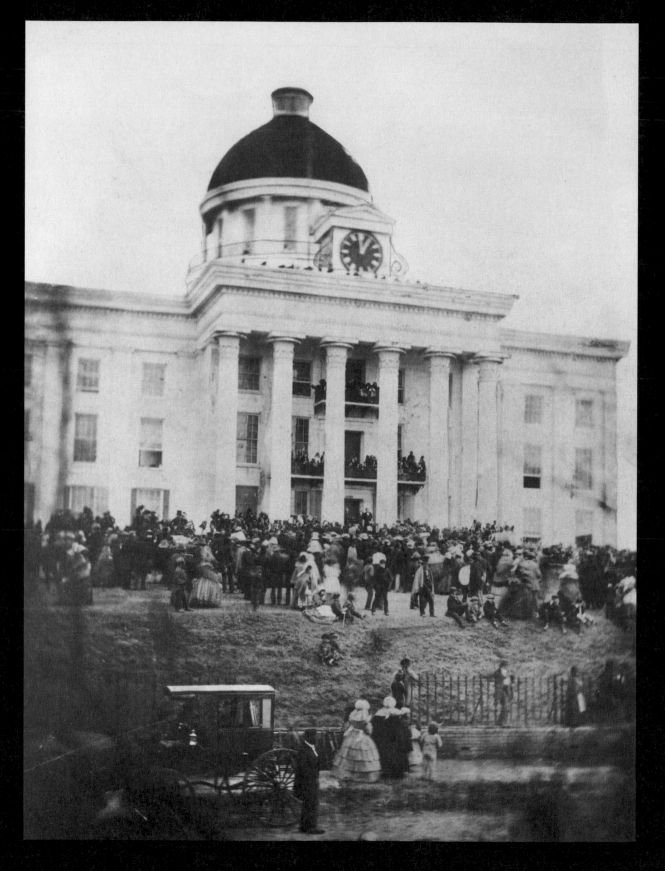

MONTGOMERY, ALABAMA 1861

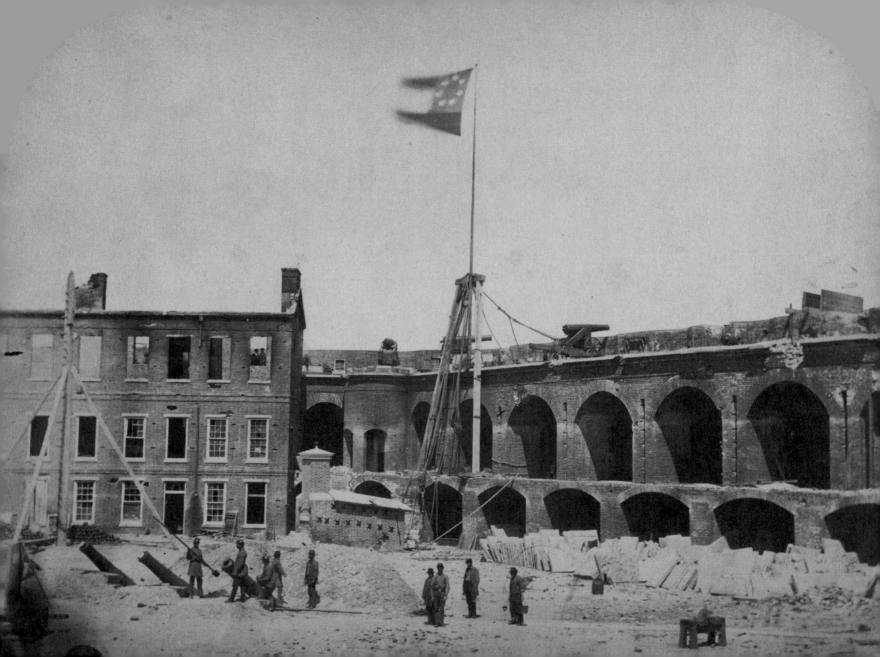

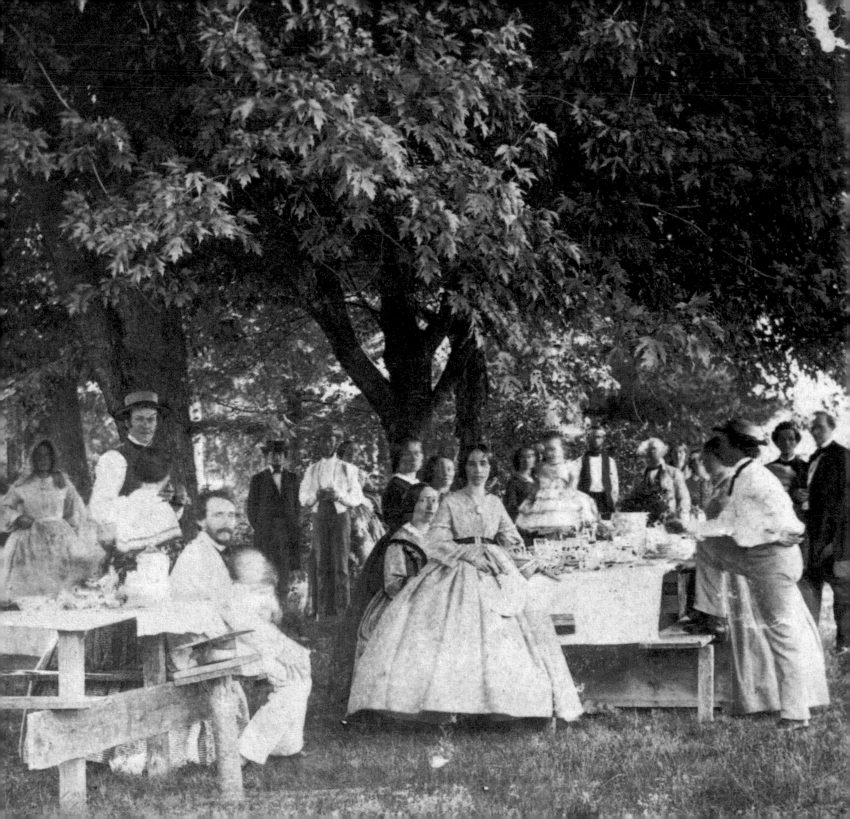

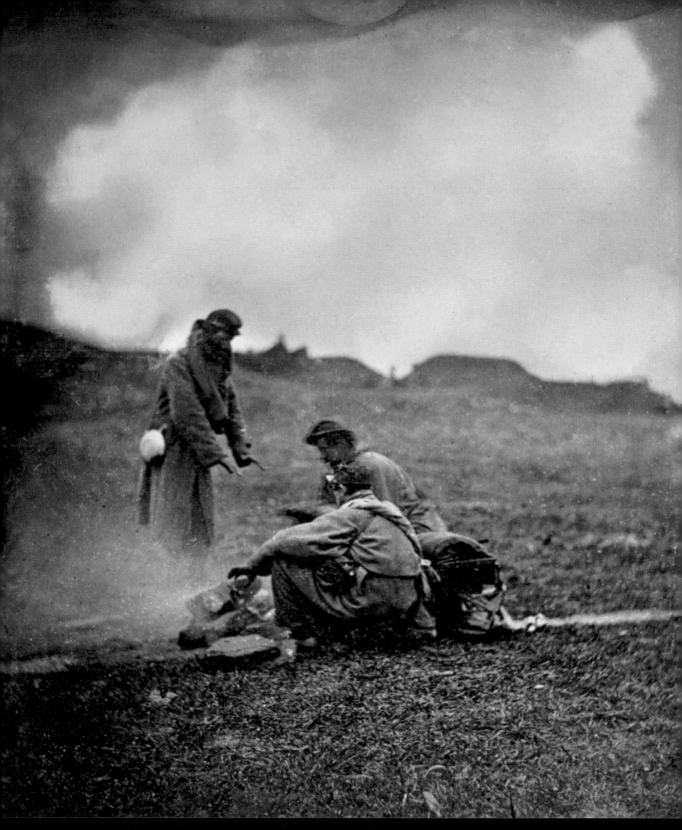

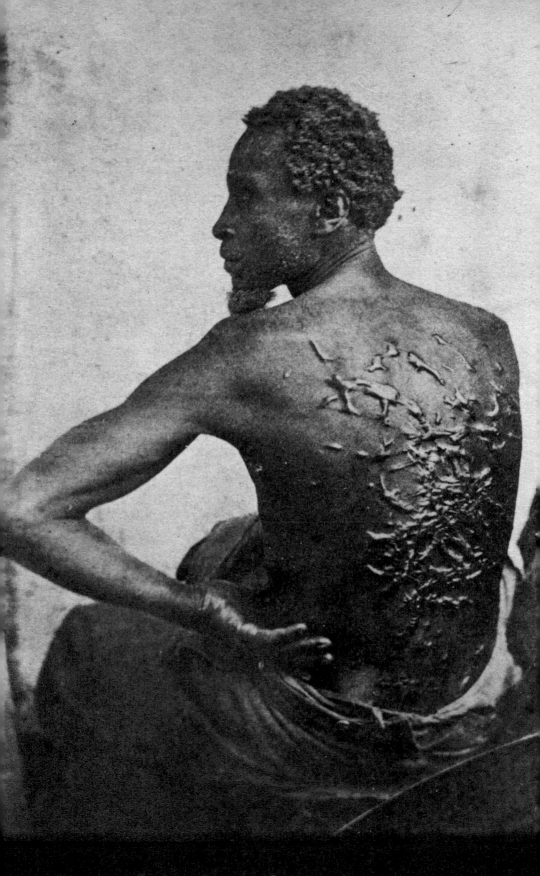

BATON ROUGE, LOUISIANA 1863

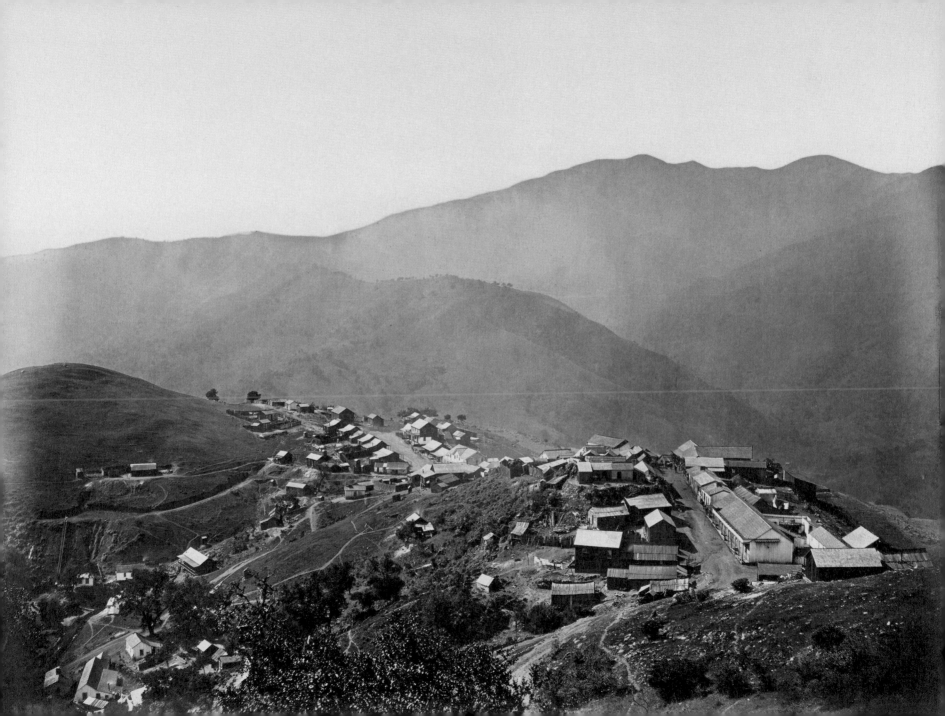

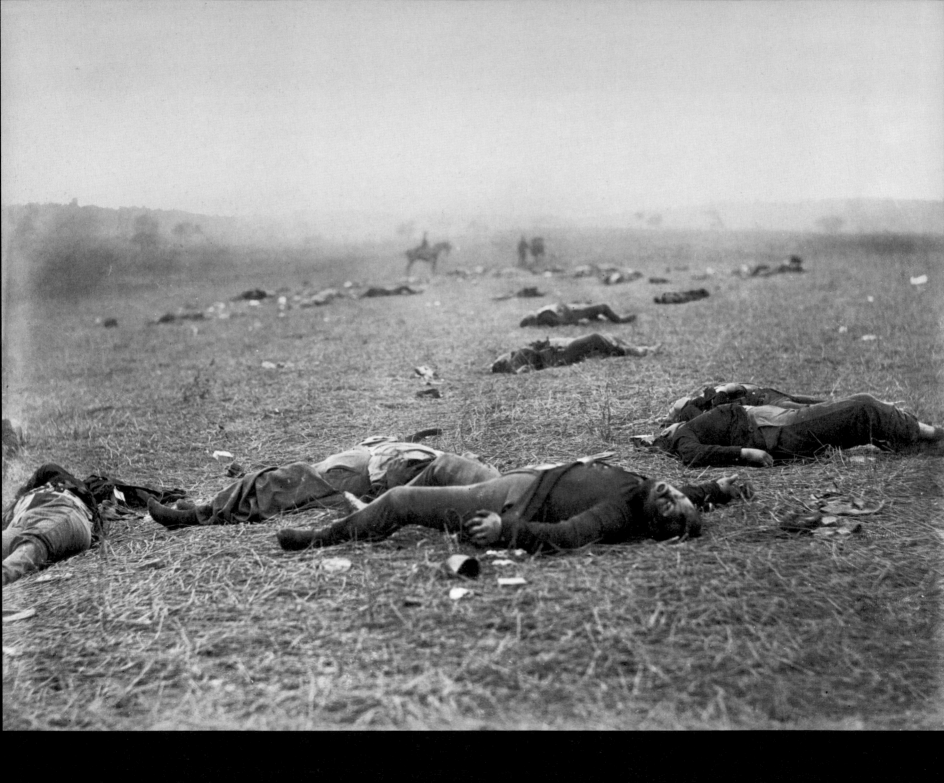

GETTYSBURG, PENNSYLVANIA 1863

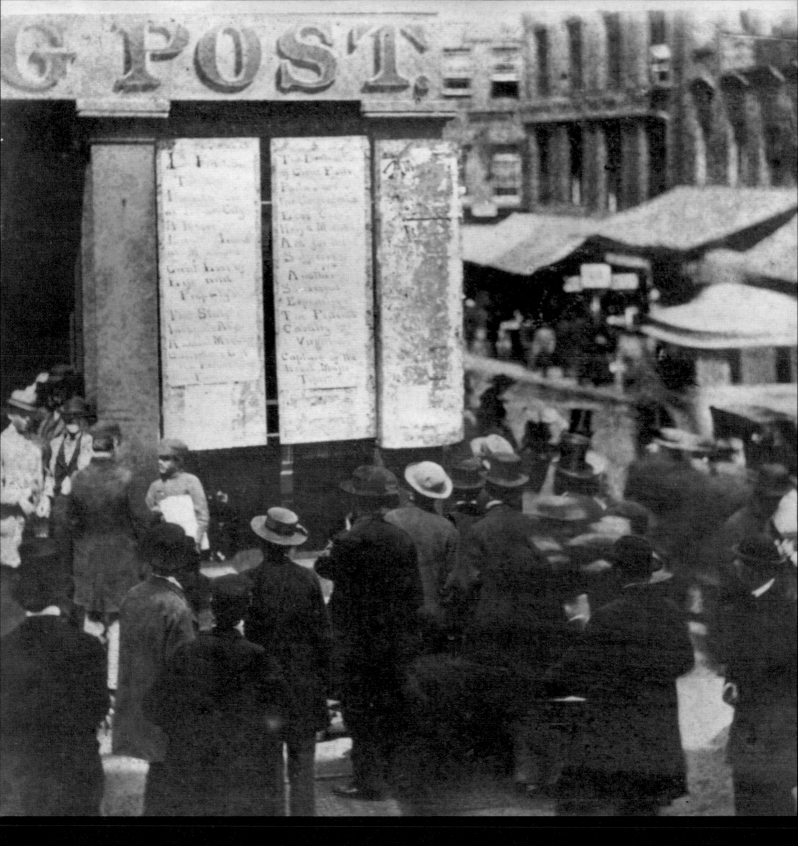

New York City c. 1863

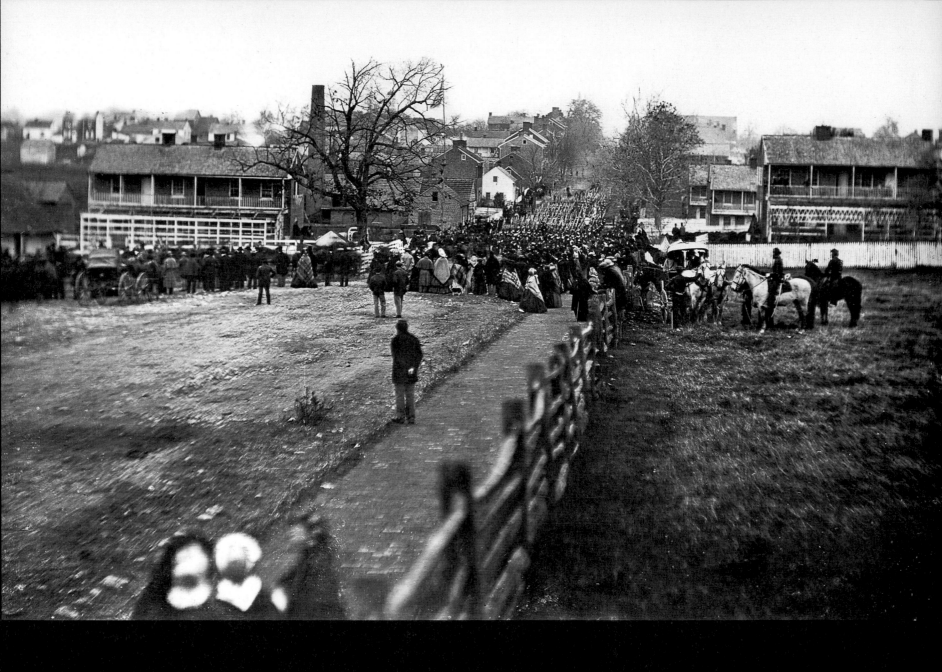

GETTYSBURG, PENNSYLVANIA 1863

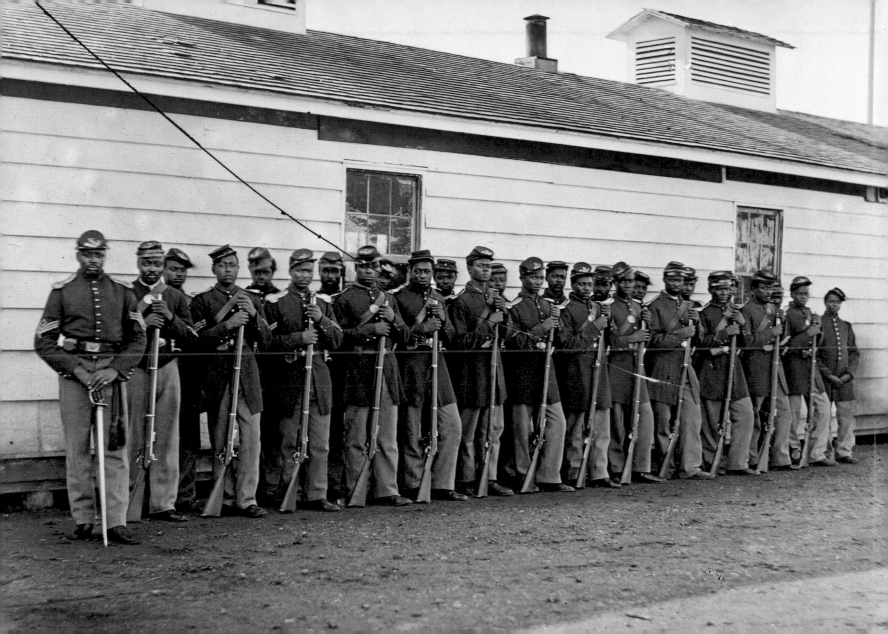

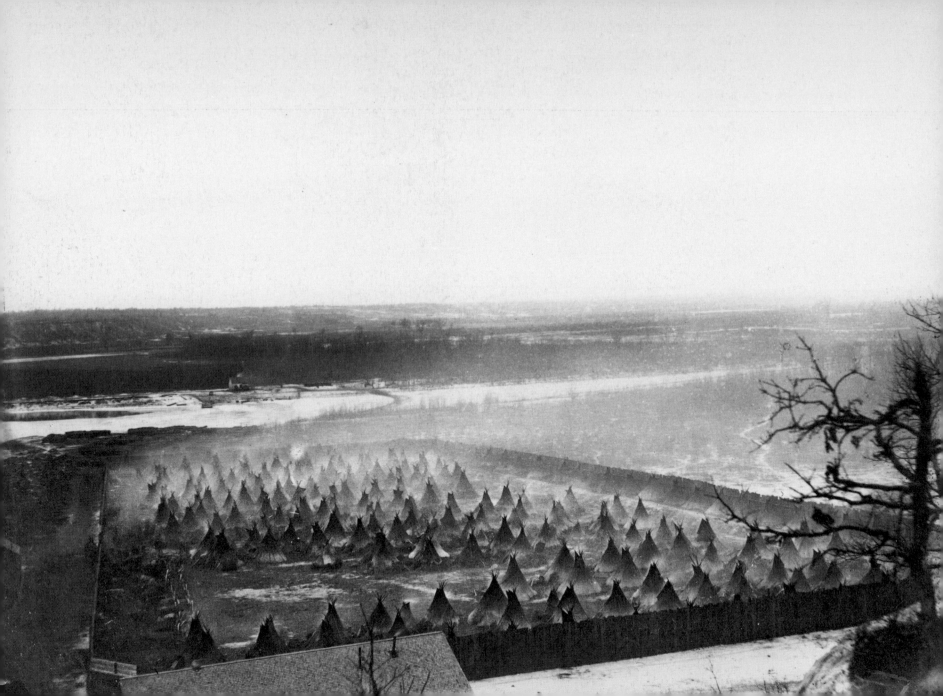

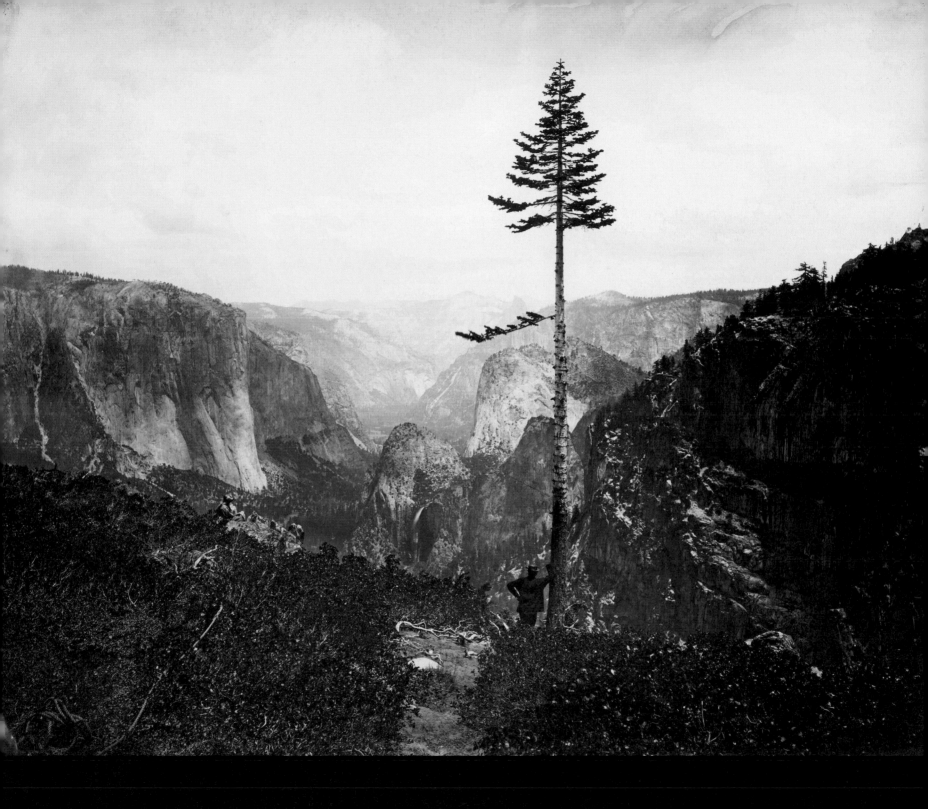

YOSEMITE VALLEY, CALIFORNIA 1864

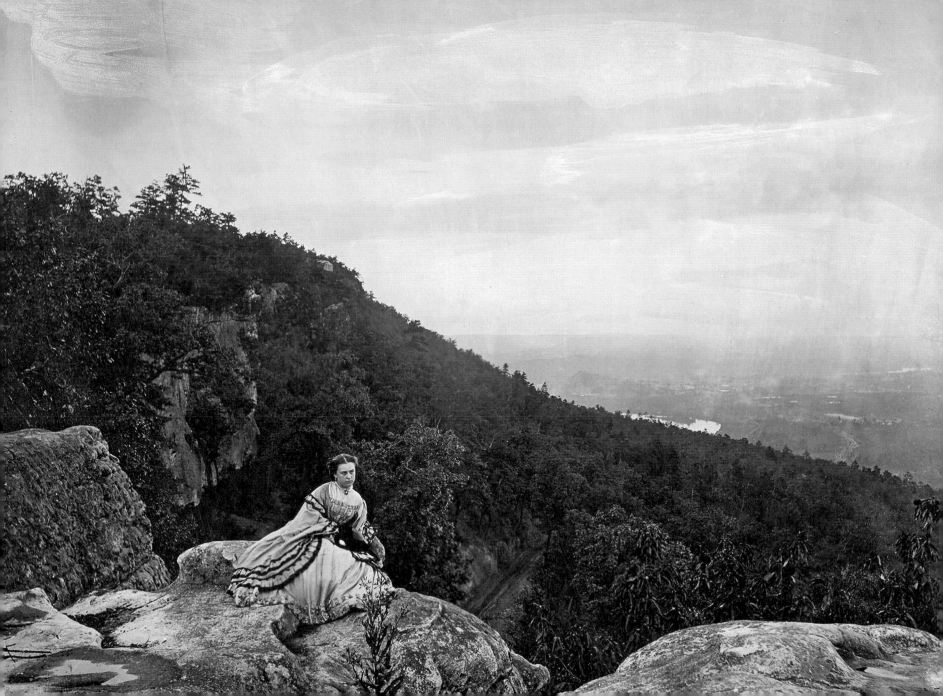

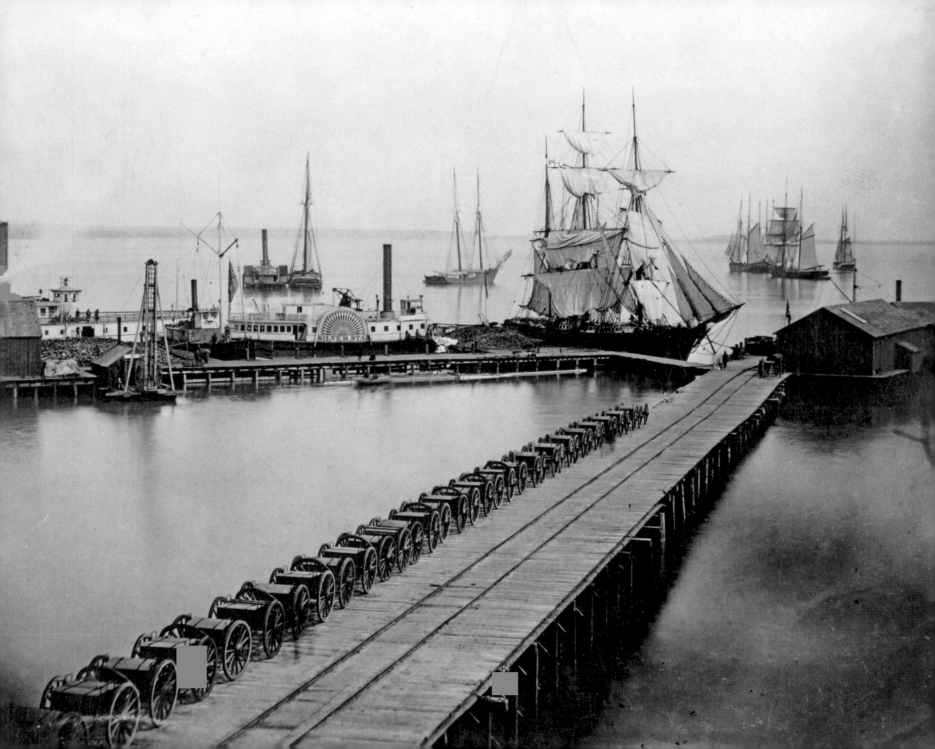

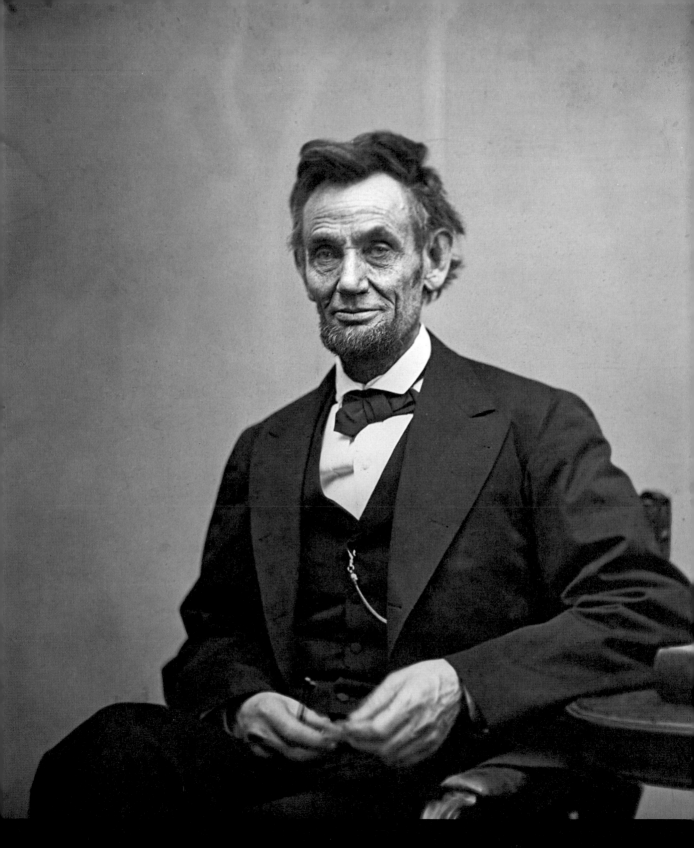

WASHINGTON D.C. 1865

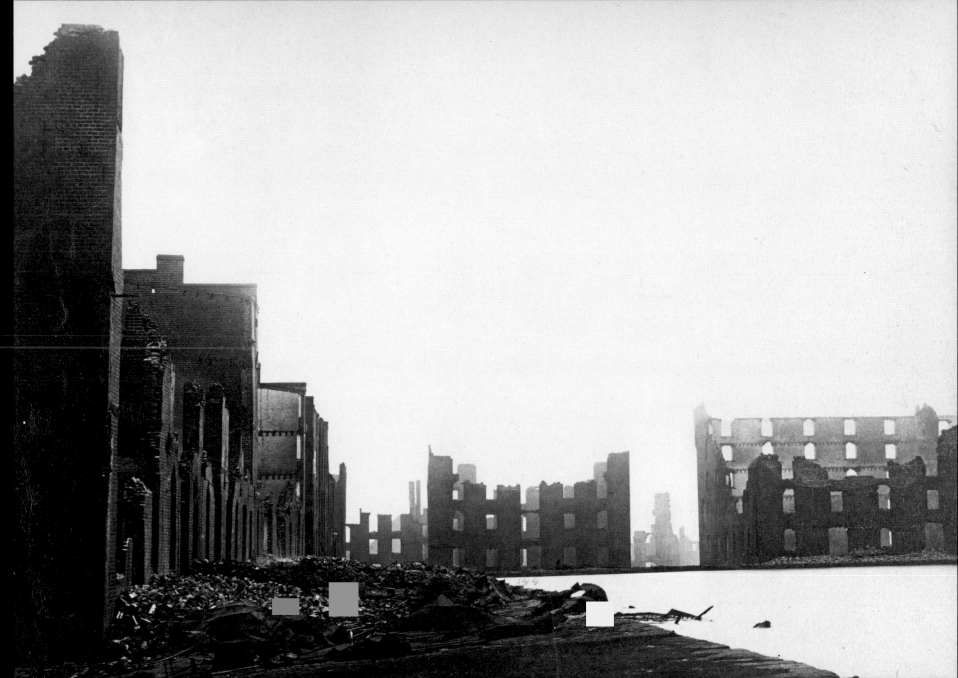

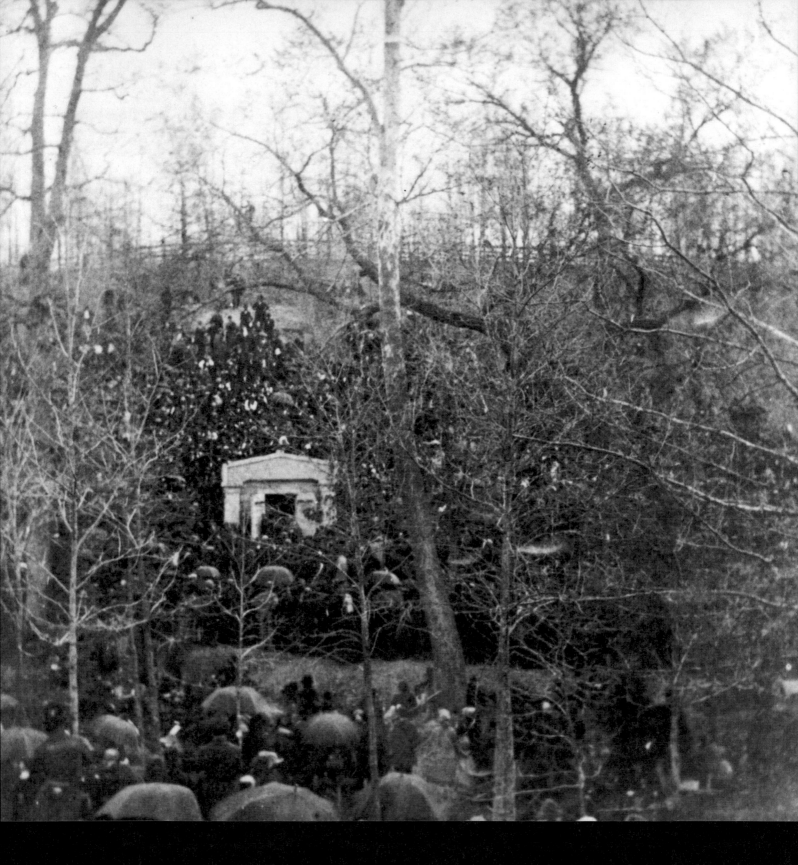

SPRINGFIELD, ILLINOIS 1865

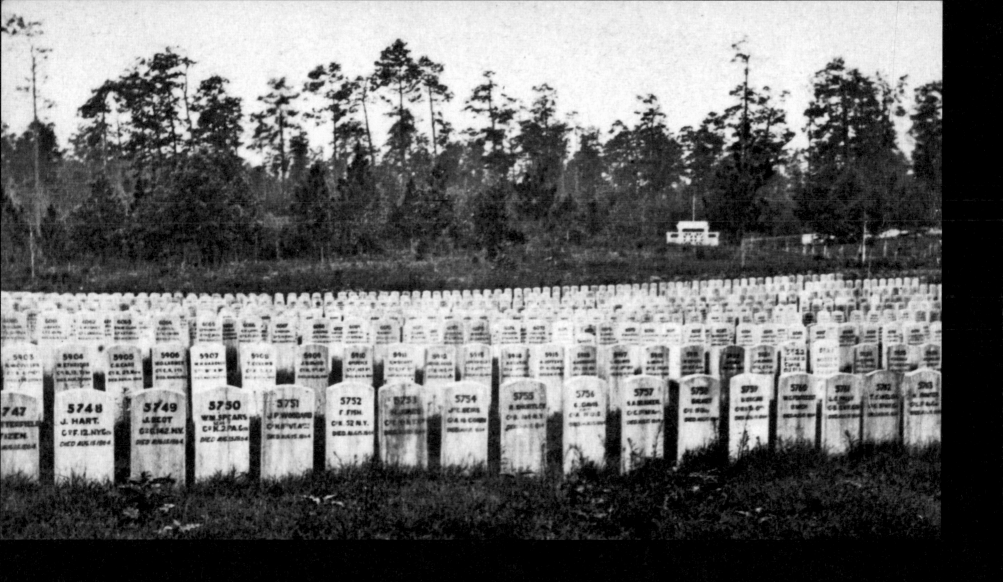

Andersonville, Georgia 1867

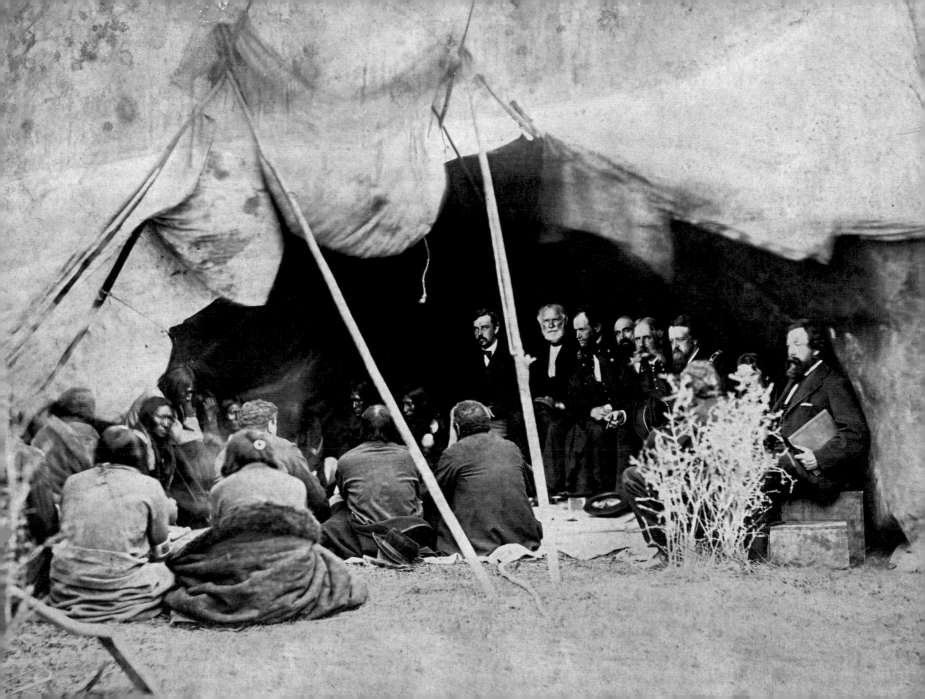

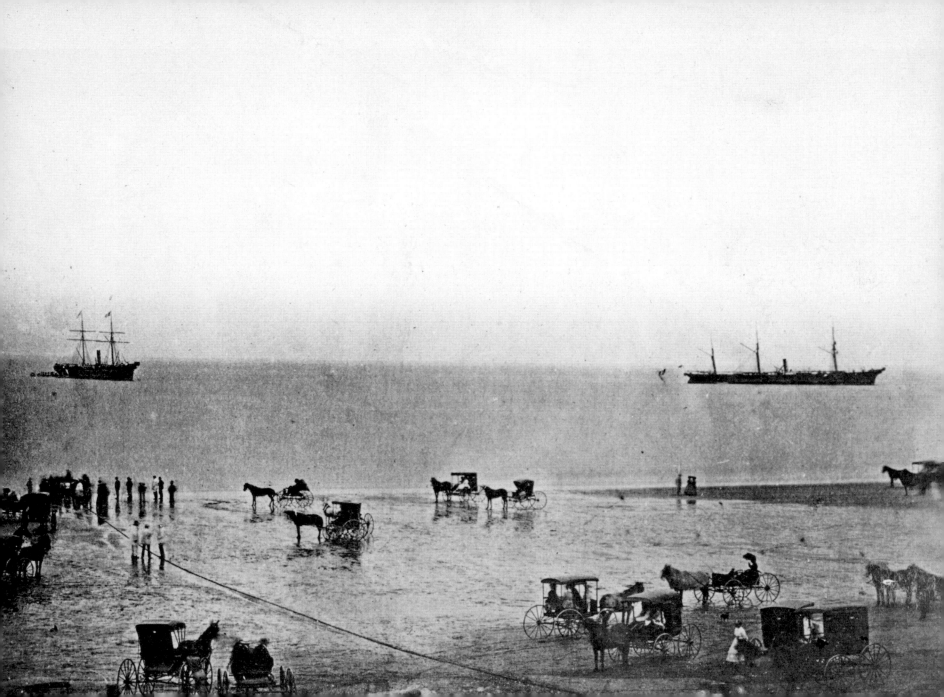

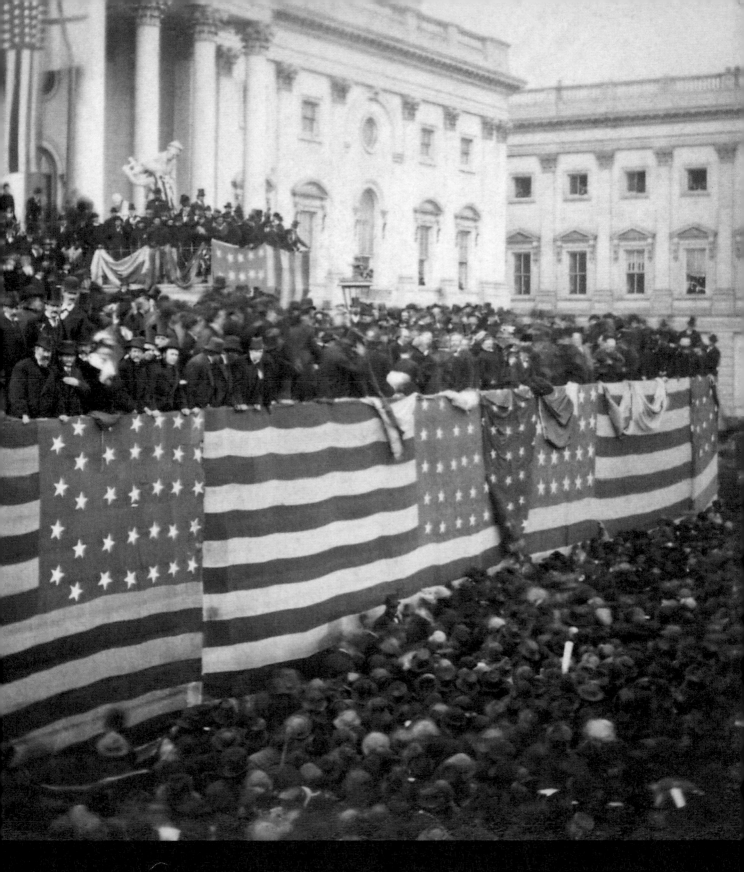

WASHINGTON, D.C. 1877

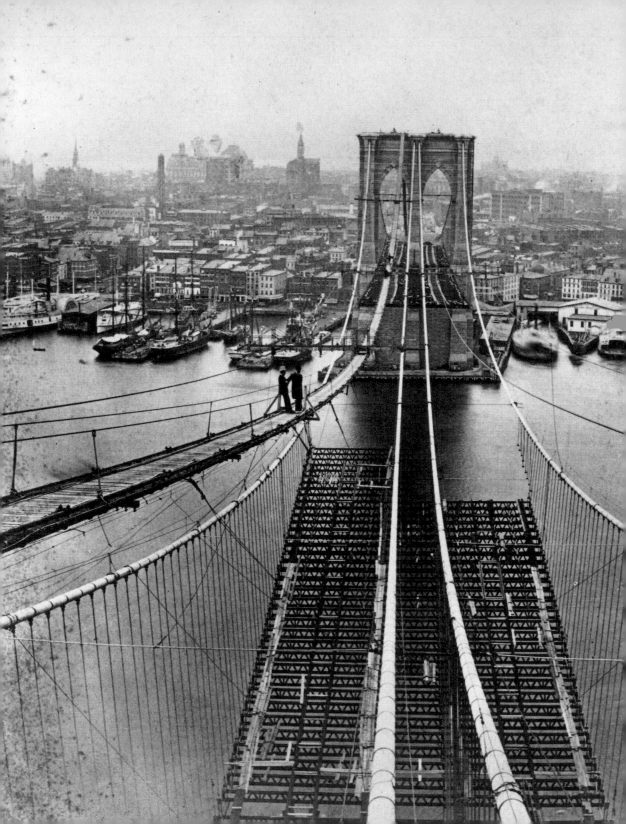

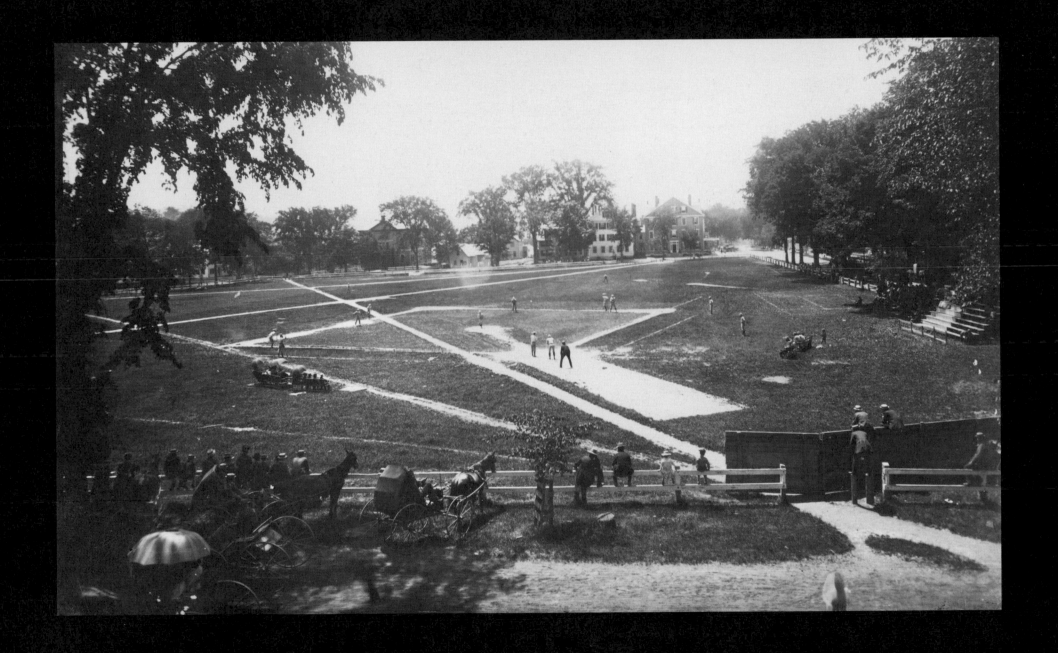

HANOVER, NEW HAMPSHIRE 1882

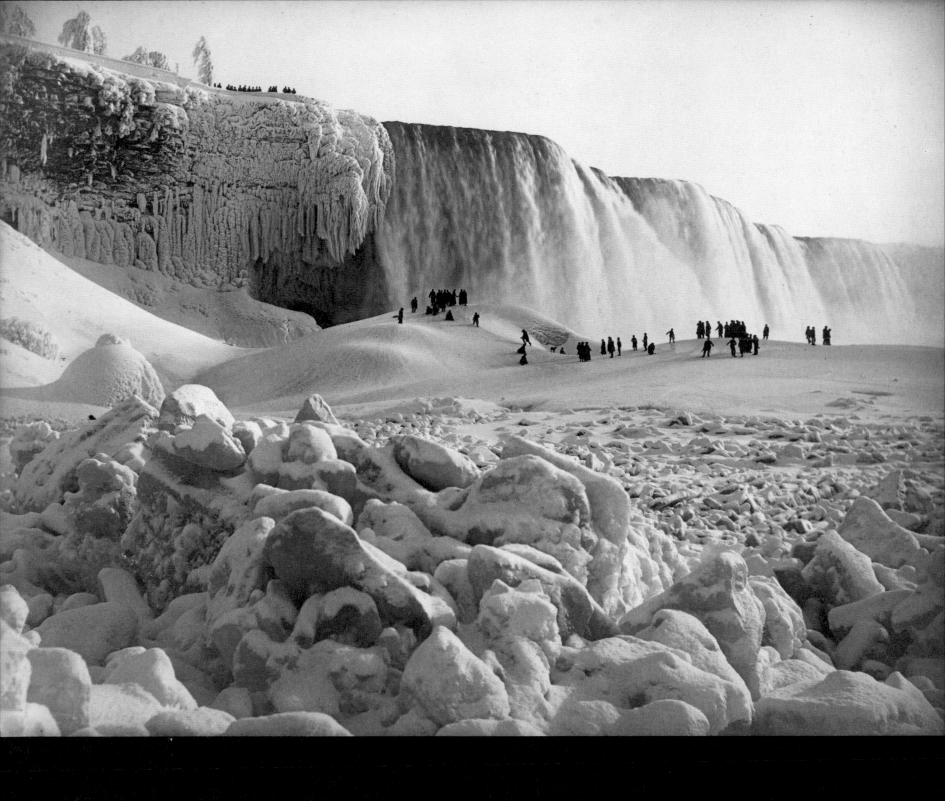

NIAGARA FALLS, NEW YORK C. 1883

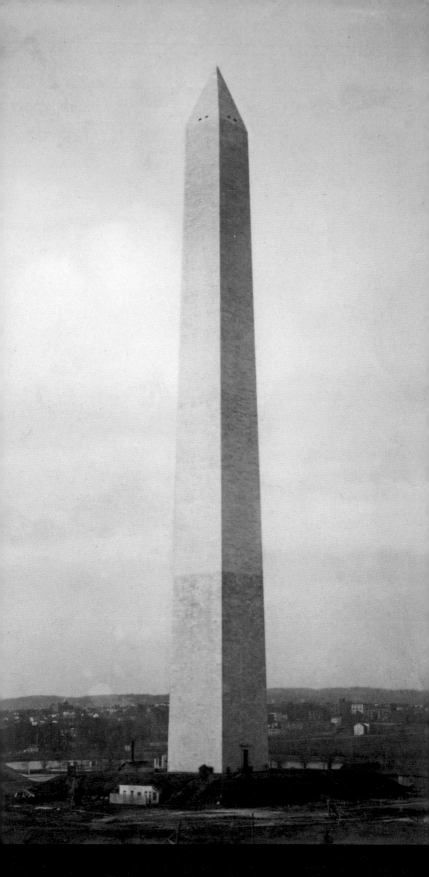

WASHINGTON, D.C. 1884.

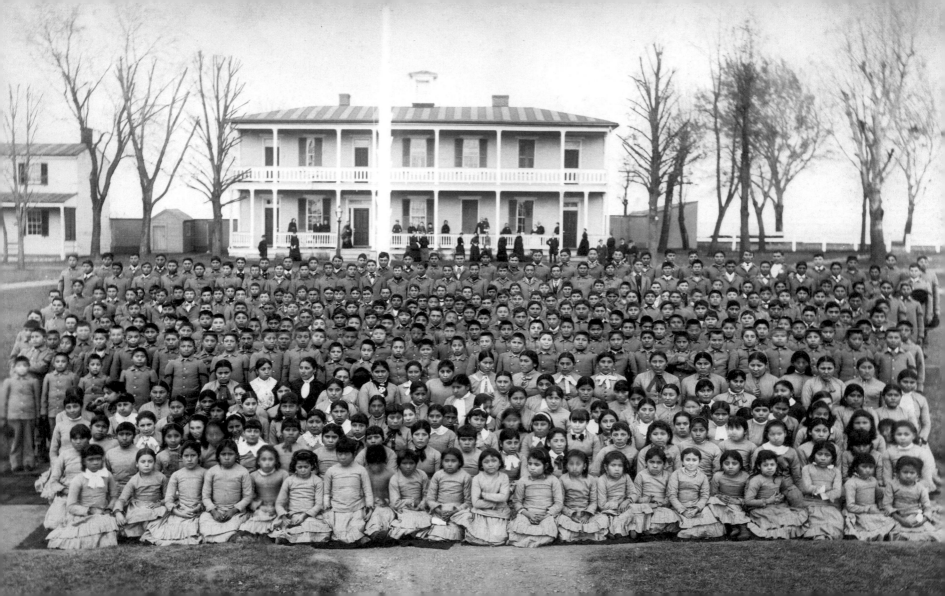

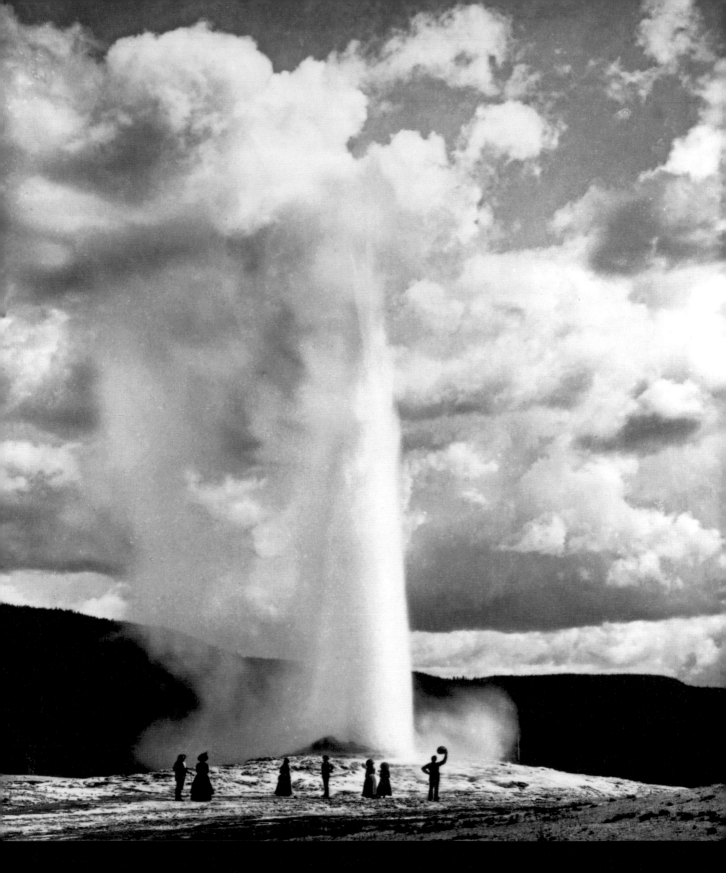

YELLOWSTONE NATIONAL PARK, WYOMING TERRITORY 1884

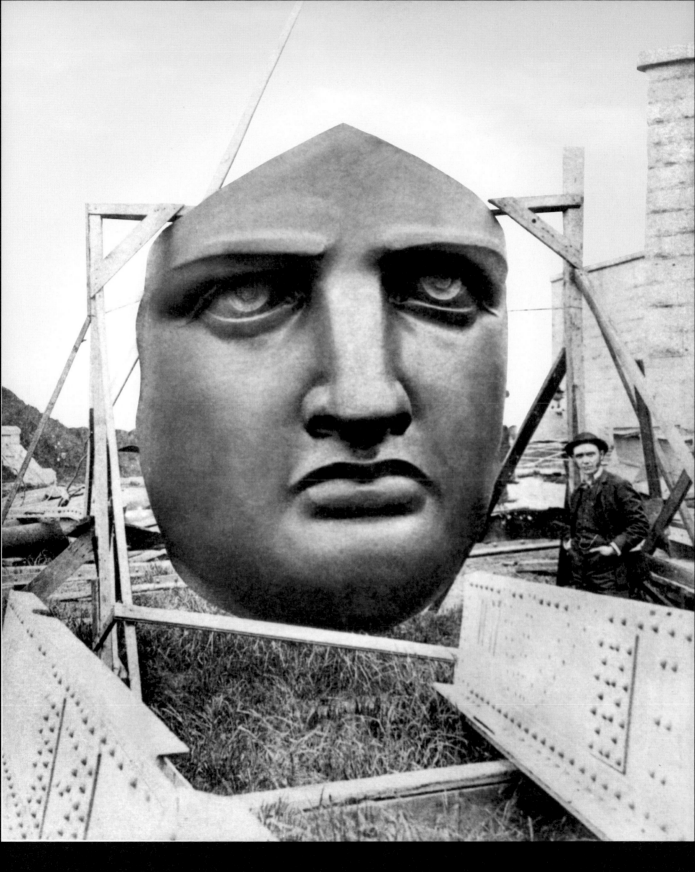

BEDLOE'S ISLAND, NEW YORK 1885

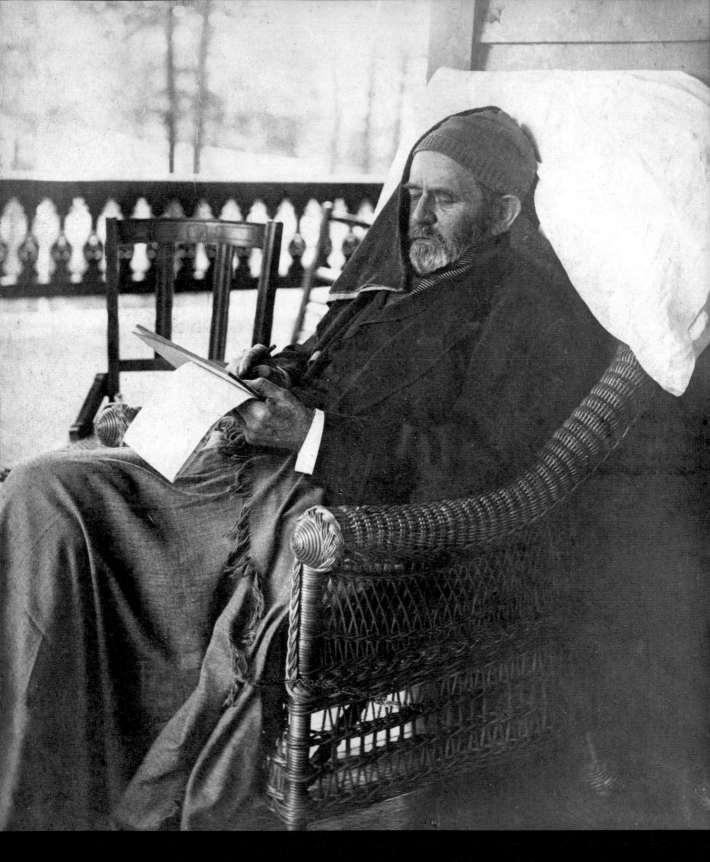

MT. McGregor, Wilton, New York 1885

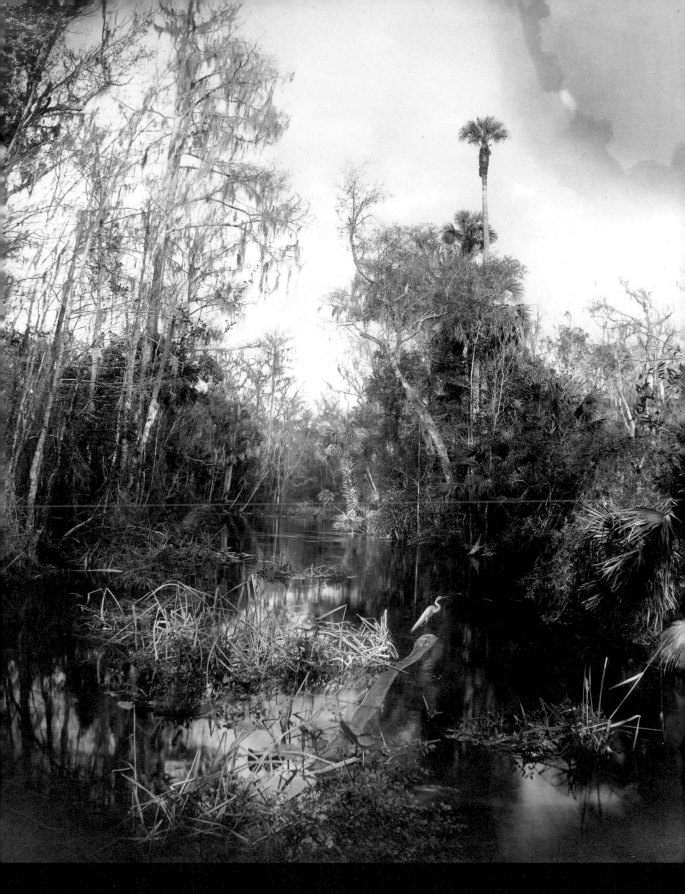

OCKLAWAHA RIVER, FLORIDA C. 1886

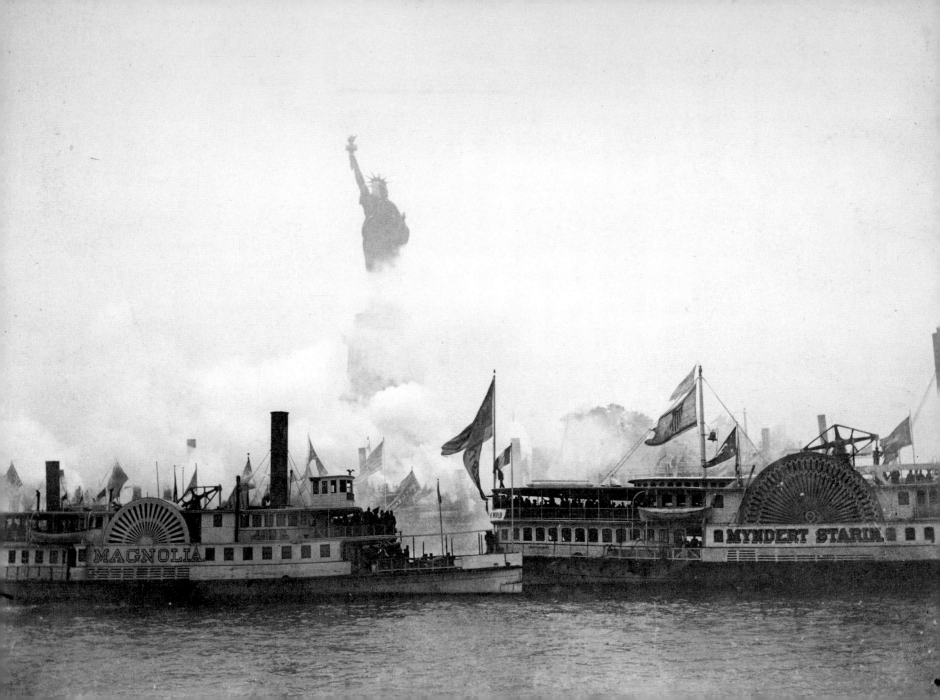

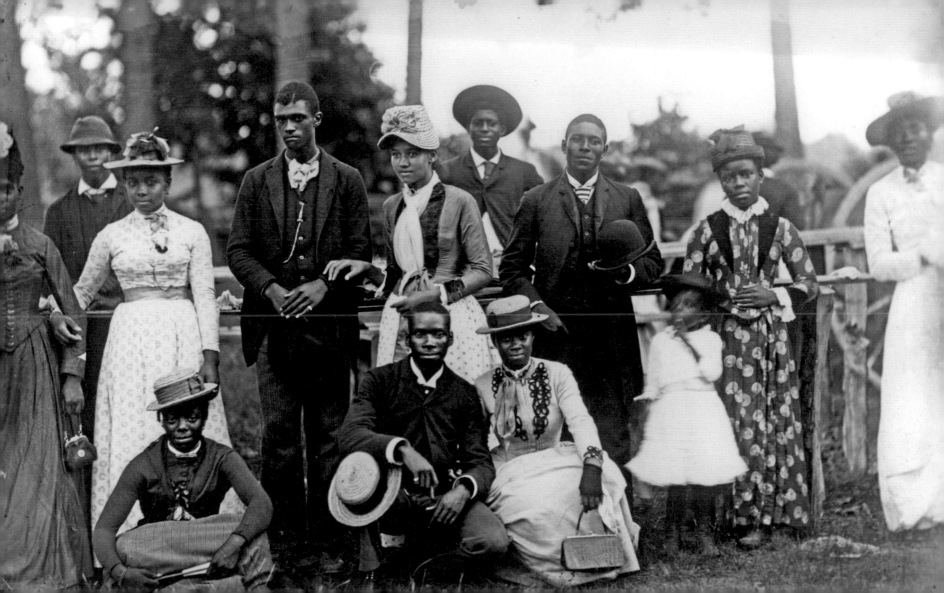

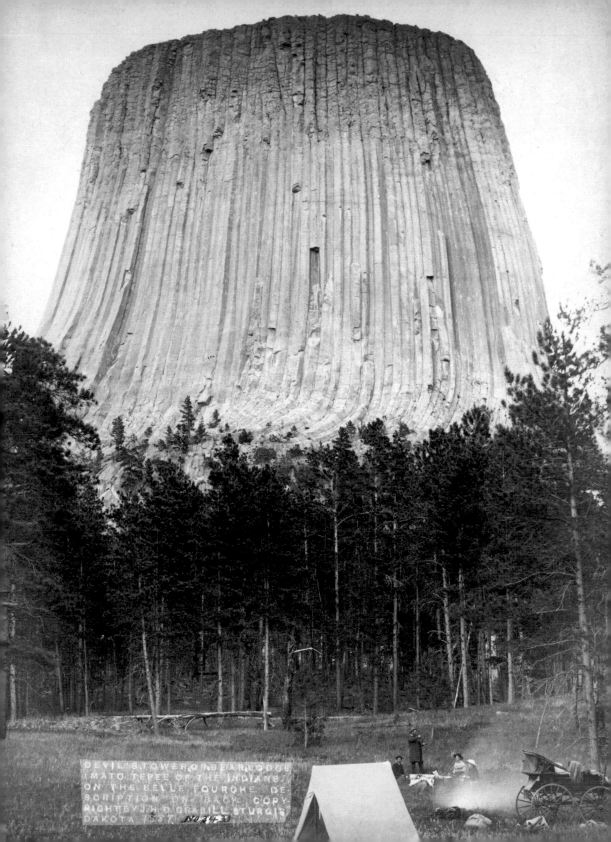

DEVIL'S TOWER OR BEAR LODGE
(MATO TEPEE OF THE INDIANS)
ON THE BELLE FOURCHE. DE
SCRIPTION ON BACK. COPY
RIGHT BY J.H.D. GRABILL STURGIS
DAKOTA 1897.

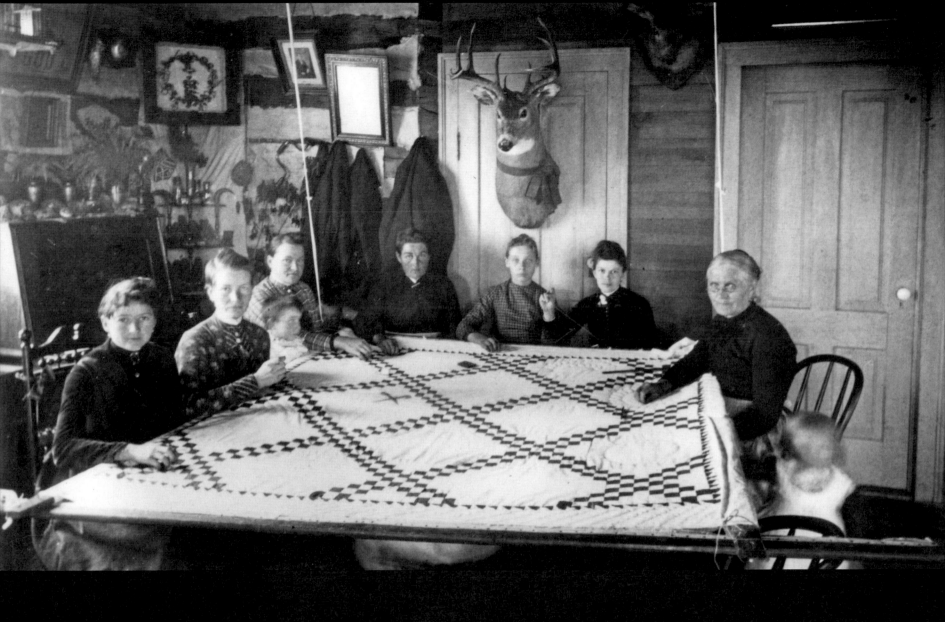

McHenry County, Dakota Territory 1888

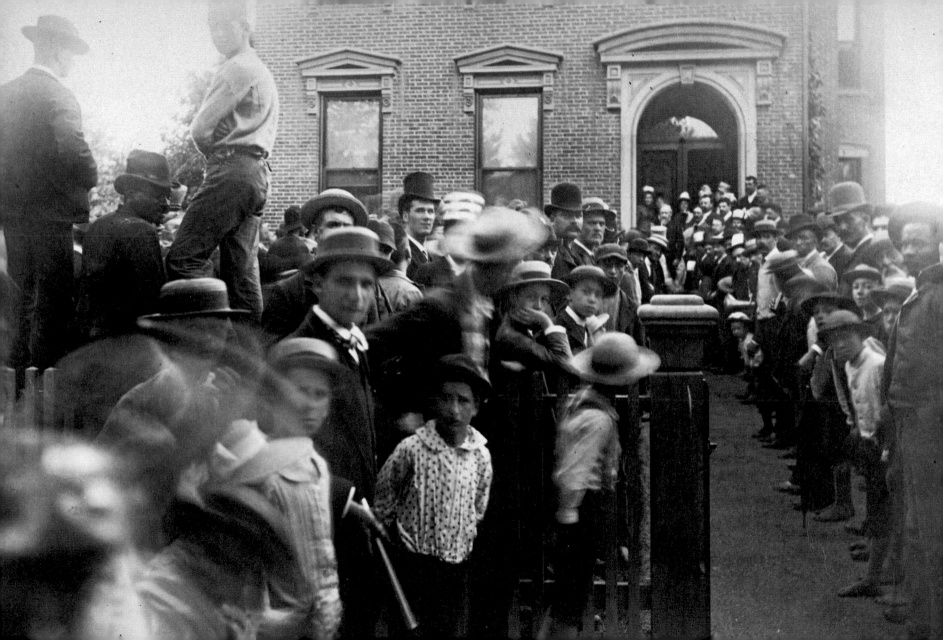

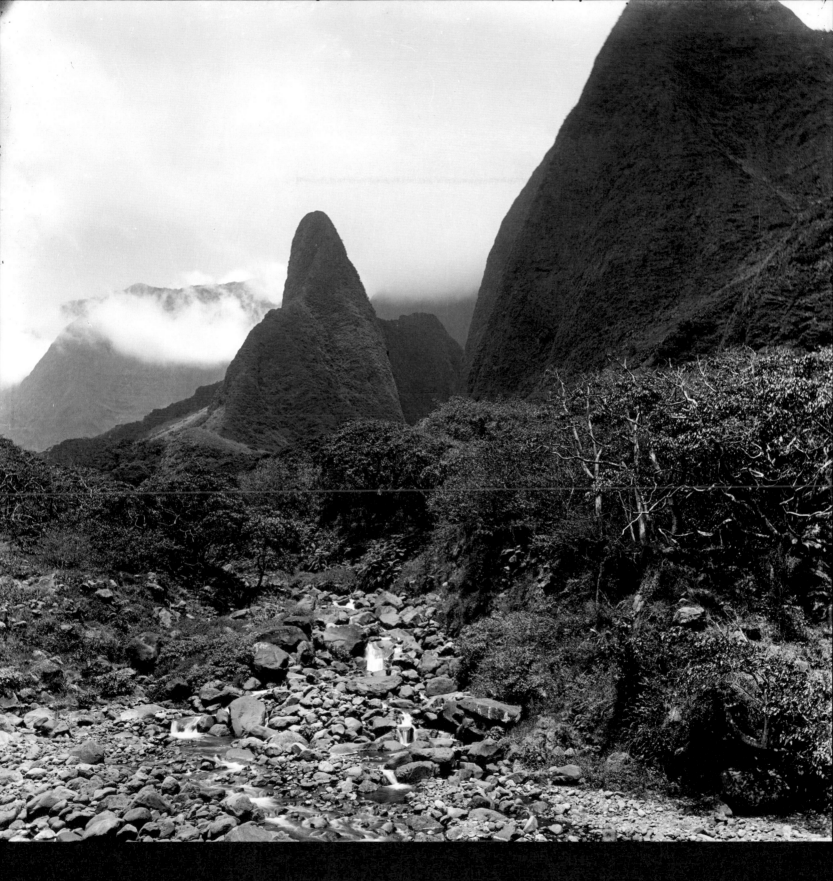

MAUI, HAWAII C. 1890

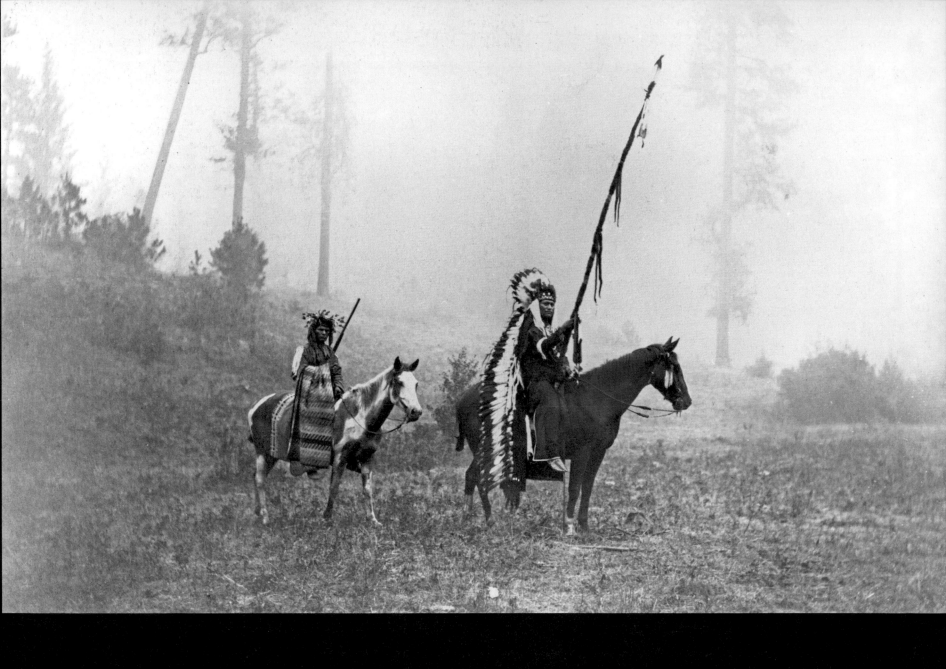

LAPWAI VALLEY, IDAHO C. 1890

70

CAMDEN, NEW JERSEY 1891

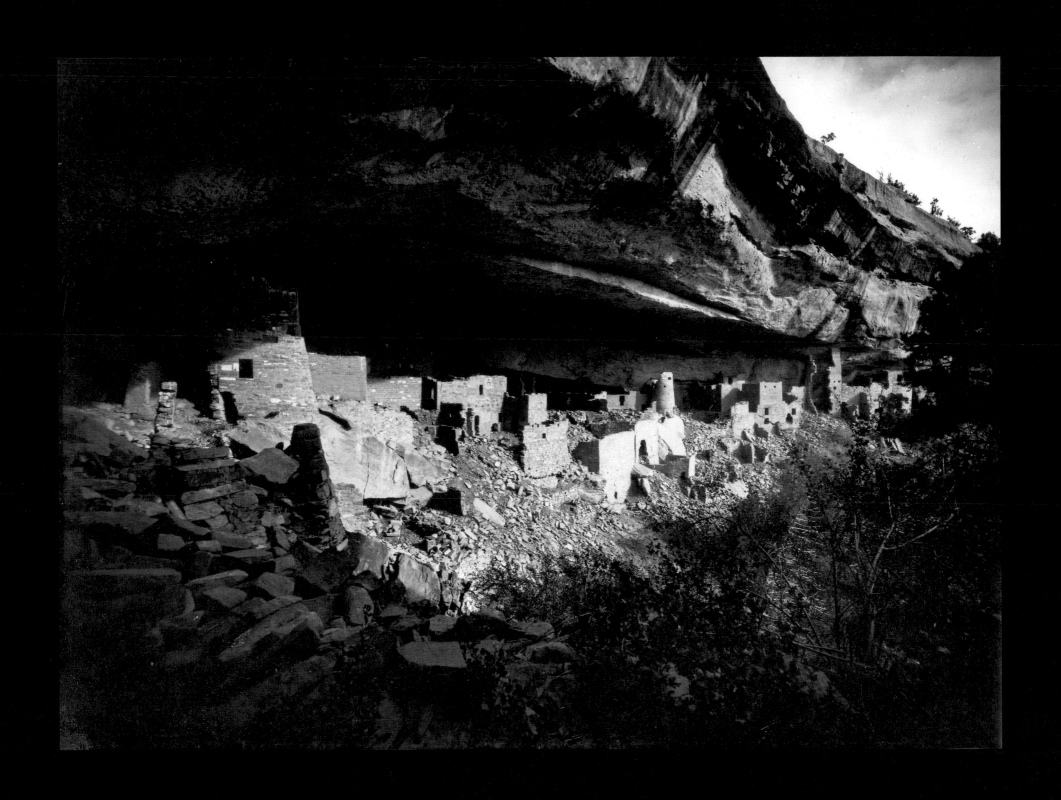

MESA VERDE, COLORADO C. 1890S

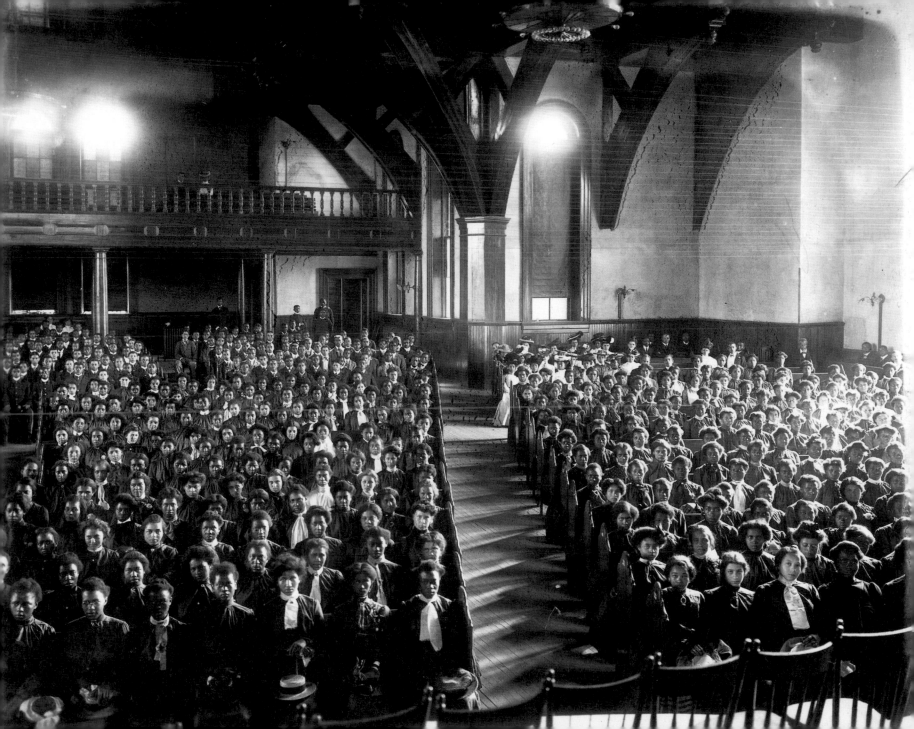

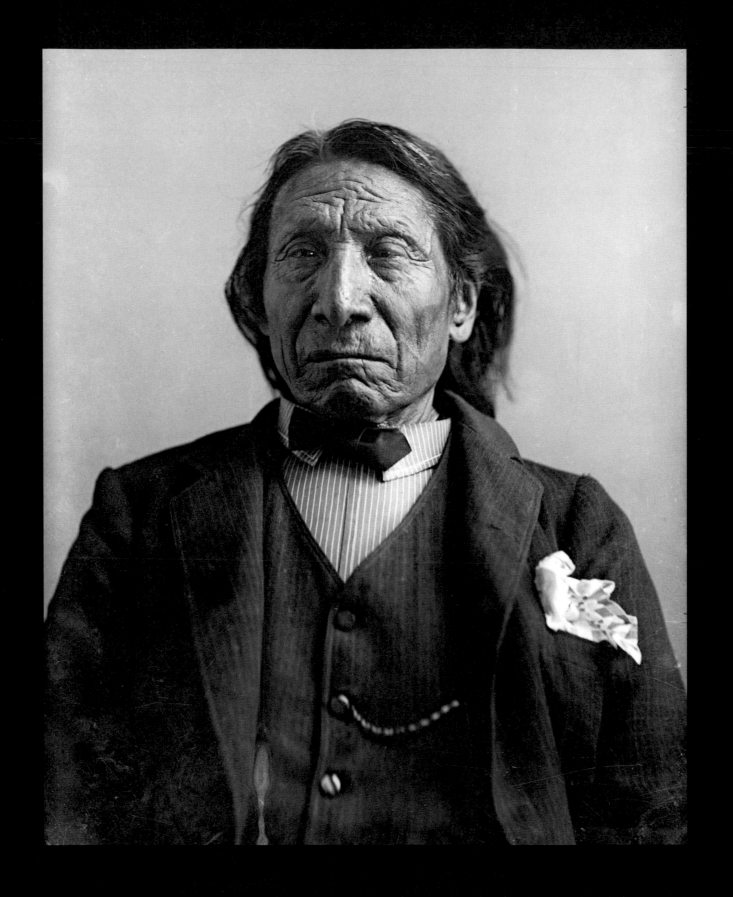

CHADRON, NEBRASKA 1891

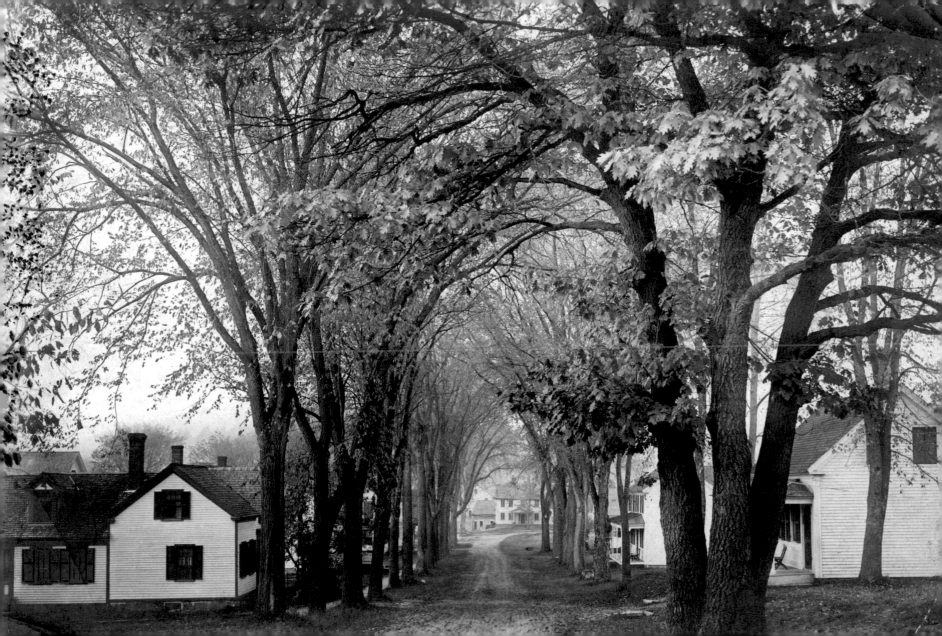

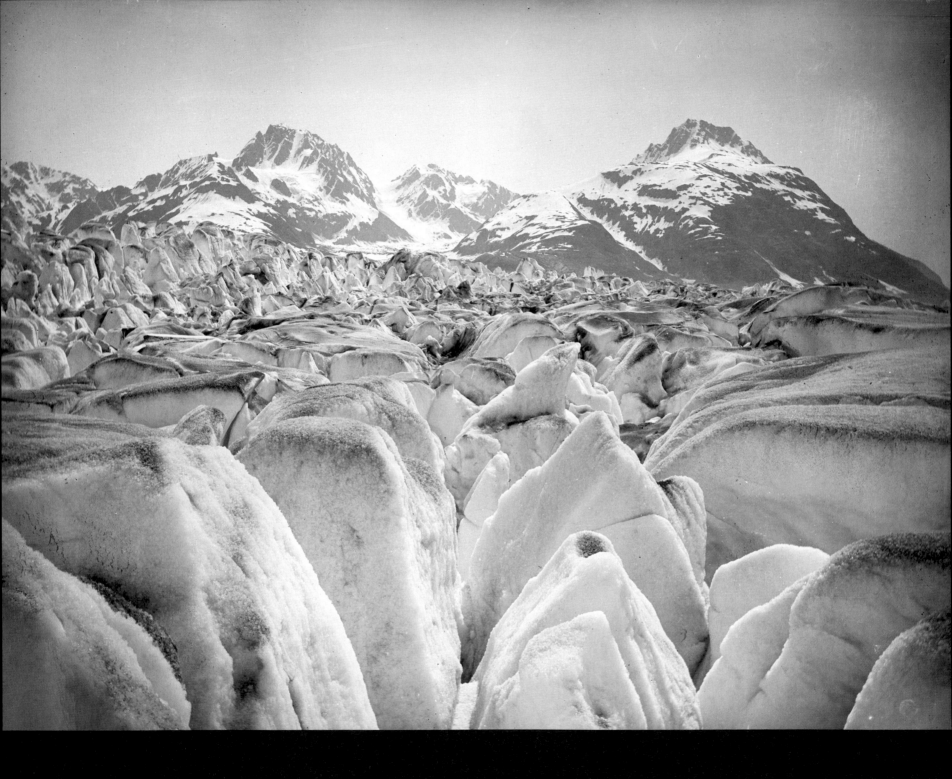

Muir Glacier, Alaska 1891

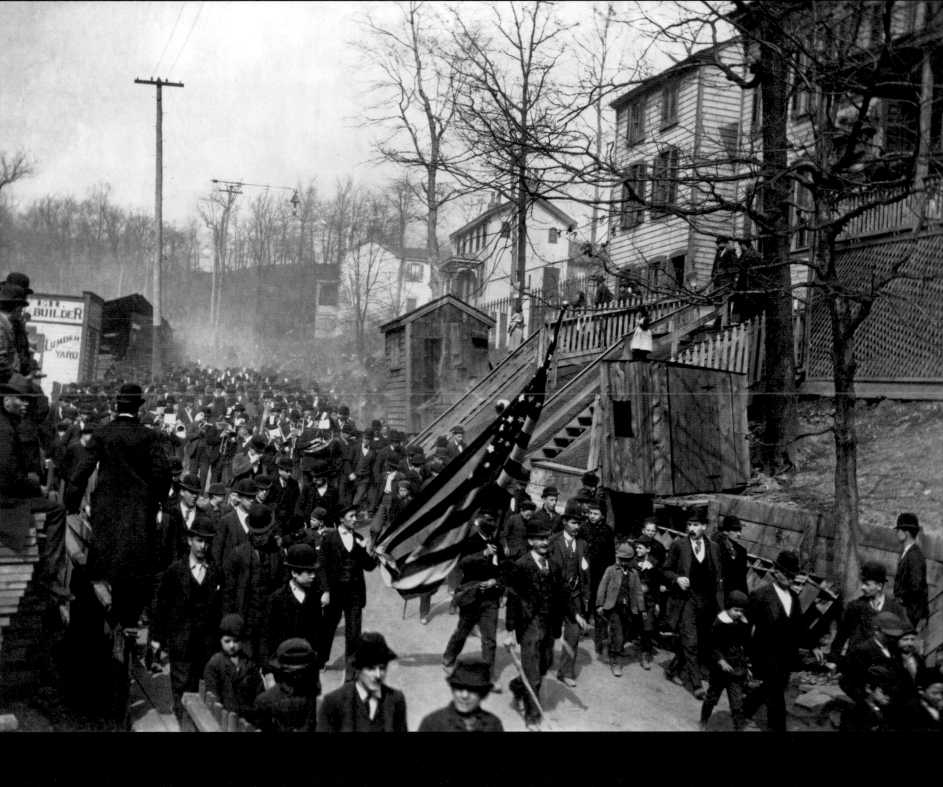

OUTSIDE PITTSBURGH, PENNSYLVANIA 1894

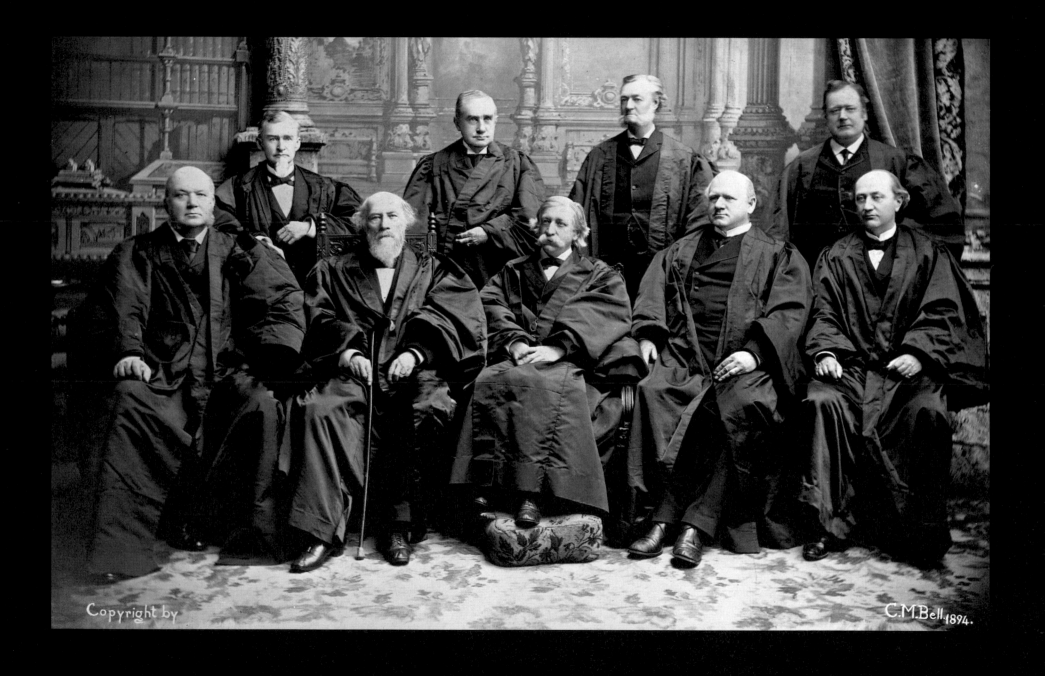

WASHINGTON, D.C. 1894

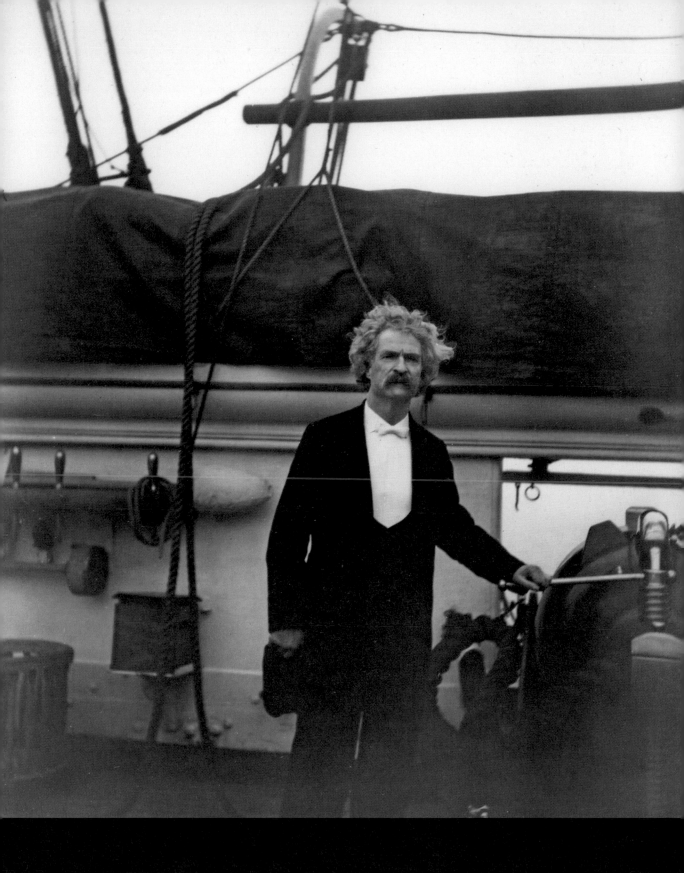

SEATTLE, WASHINGTON 1895

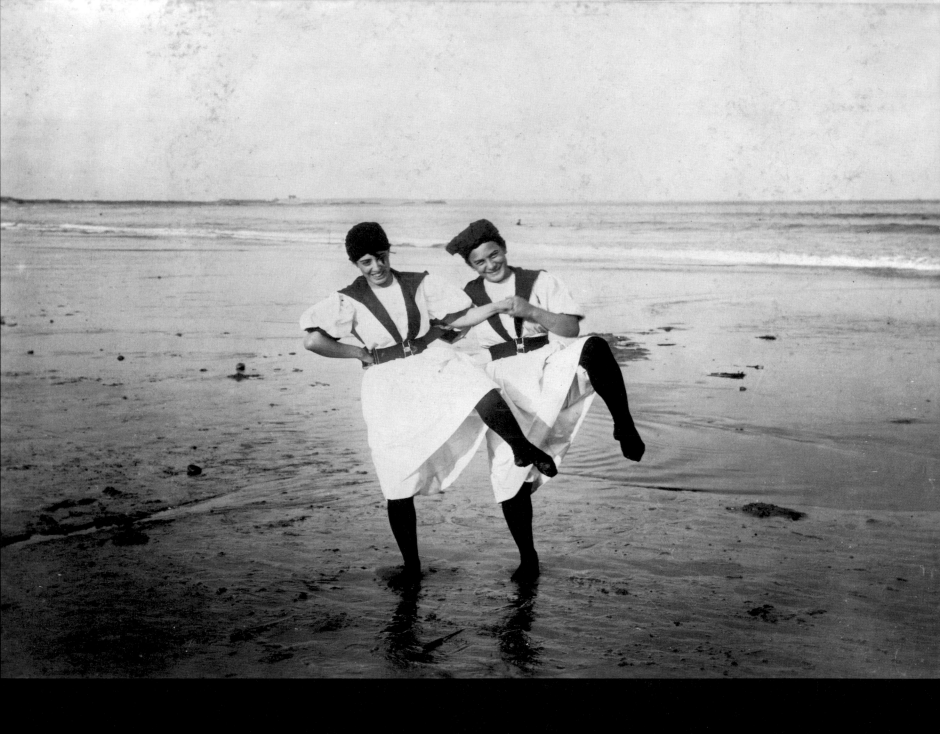

JAMESTOWN, RHODE ISLAND c. 1897

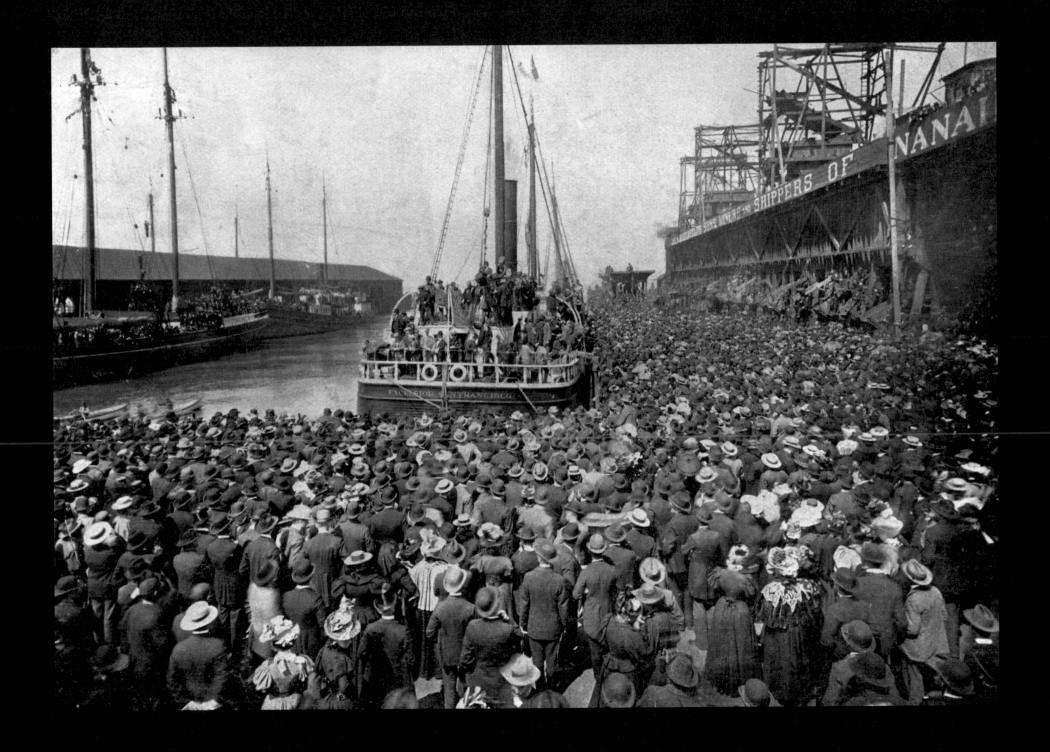

SAN FRANCISCO, CALIFORNIA 1897

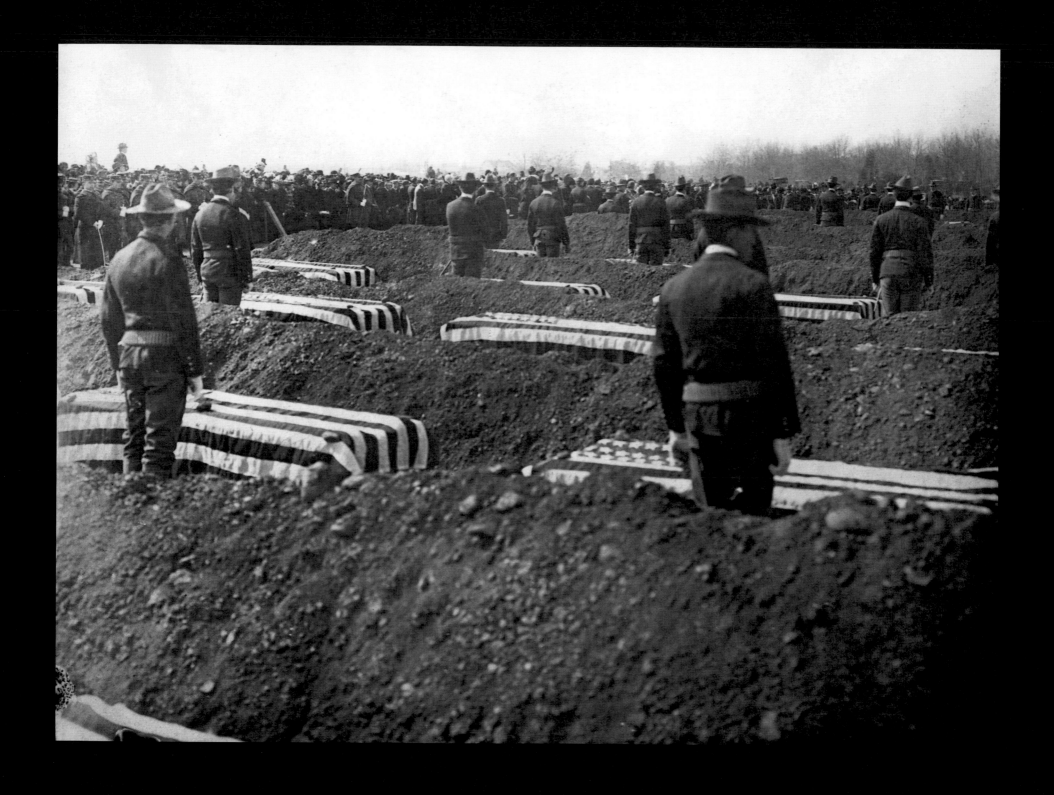

ARLINGTON, VIRGINIA 1899

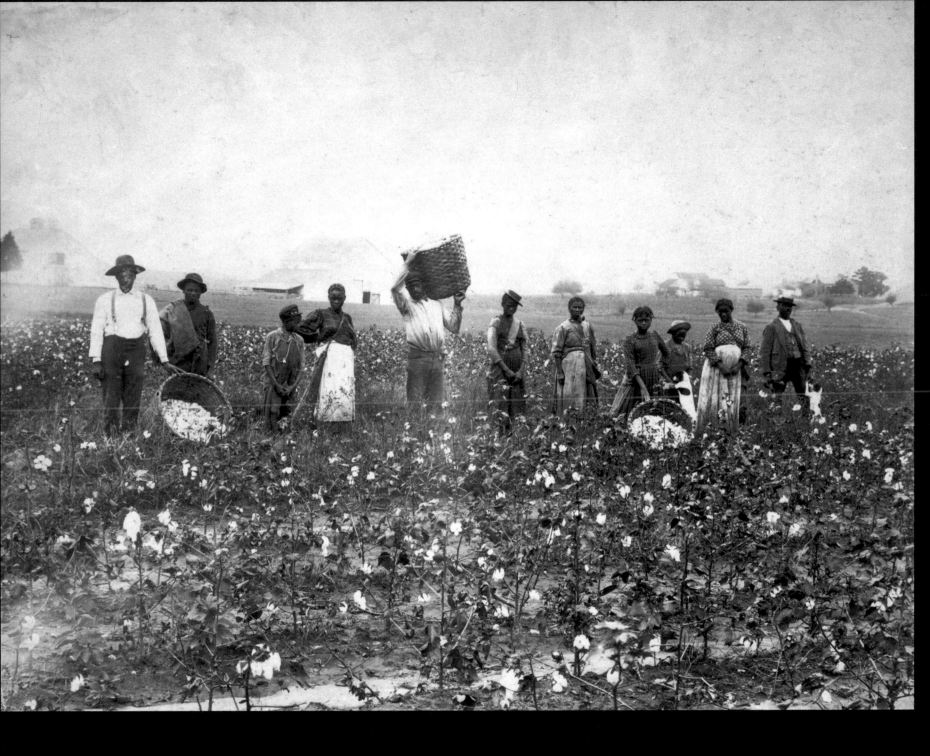

CHARLOTTE, NORTH CAROLINA 1900

83

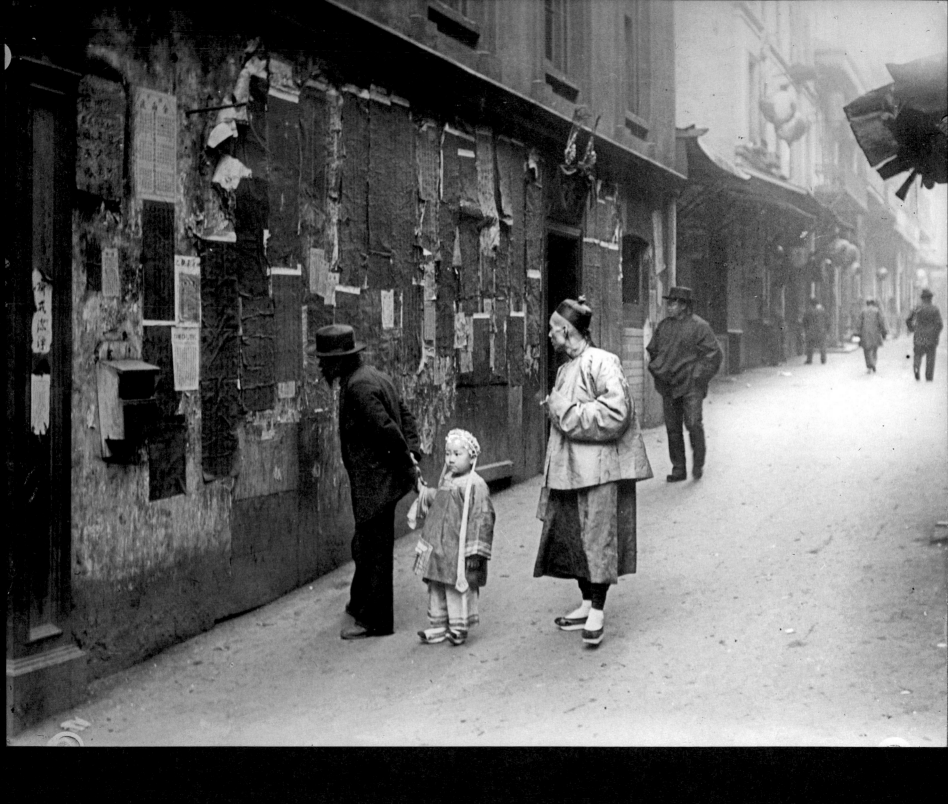

San Francisco, California c. 1900

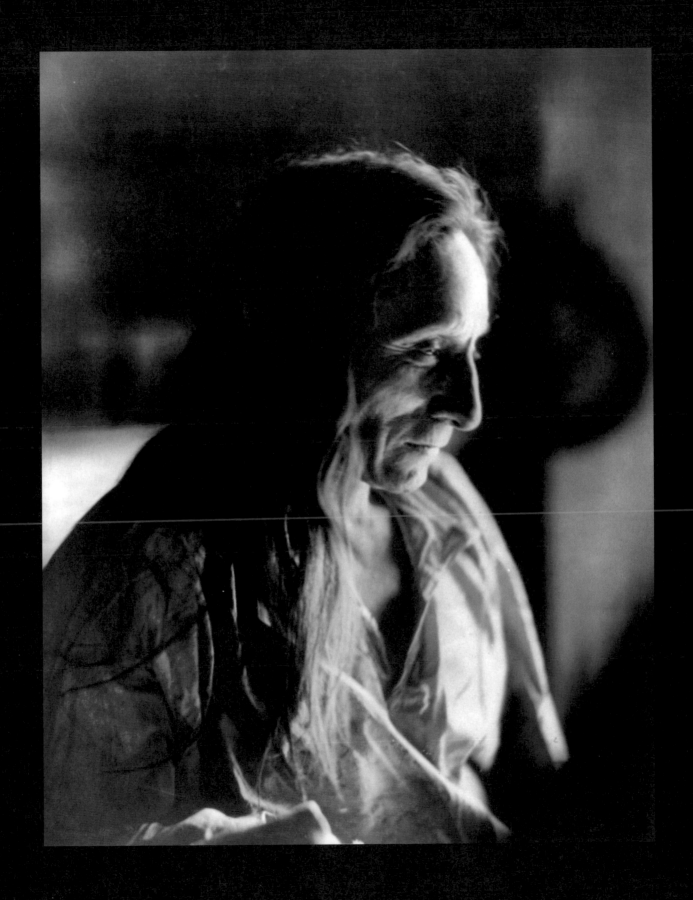

OMAHA, NEBRASKA 1900

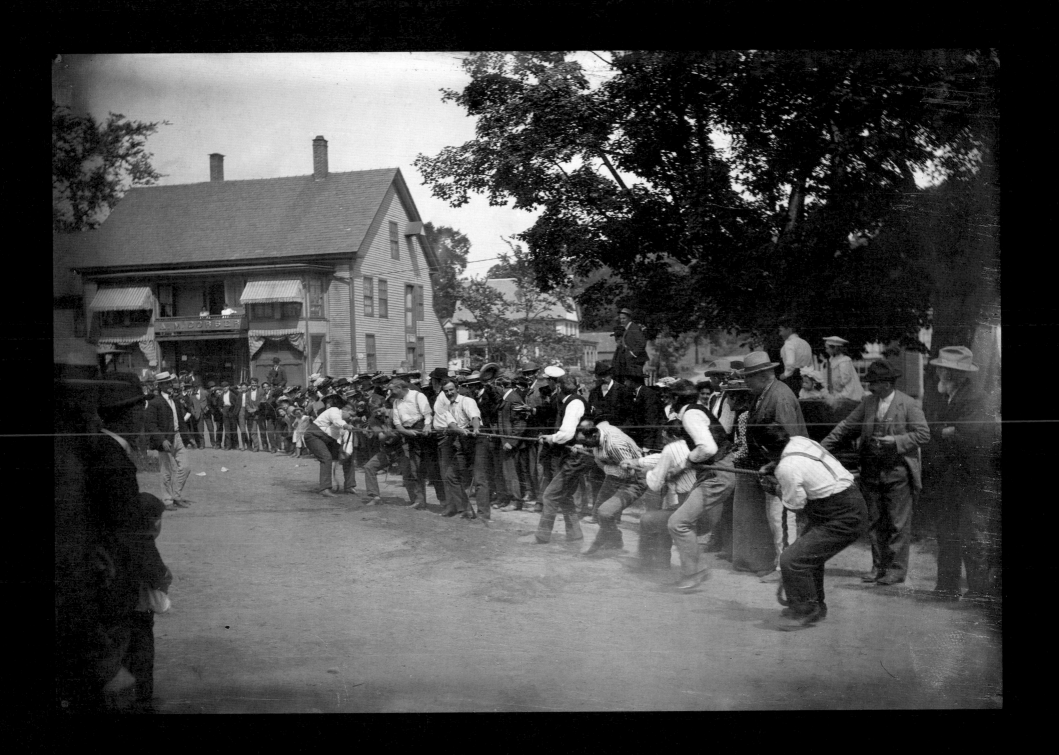

PUTNEY, VERMONT C. 1900

HARTFORD, CONNECTICUT 1900

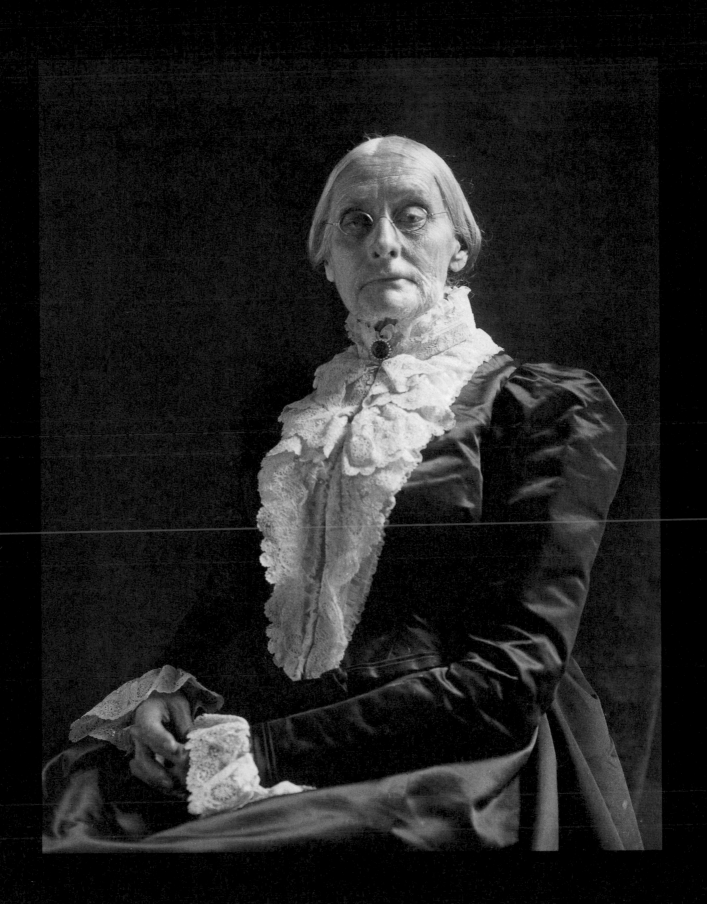

WASHINGTON, D.C. C. 1900

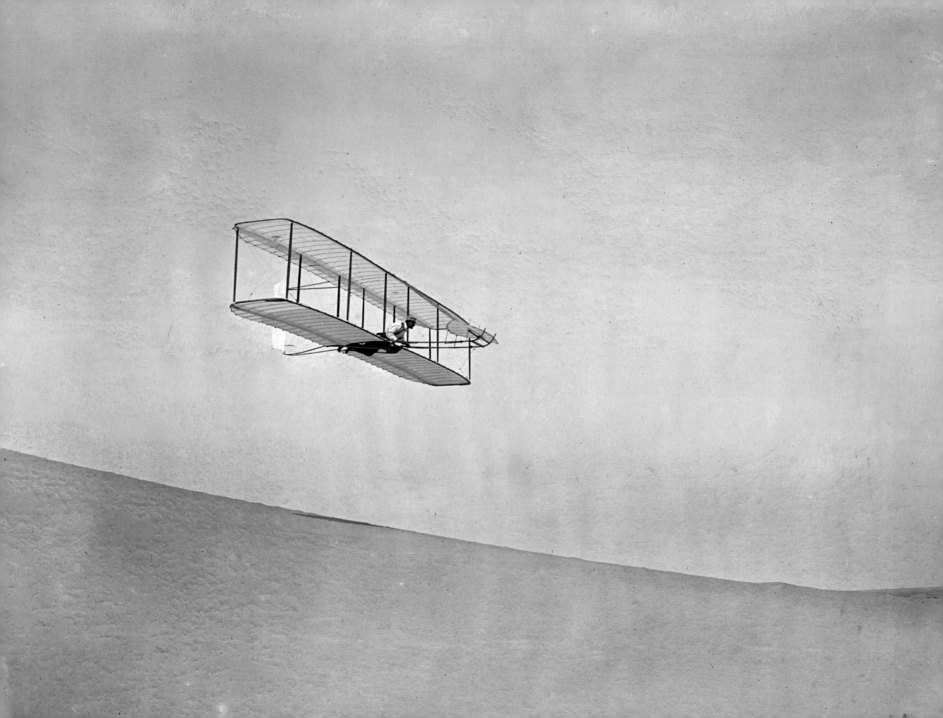

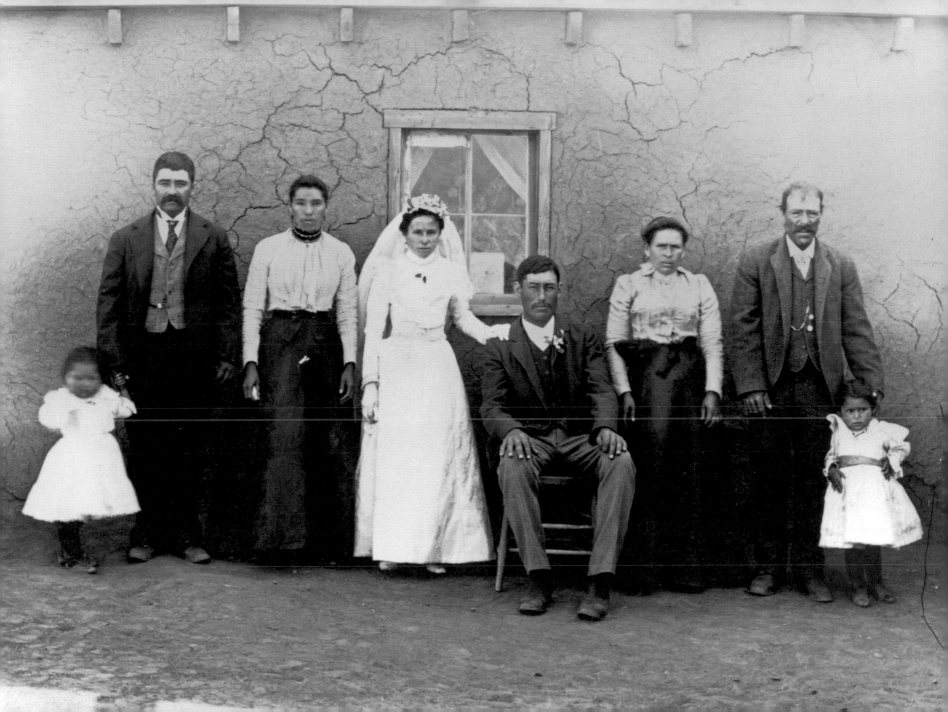

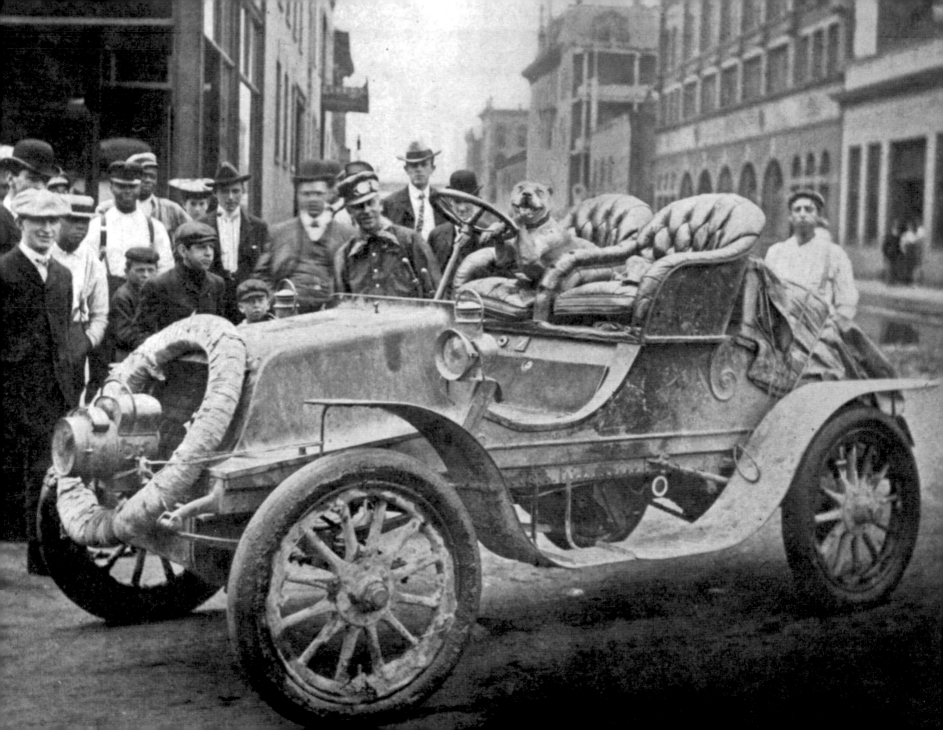

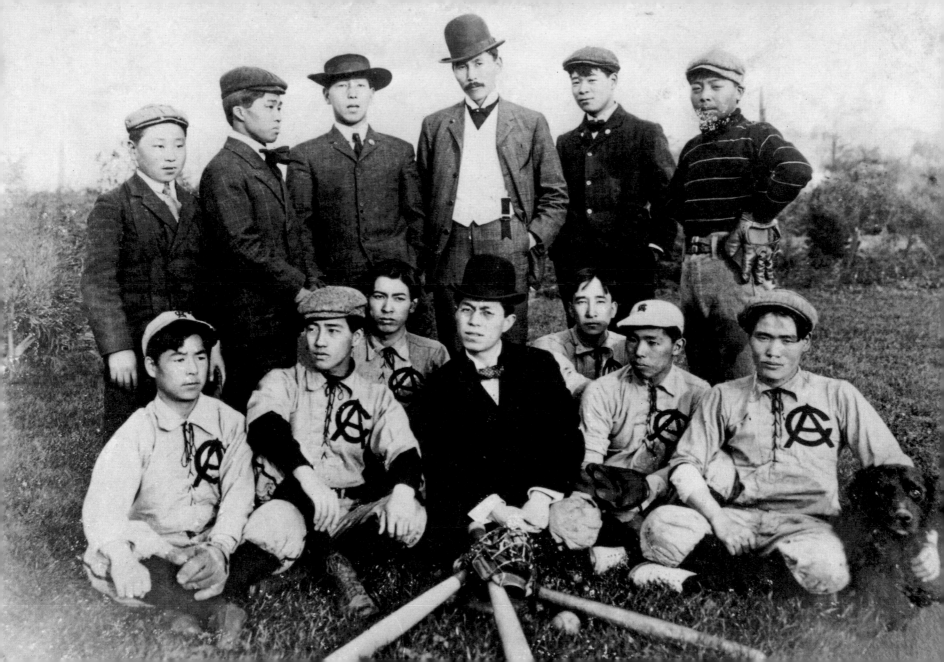

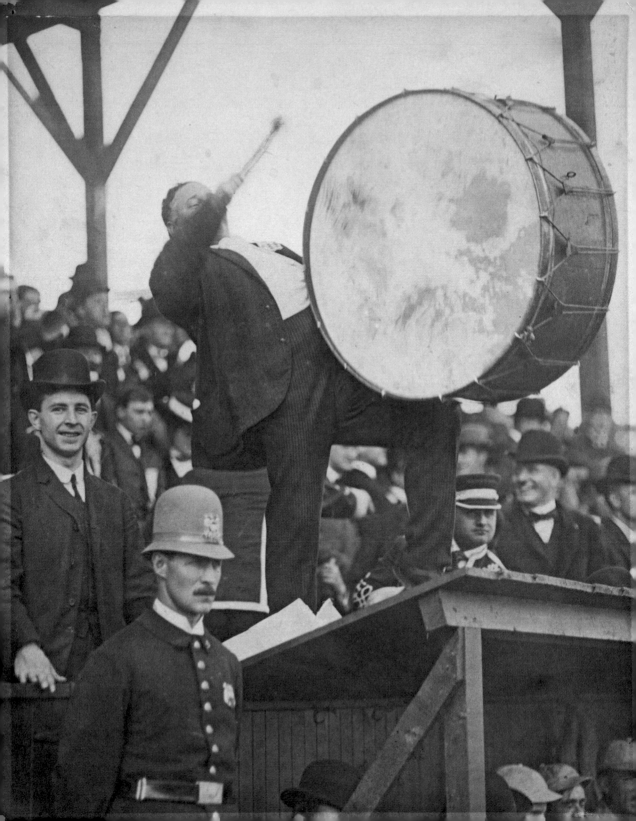

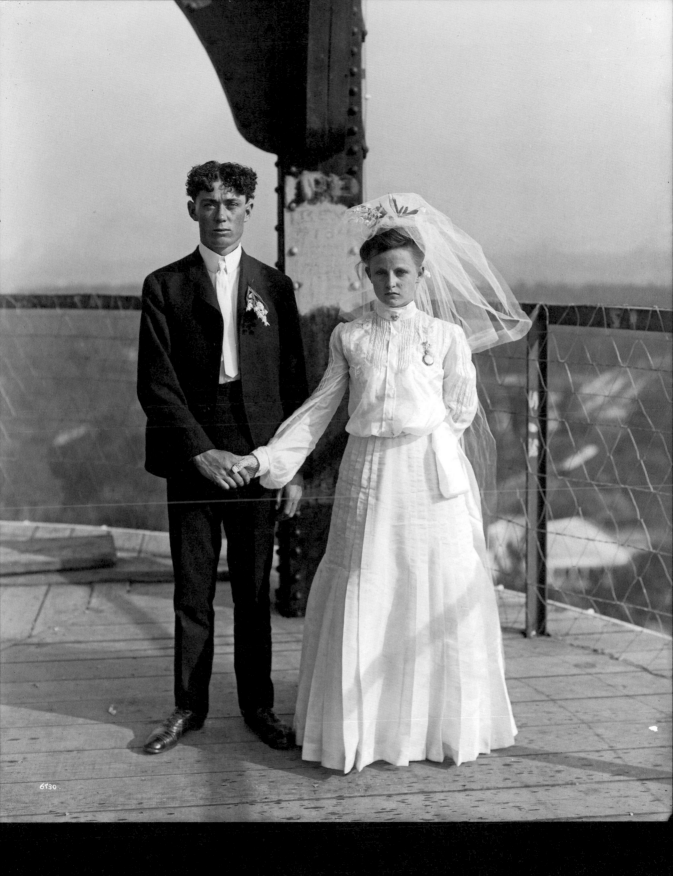

ST. LOUIS, MISSOURI 1904

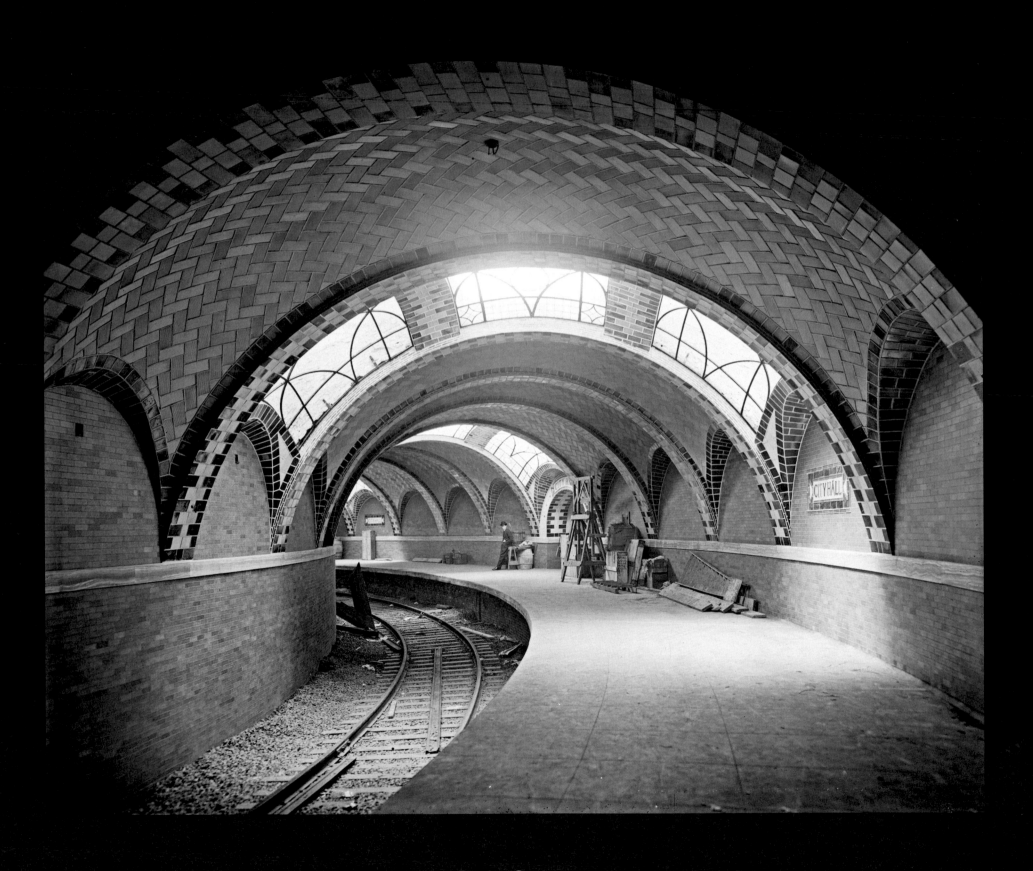

NEW YORK CITY C. 1904

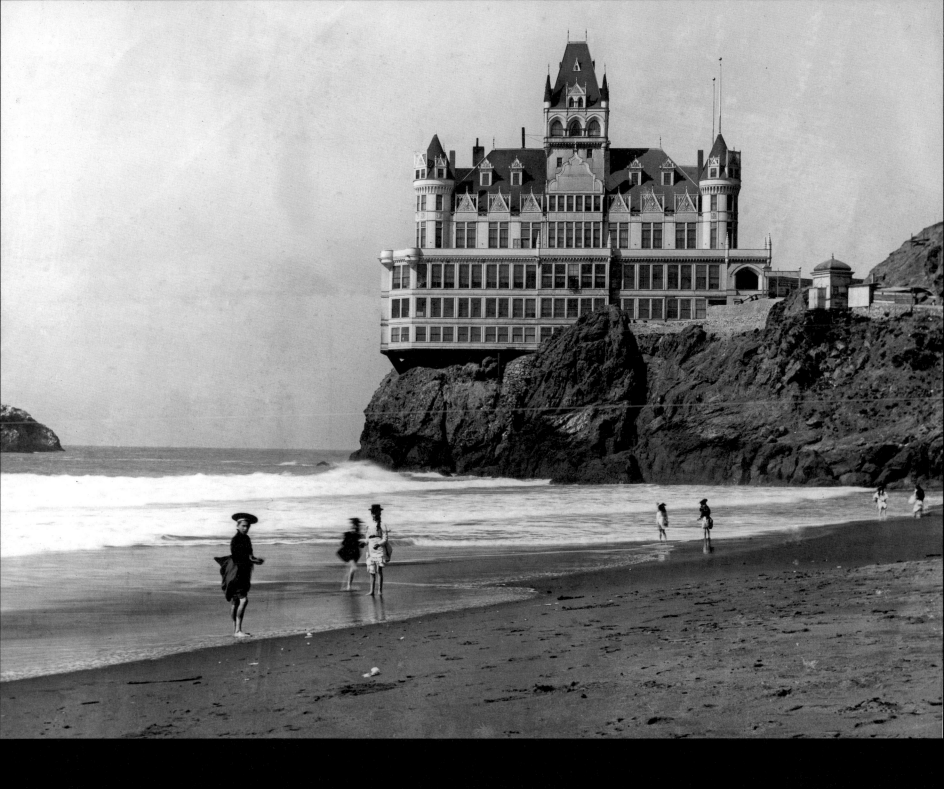

SAN FRANCISCO, CALIFORNIA EARLY 1900S

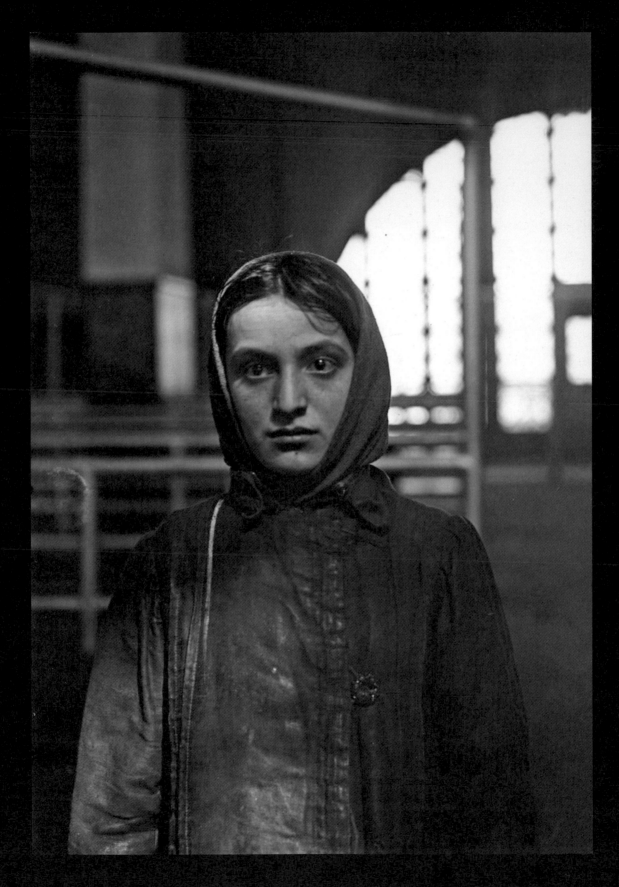

ELLIS ISLAND, NEW YORK 1905

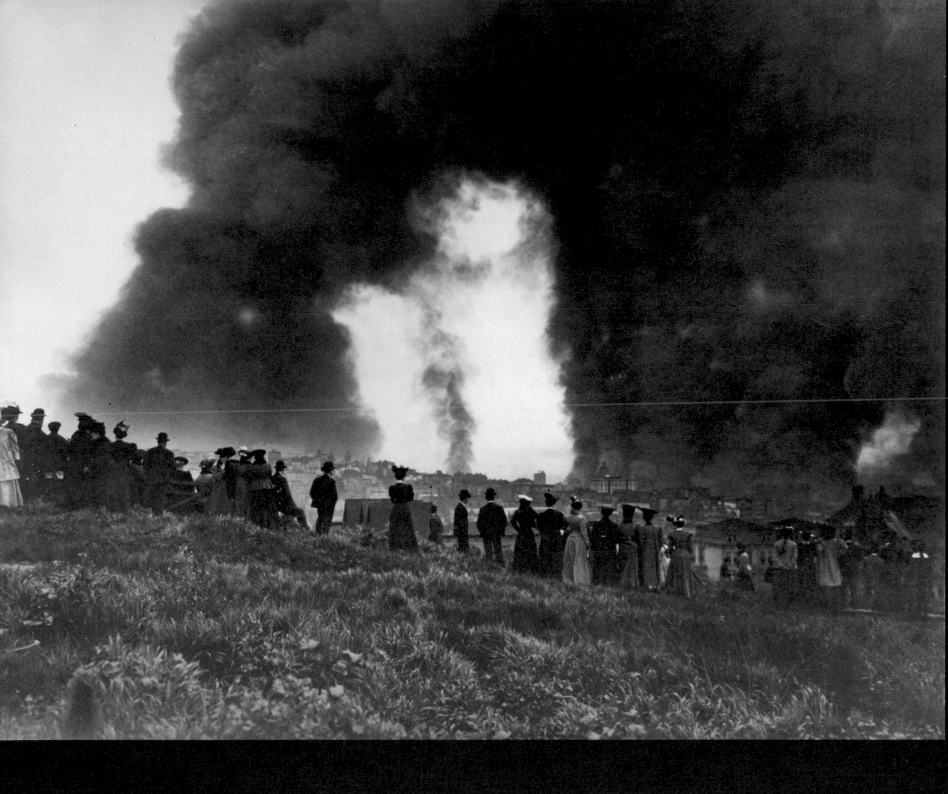

SAN FRANCISCO, CALIFORNIA 1906

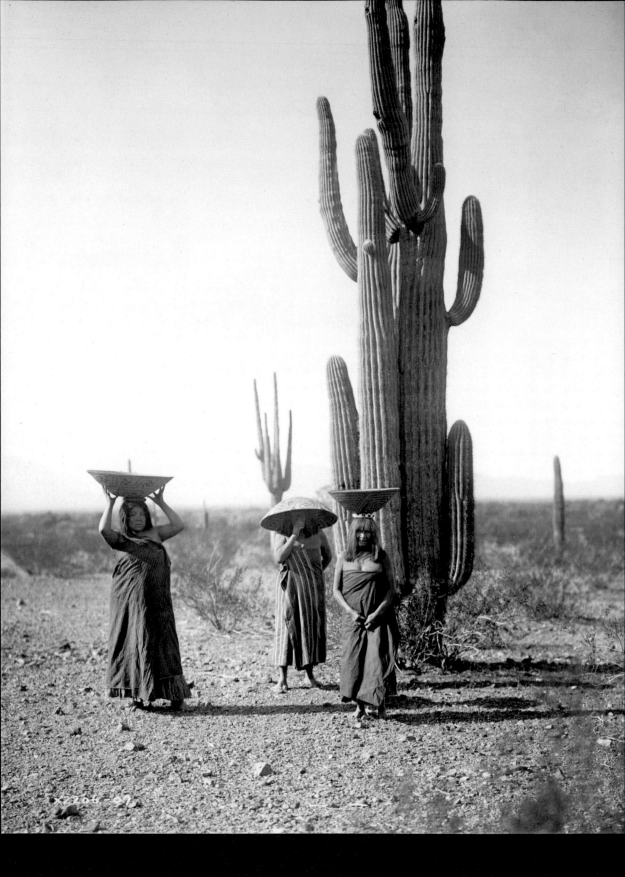

GILA RIVER VALLEY, ARIZONA C. 1907

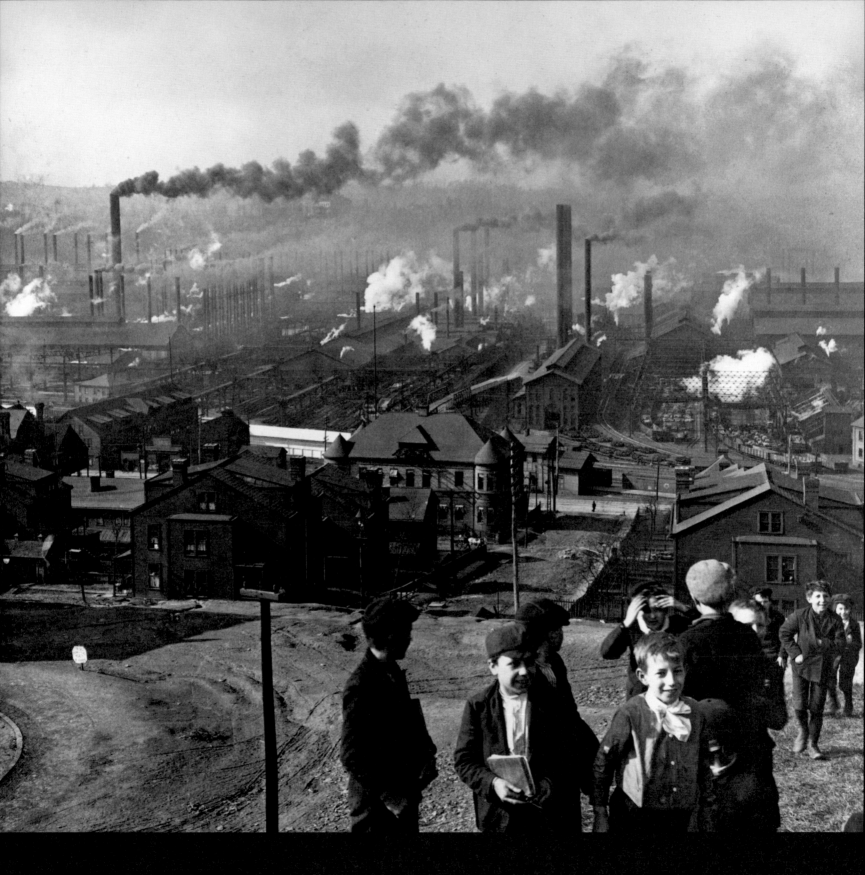

HOMESTEAD, PENNSYLVANIA 1907

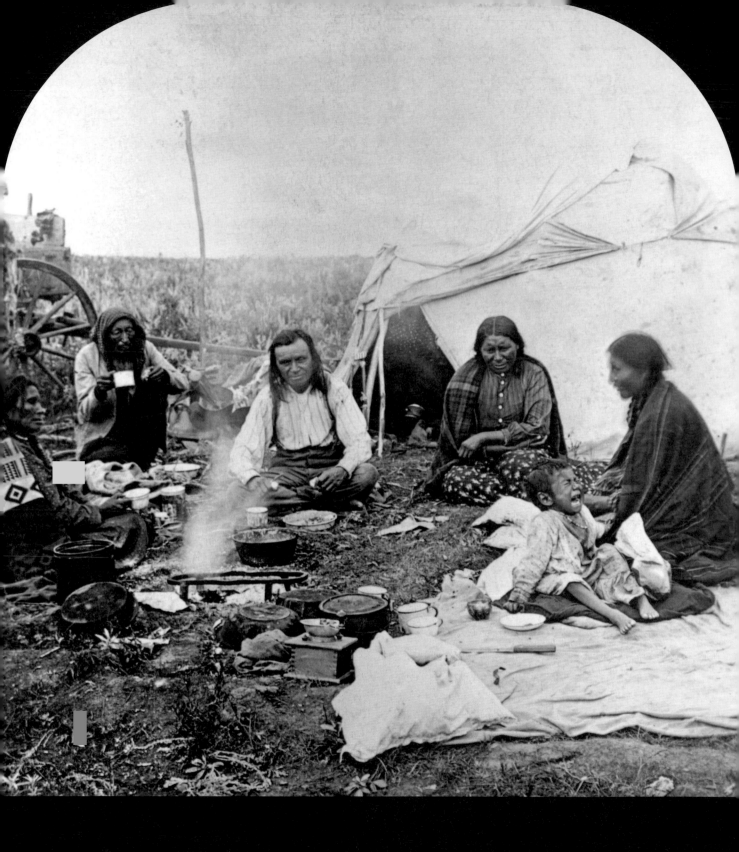

STANDING ROCK RESERVATION, NORTH DAKOTA C. 1908

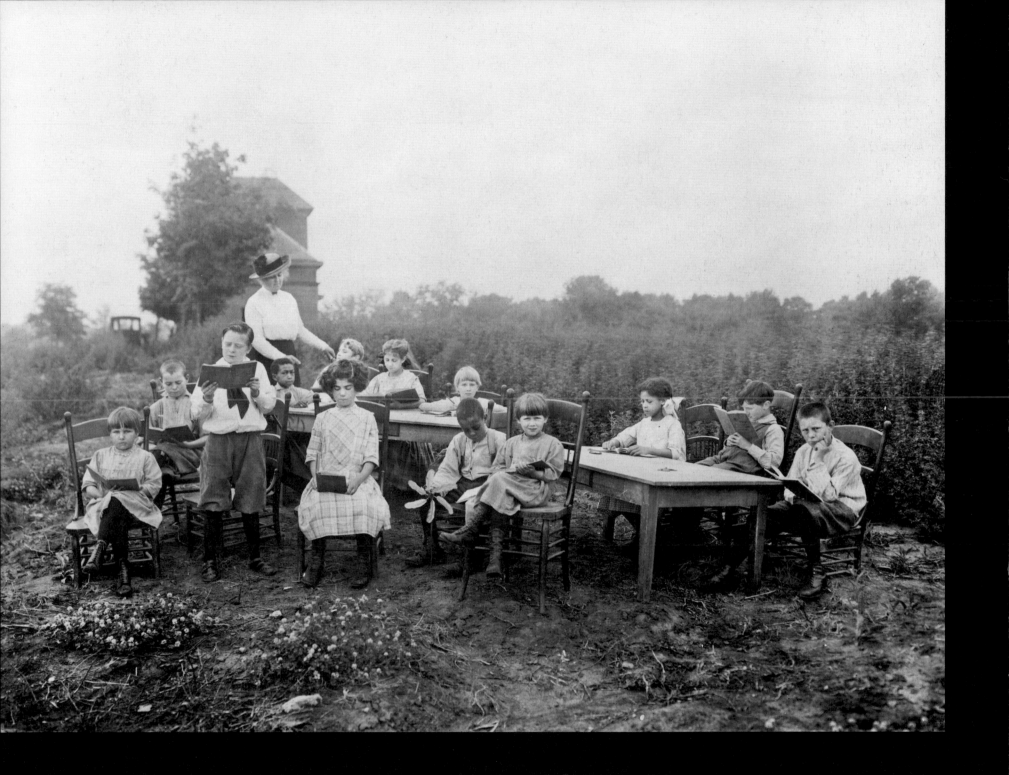

CINCINNATI, OHIO C. 1908

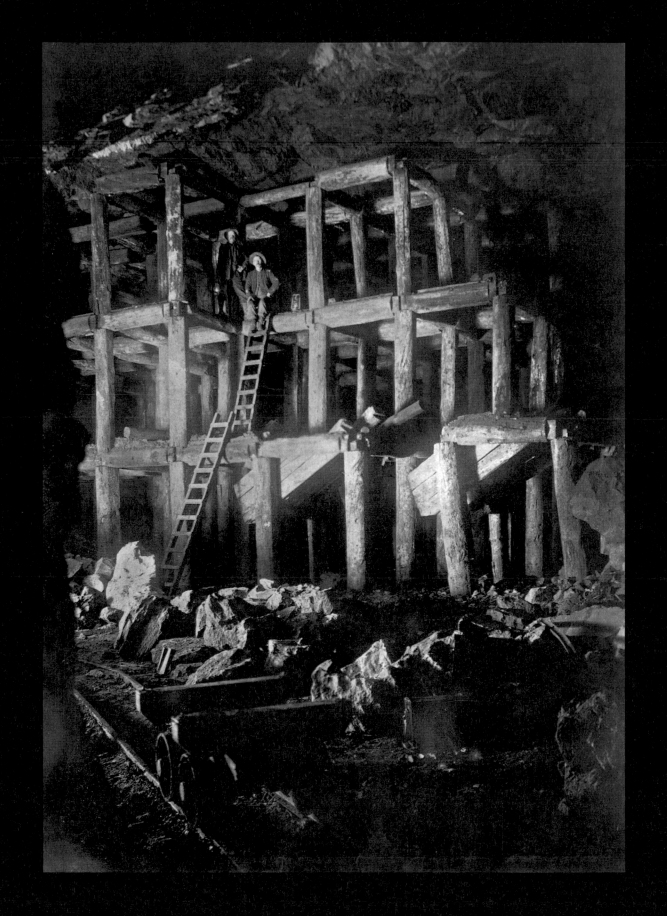

LEAD, SOUTH DAKOTA C. 1908

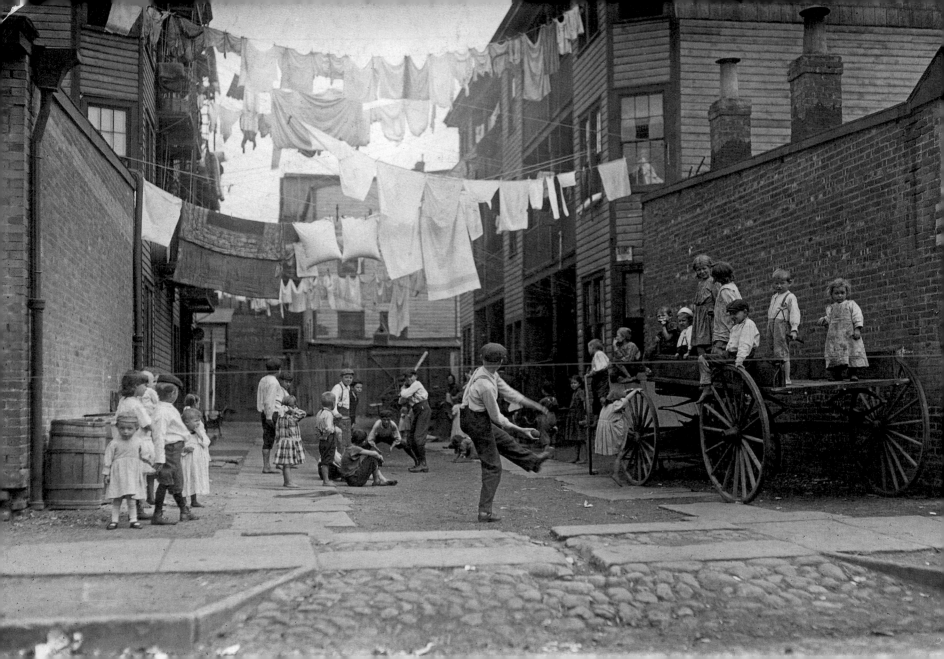

VIRGINIA OR NORTH CAROLINA 1909

Saranac Lake, New York c. 1909

DETROIT, MICHIGAN C. 1910

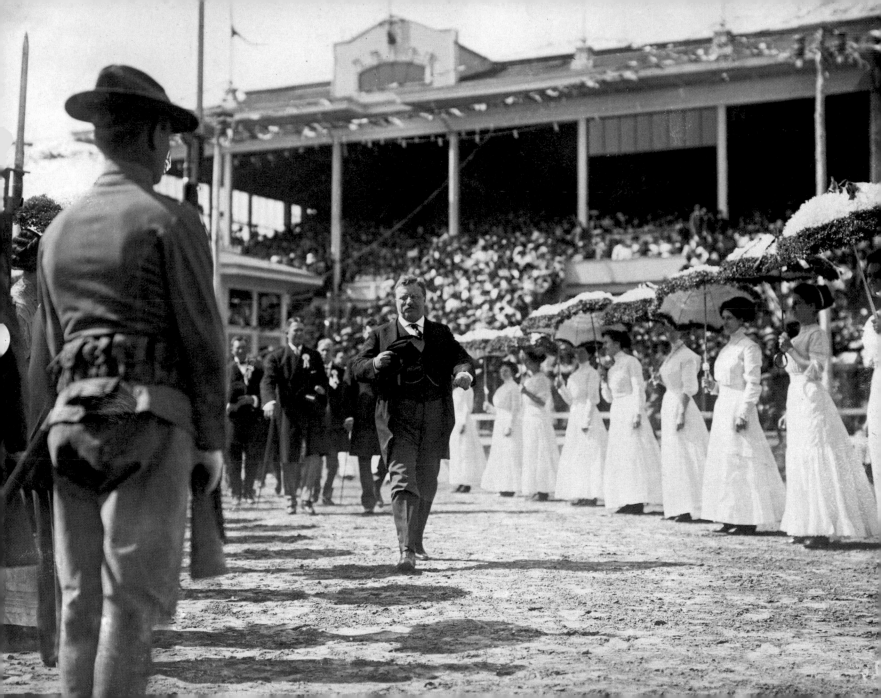

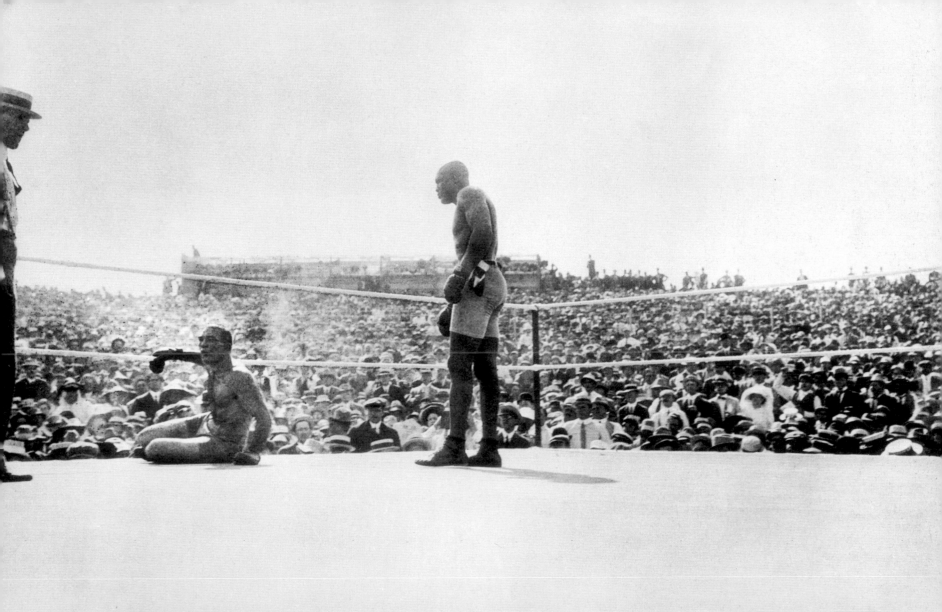

SADORUS, ILLINOIS 1910

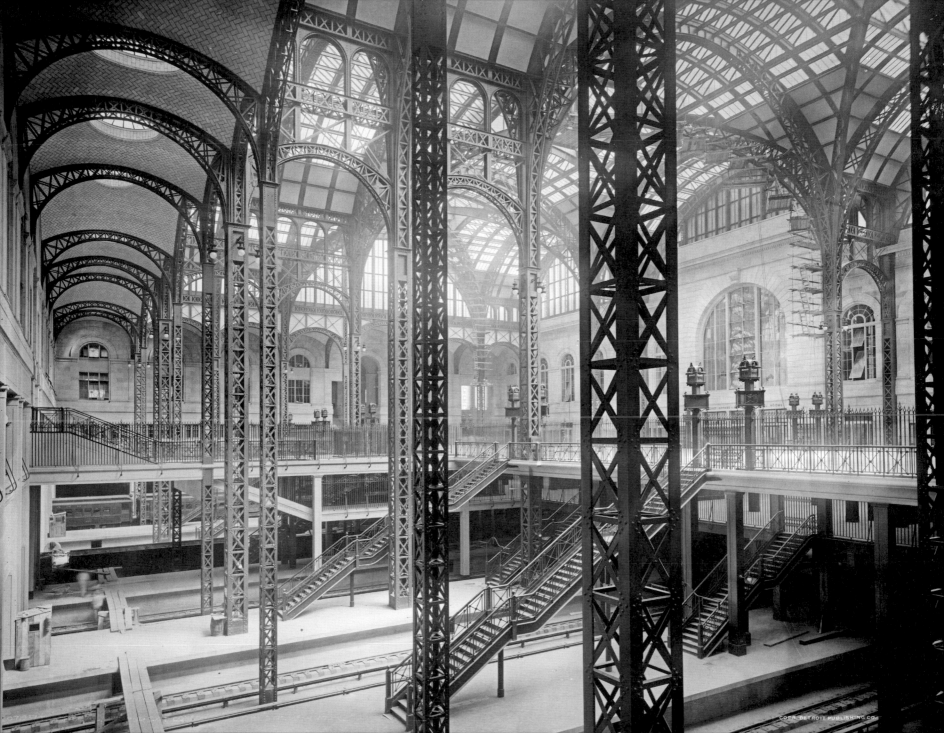

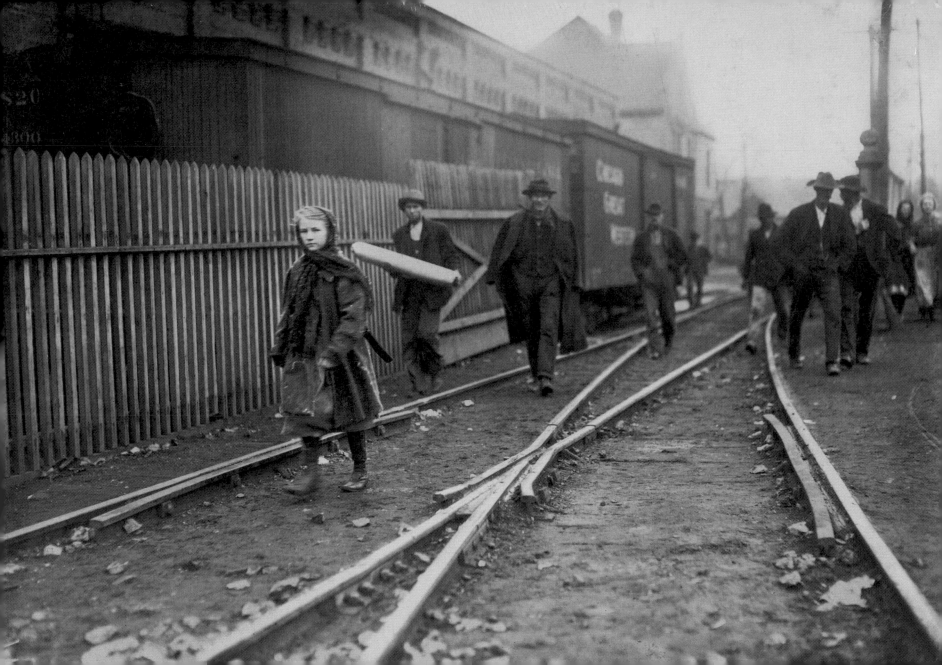

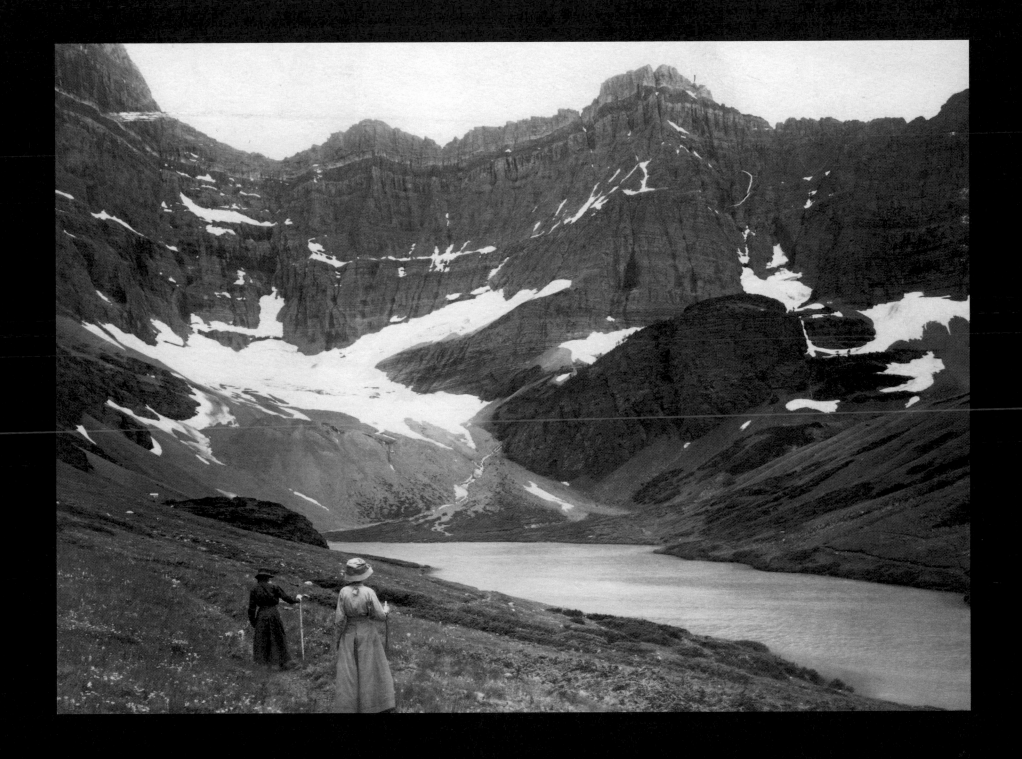

GLACIER NATIONAL PARK, MONTANA EARLY 1910S

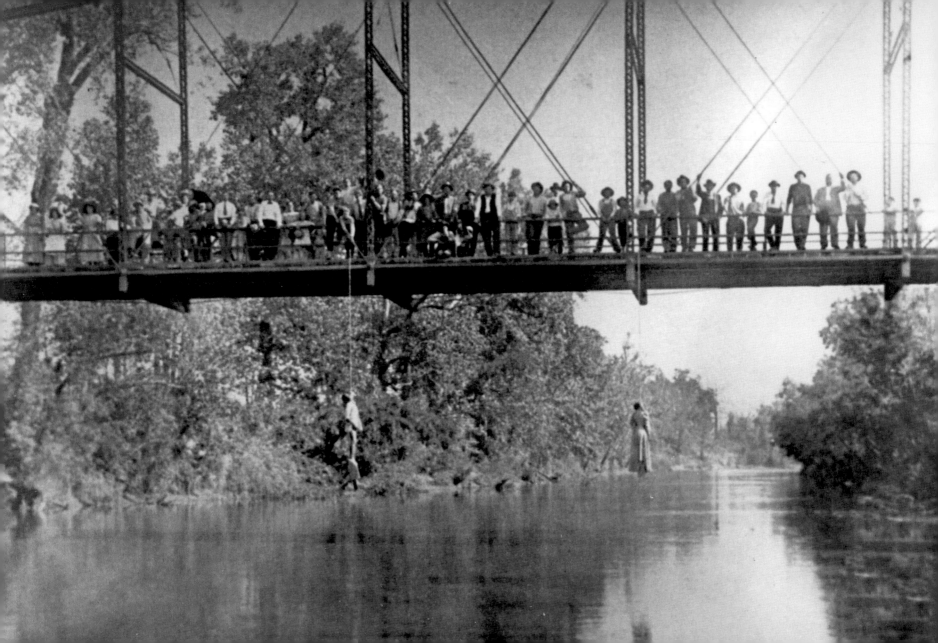

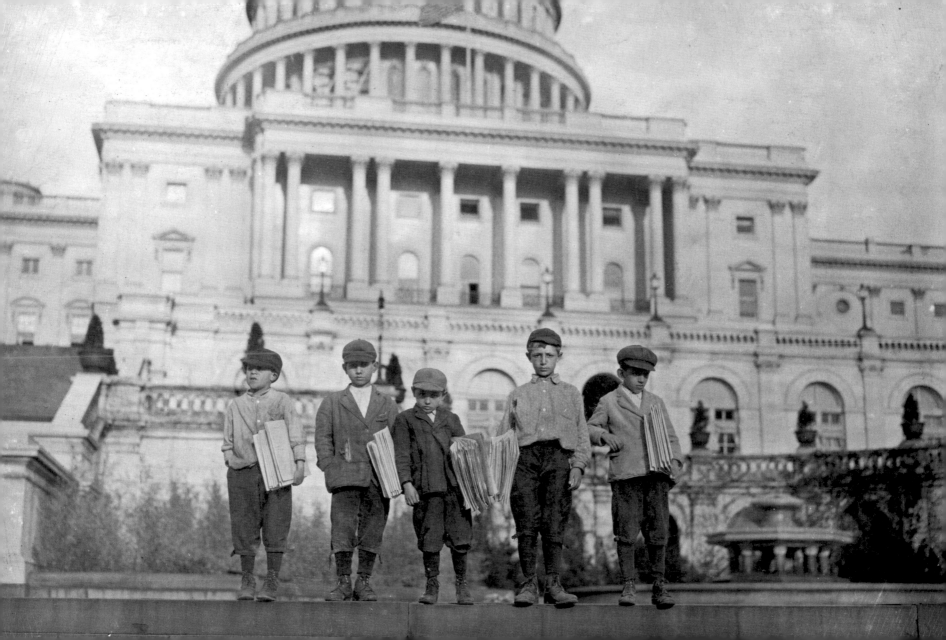

NEW ORLEANS, LOUISIANA 1912

NEW YORK CITY 1912

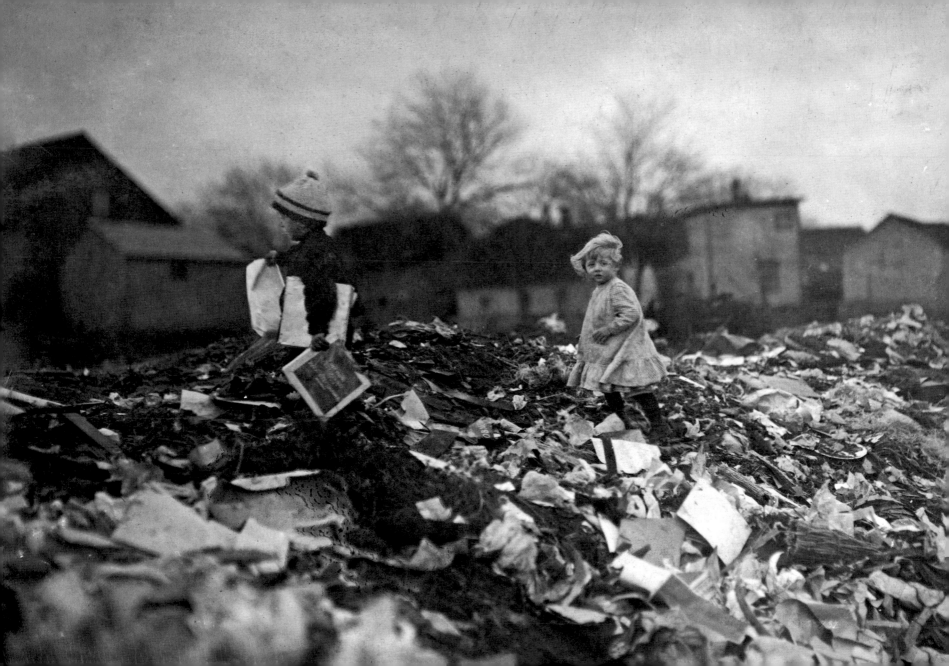

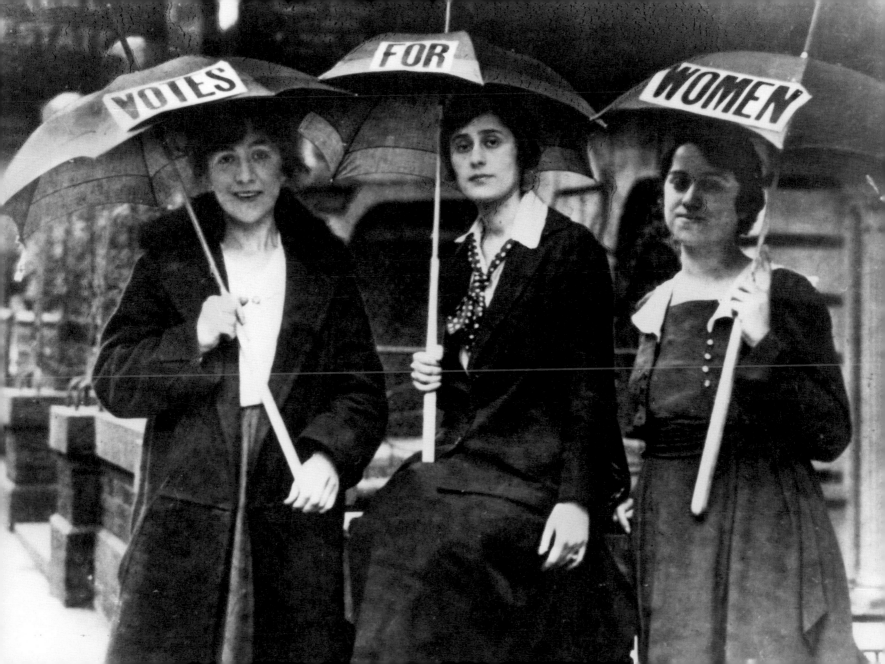

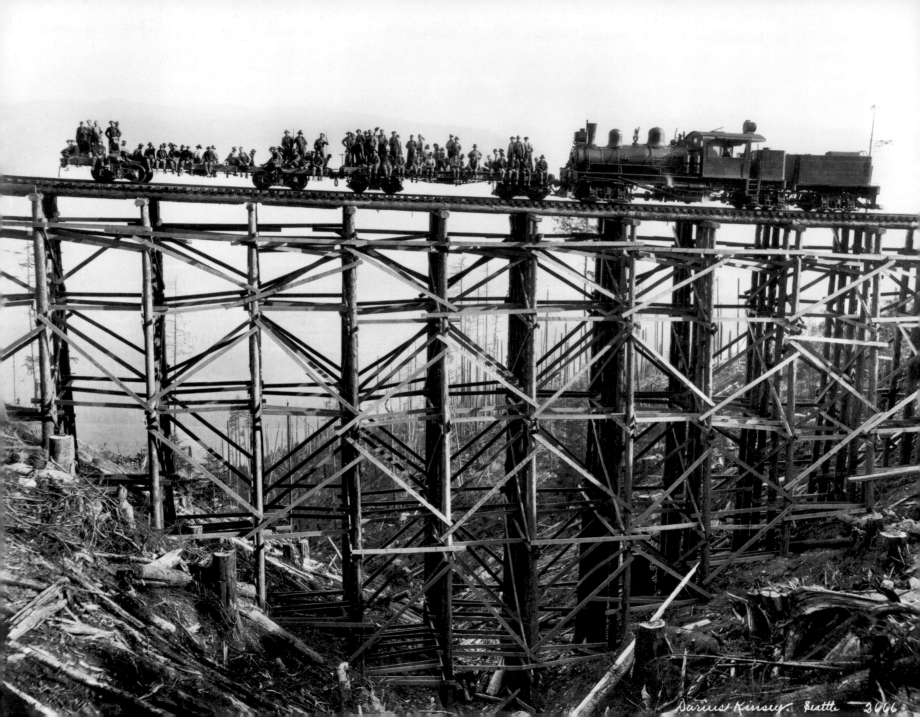

Darius Kinsey. Seattle 3066

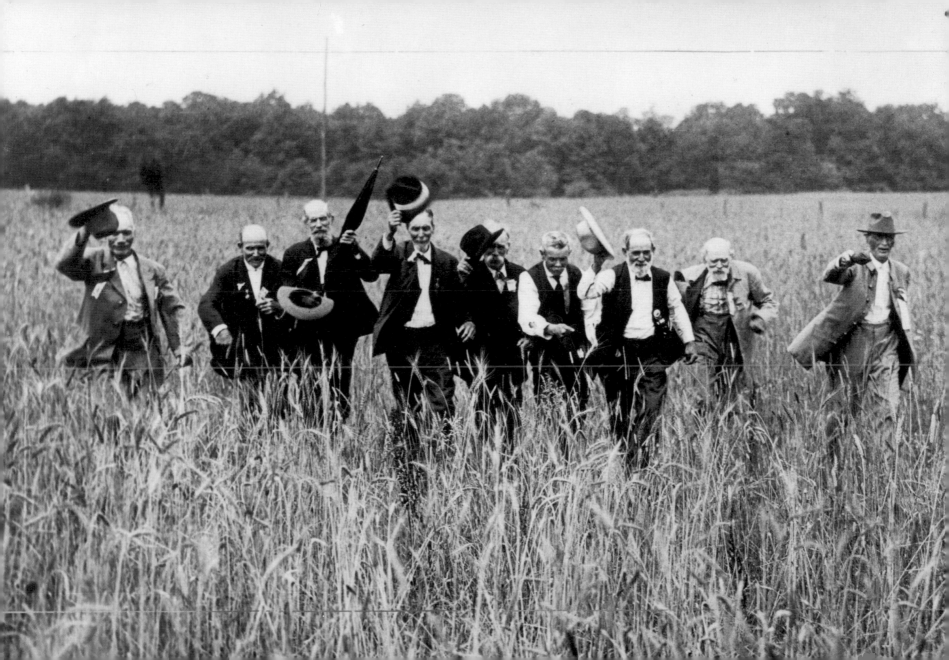

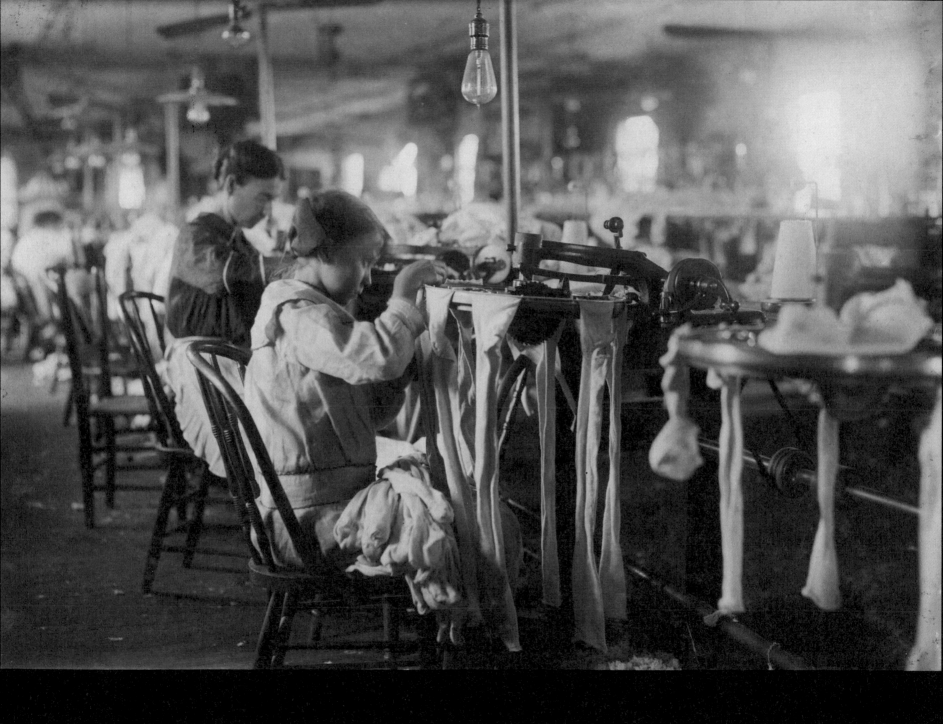

SCOTLAND NECK, NORTH CAROLINA 1914

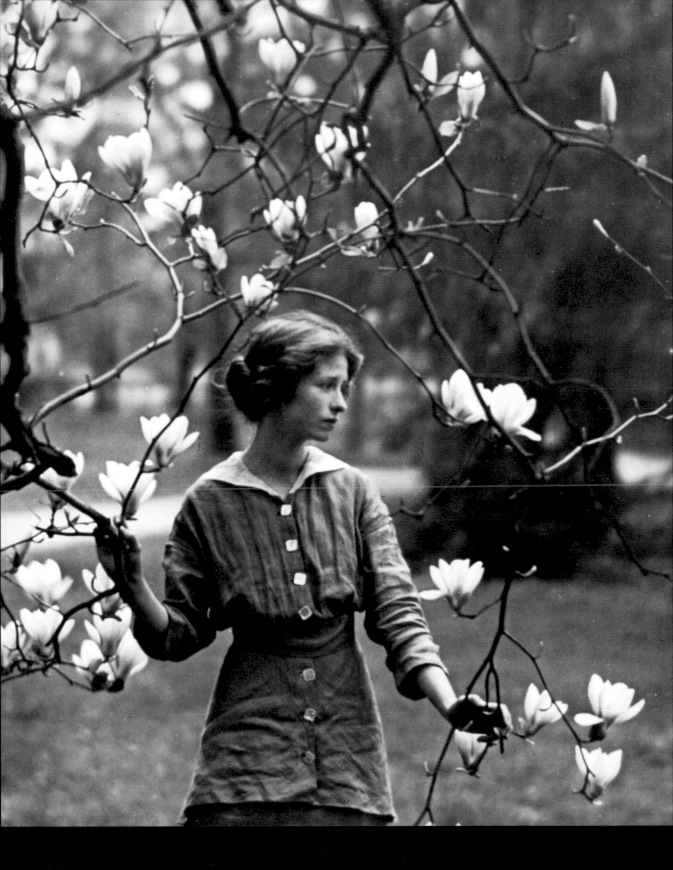

MAMARONECK, NEW YORK 1914

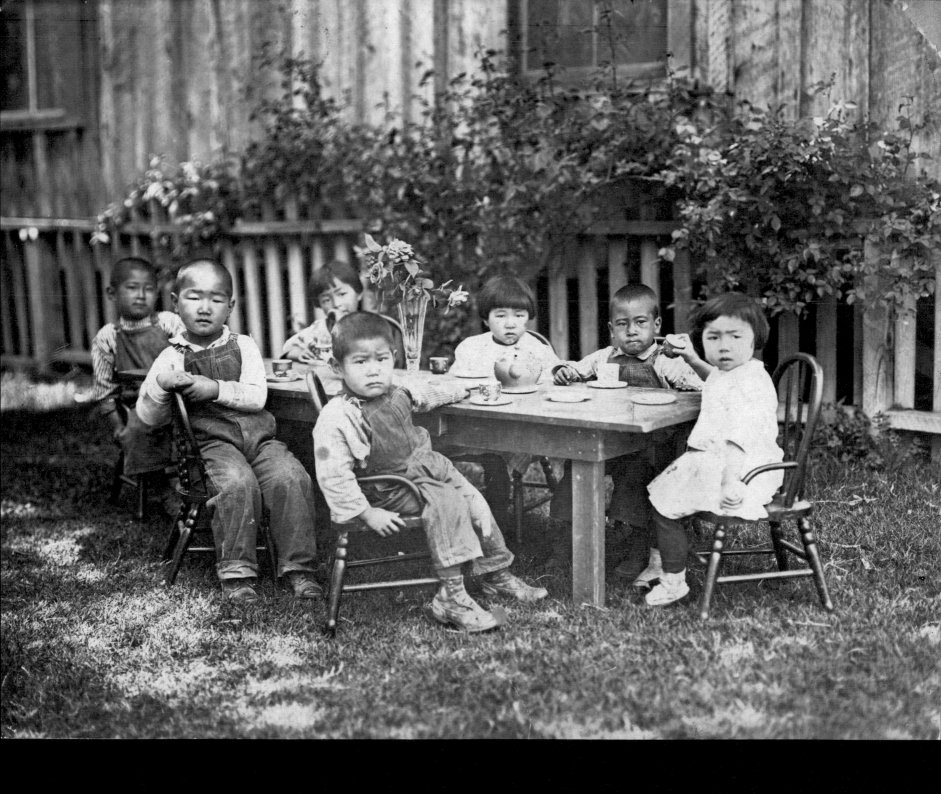

HANFORD, CALIFORNIA 1914

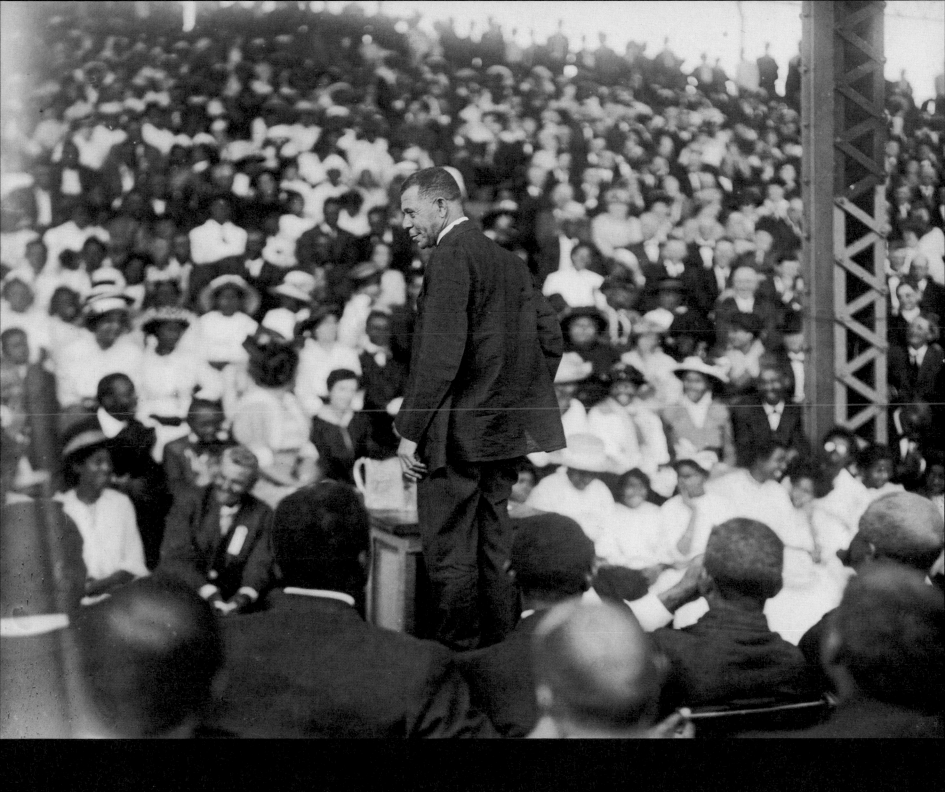

SHREVEPORT, LOUISIANA 1915

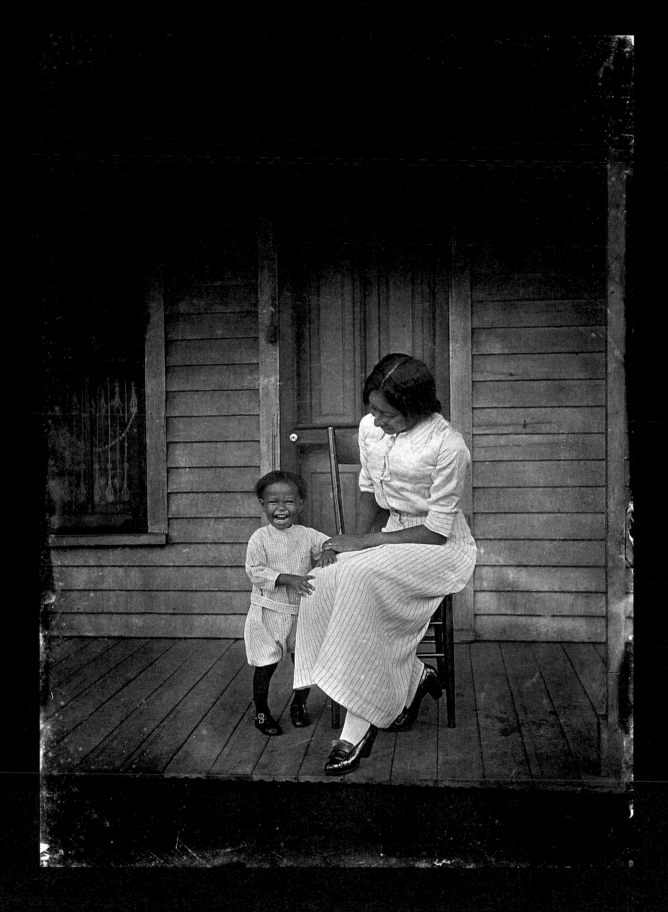

LINCOLN, NEBRASKA 1915

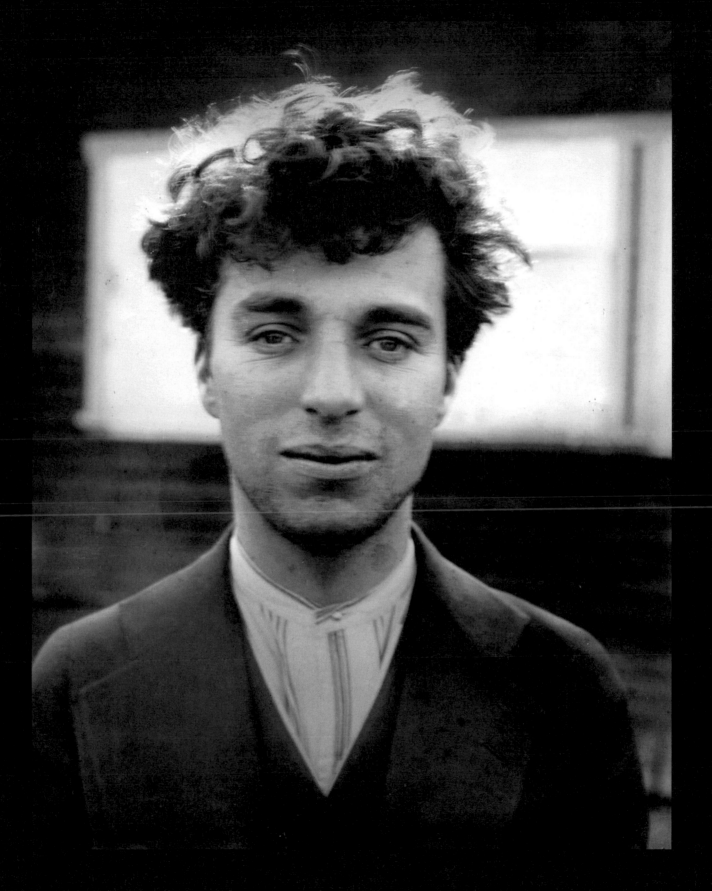

HOLLYWOOD, CALIFORNIA 1916

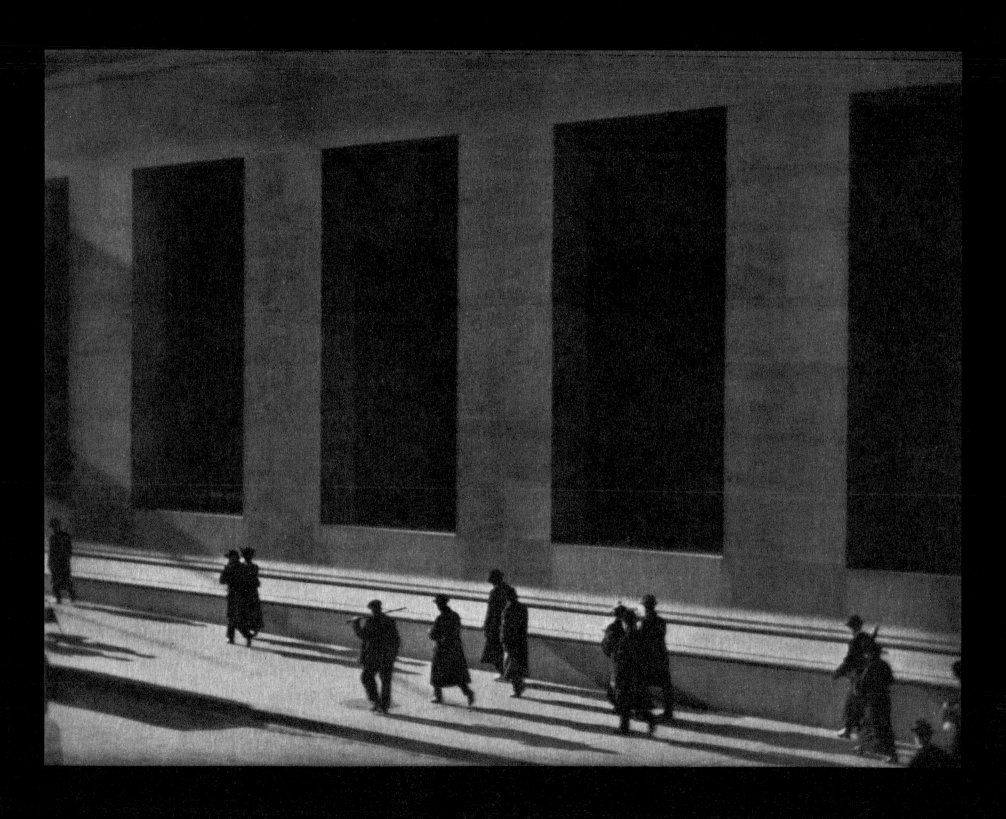

NEW YORK CITY 1916

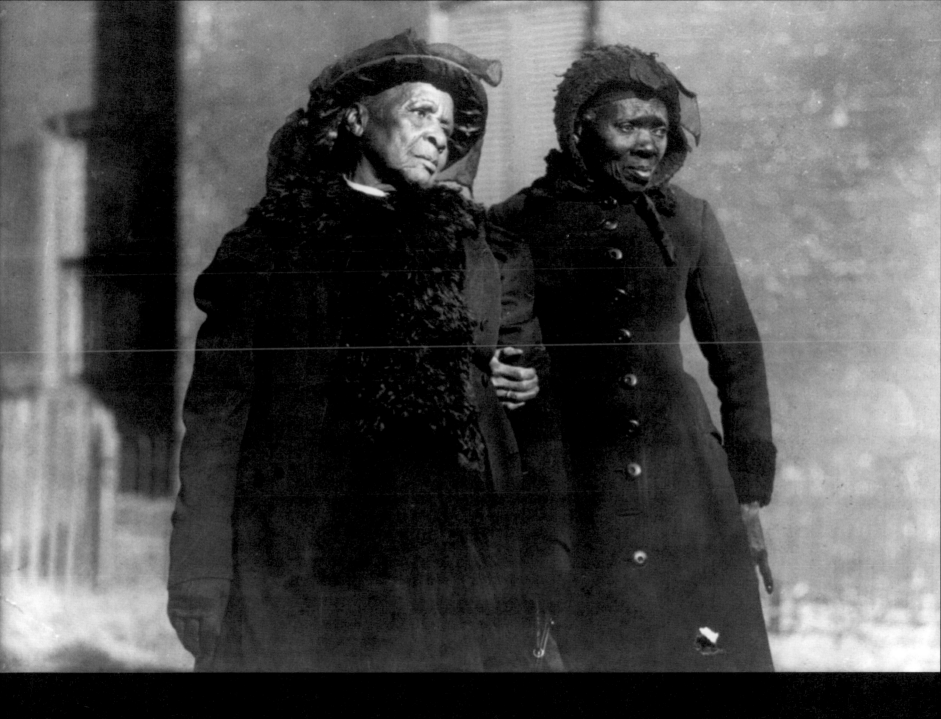

WASHINGTON, D.C. 1916

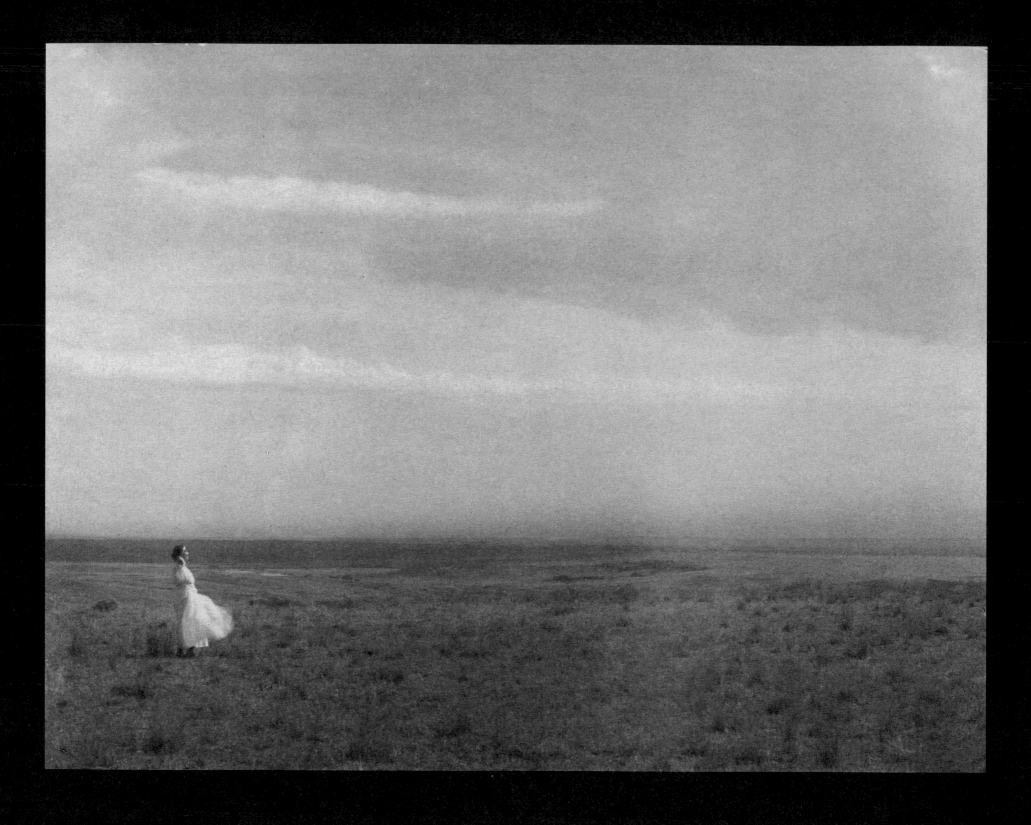

Colorado 1917

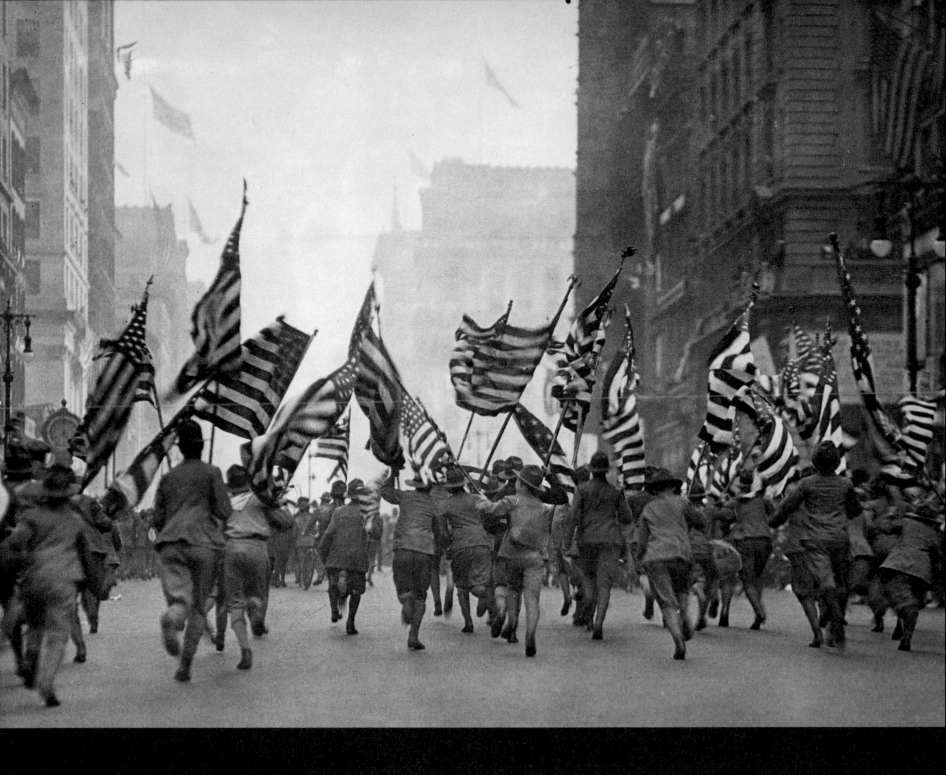

NEW YORK CITY 1917

NEW YORK CITY 1919

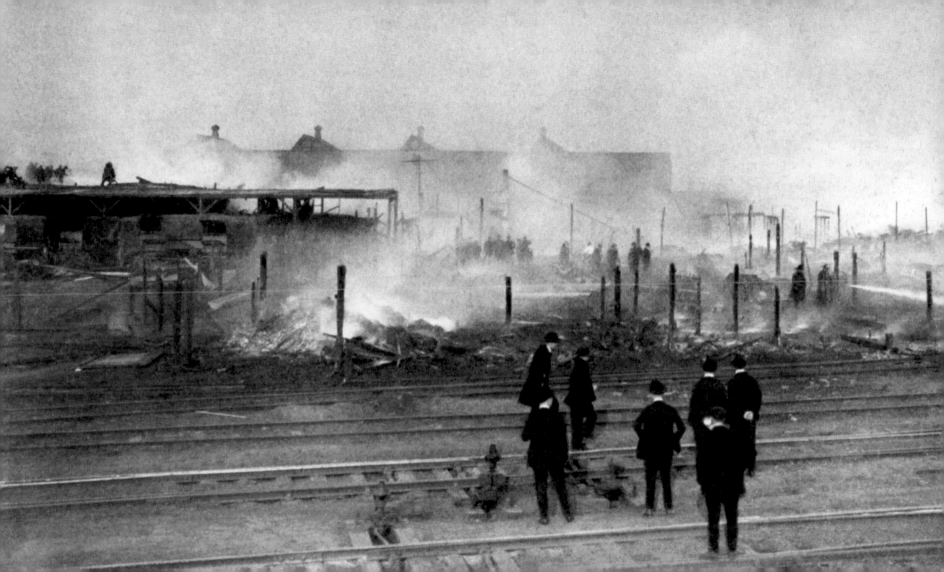

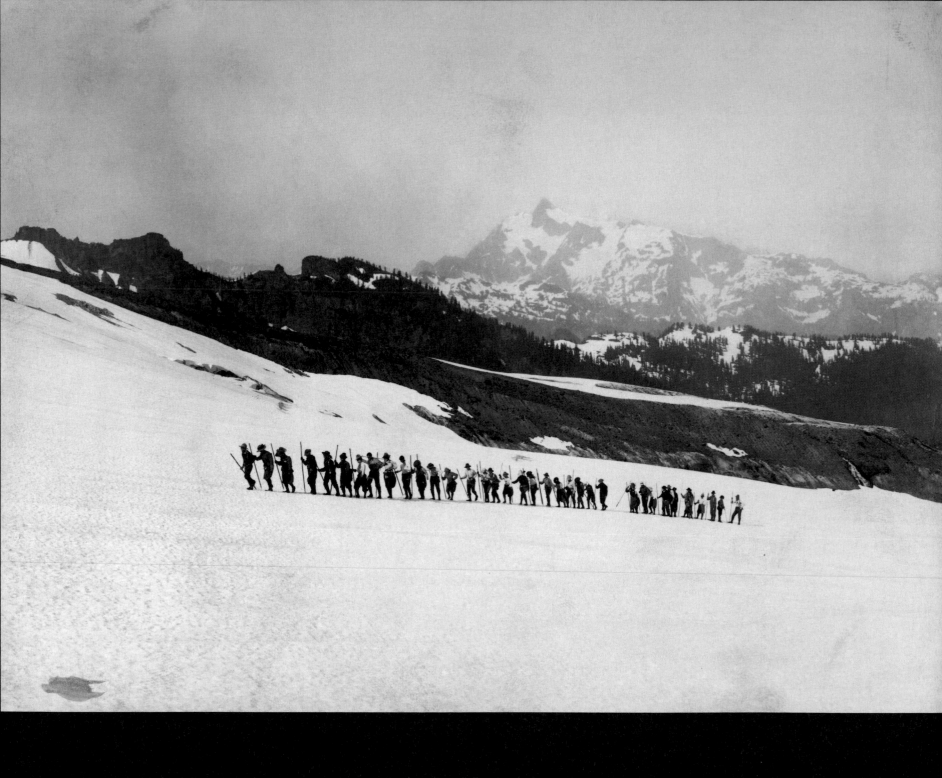

CASCADE MOUNTAINS, WASHINGTON 1919

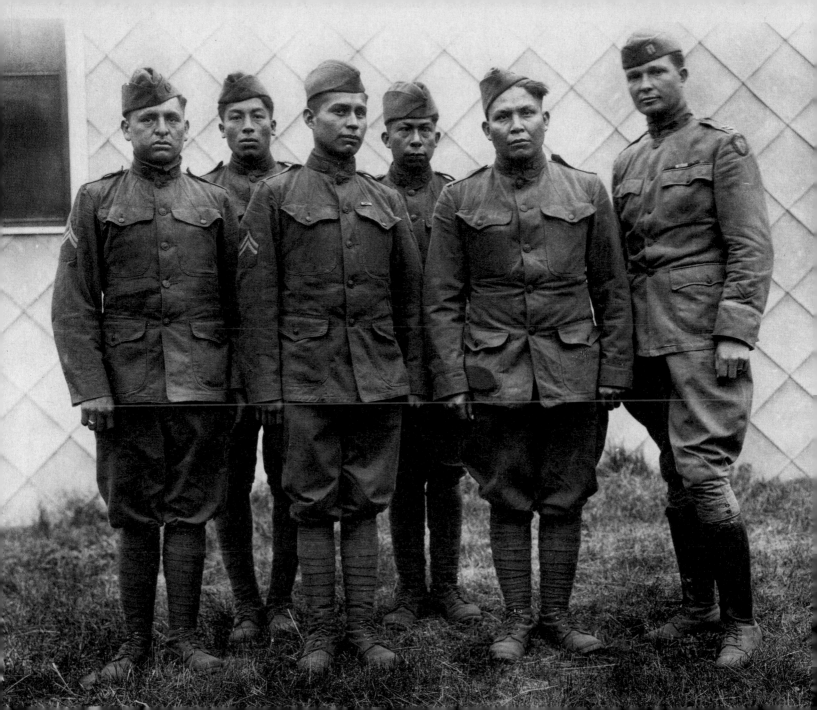

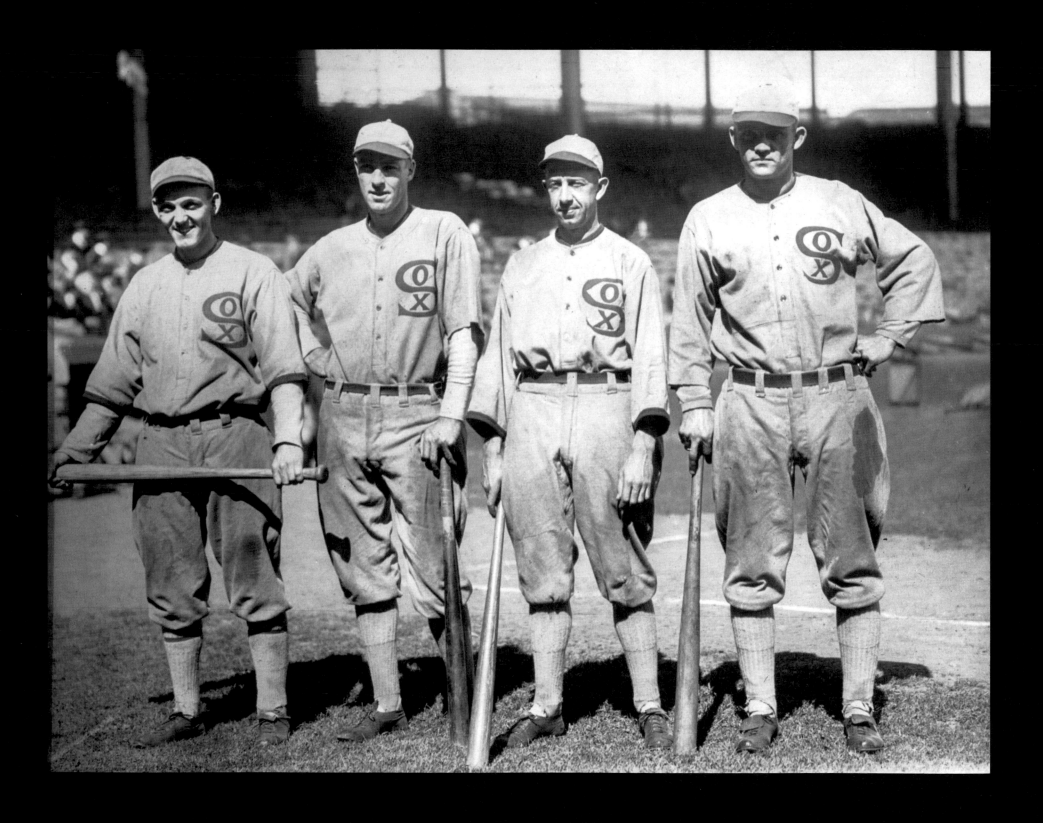

NEW YORK CITY 1920

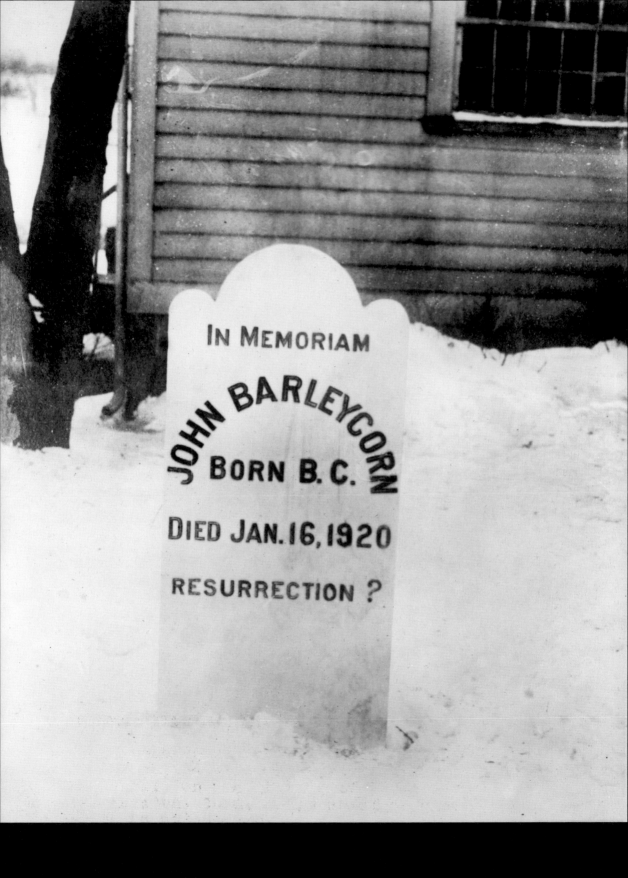

MERIDEN, CONNECTICUT 1920

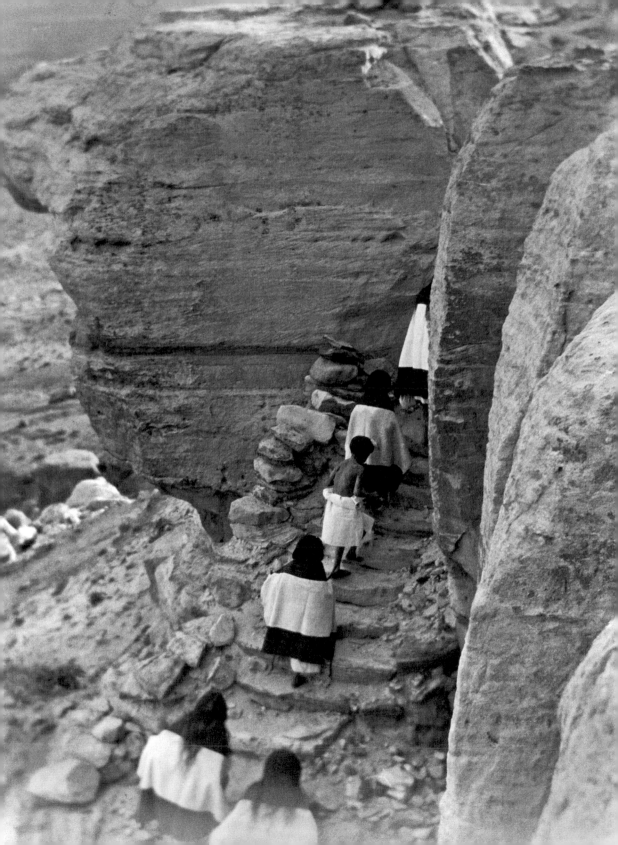

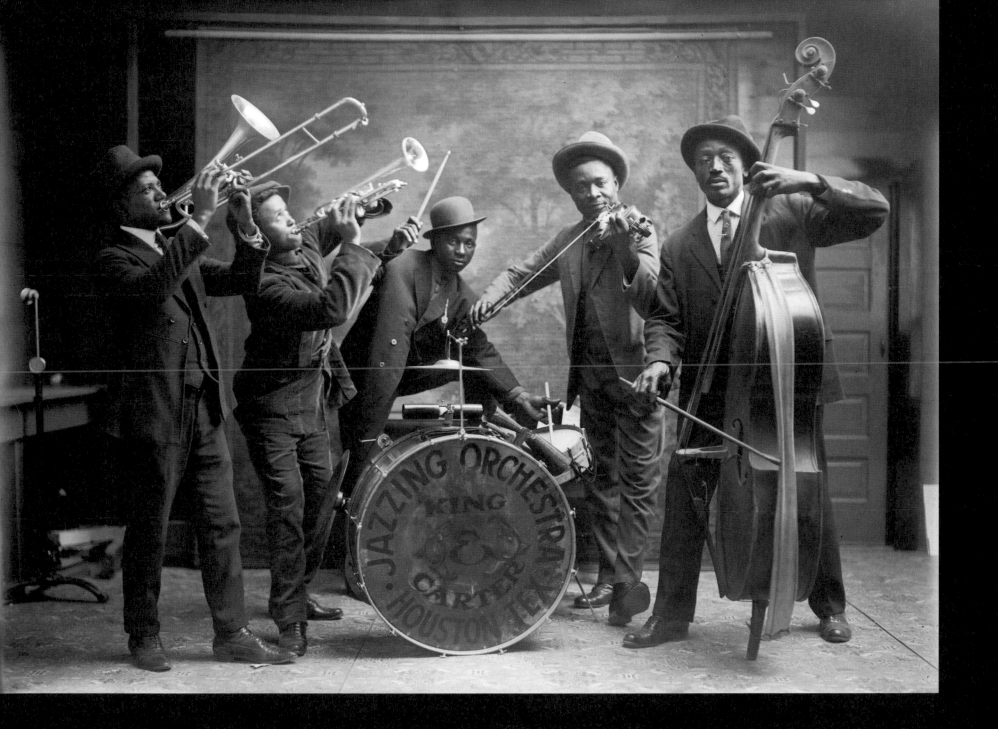

HOUSTON, TEXAS 1921

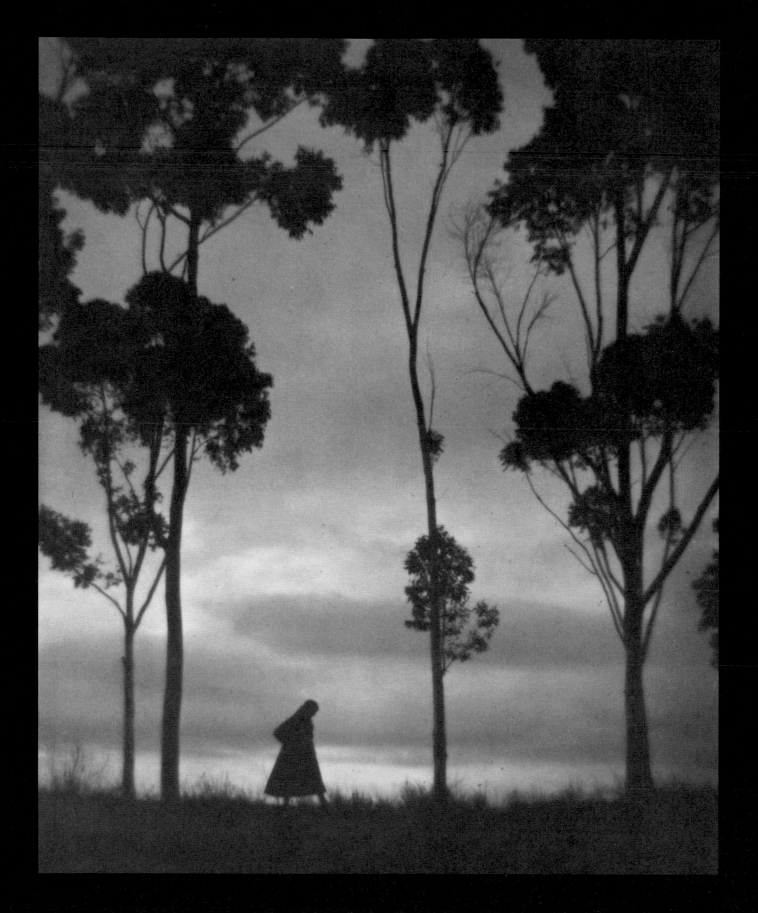

La Mesa, California 1921

LAKE GEORGE, NEW YORK 1922

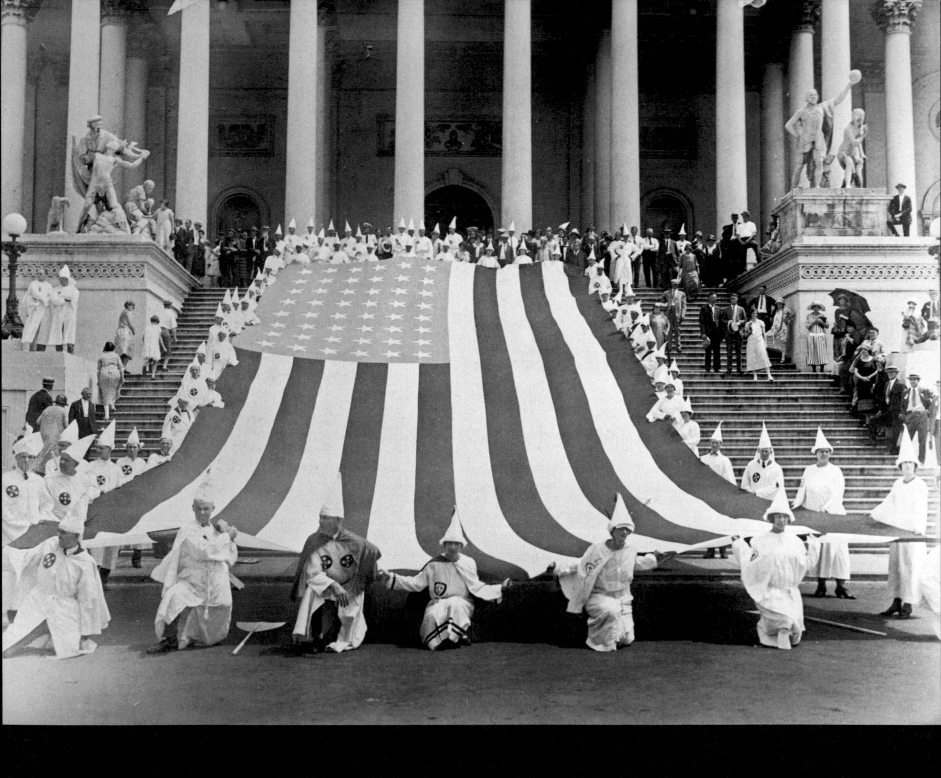

WASHINGTON, D.C. 1925

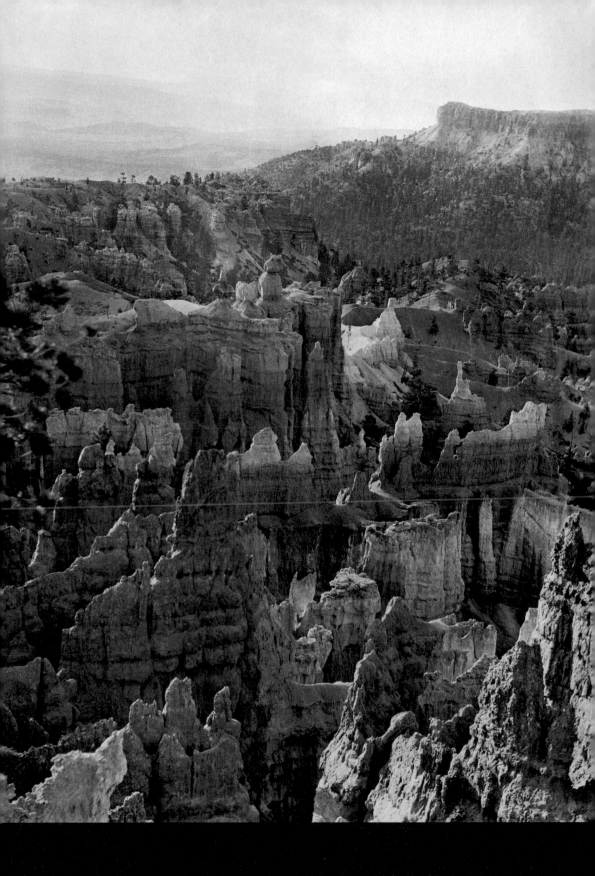

BRYCE CANYON NATIONAL MONUMENT, UTAH 1926

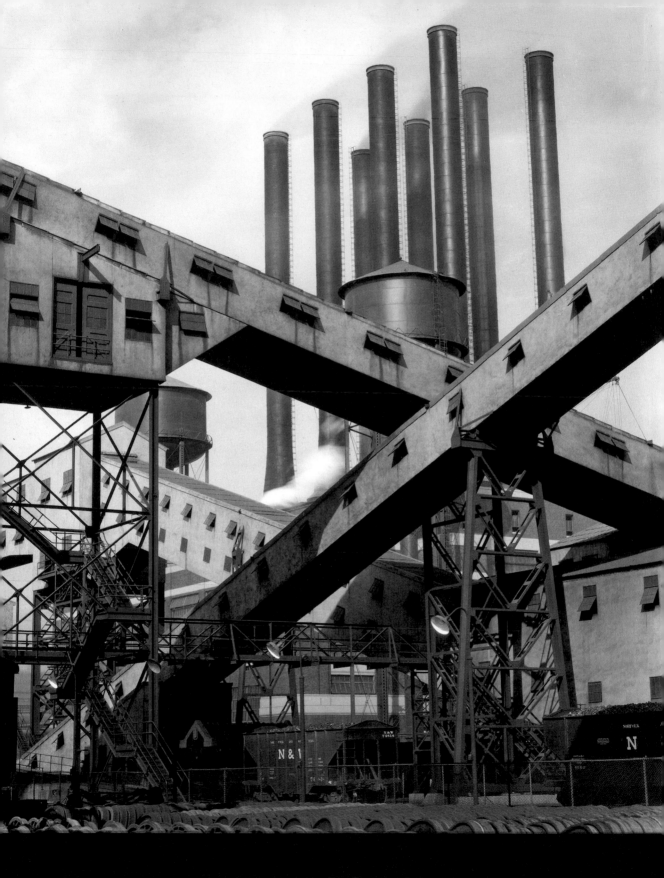

DEARBORN, MICHIGAN 1927

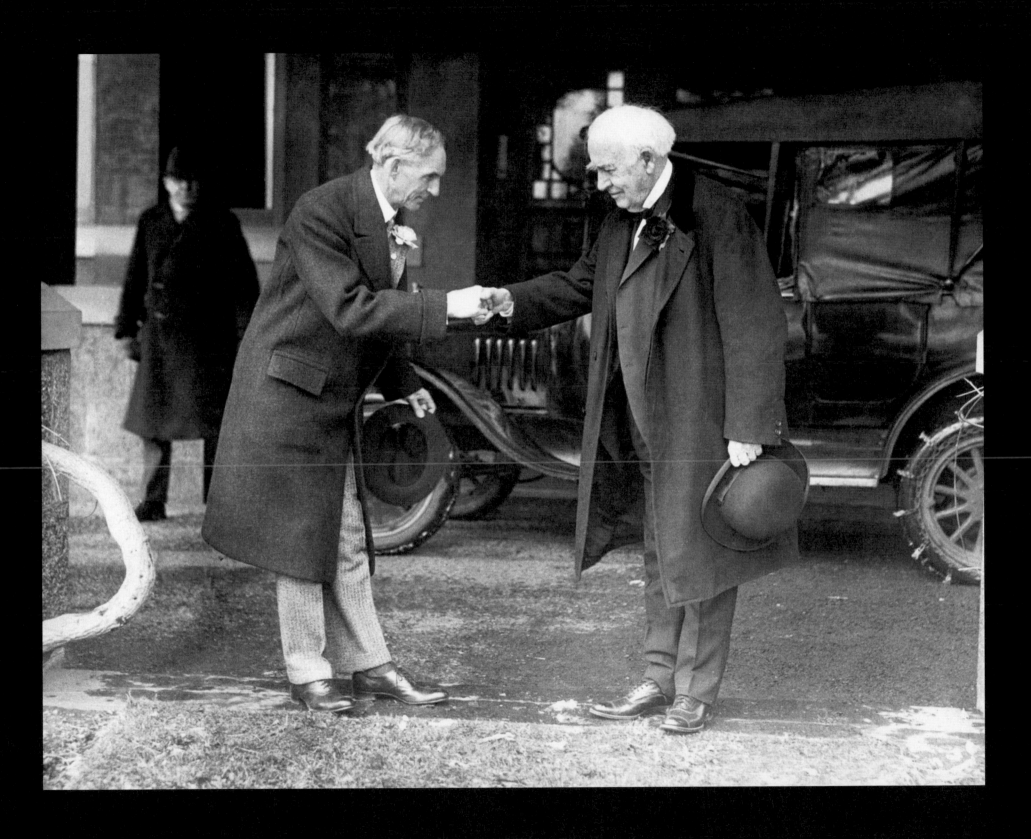

WEST ORANGE, NEW JERSEY 1927

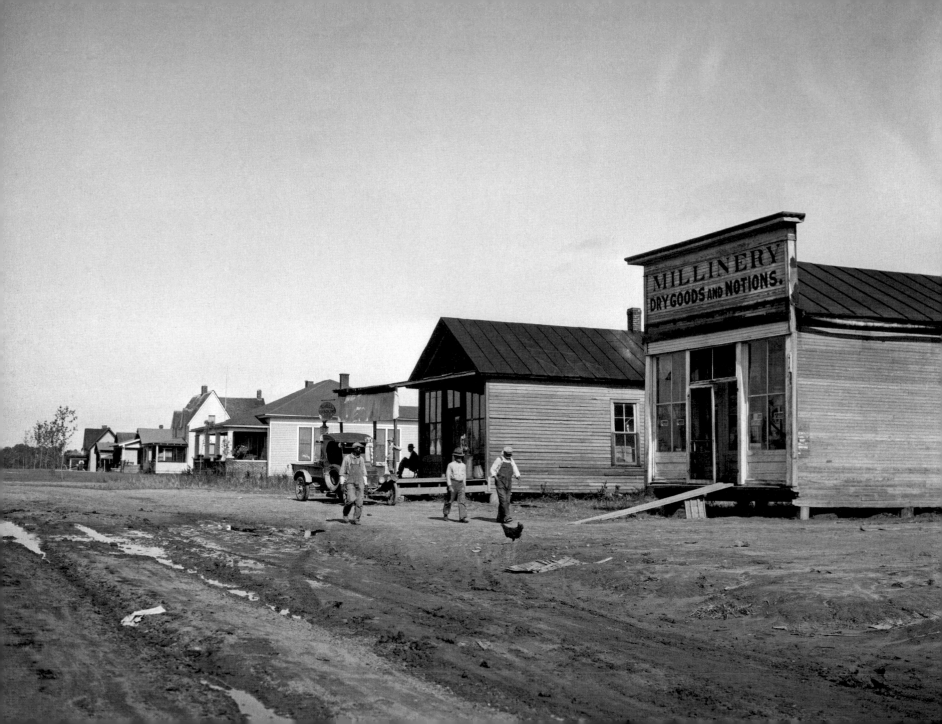

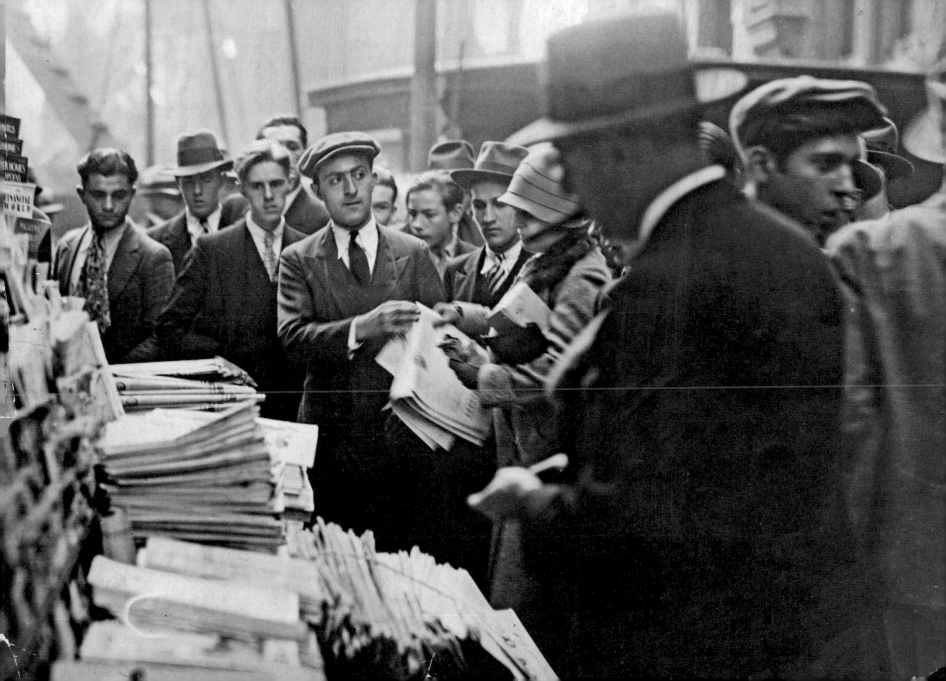

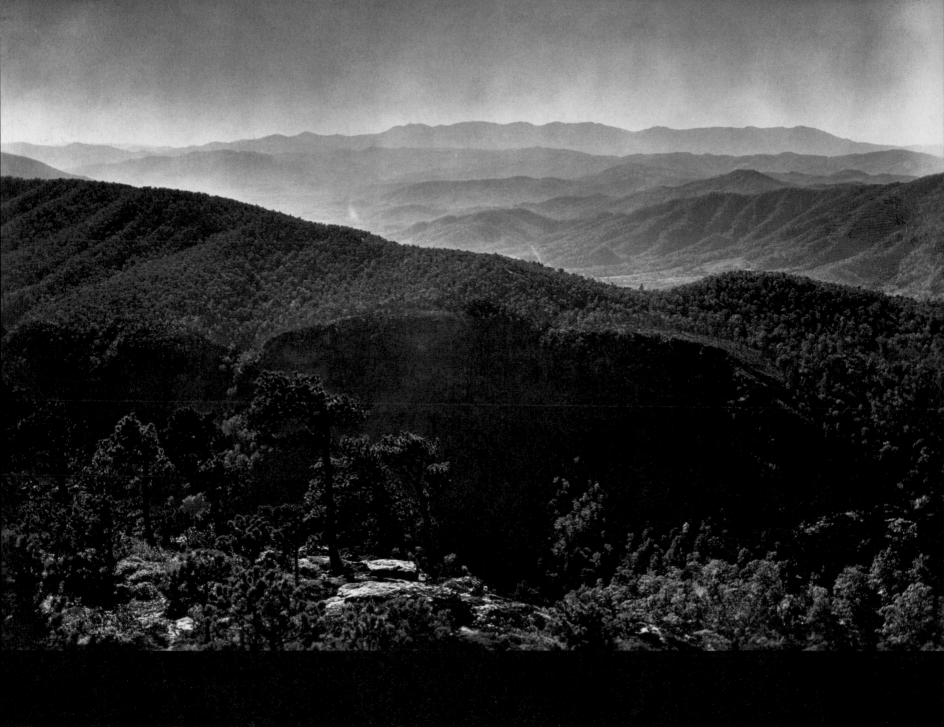

GREAT SMOKY MOUNTAINS C. 1930

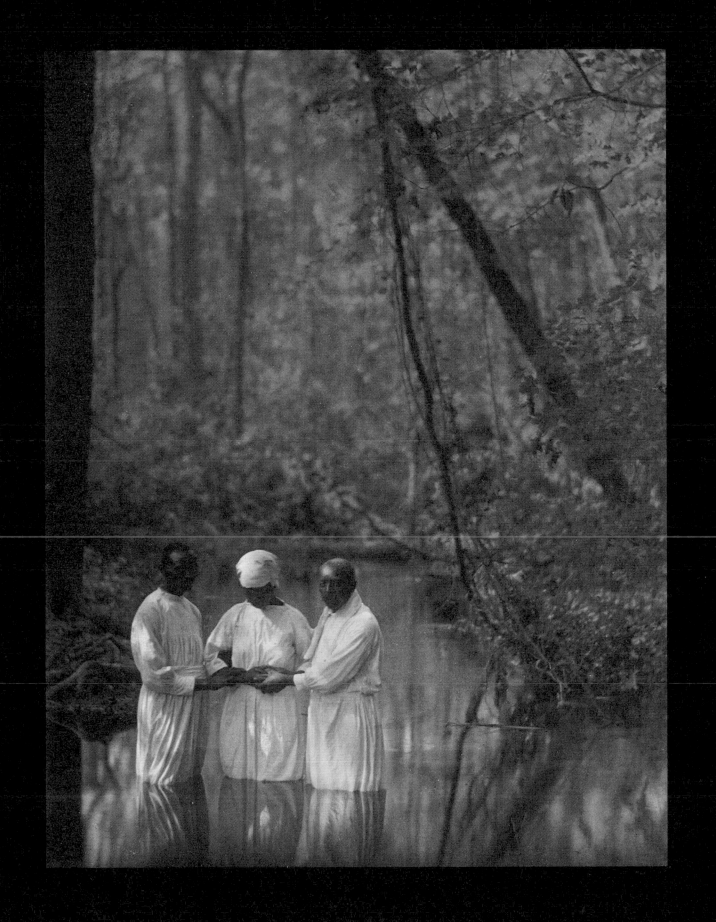

SOUTH CAROLINA C. 1930

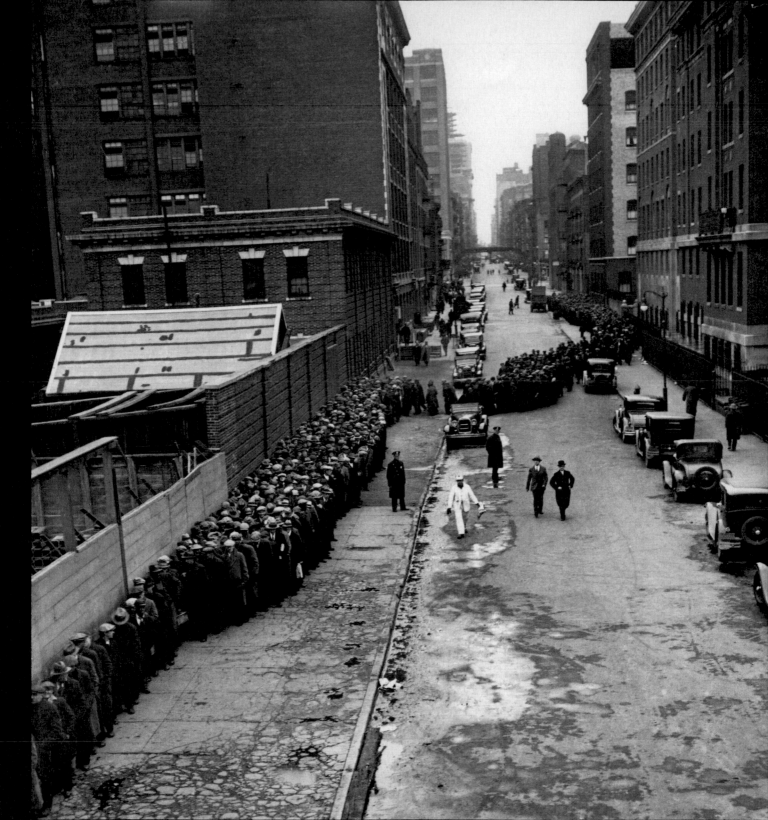

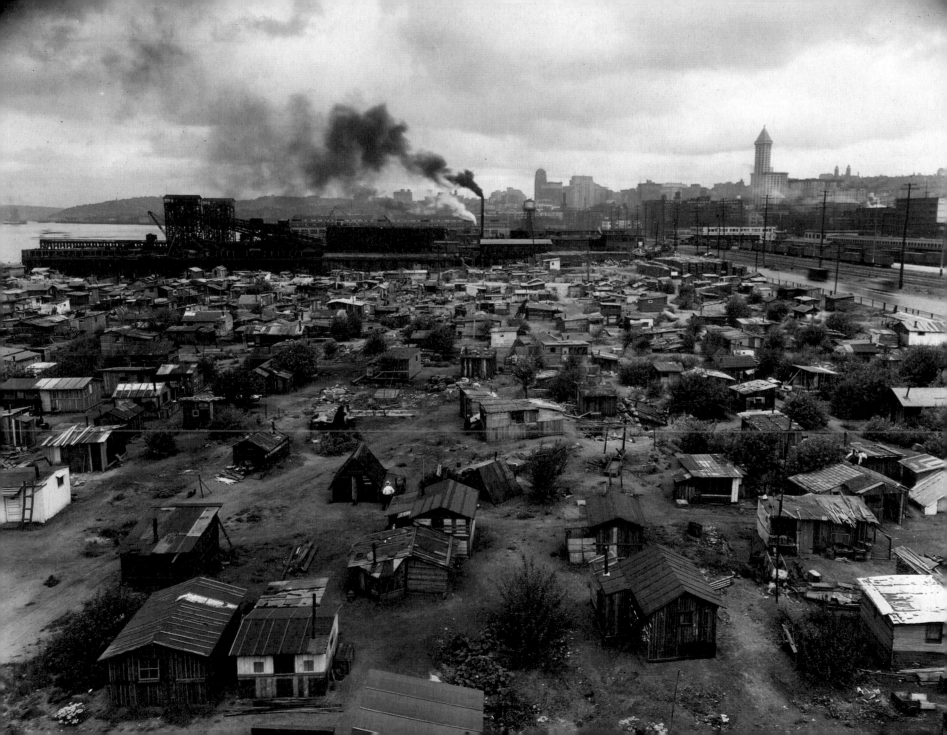

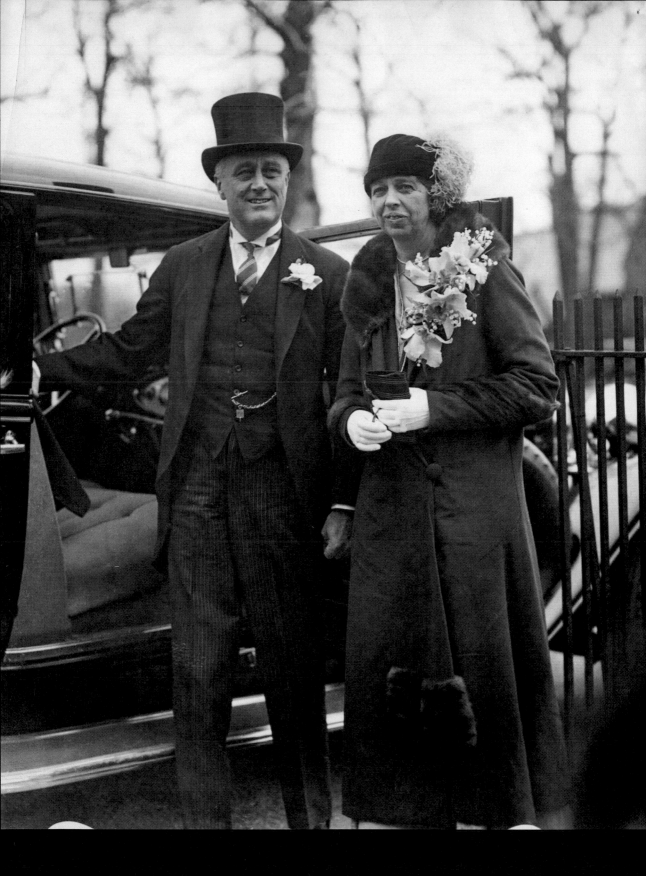

BRYN MAWR, PENNSYLVANIA 1932

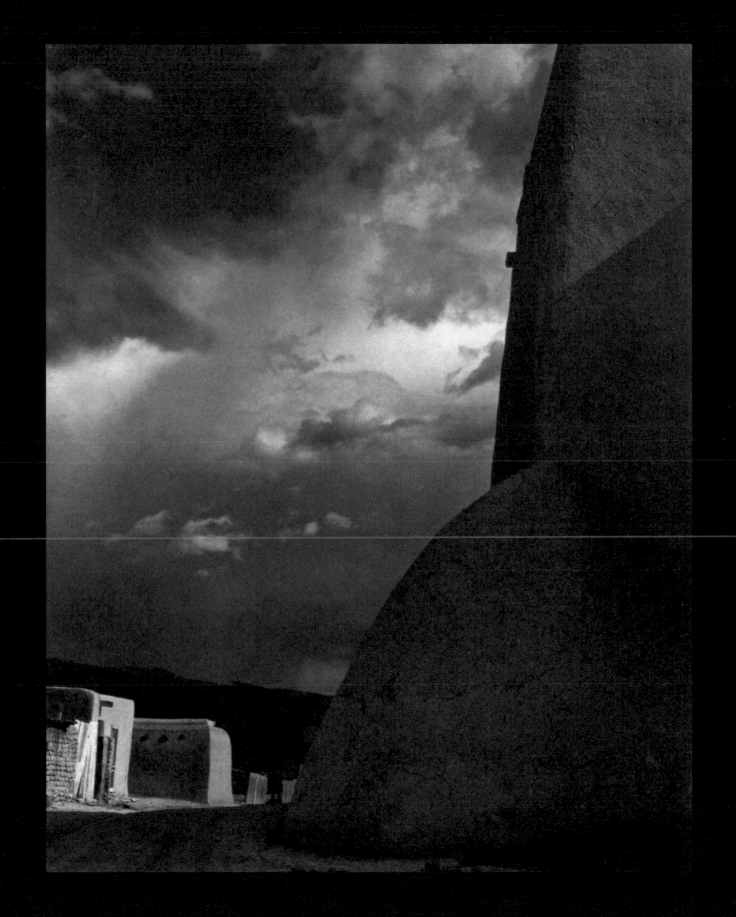

RANCHOS DE TAOS, NEW MEXICO 1932

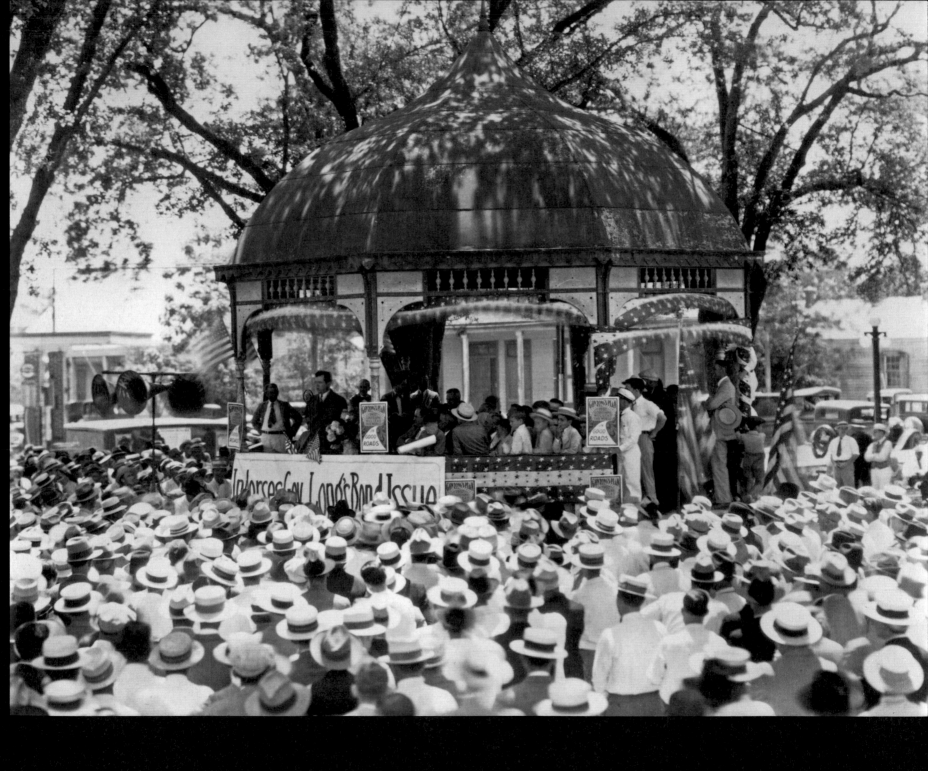

LEESVILLE, LOUISIANA 1932

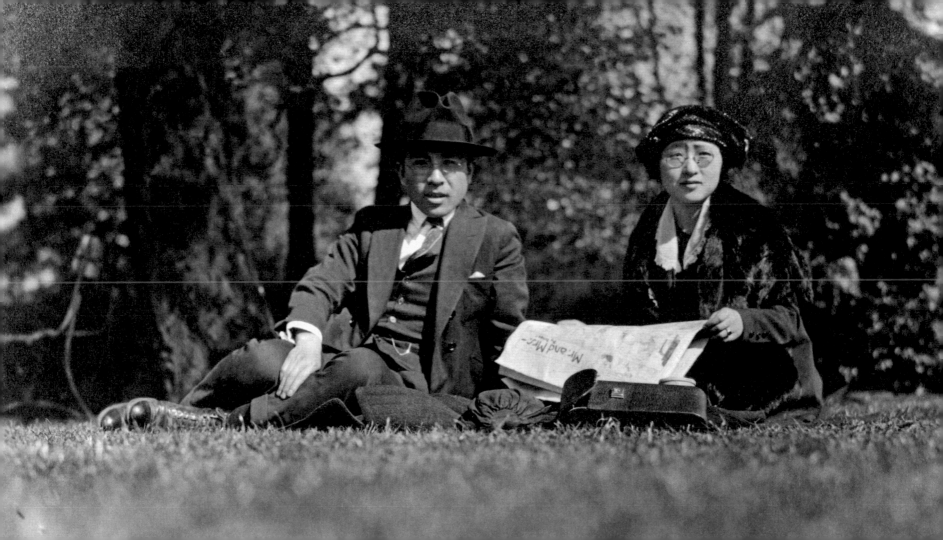

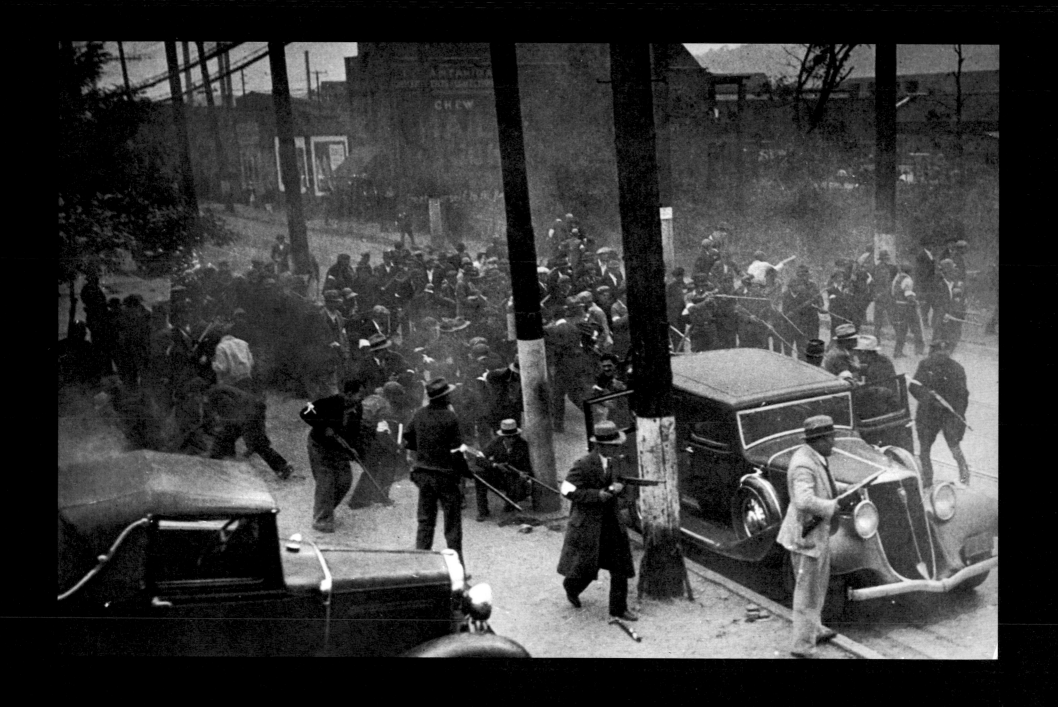

AMBRIDGE, PENNSYLVANIA 1932

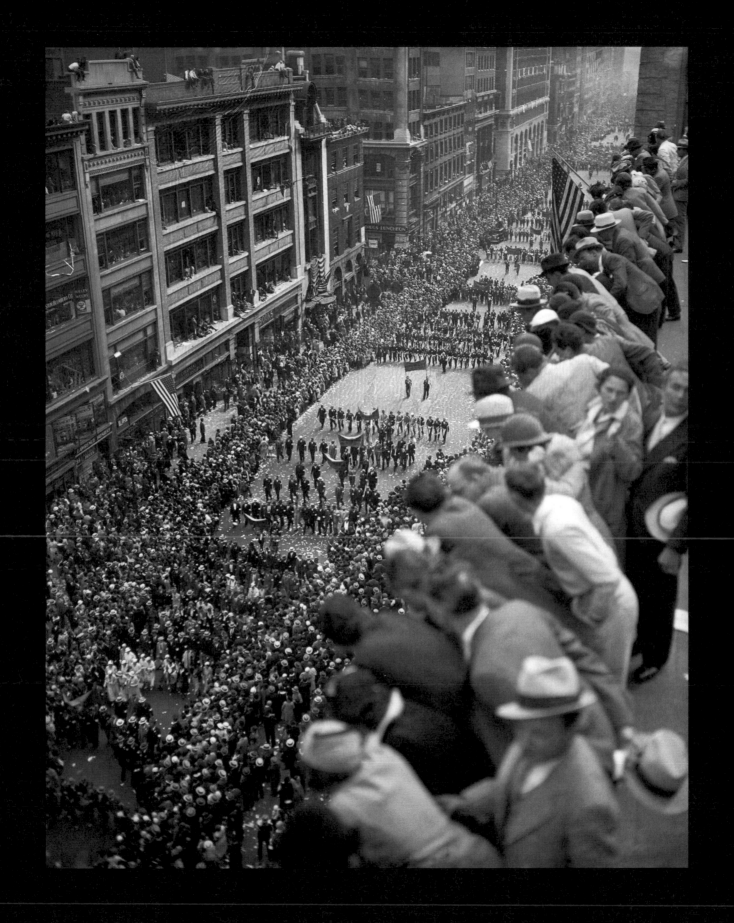

NEW YORK CITY 1933

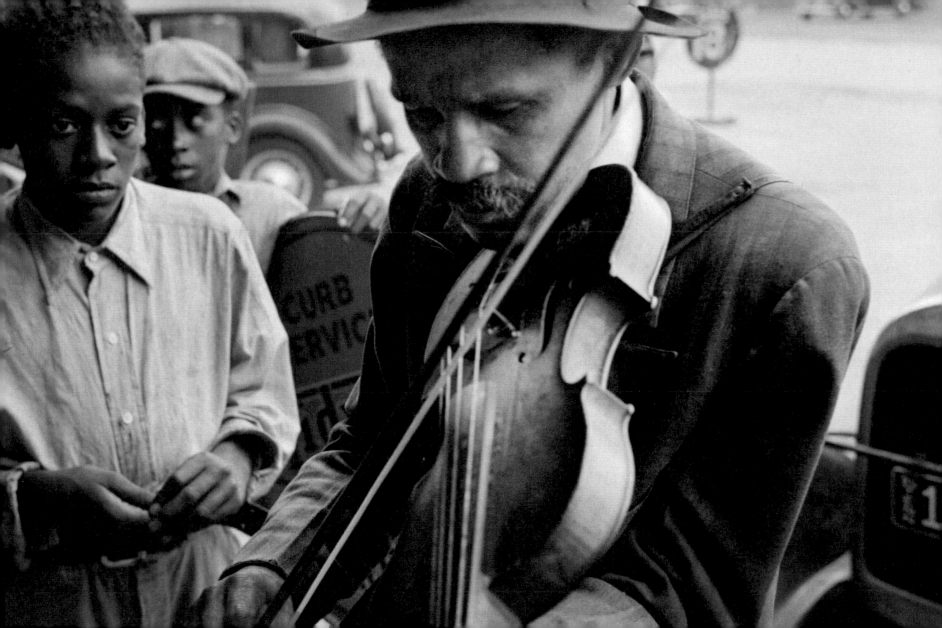

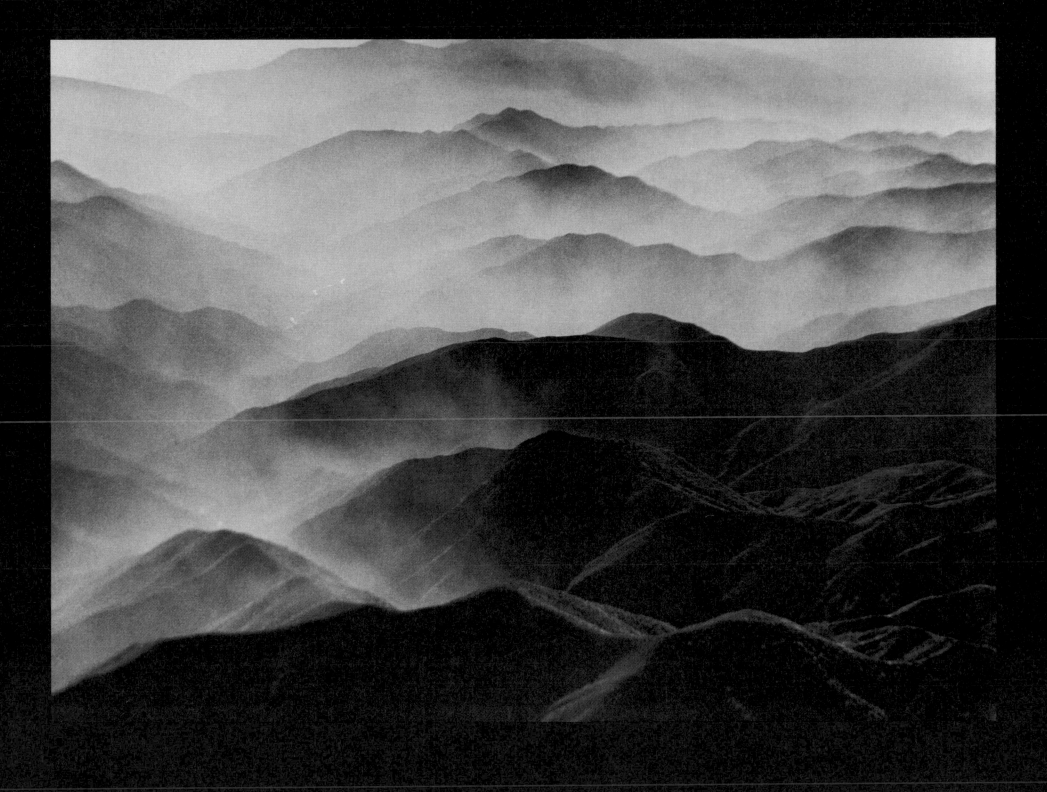

CALIFORNIA 1935

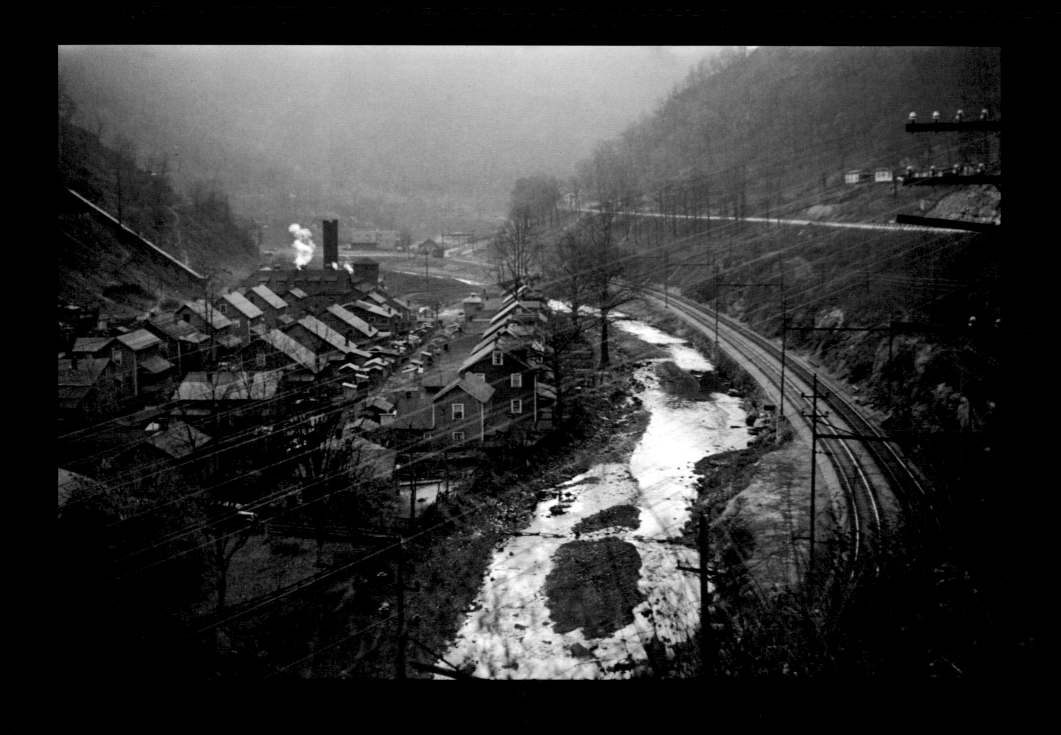

KIMBALL, WEST VIRGINIA 1935

FLORIDA 1935

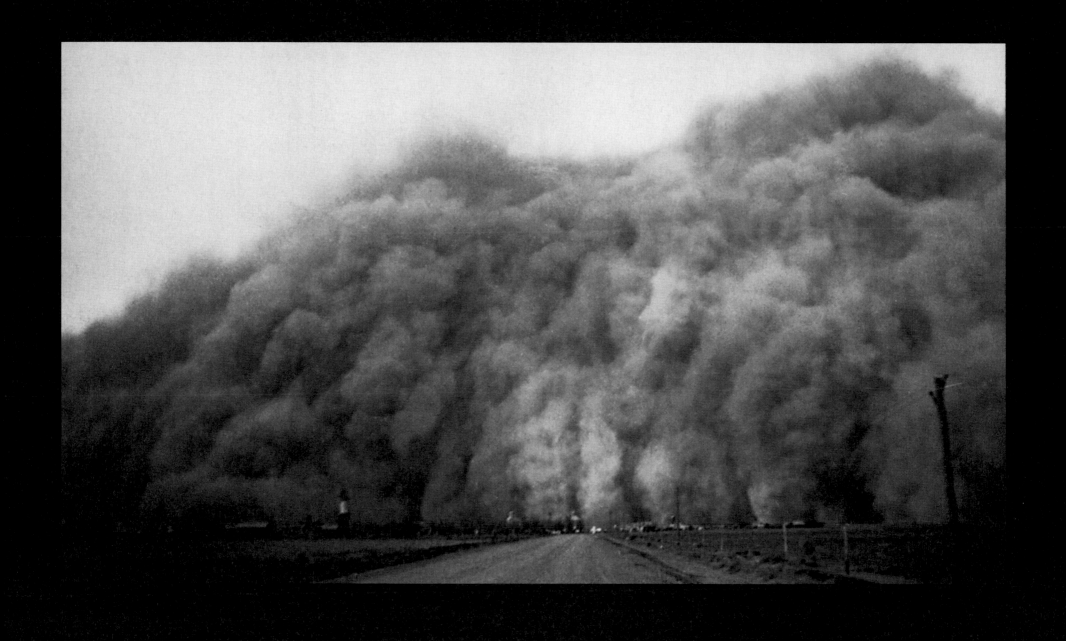

BACA, COLORADO 1935

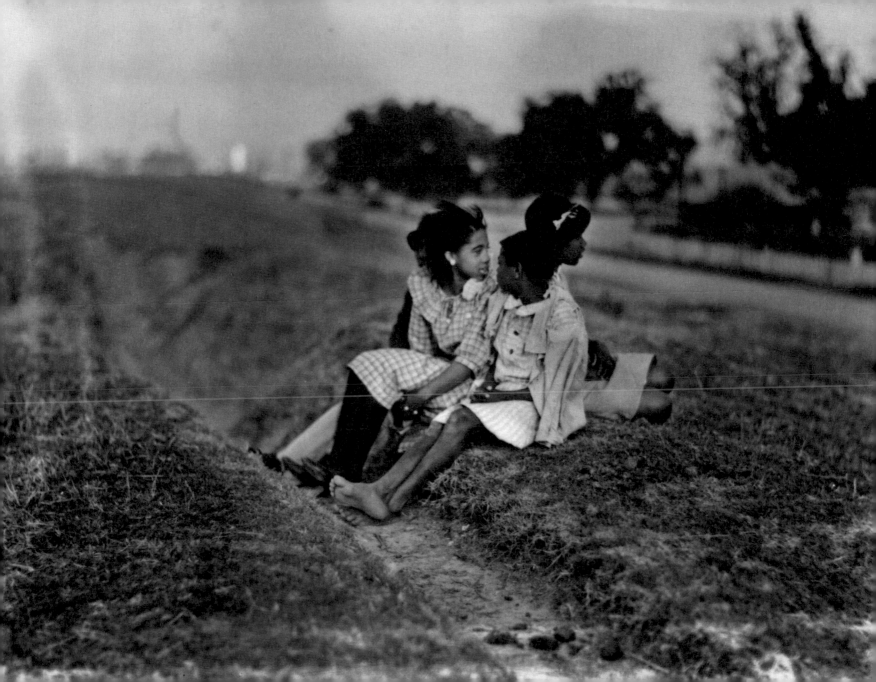

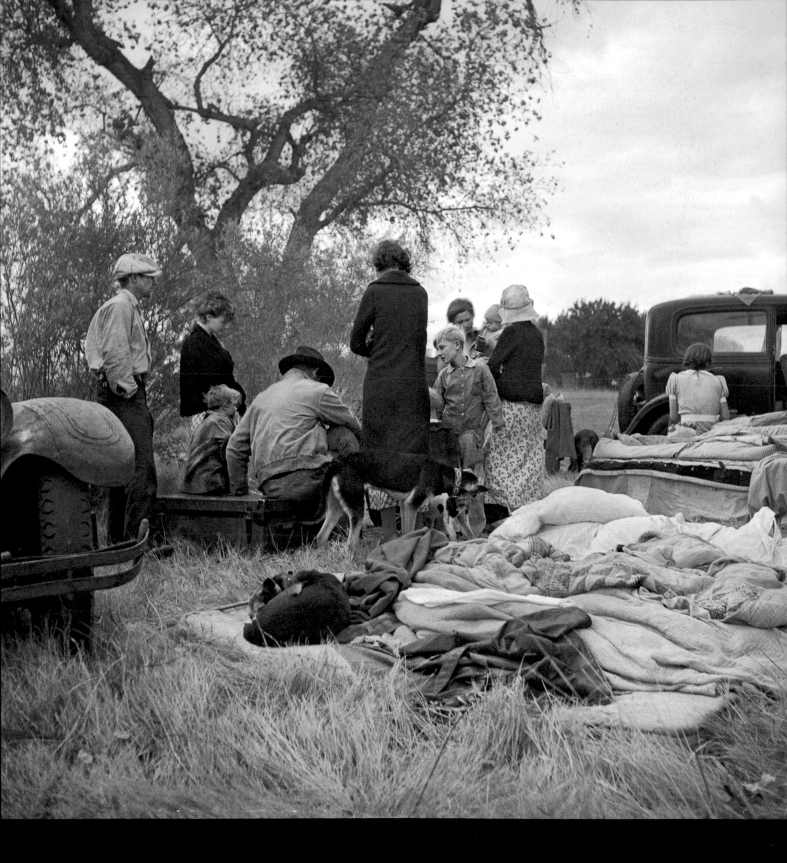

NEAR BAKERSFIELD, CALIFORNIA 1935

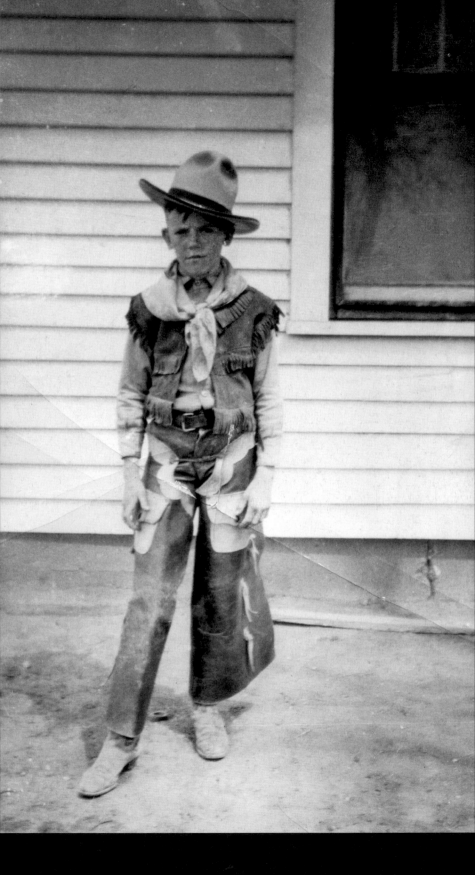

GUYMON, OKLAHOMA 1935

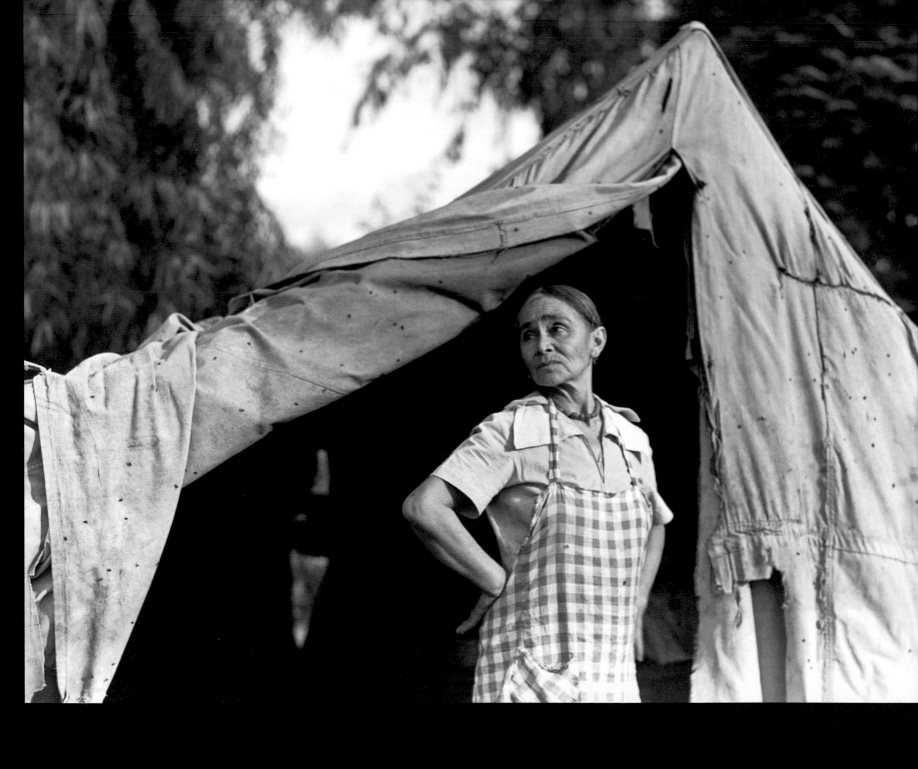

NEAR EXETER, CALIFORNIA 1936

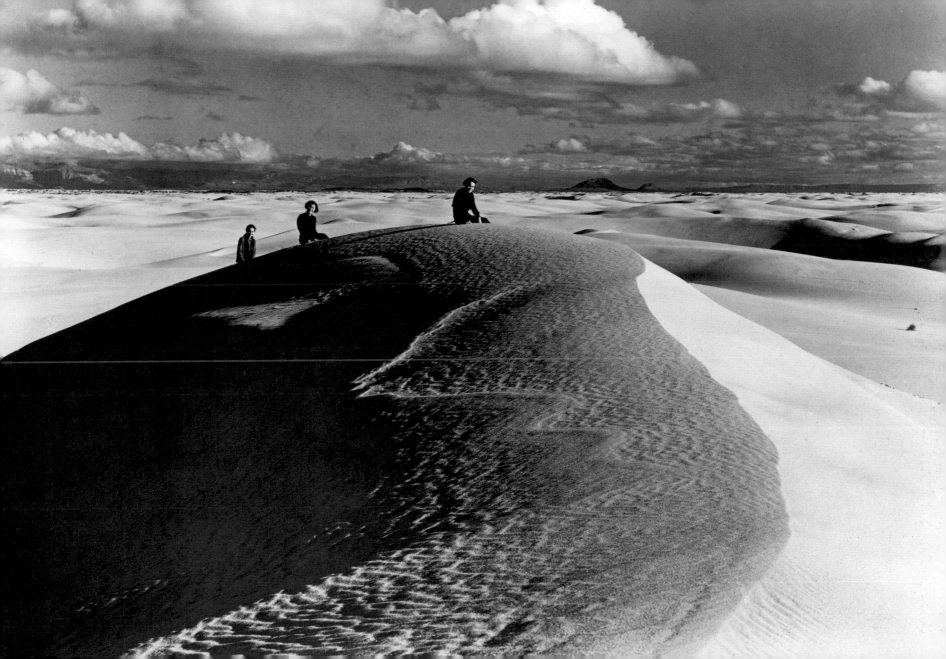

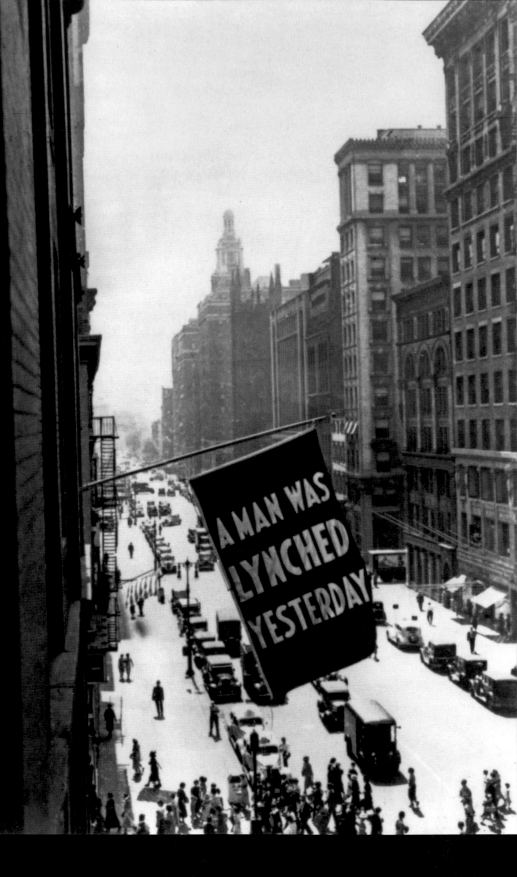

NEW YORK CITY 1936

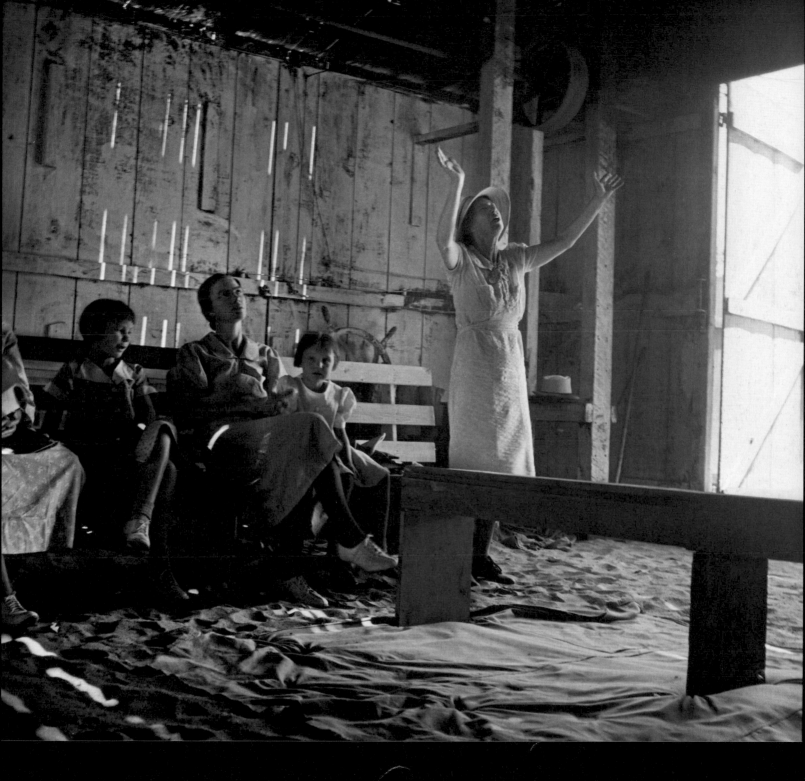

DOS PALOS, CALIFORNIA 1938

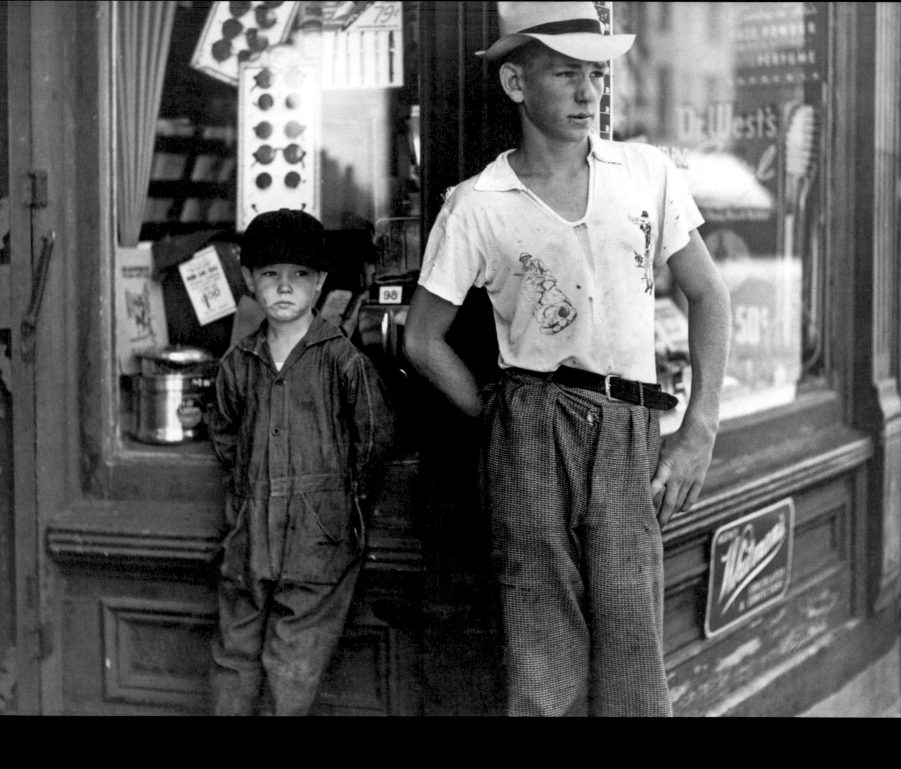

DOVER, DELAWARE 1938

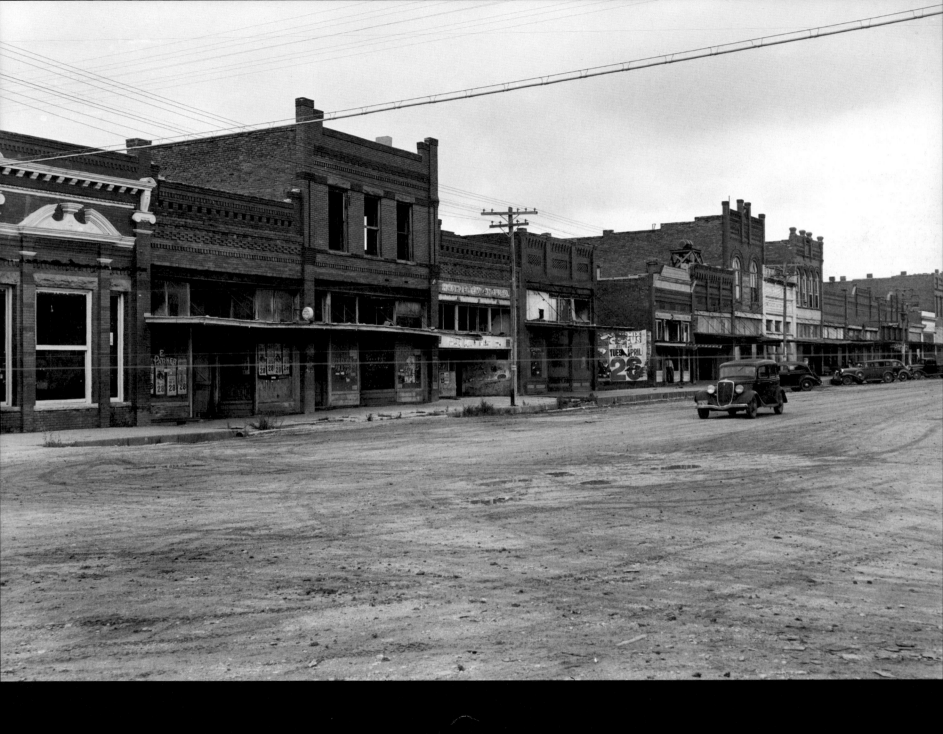

CADDO, OKLAHOMA 1938

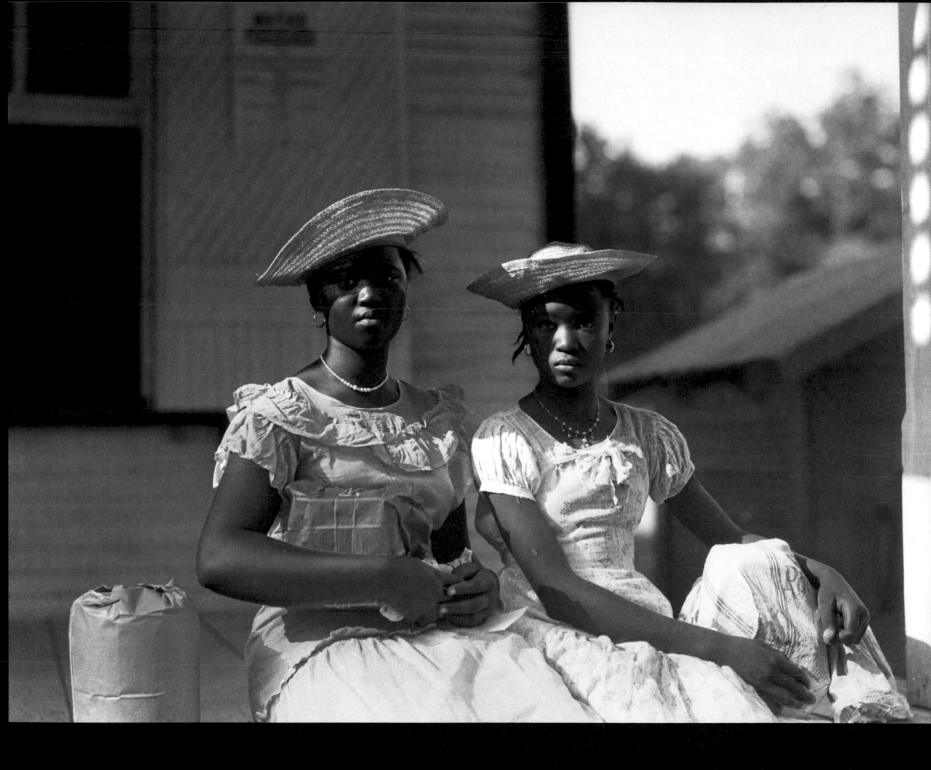

CROWLEY, LOUISIANA 1938

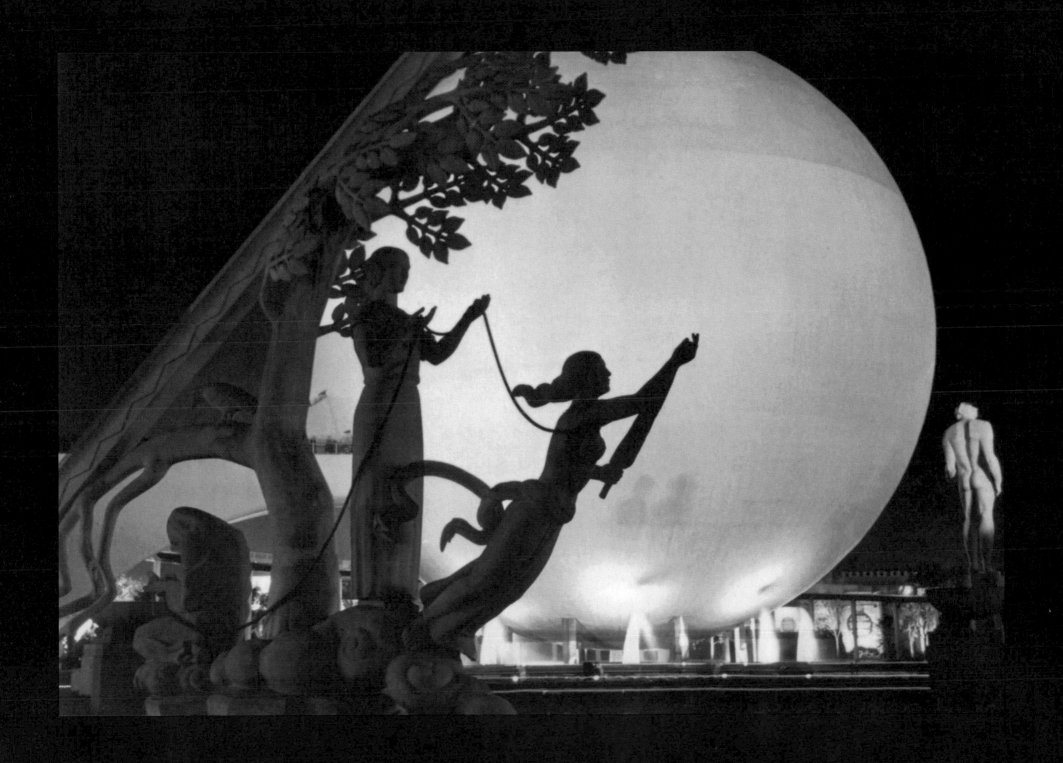

NEW YORK CITY 1939

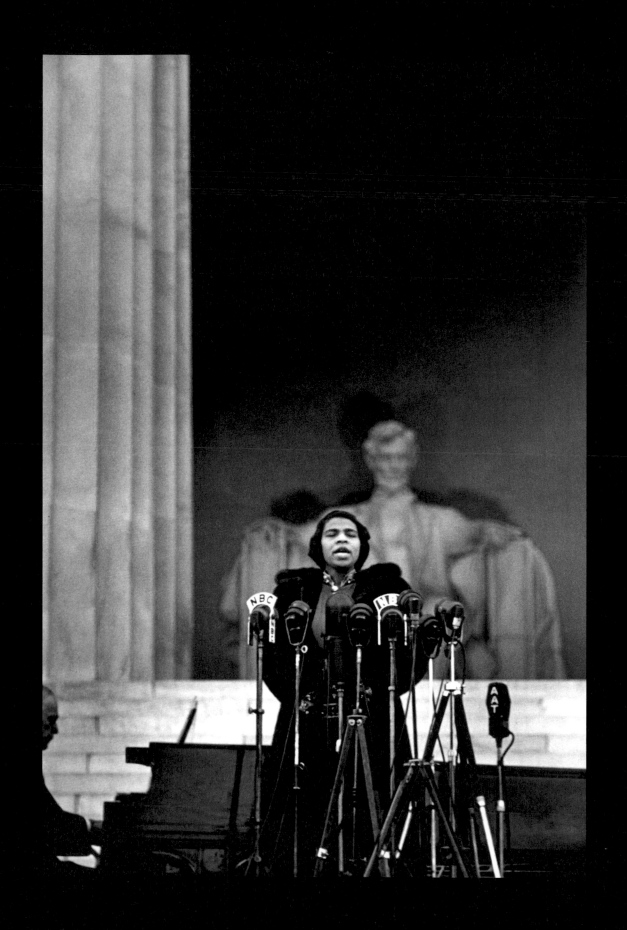

WASHINGTON, D.C. 1939

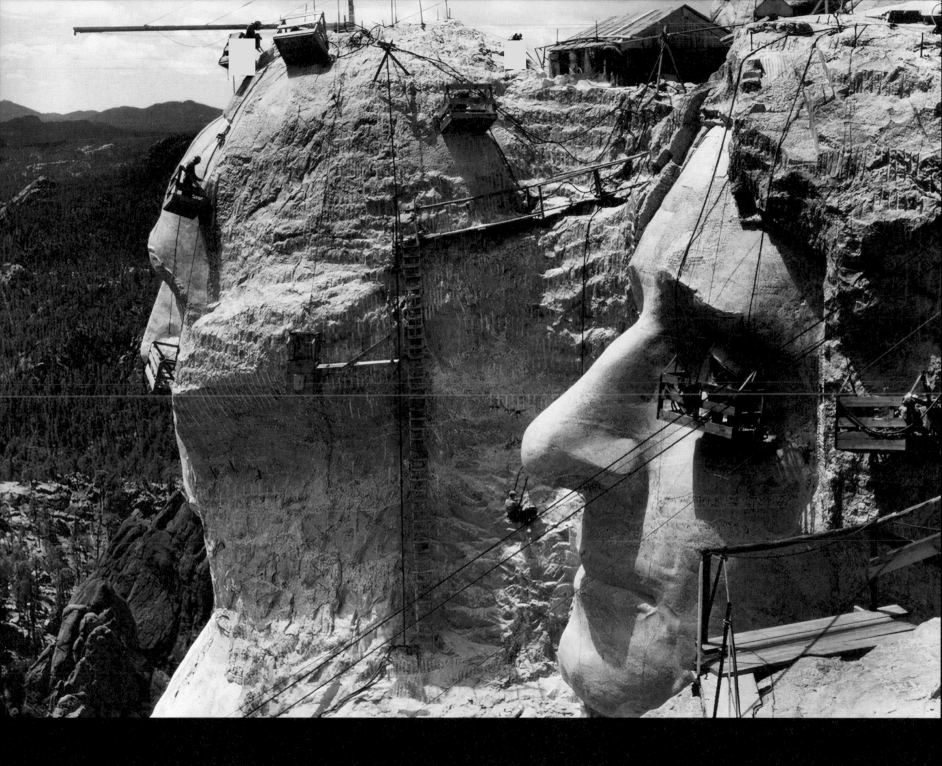

MOUNT RUSHMORE, SOUTH DAKOTA 1939

177

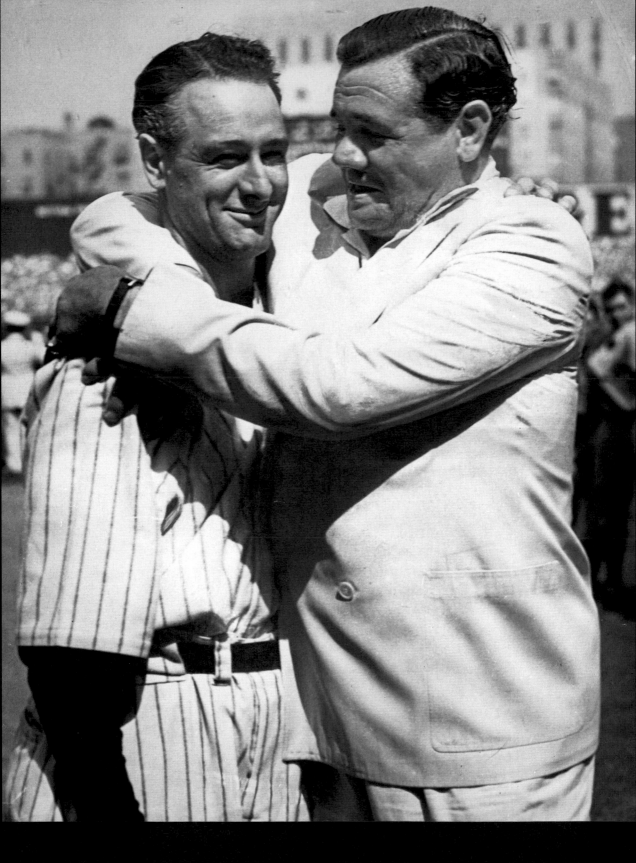

NEW YORK CITY 1939

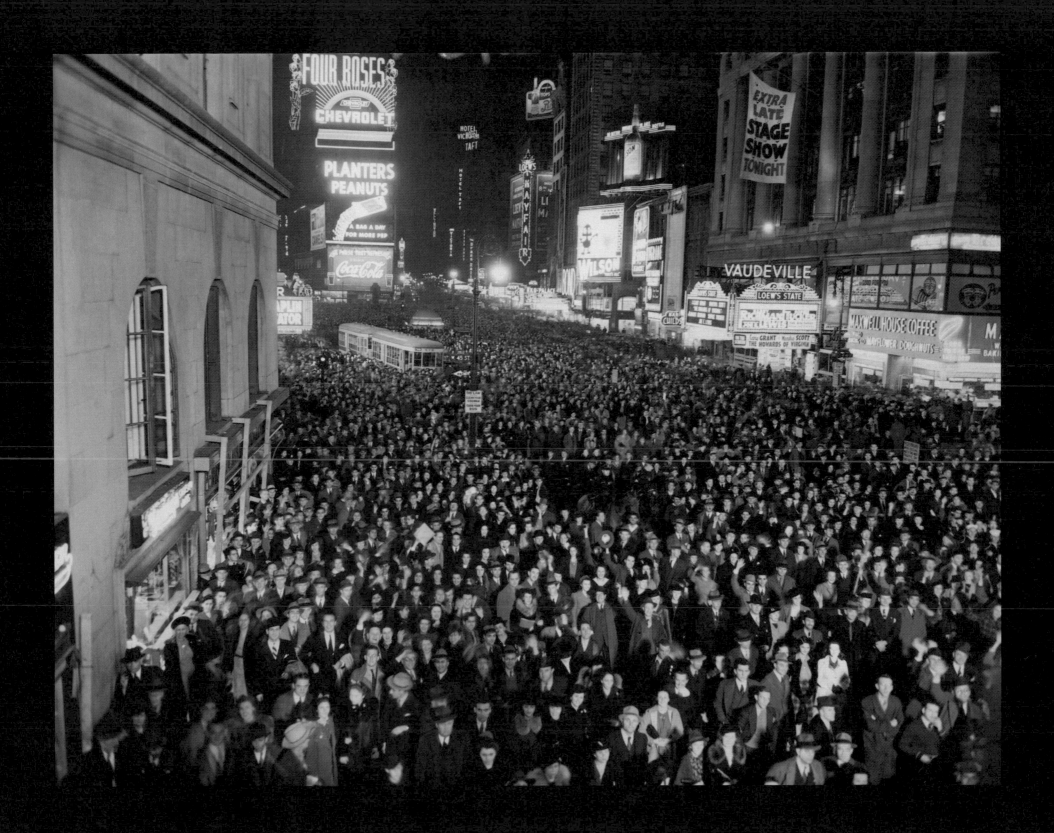

New York City 1940

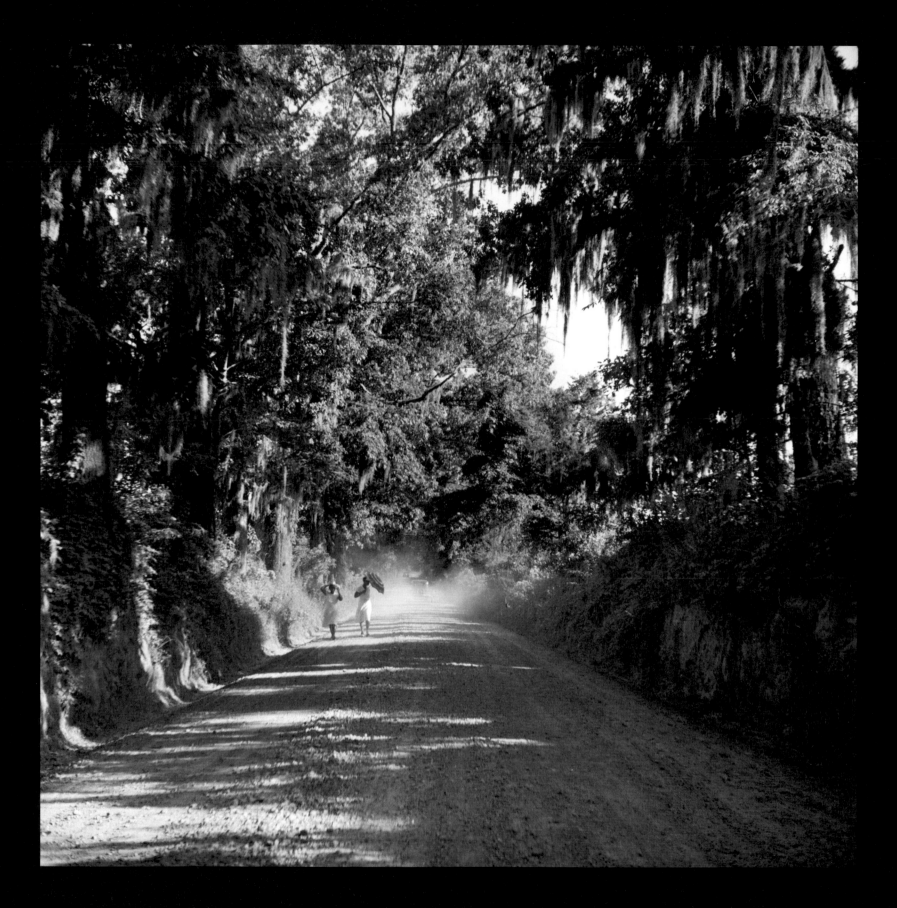

NATCHEZ, MISSISSIPPI 1940

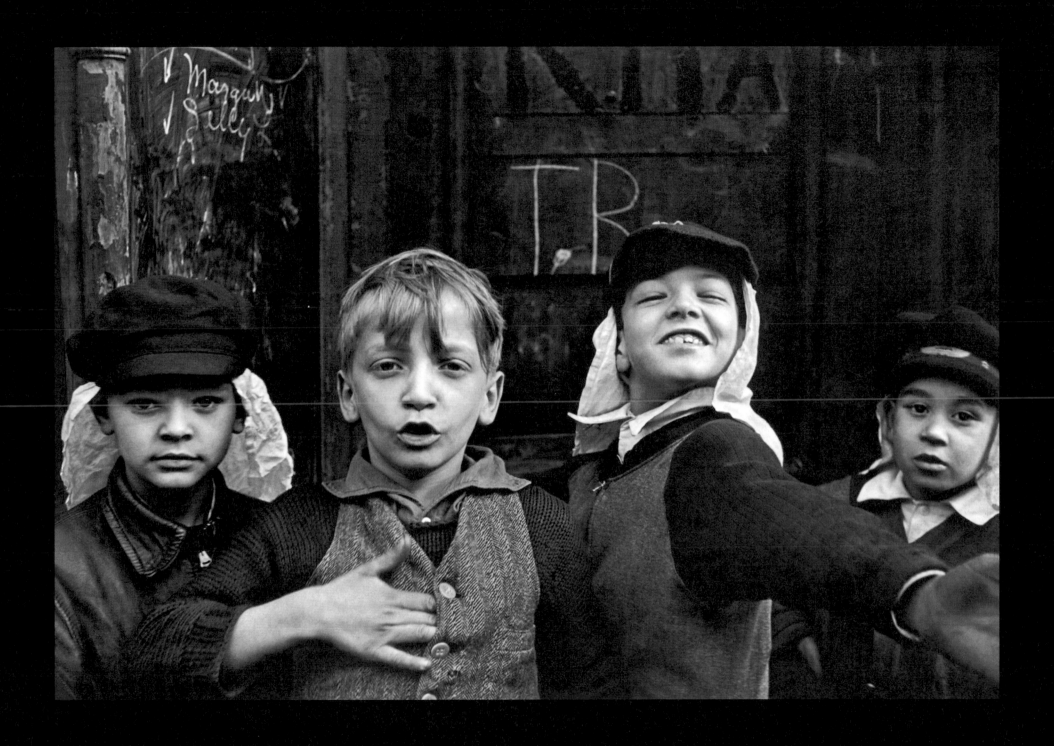

NEW YORK CITY C. 1940

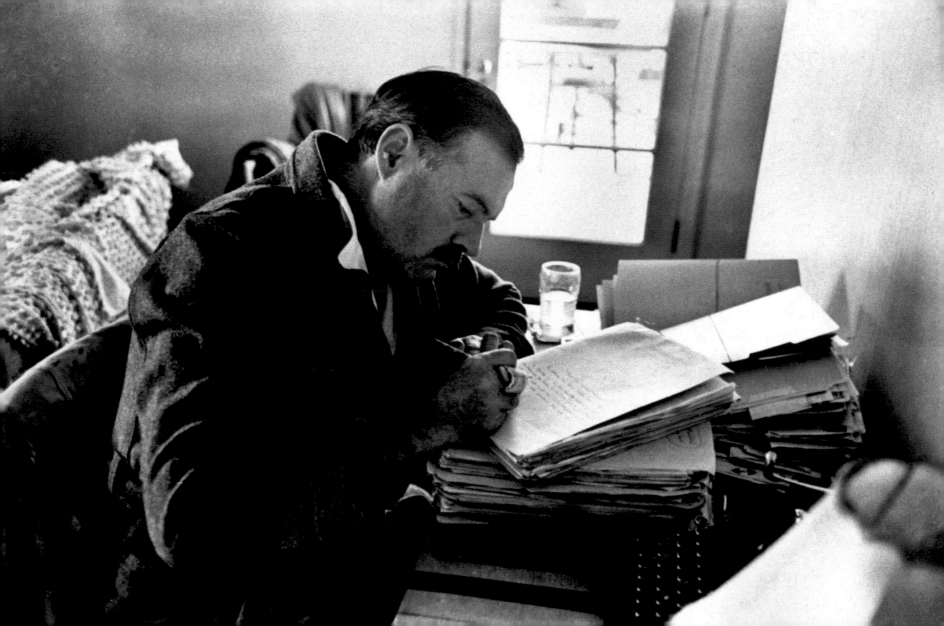

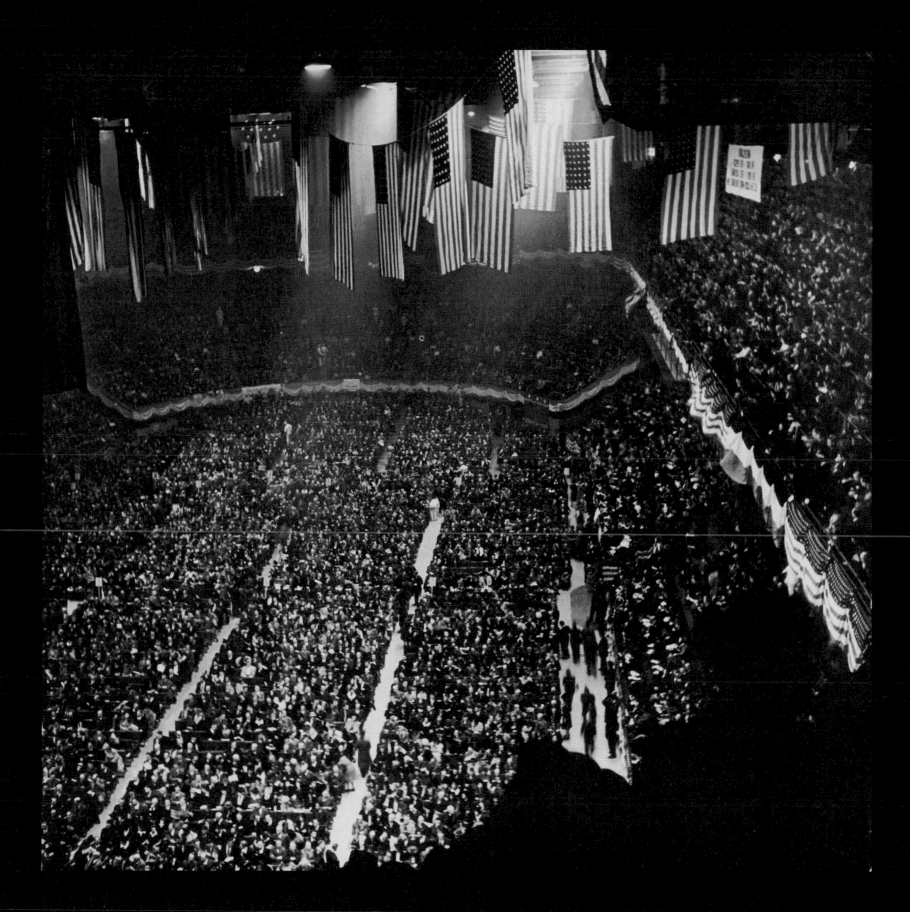

NEW YORK CITY 1941

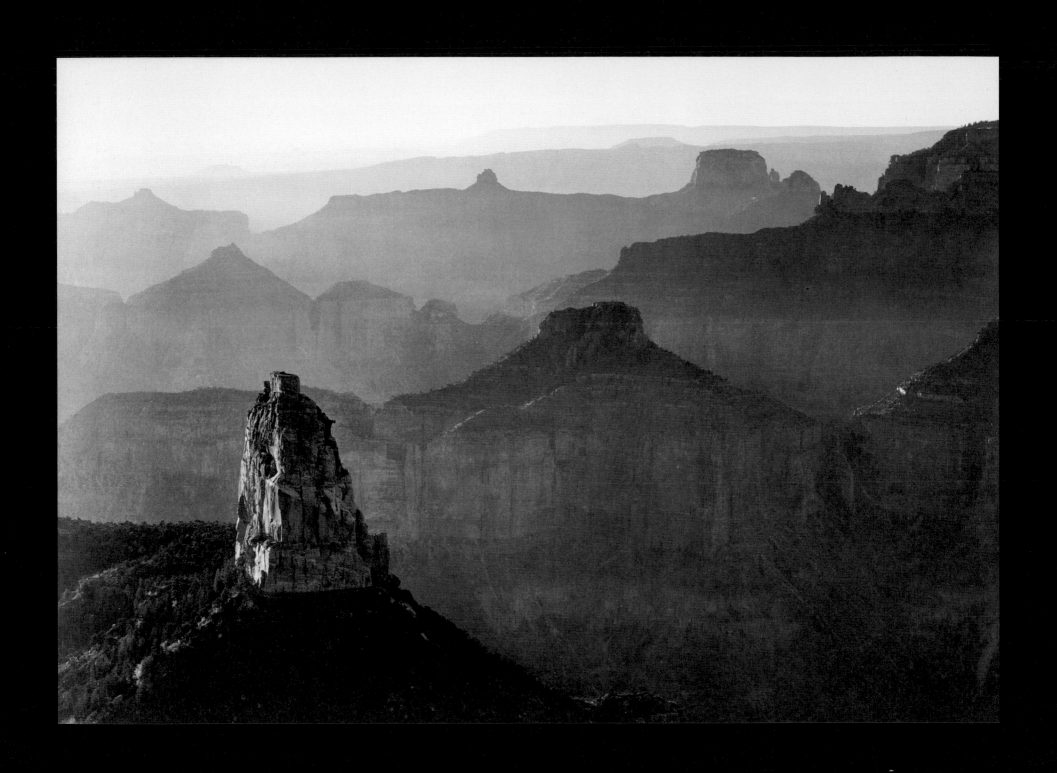

GRAND CANYON, ARIZONA 1941

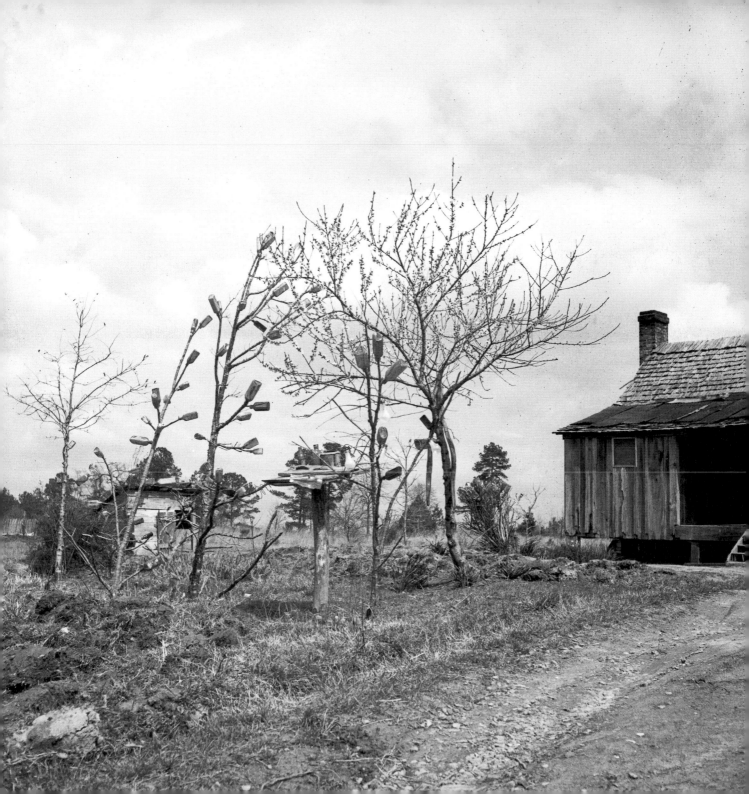

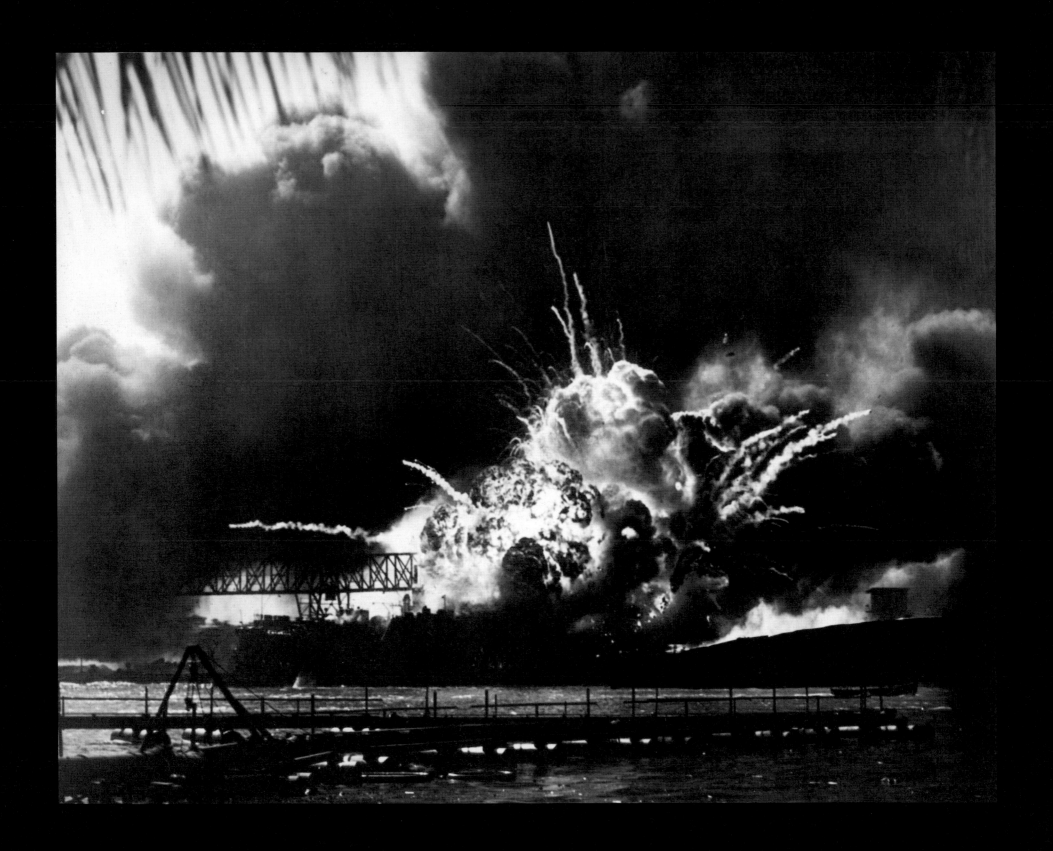

PEARL HARBOR, HAWAII 1941

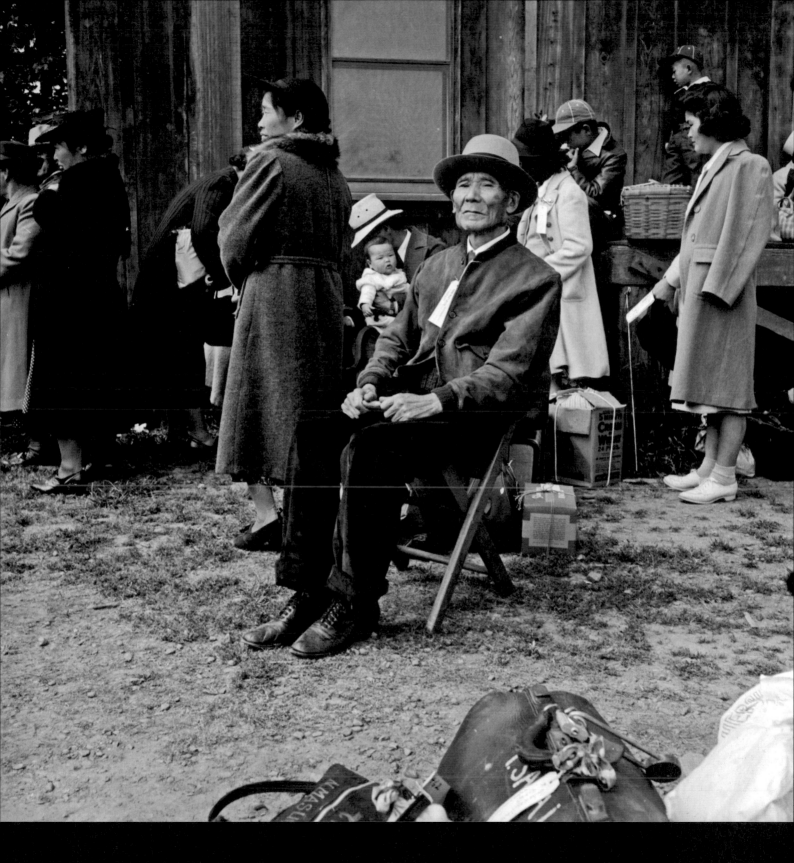

CENTERVILLE, CALIFORNIA 1942

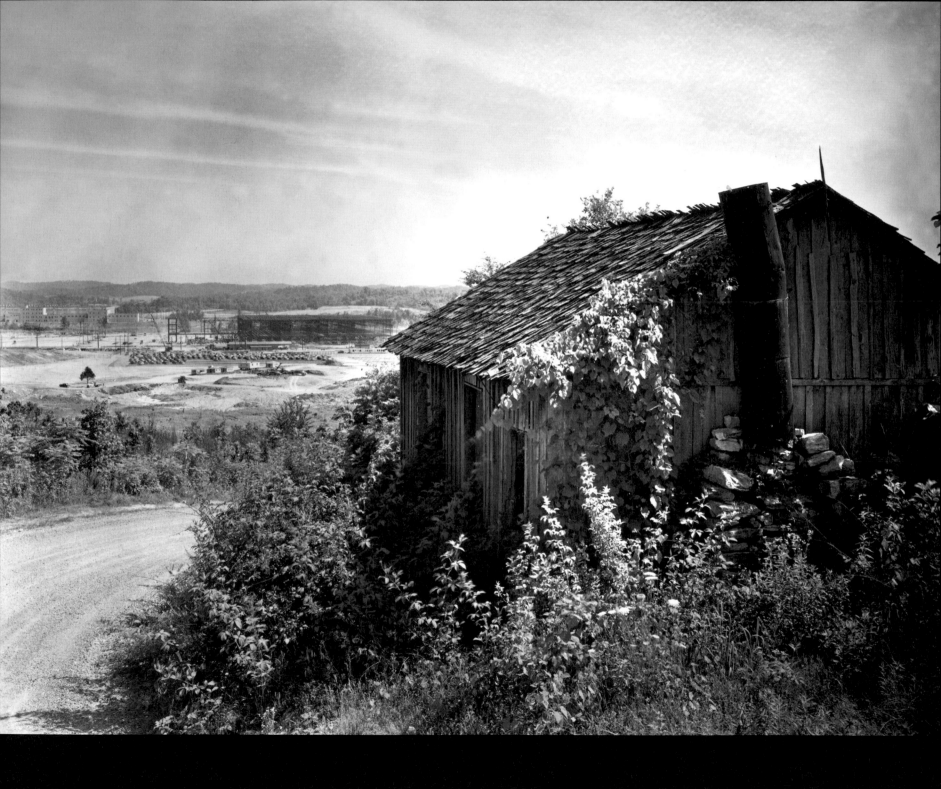

Oak Ridge, Tennessee 1942

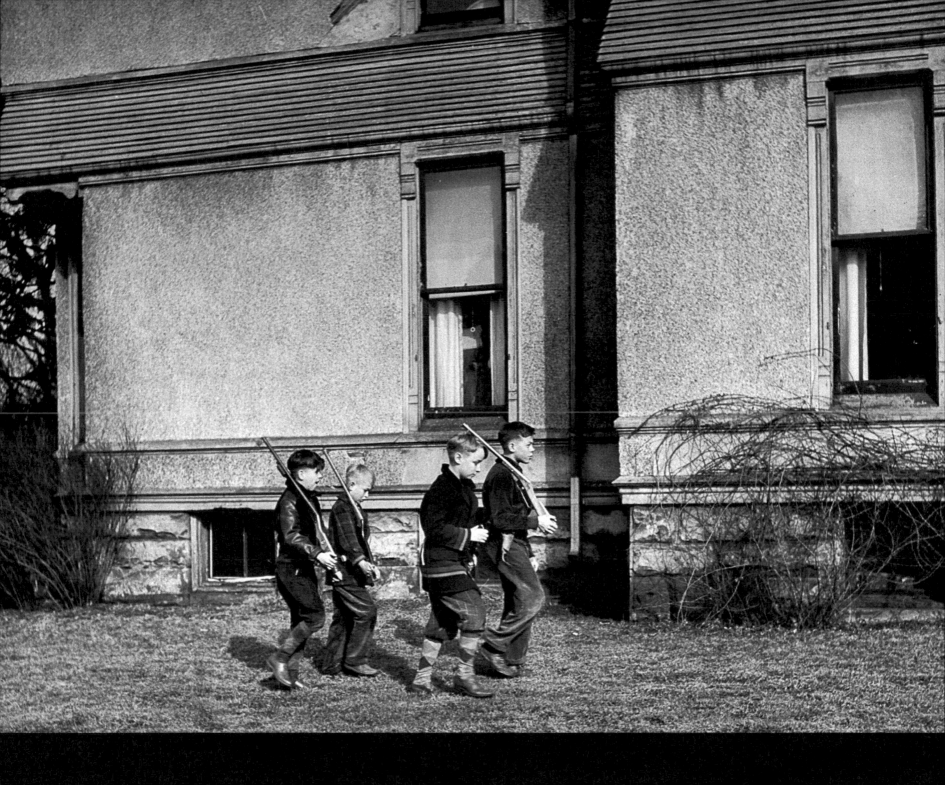

Mansfield, Ohio 1942

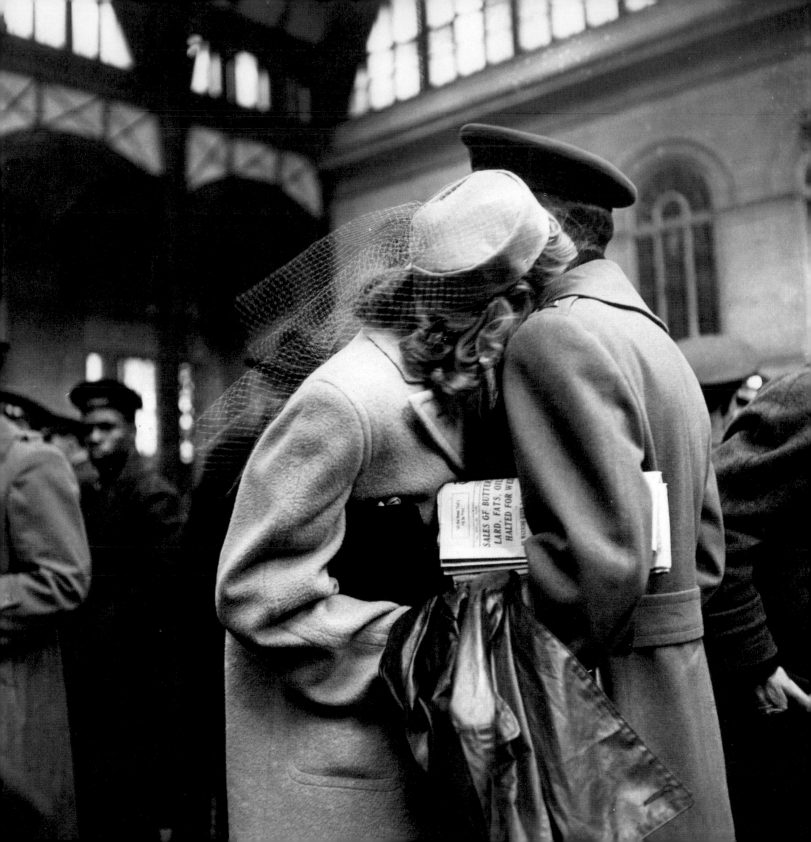

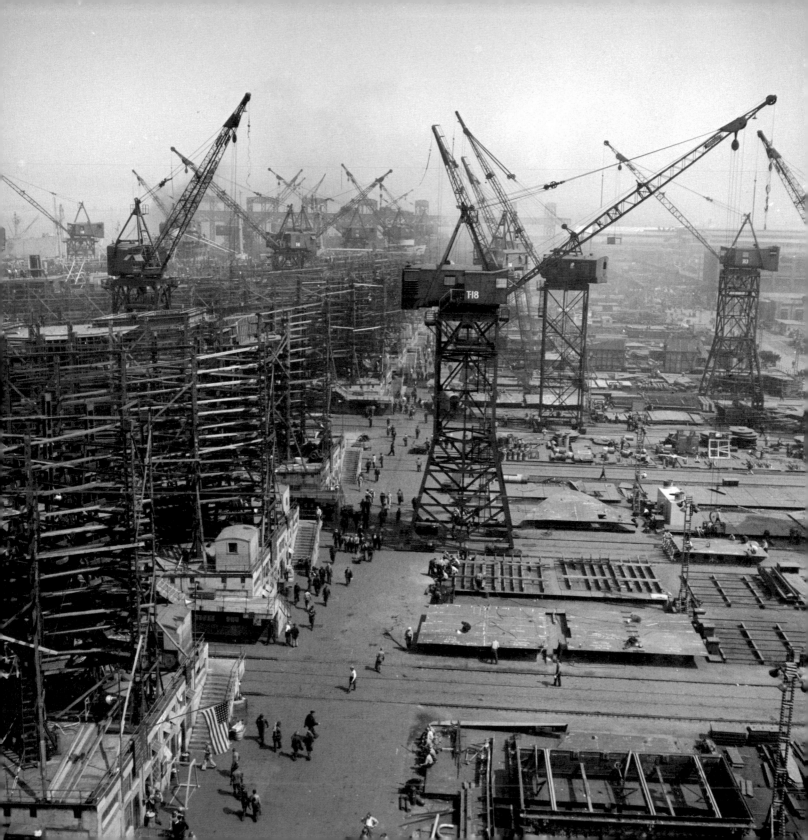

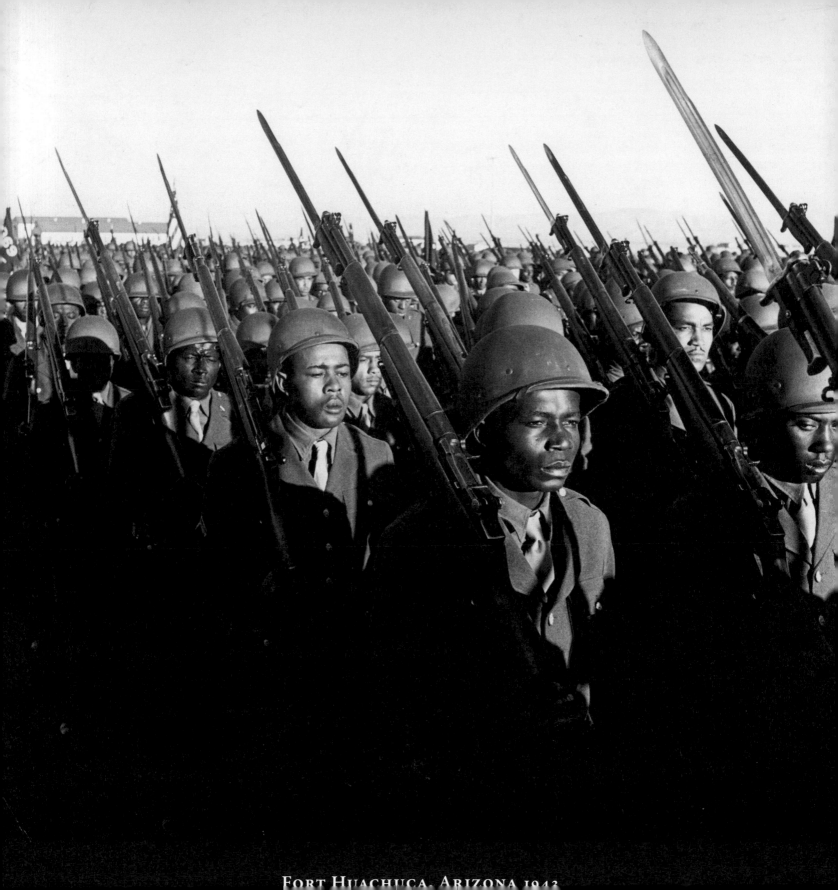

FORT HUACHUCA, ARIZONA 1942

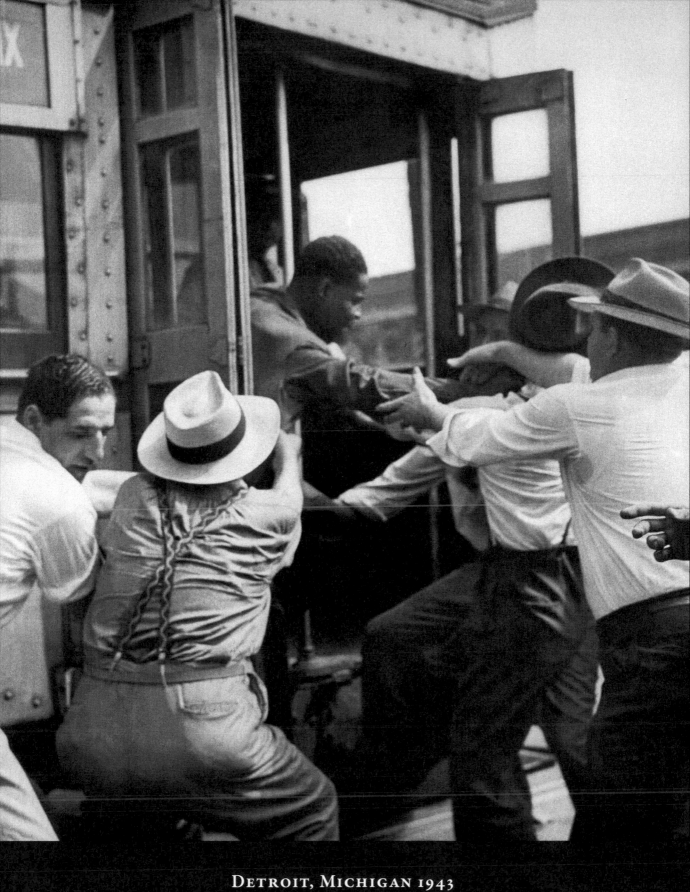

DETROIT, MICHIGAN 1943

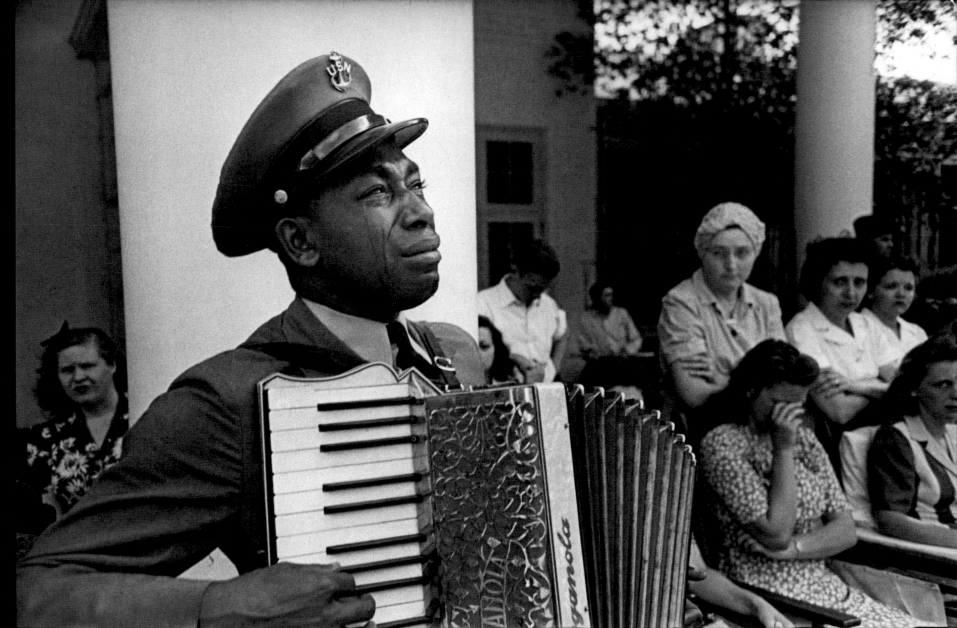

WASHINGTON, D.C. 1945

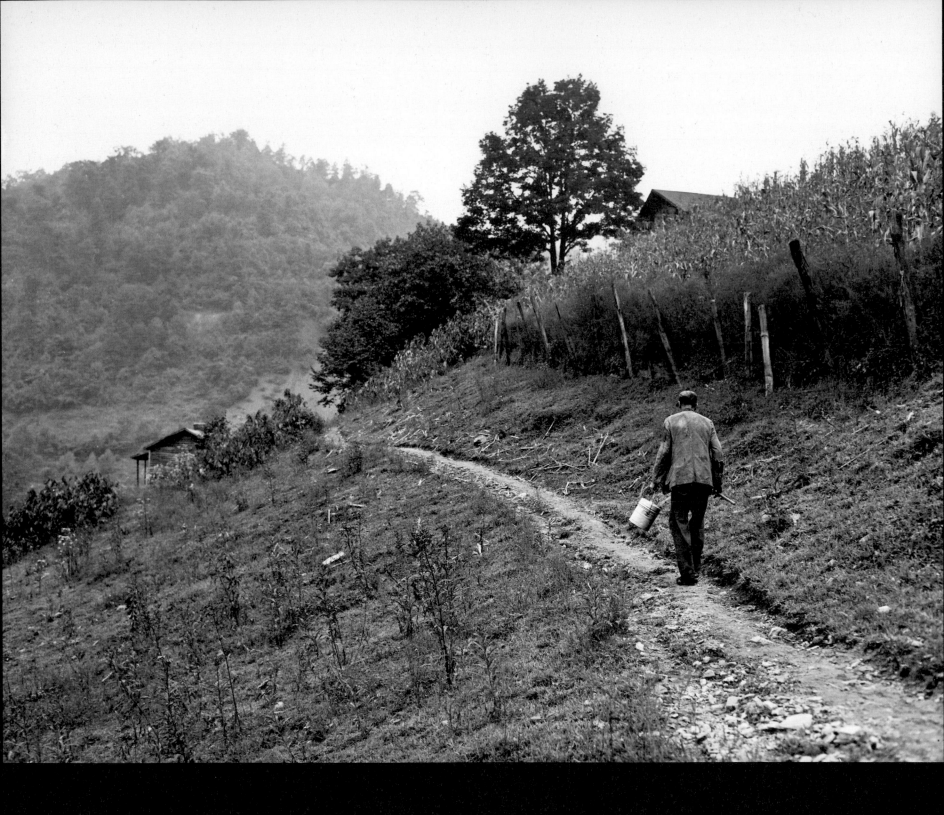

HARLAN COUNTY, KENTUCKY 1946

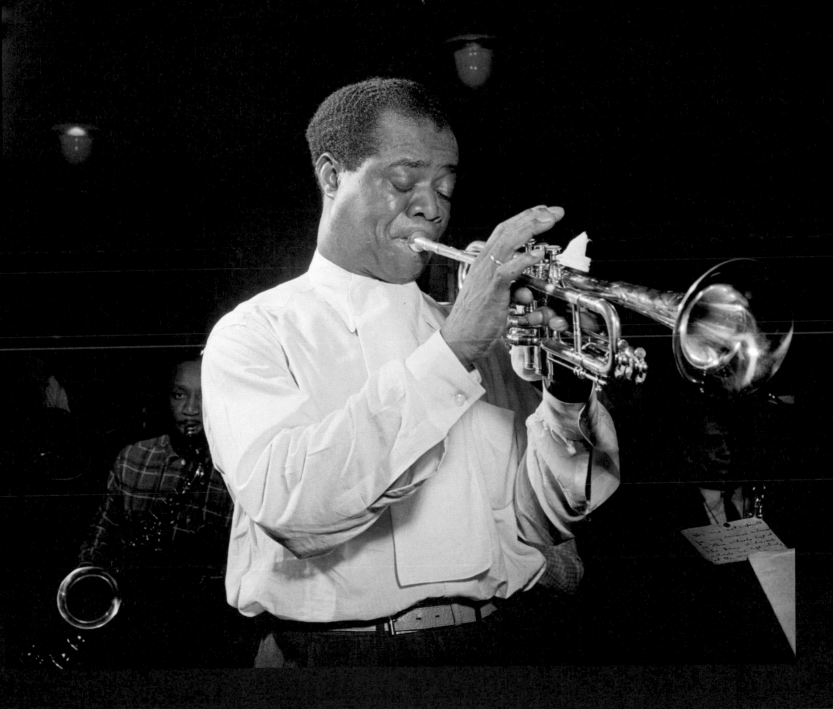

NEW YORK CITY 1947

WASHINGTON, D.C. 1948

198

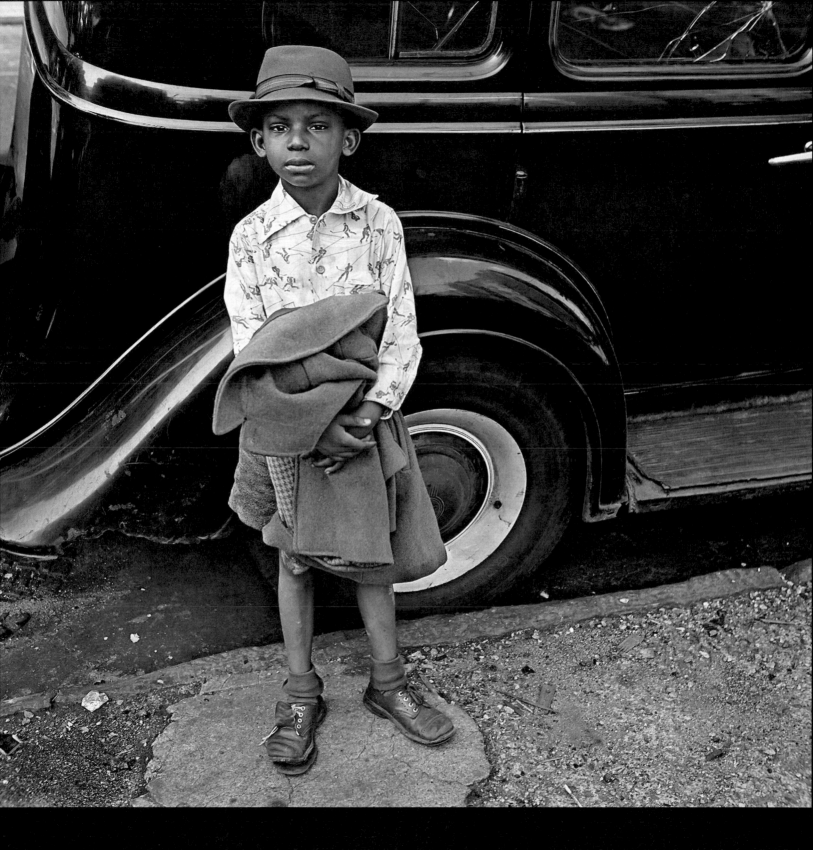

NEW YORK CITY 1949

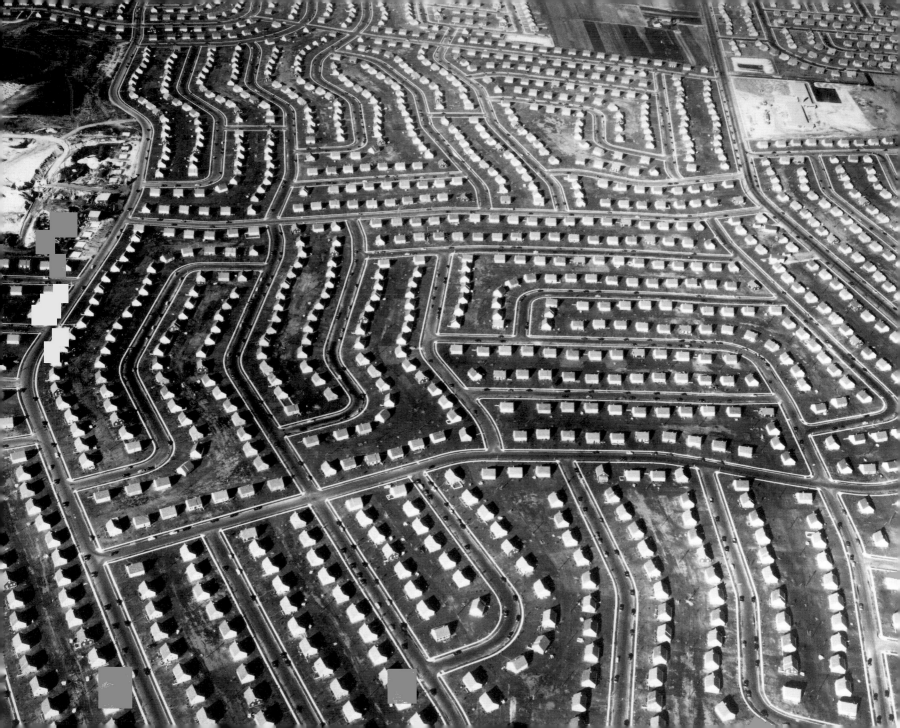

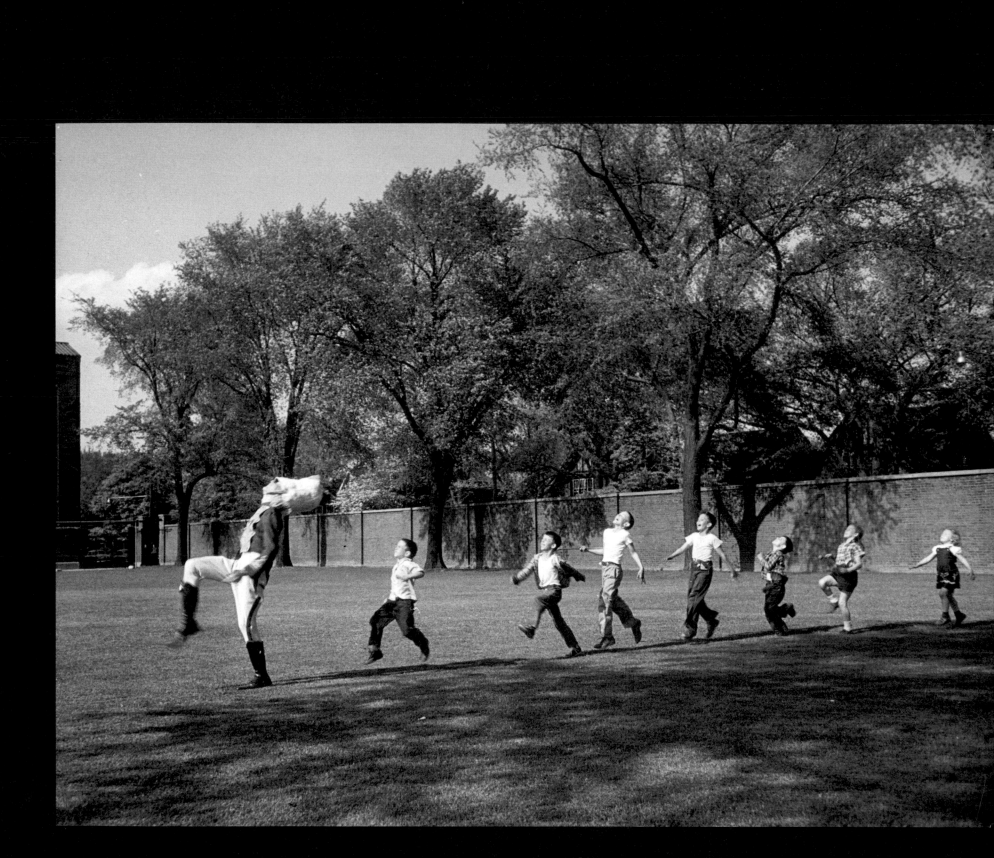

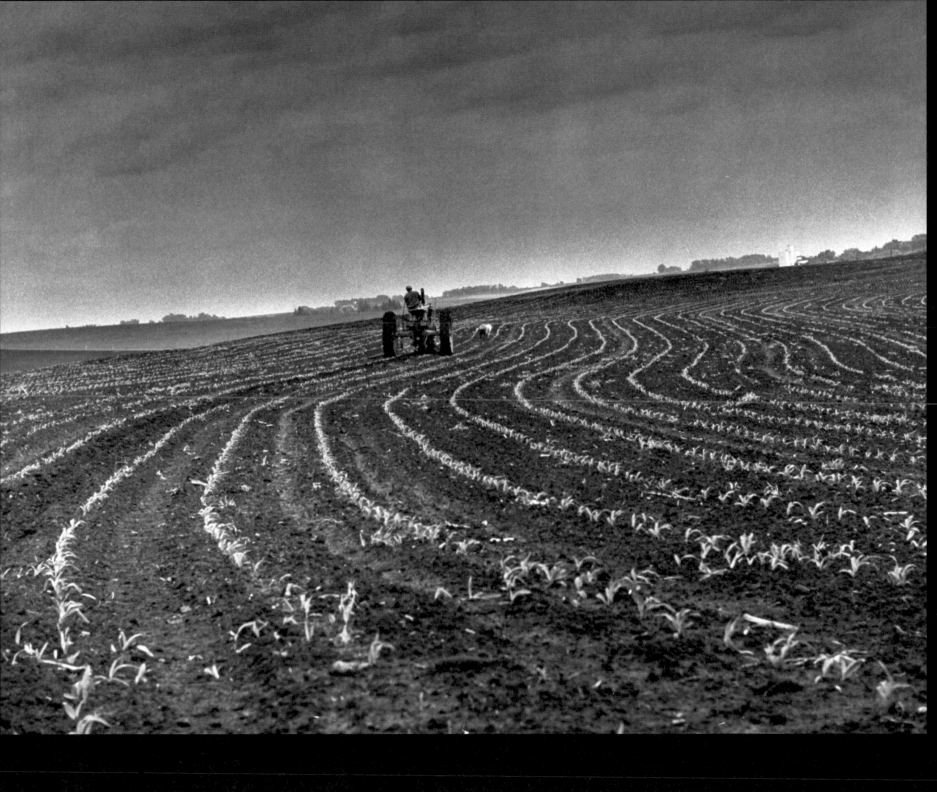

Iowa 1954

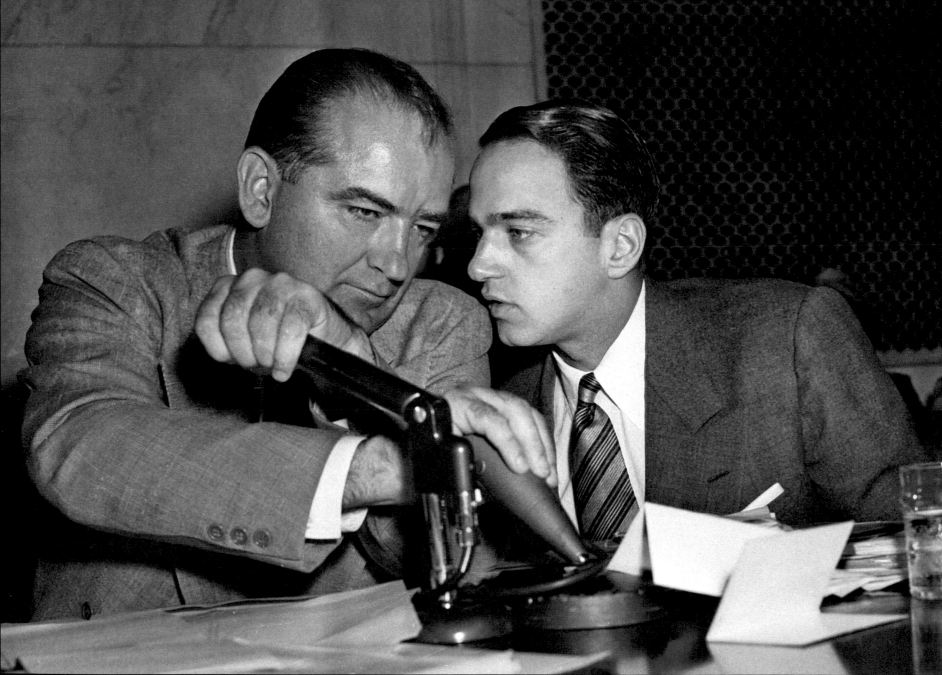

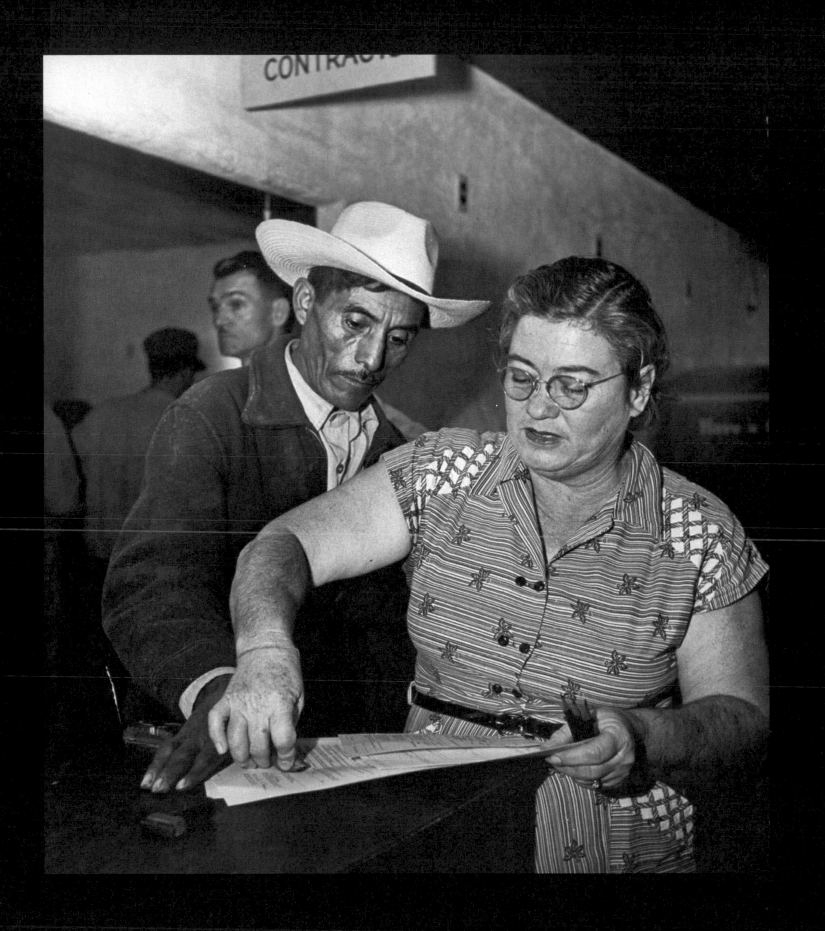

CALIFORNIA 1954

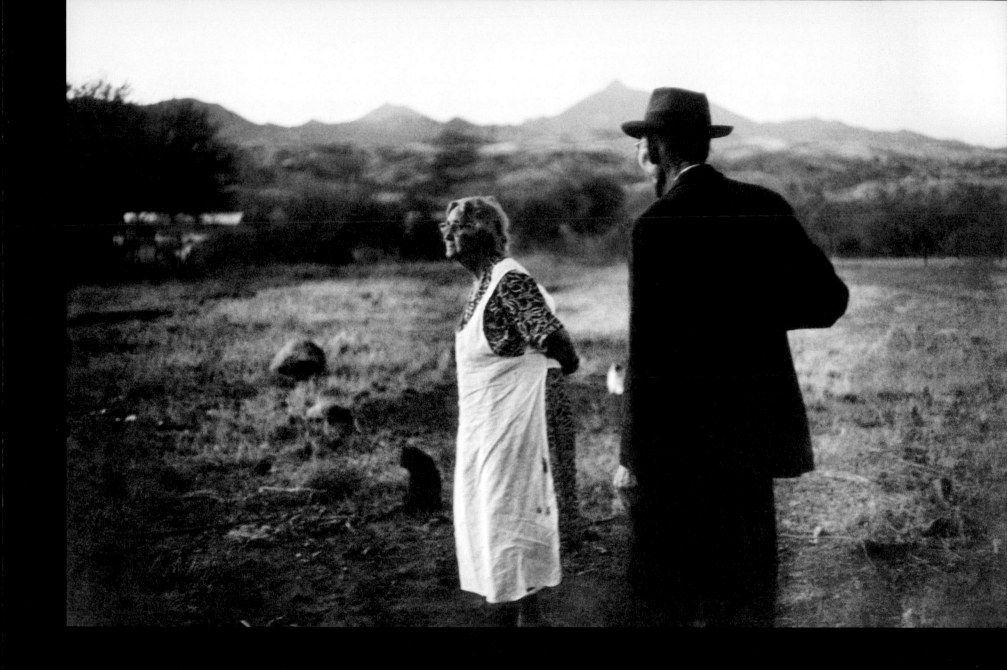

PATAGONIA, ARIZONA 1955

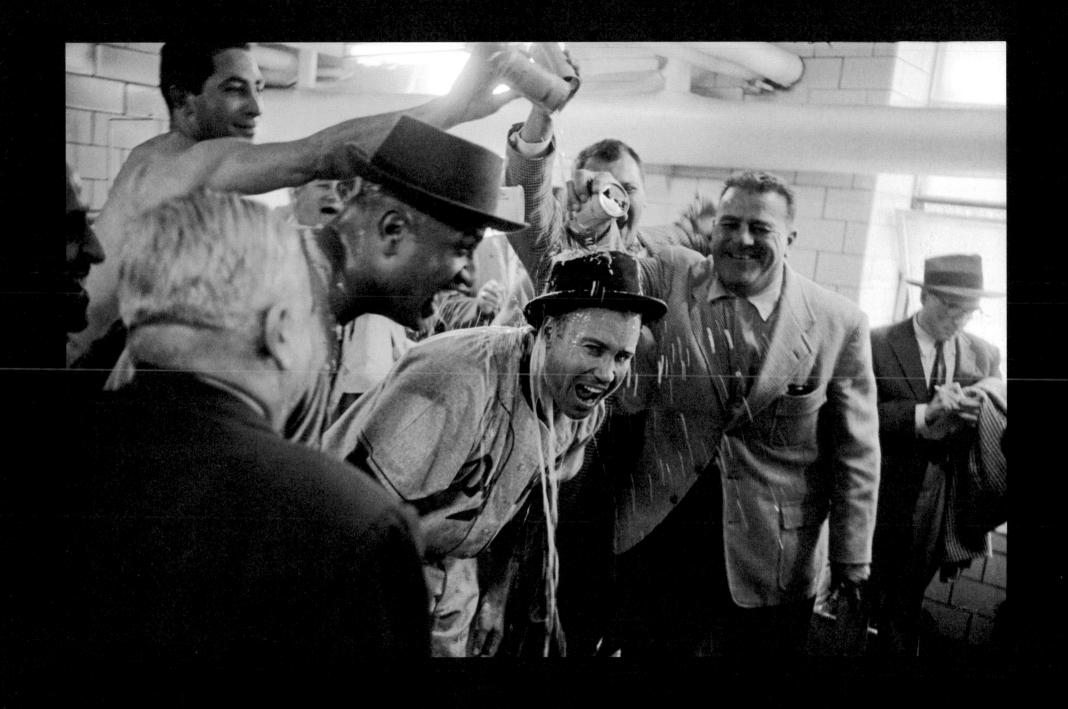

NEW YORK CITY 1955

207

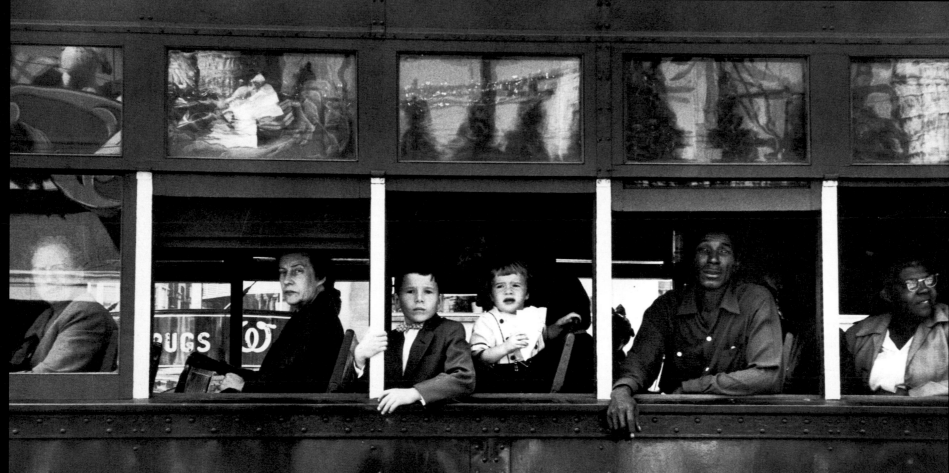

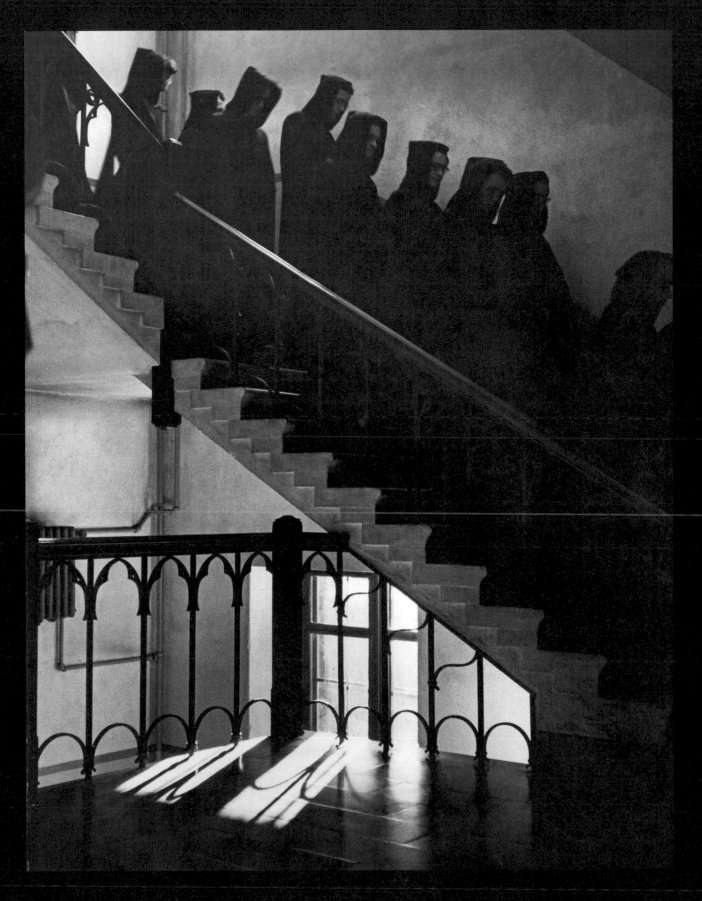

ATCHISON, KANSAS 1955

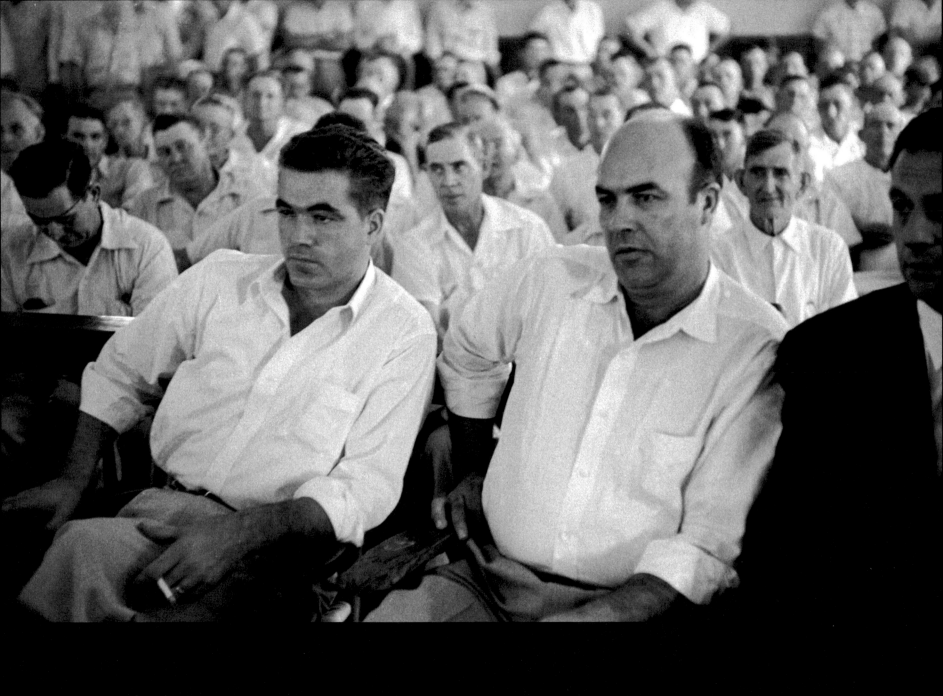

MONEY, MISSISSIPPI 1955

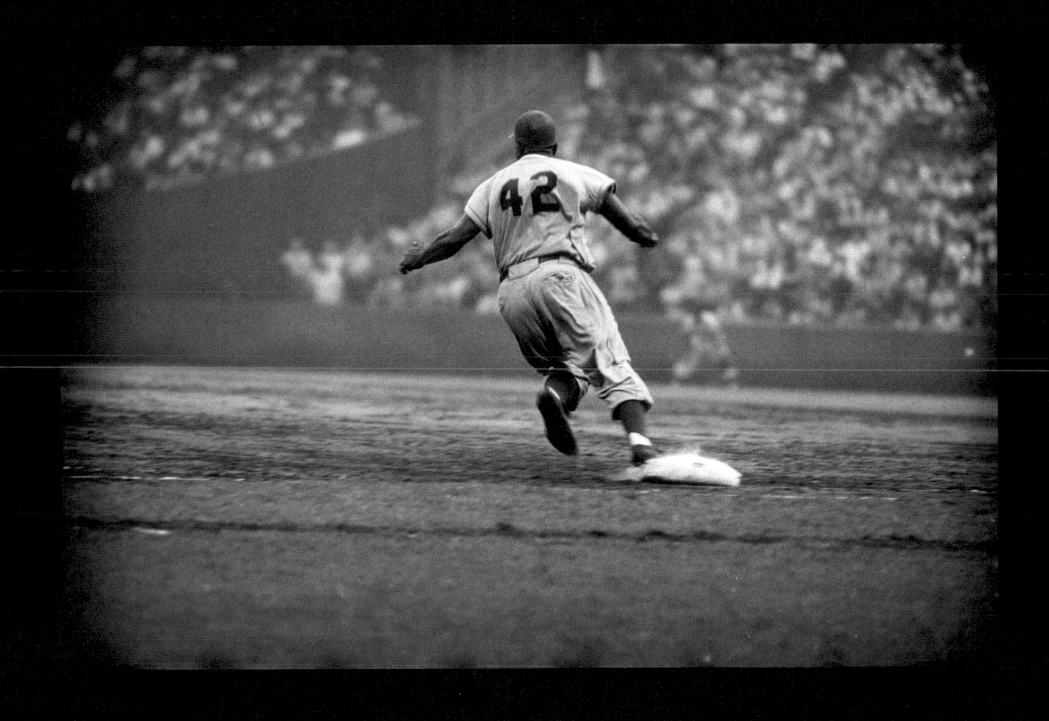

NEW YORK CITY 1956

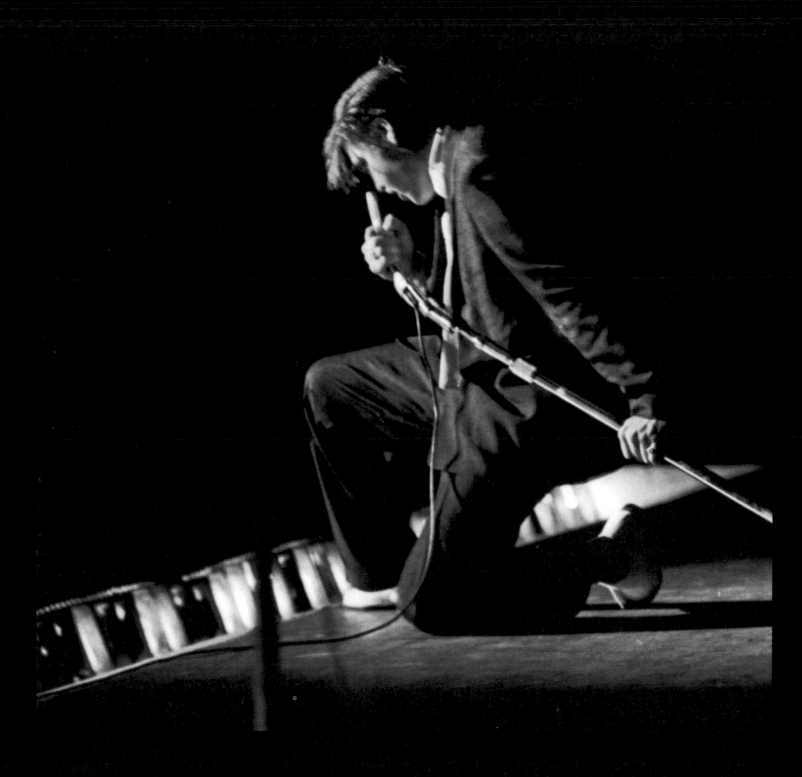

RICHMOND, VIRGINIA 1956

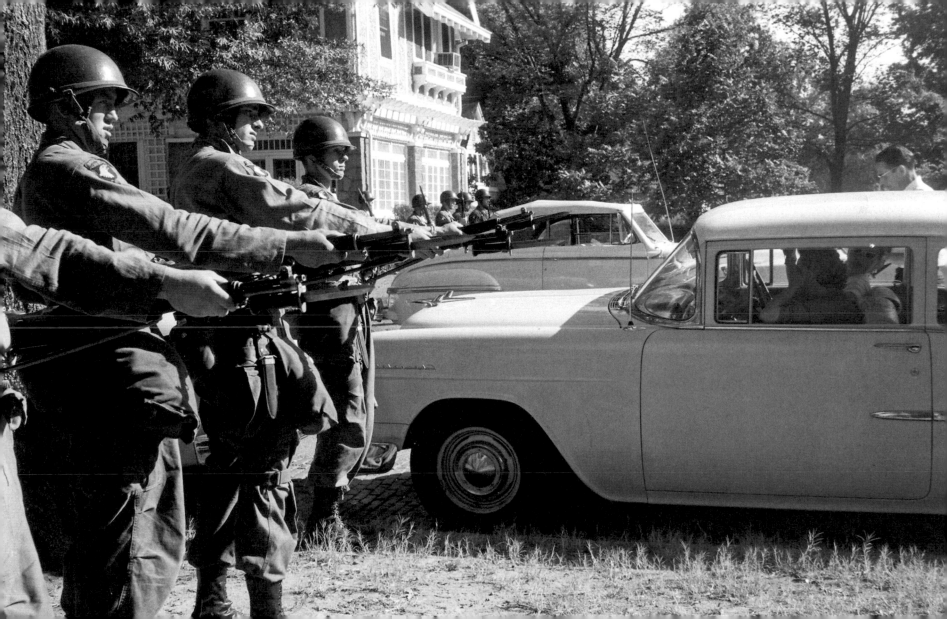

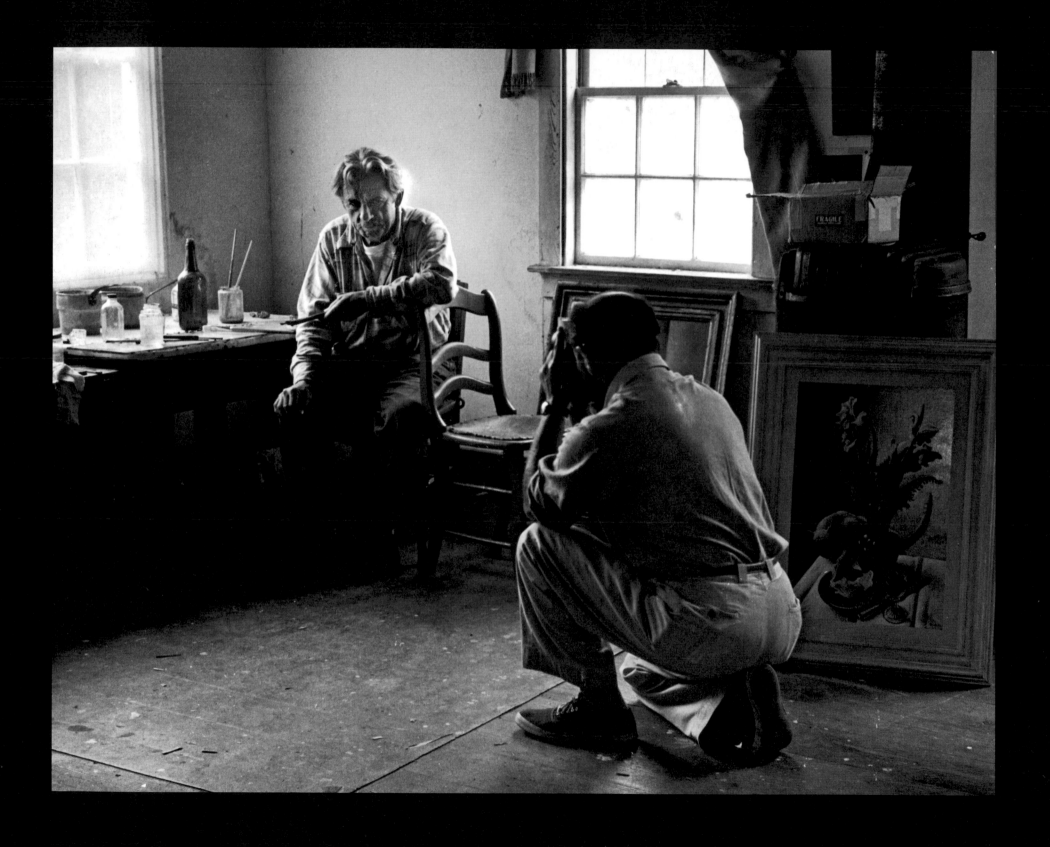

MARTHA'S VINEYARD, MASSACHUSETTS 1957

214

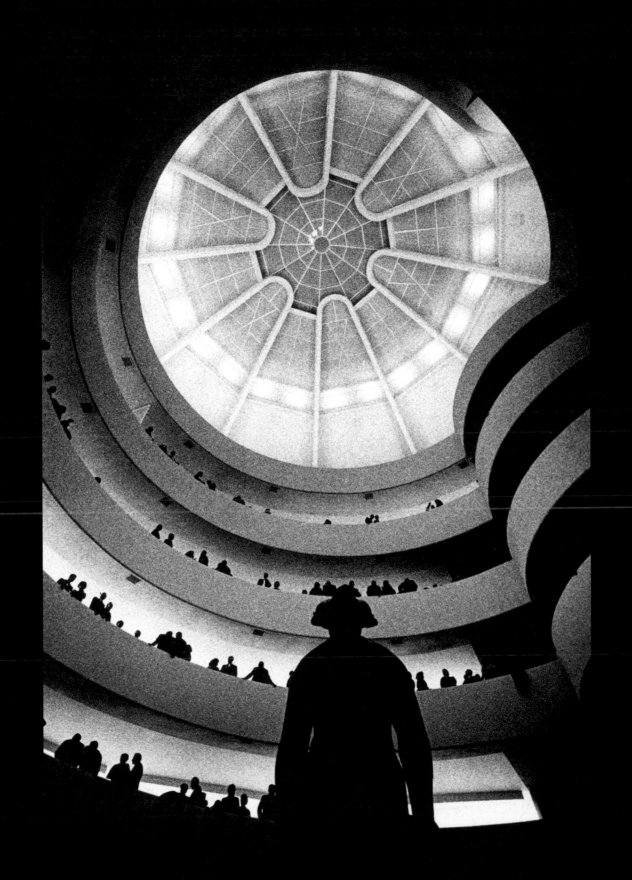

New York City 1959

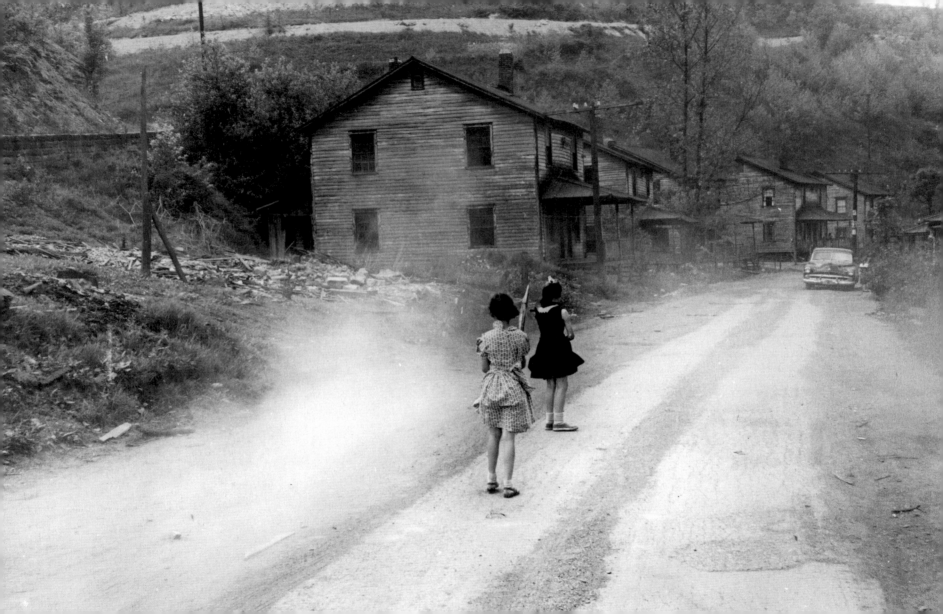

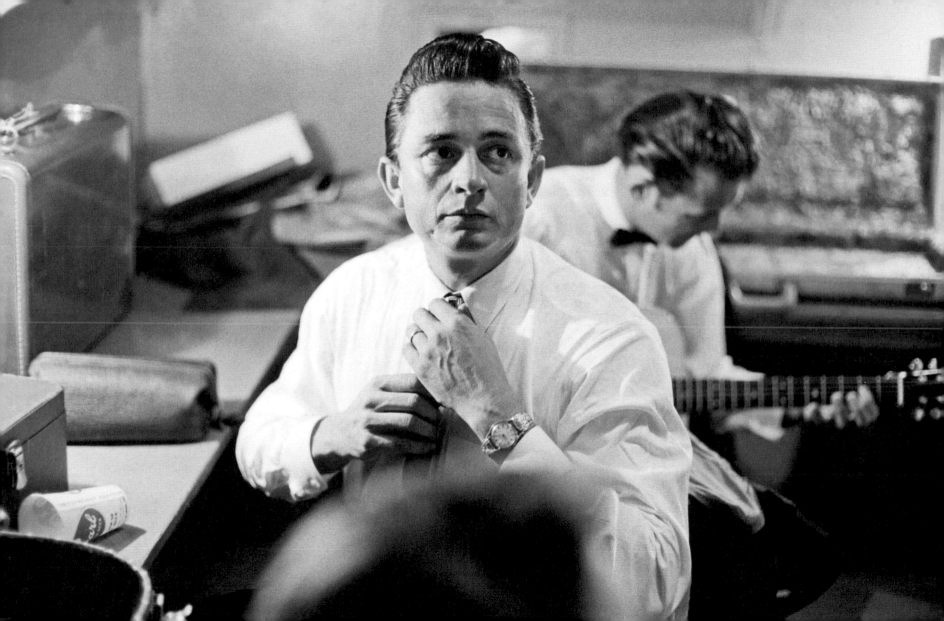

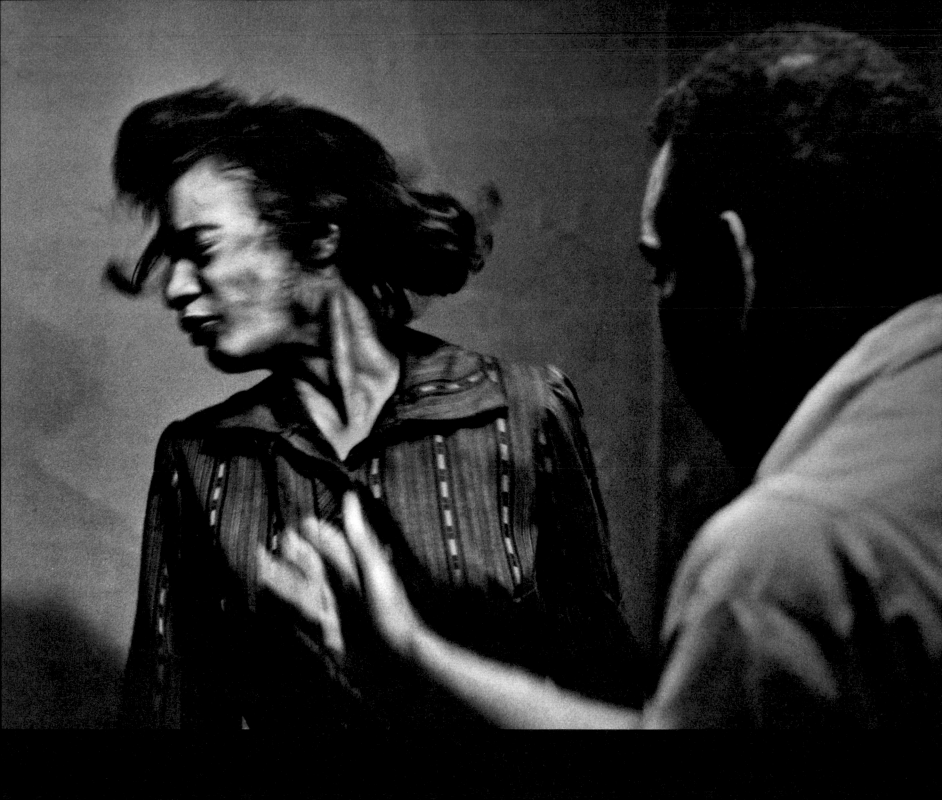

ATLANTA, GEORGIA 1960

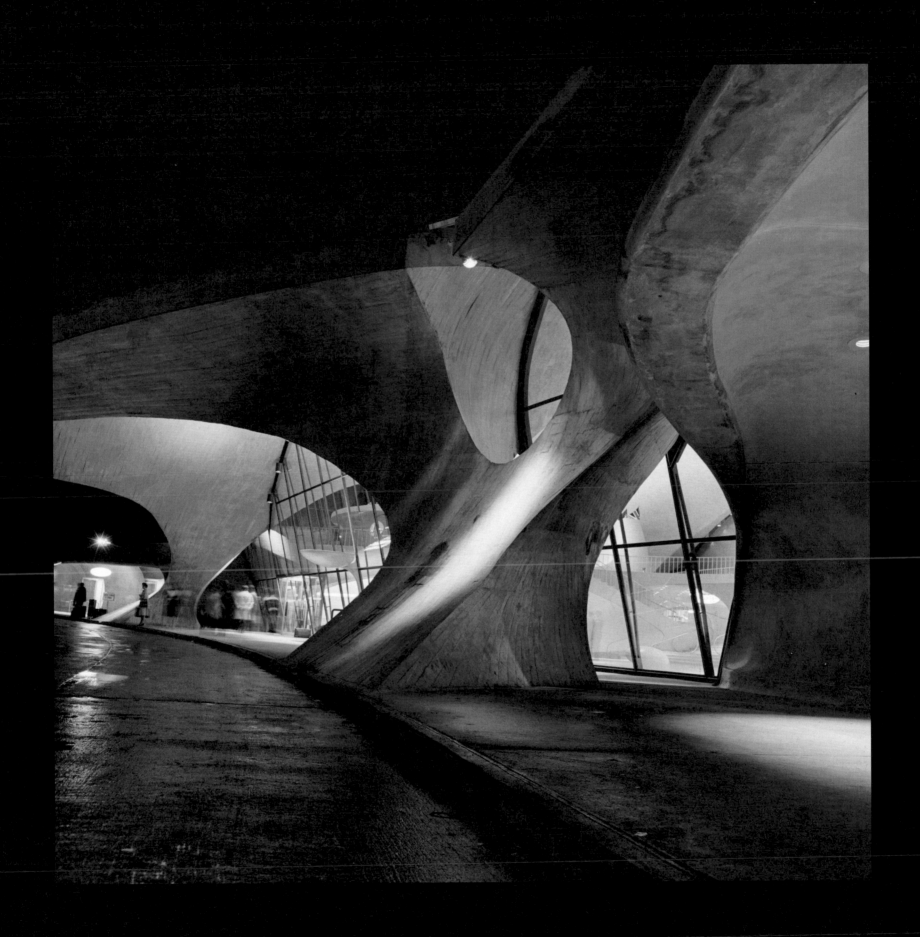

QUEENS, NEW YORK 1960

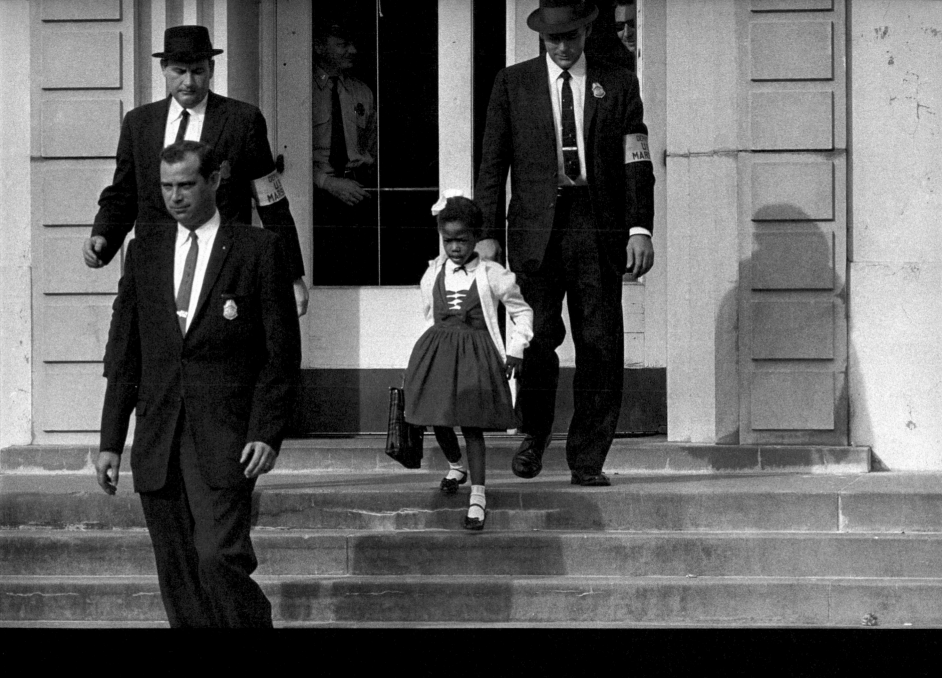

New Orleans, Louisiana 1960

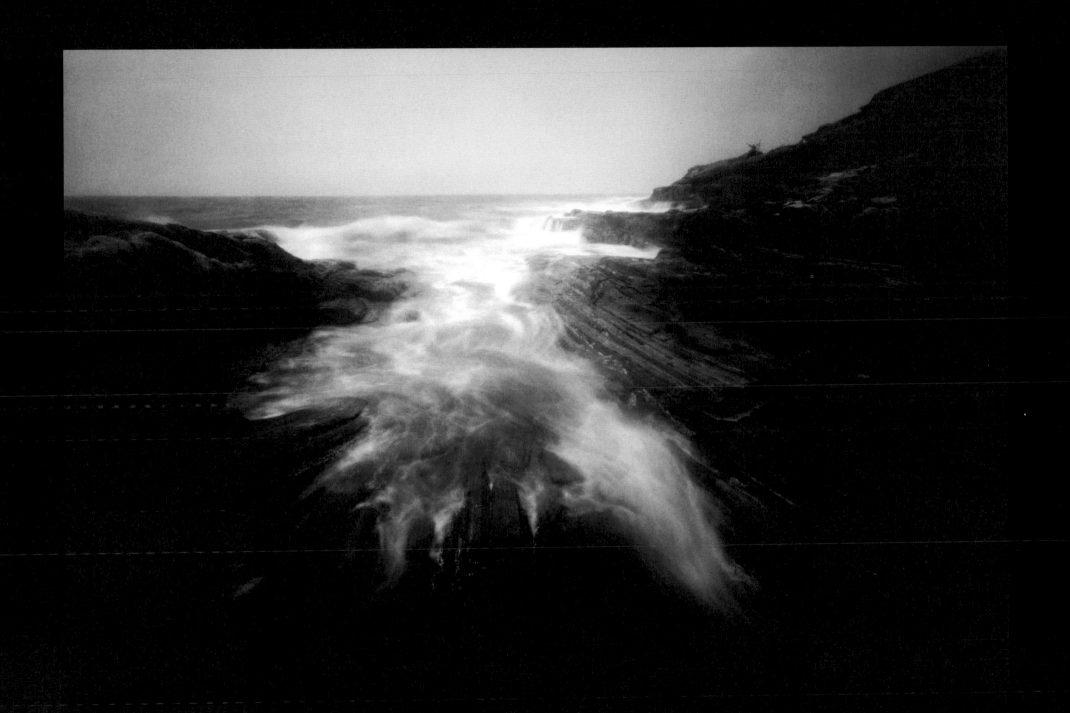

Pemaquid Point, Maine 1960

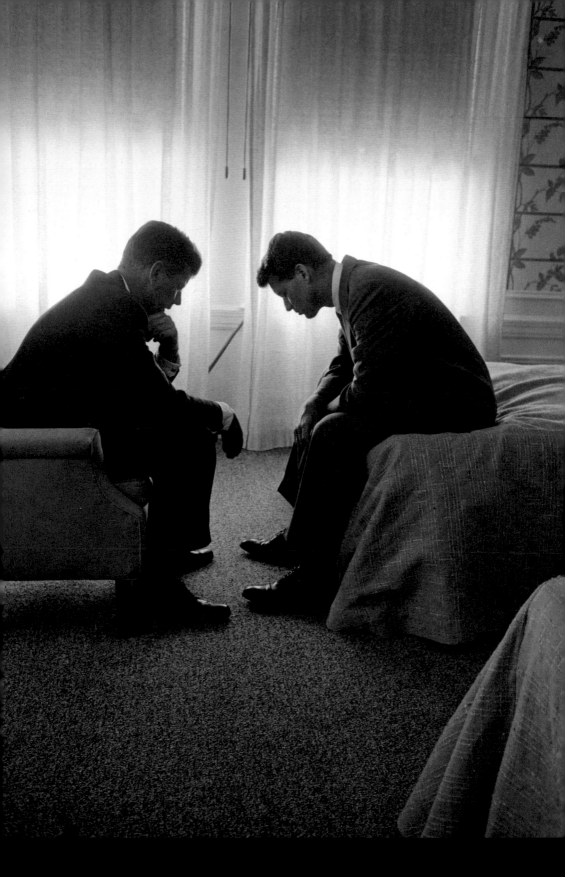

LOS ANGELES, CALIFORNIA 1960

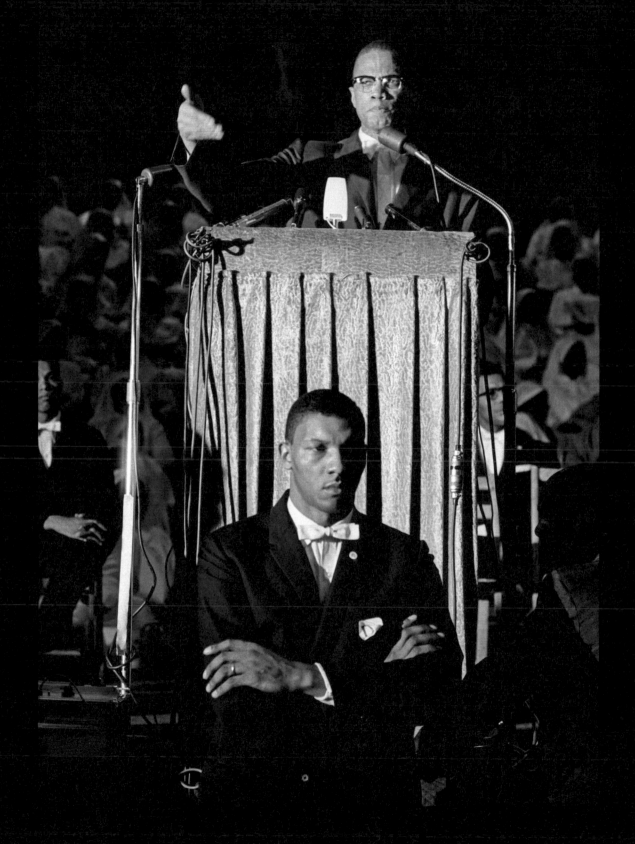

WASHINGTON, D.C. 1961

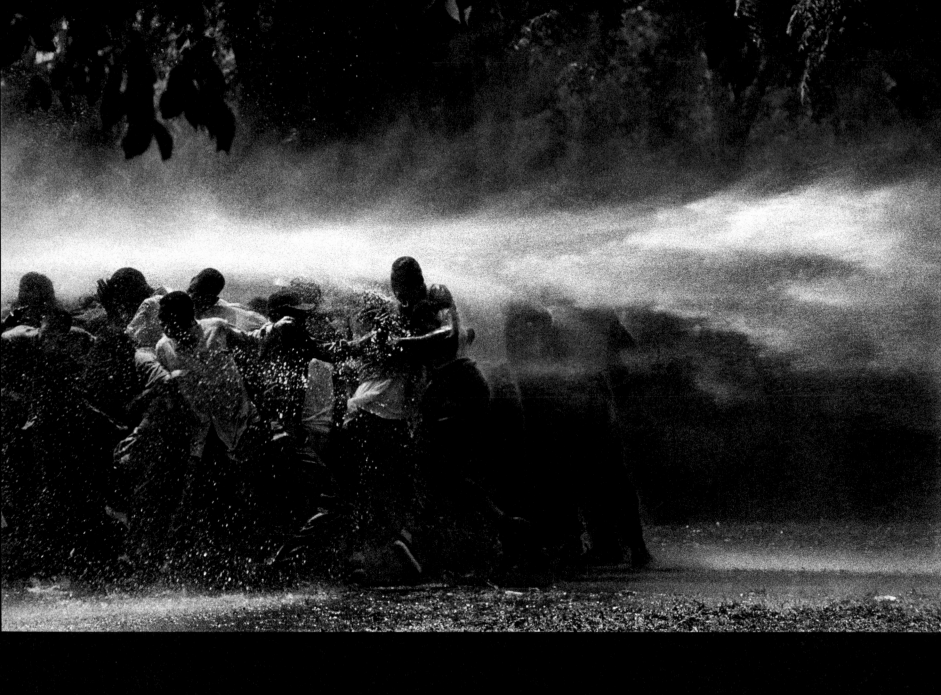

BIRMINGHAM, ALABAMA 1963

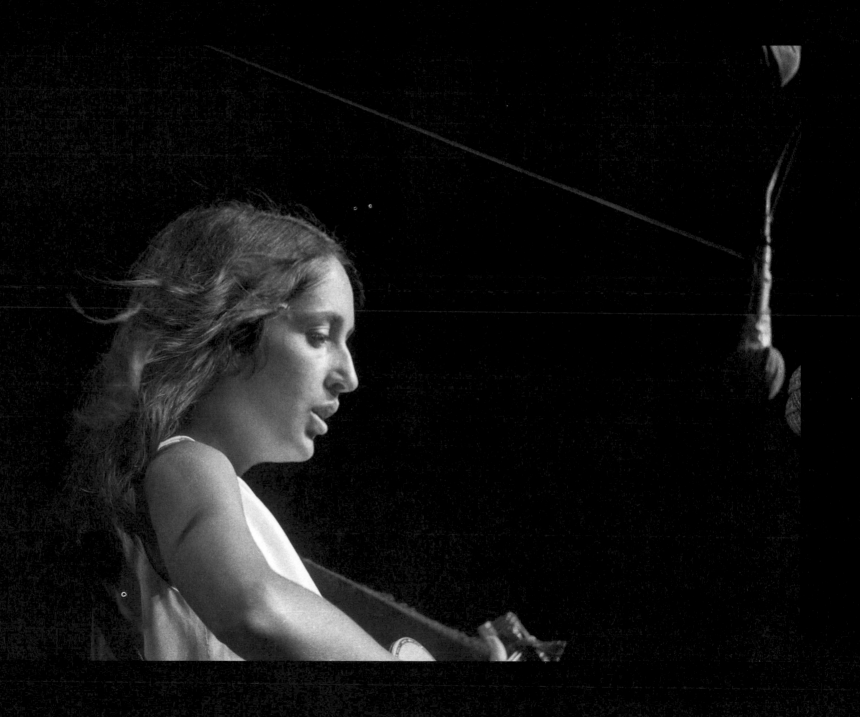

NEWPORT, RHODE ISLAND 1963

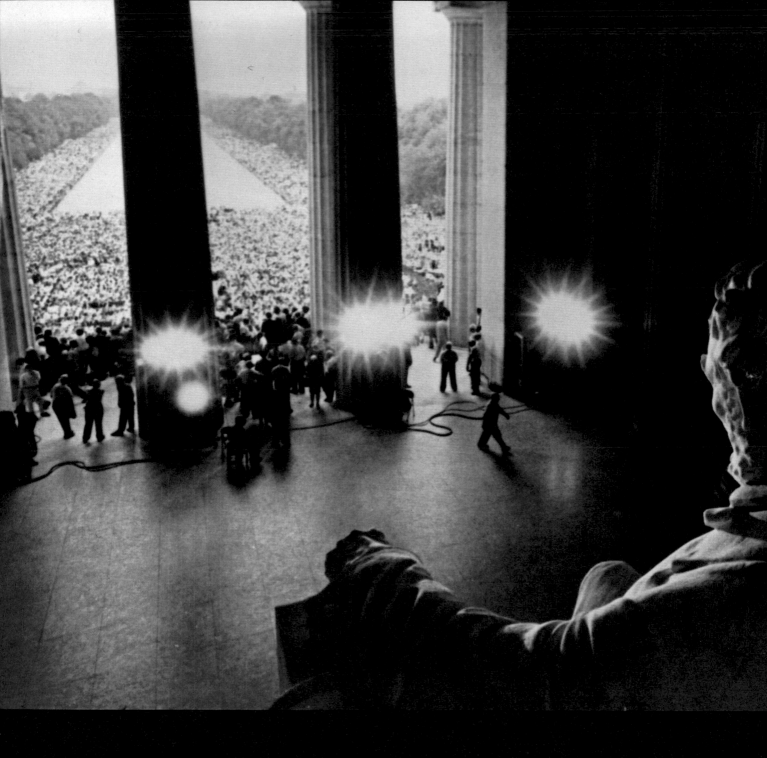

WASHINGTON, D.C. 1963

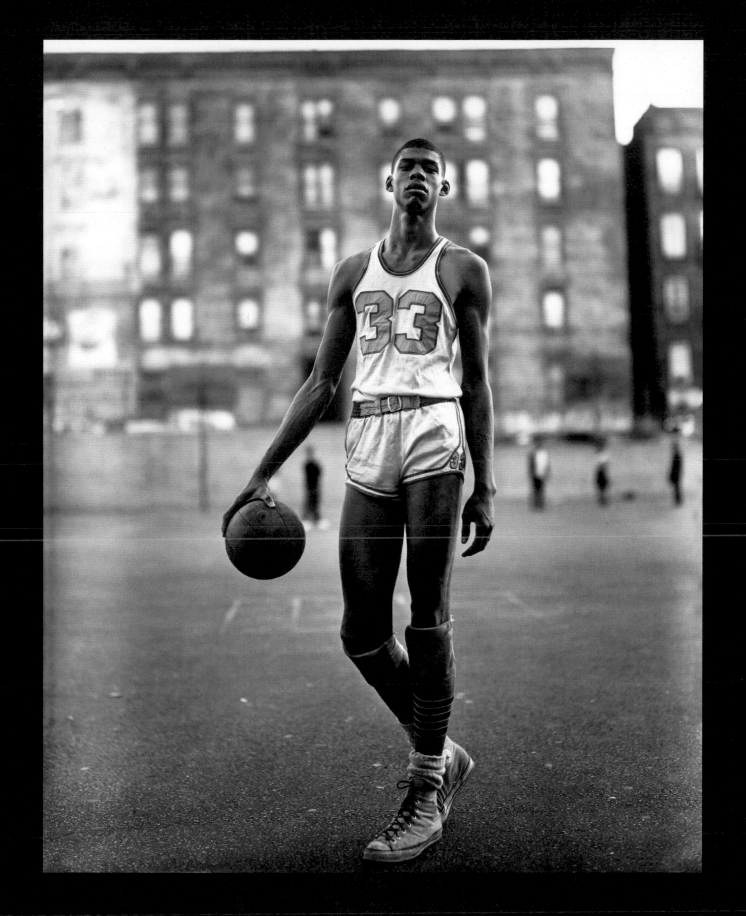

NEW YORK CITY 1963

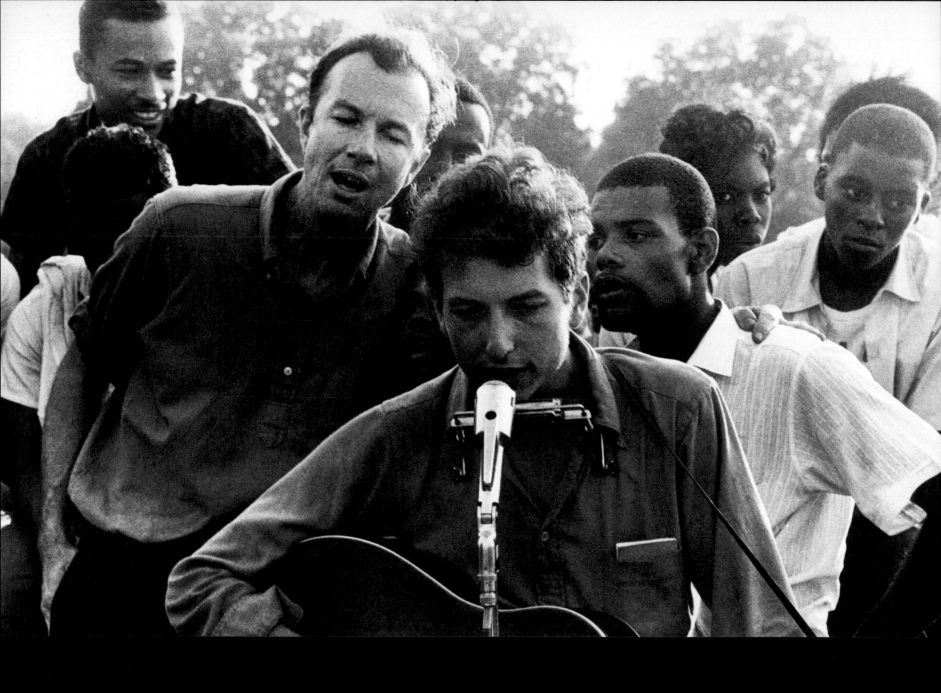

GREENWOOD, MISSISSIPPI 1963

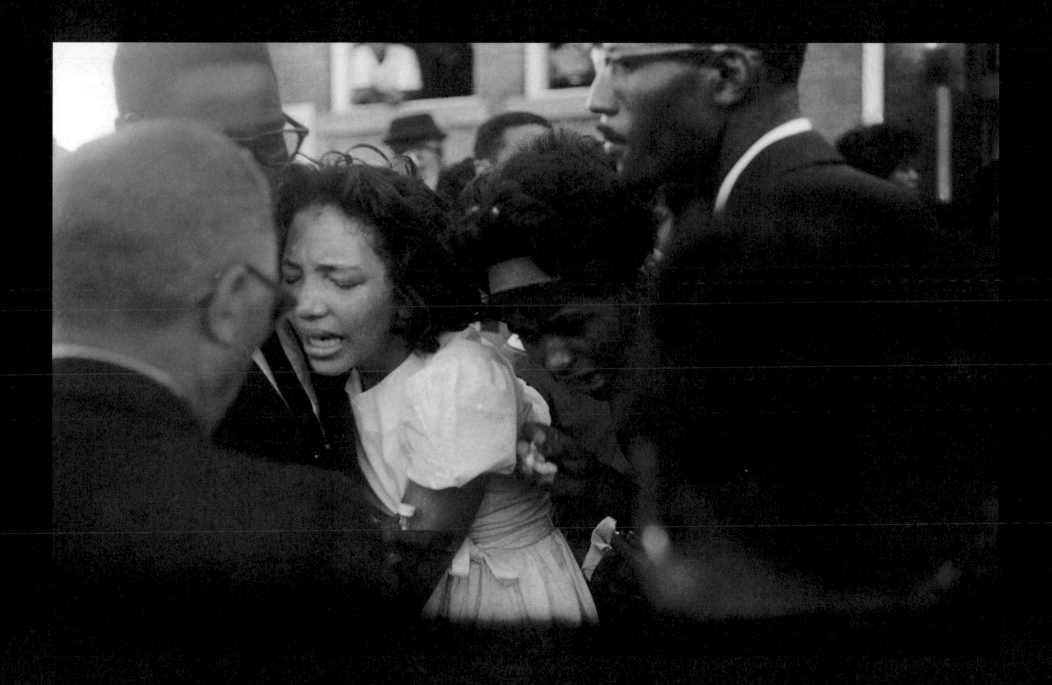

BIRMINGHAM, ALABAMA 1963

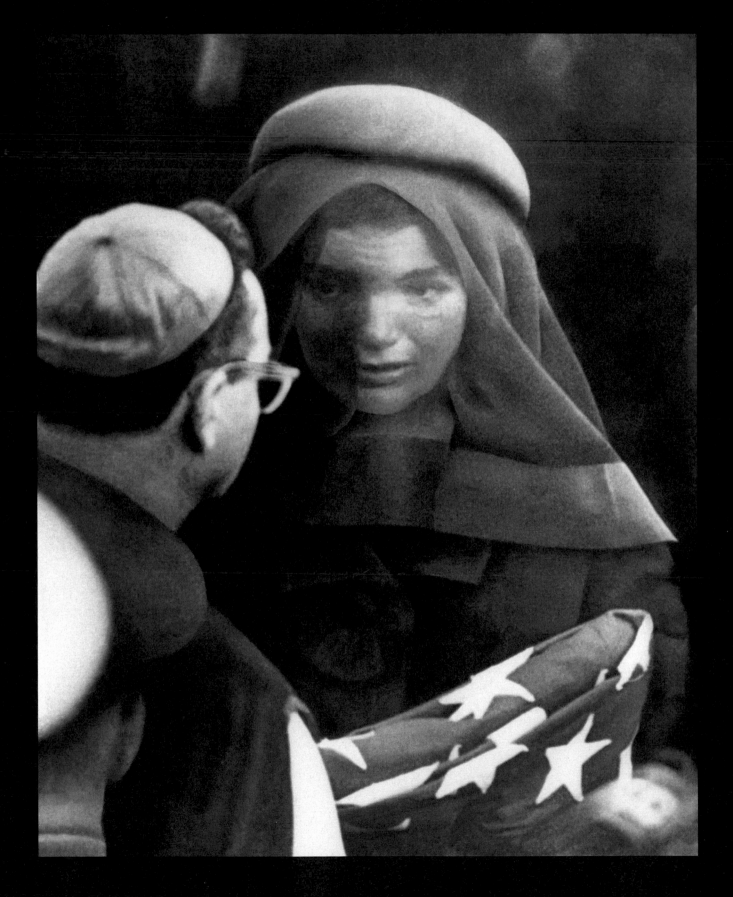

ARLINGTON, VIRGINIA 1963

230

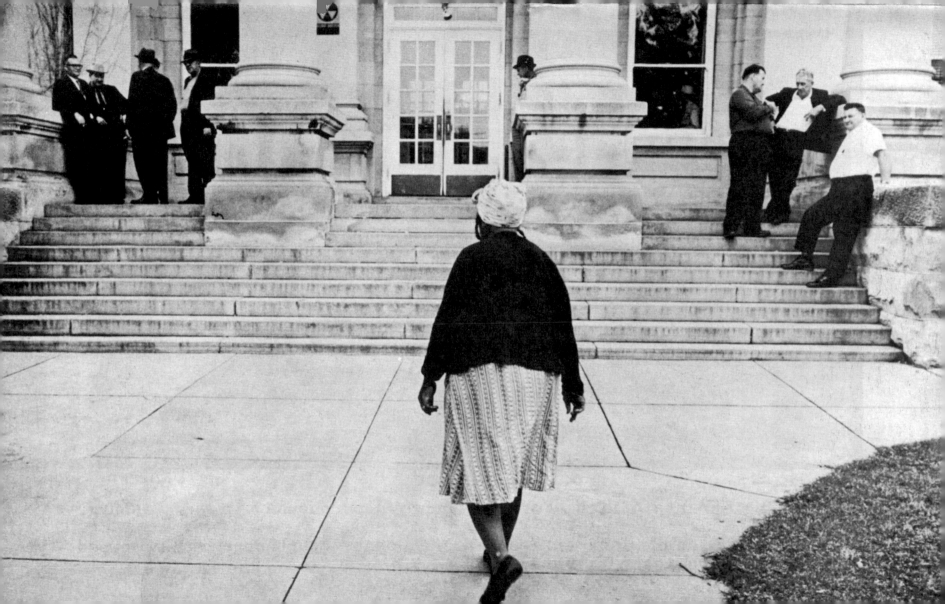

PORTLAND, OREGON 1964

PHILADELPHIA, PENNSYLVANIA 1964

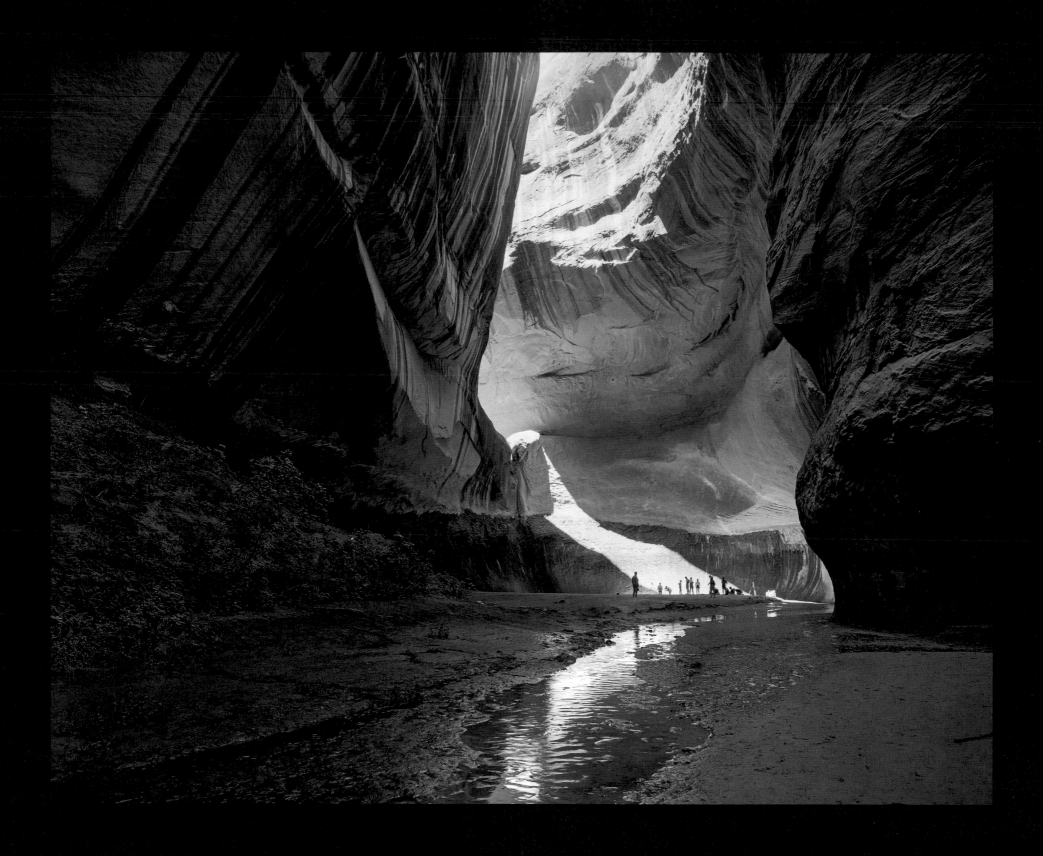

GLEN CANYON, UTAH 1964

234

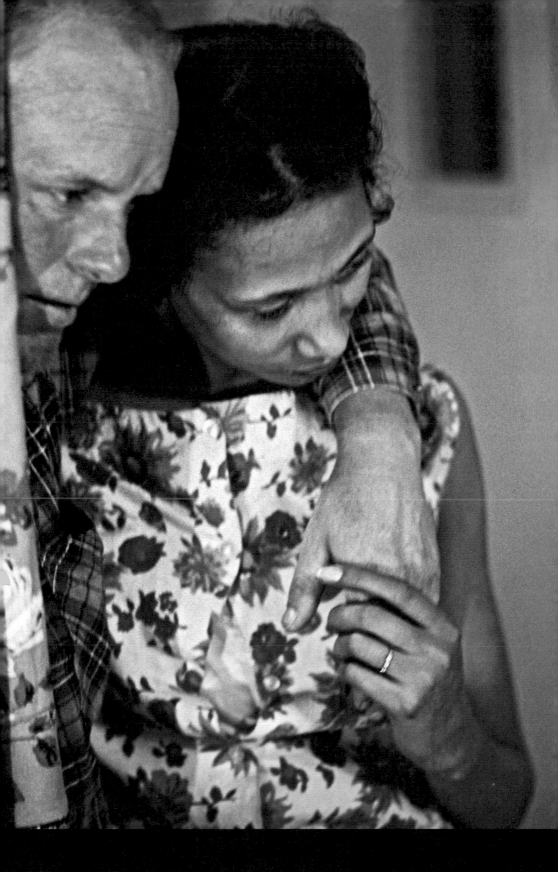

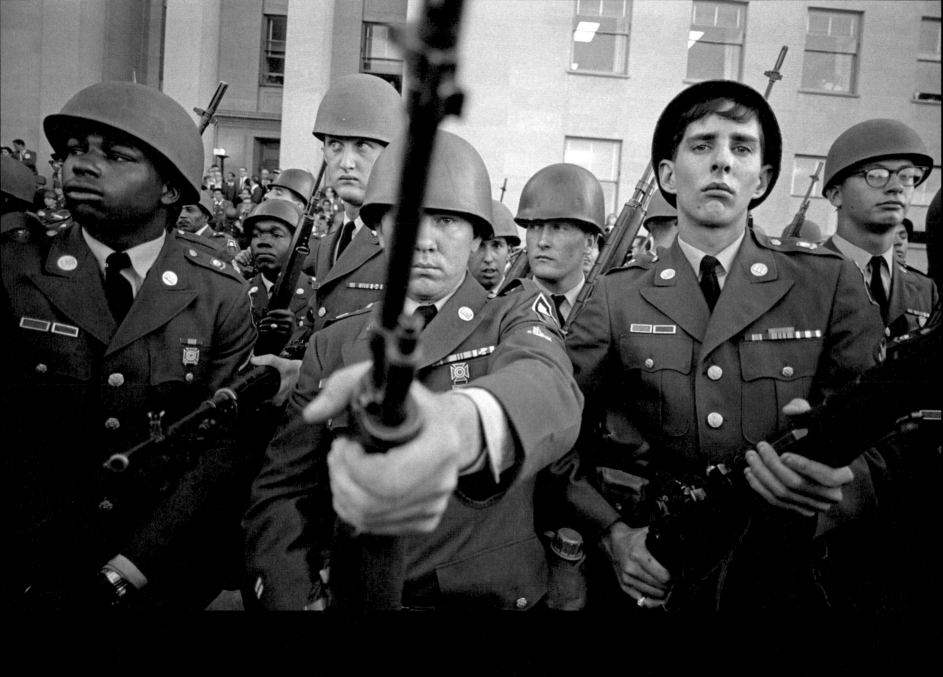

WASHINGTON, D.C. 1967

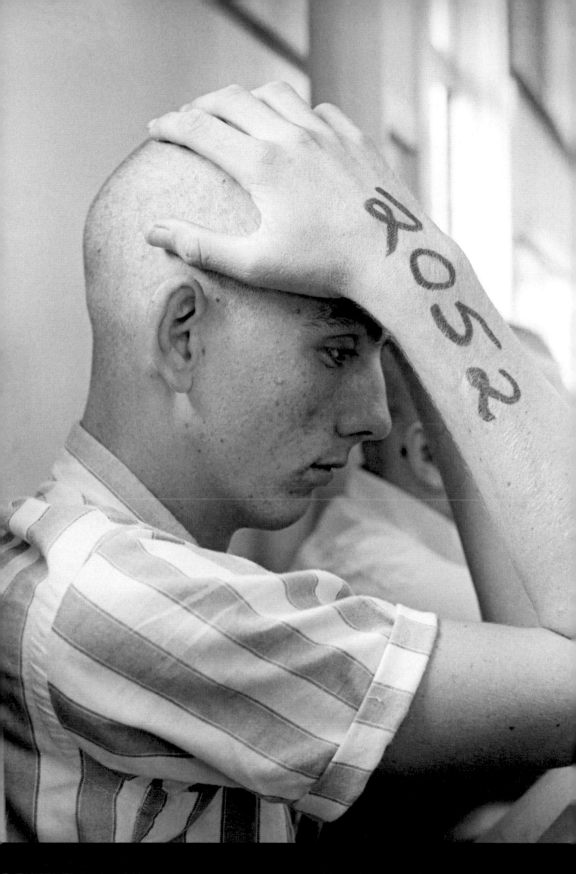

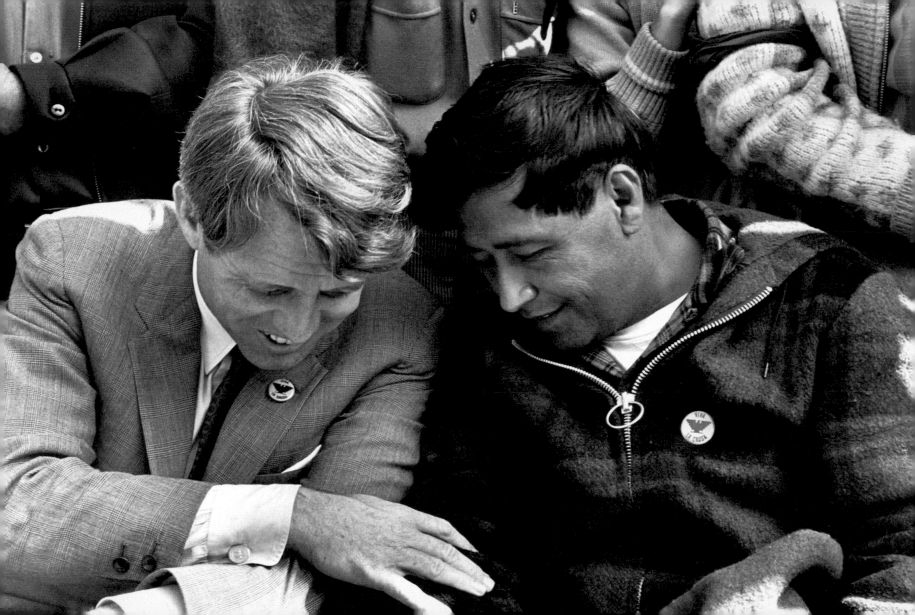

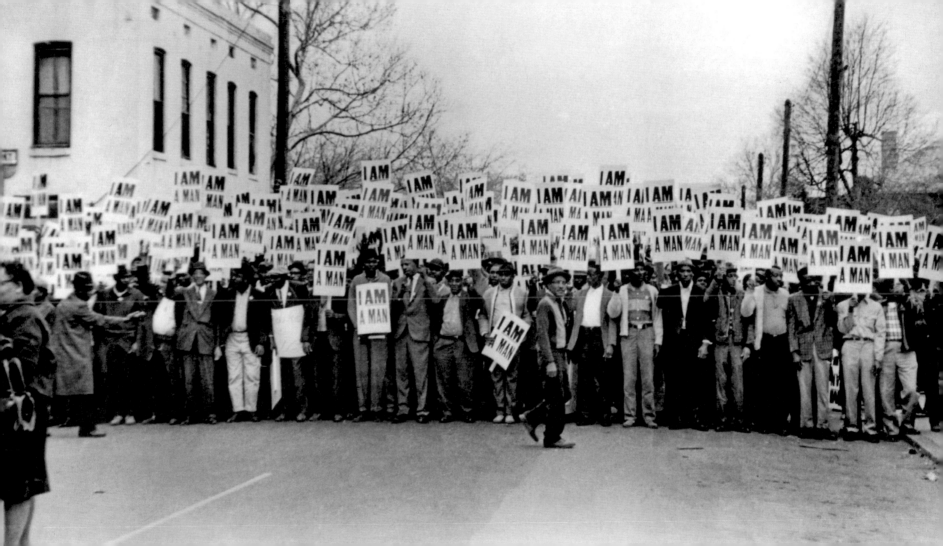

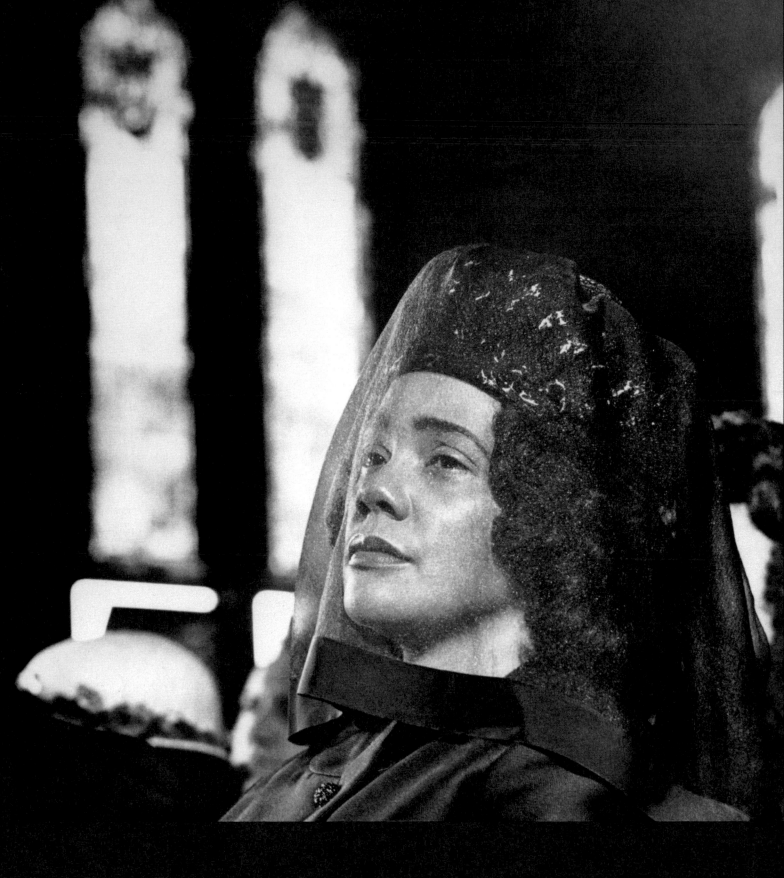

ATLANTA, GEORGIA 1968

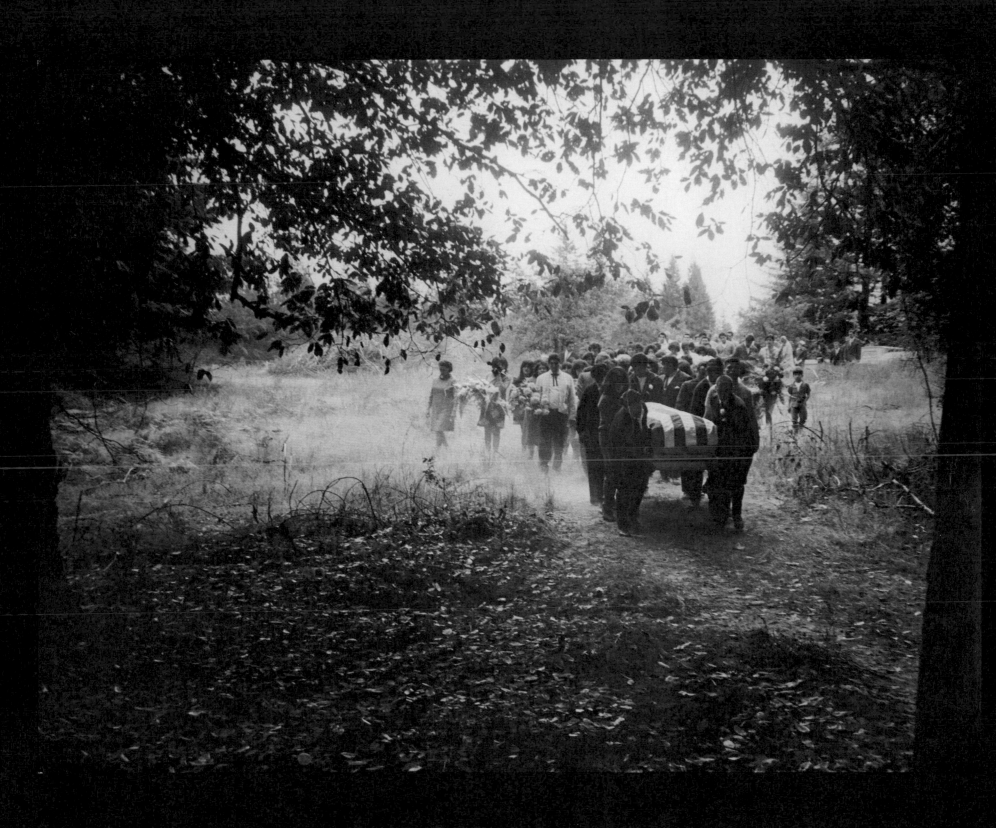

SONOMA COUNTY, CALIFORNIA 1968

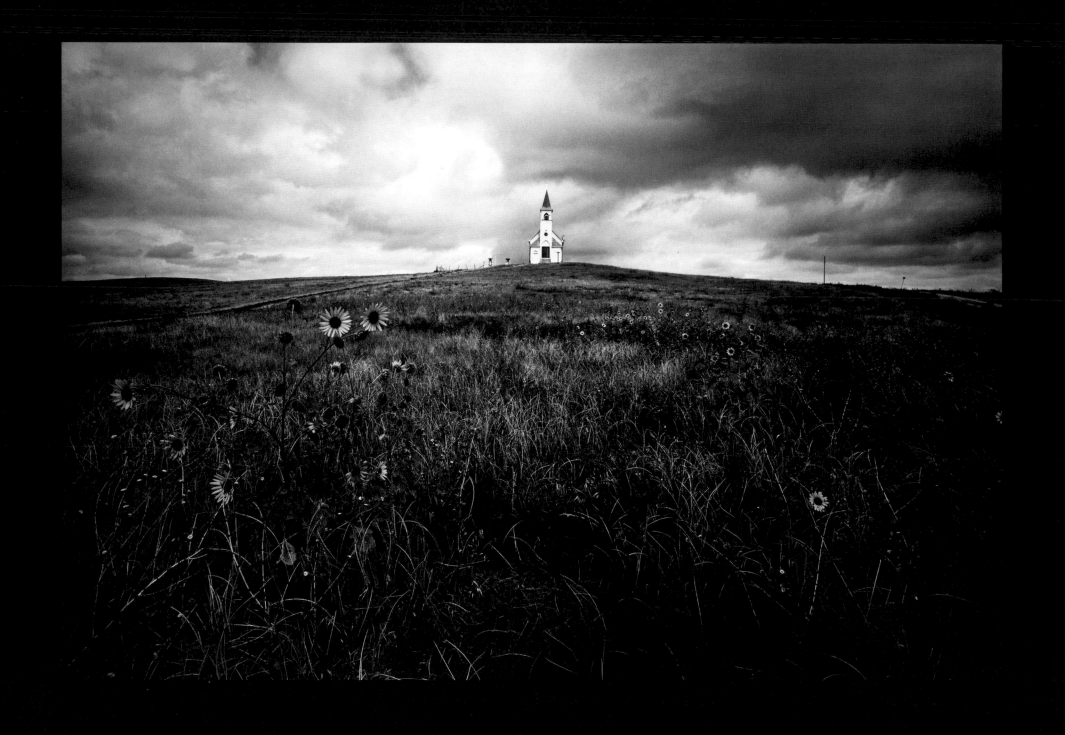

WOUNDED KNEE, SOUTH DAKOTA 1969

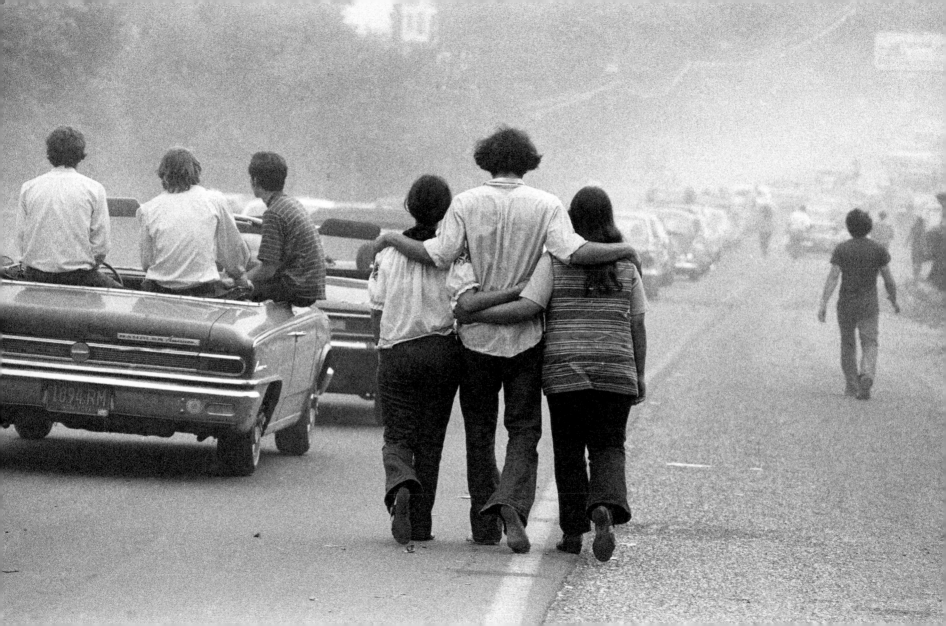

PALATINE, ILLINOIS 1970

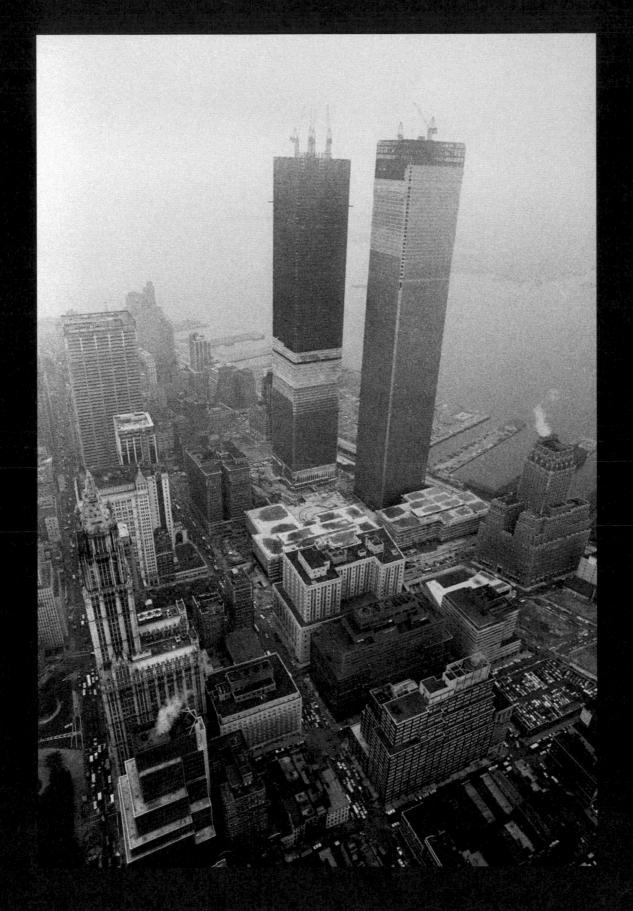

New York City 1971

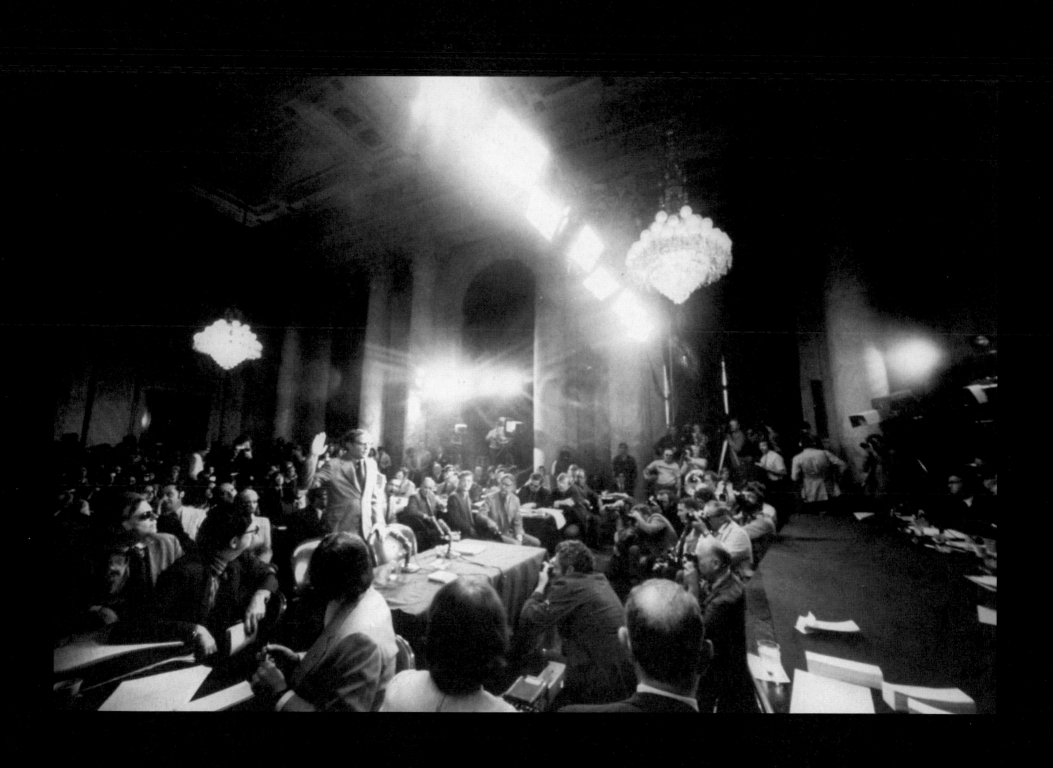

WASHINGTON, D.C. 1973

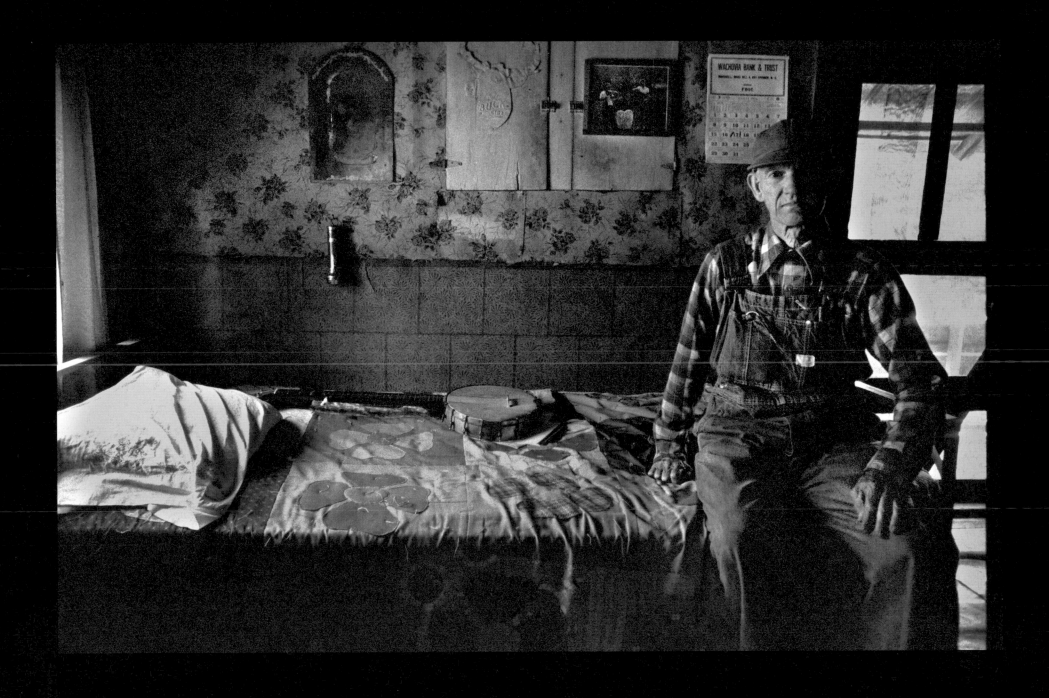

NEAR SODOM, NORTH CAROLINA 1976

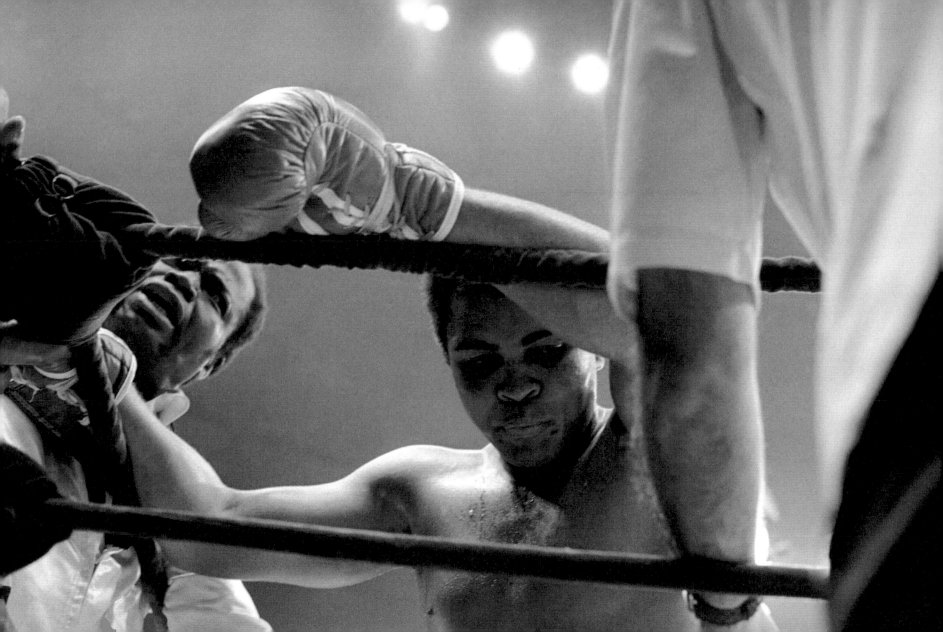

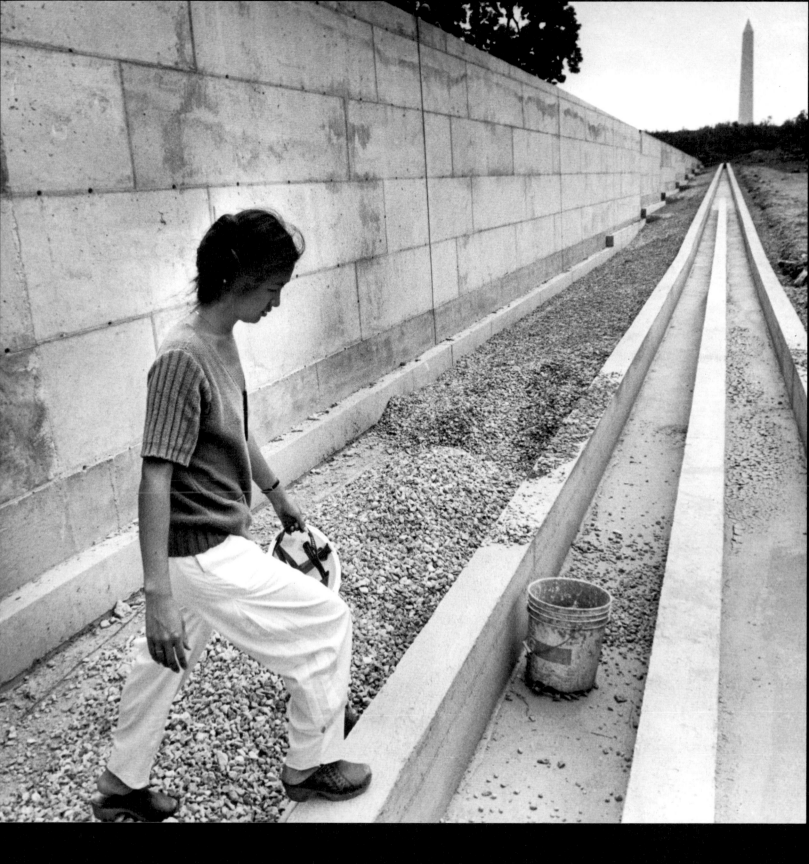

WASHINGTON, D.C. 1982

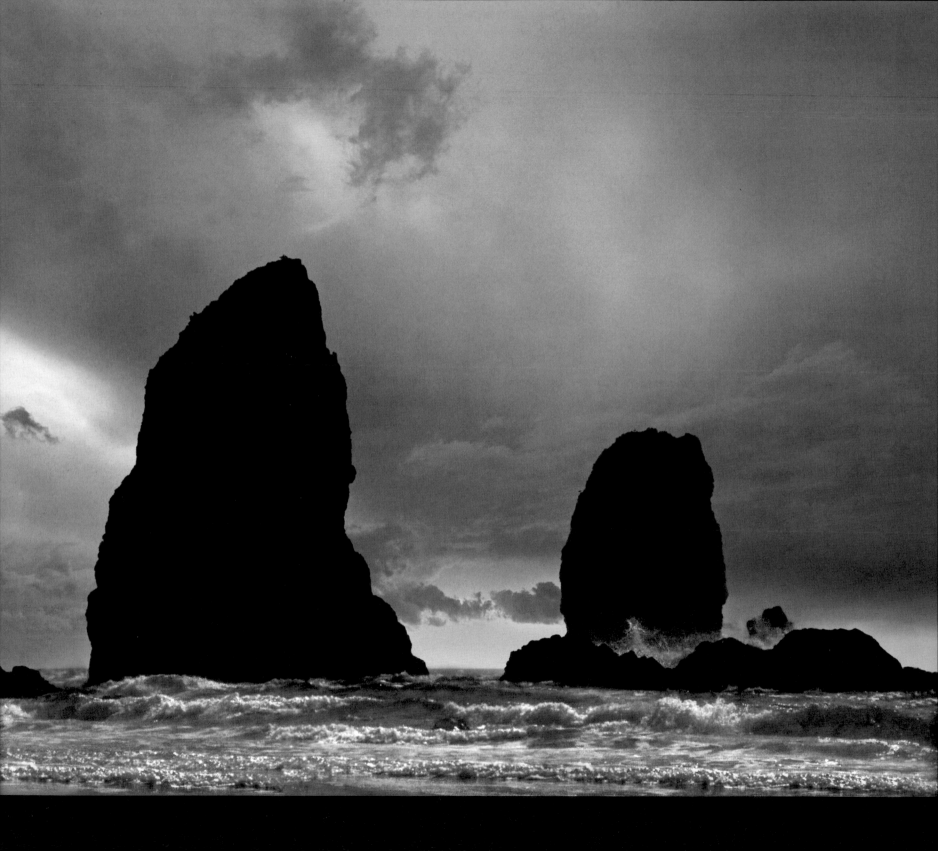

CANNON BEACH, OREGON 1982

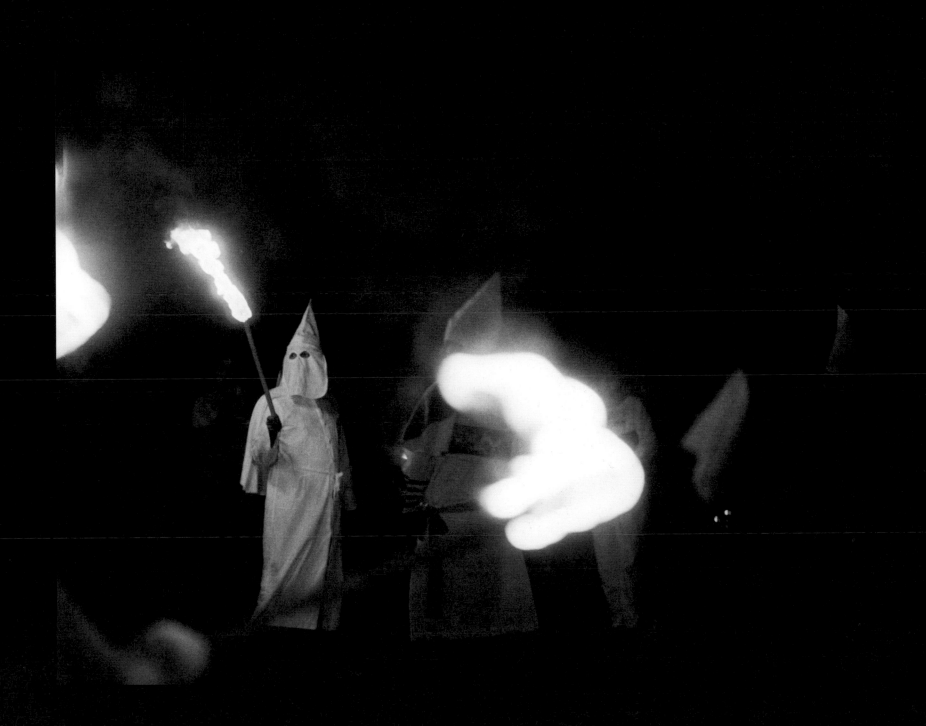

EAST WINDSOR, CONNECTICUT 1986

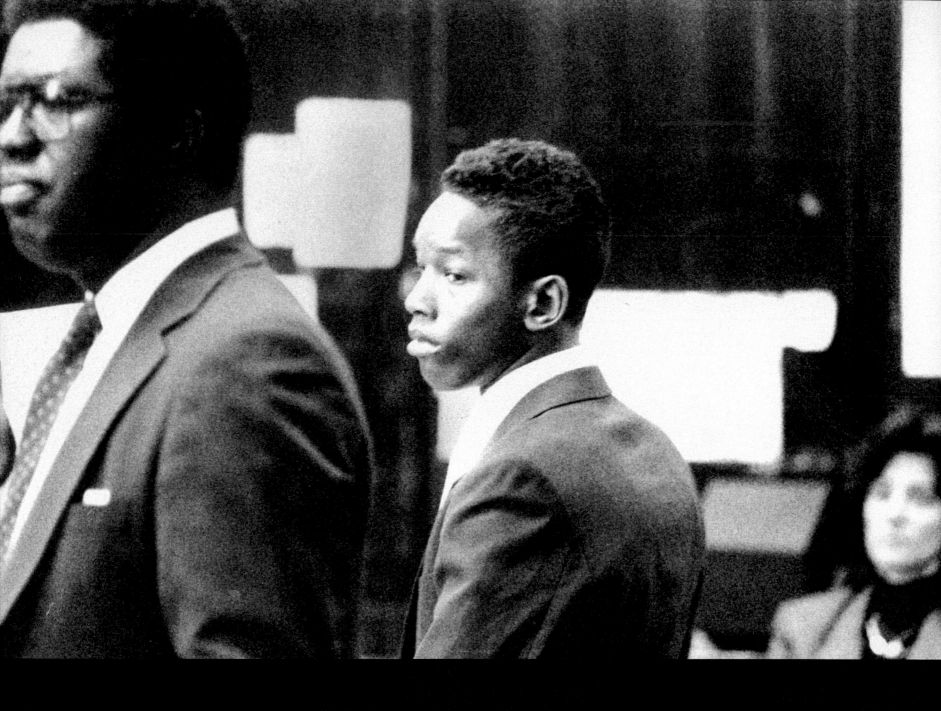

NEW YORK CITY 1989

252

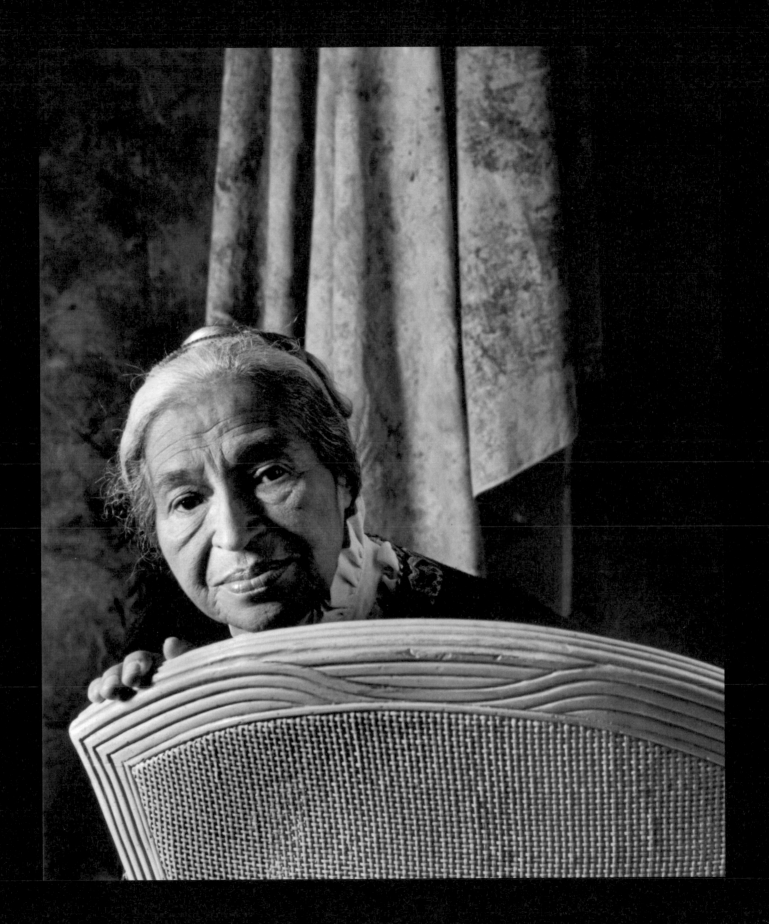

DETROIT, MICHIGAN 1993

253

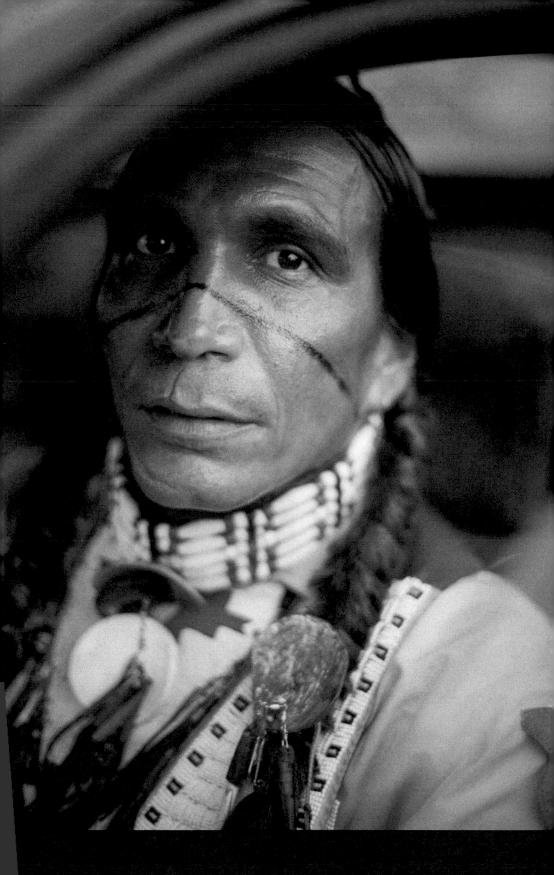

CLAIBORNE COUNTY, MISSISSIPPI 1998

Antelope Canyon, Arizona 1998

BOWLING BALL BEACH, CALIFORNIA 2005

FRIENDSHIP, WISCONSIN 2008

MURFREESBORO, TENNESSEE 2014

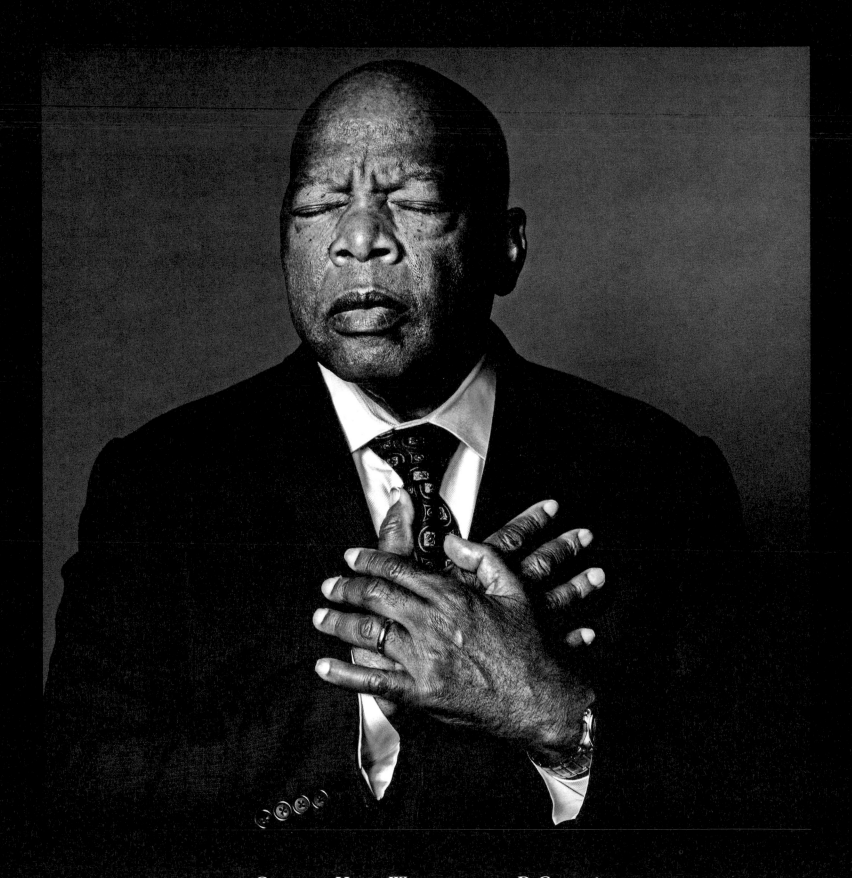

CAPITOL HILL, WASHINGTON, D.C. 2016

ILLUSTRATION NOTES

SELF-PORTRAIT

Photograph by Robert Cornelius

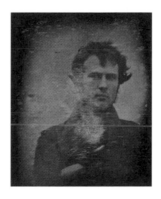

In Paris in 1839, Louis Daguerre revealed his new photographic method: daguerreotypes. Scientists, artists, and inventors in many countries began experimenting with his process, including in the United States.

Thirty-year-old Robert Cornelius worked in his father's business in Philadelphia, manufacturing lamps and chandeliers. He was well educated, interested in chemistry, and skilled in metallurgy.

Around October 1839, he started experimenting with daguerreotypes. Soon after, using a wooden box fitted with a lens from an opera glass for the camera, Cornelius took this self-portrait behind his father's shop. It is believed to be the earliest portrait taken in America.

He started two photographic studios in Philadelphia, but as other professional studios opened and competition grew, he realized that he could make more money running the family lighting company.

It appears that Cornelius only took two more photographs during the rest of his life. One was of an unidentified man in 1846, and another of Captain Charles John Biddle, in his Mexican War uniform, in 1847.

Photo credit: Library of Congress Prints and Photographs, LC-DIG-ppmsca-40464

PETERSBURG, VIRGINIA C. 1845

ISAAC JEFFERSON

Photograph by John Plumbe Jr.

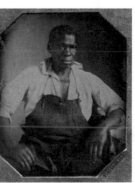

Isaac Jefferson was born in 1775 to parents living in slavery at Thomas Jefferson's home, Monticello. Trained as a tinsmith and nail maker, he was able to gain his freedom around 1822, four years before the death of Jefferson, and eventually settled in Petersburg, Virginia.

Thomas Jefferson enslaved more than 600 men, women, and children during his life—with as many as 130 of them living and working at Monticello at any one time.

Twelve of the first eighteen American presidents enslaved other human beings.

Photo credit: Tracy W. McGregor Library of American History, Small Special Collections, University of Virginia

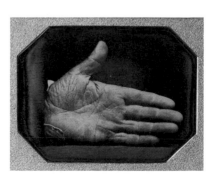

BOSTON, MASSACHUSETTS 1845

"THE BRANDED HAND"

Photograph by Southworth and Hawes

In 1845, the abolitionist Captain Jonathan Walker was convicted and sentenced for trying to help seven runaway enslaved people escape from

Florida to the Bahamas. For his crime, the judge at his trial ordered that he be placed in the pillory for one hour, then brought into court and branded on the right hand with the letters *S.S.*, for "slave stealer." He was then remanded to prison for fifteen days, or until the fine and costs of prosecution were paid.

Walker's hand was duly branded. He asked the studio of Southworth and Hawes in Boston to take this photograph. "The Branded Hand" was made on one of the smallest daguerreotype plates then in use—a ninth plate—measuring just 2 x 2.5 inches.

In addition to being printed on abolitionist pamphlets, the photo appeared in newspaper accounts of Walker's ordeal, in his best-selling autobiography, and even carved into the obelisk erected to mark his grave upon his death in 1878.

Photo credit: Massachusetts Historical Society, Daguerreotype Collection, 1.373

WASHINGTON, D.C. 1846

U.S. CAPITOL

Photograph by John Plumbe Jr.

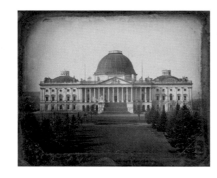

Mr. Plumbe's National Daguerrian Gallery at Concert Hall in Washington is an establishment whose superior merits are well deserving the notice of all who feel an interest in the beautiful art of Photography . . . We are glad to learn that this artist is now engaged in taking views of all the public buildings which are executed in a style of elegance that far surpasses any we have ever seen.—*United States Journal*, January 29, 1846

John Plumbe Jr. opened his first daguerreotype studio in Boston and, on its success, opened thirteen more, including one in Washington, D.C. However, as more studios opened, competition drove the price of portraits down from $6 in 1840 to as little as a quarter in 1848.

Plumbe began to sell his franchises and headed west, trying to peddle the idea of a transcontinental railroad.

Eleven years later, after returning east, the financial panic in 1857 wiped out the rest of Plumbe's fortune. With that and suffering from ill health, he died by suicide and was buried in an unmarked grave.

In 1972, a collector found seven daguerreotypes of Washington, D.C., at the Alameda flea market in San Francisco. This image of the Capitol was one of them.

Photo credit: Library of Congress Prints and Photographs, LC-DIG-ppmsca-51816

ST. LOUIS, MISSOURI 1849

IOWAS, MAH-HEE (KNIFE), KUNZAYAMI (SOARING), AND CHILD

Photograph by Thomas Easterly

With the advancement of white settlers into the West, the Iowa tribe ceded their lands in northern Missouri in 1824 and 1836.

Lands in Iowa were ceded in 1830, 1837, and again a year later, and the tribe was removed to an area across the Missouri River.

The Iowa, whose lands once encompassed an area of the Missouri and Mississippi River Valleys in what is today Wisconsin, Iowa, Minnesota, Missouri, Kansas, and Nebraska, now found themselves with a strip of land ten miles wide and twenty miles long.

Subsequent treaties and then allotments would reduce this land even further. In 1854, another cession lost additional lands, and as part of the Kansas-Nebraska Act that same year, a line was drawn across the reservation which became the Kansas-Nebraska border. In 1861, the reservation was whittled down to its present size of twelve thousand acres.

Photo credit: Missouri Historical Society, Easterly Daguerreotype Collection, 17192

BATON ROUGE, LOUISIANA 1850

NURSEMAID

Photographer unknown

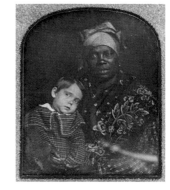

The first slave ships from Africa arrived in the French colony of Louisiana in 1719, only a year after the founding of New Orleans. Between 1719 and 1731, twenty-three ships brought six thousand Africans to the territory, where traders sold them into slavery.

Throughout the 1700s, enslaved men and women in Louisiana lived under French legal codes giving them more rights than those in colonies in the rest of the country. Torture, separation of married couples, and taking young children from their mothers were all forbidden. After the United States acquired the Louisiana territories from the French in 1803, enslaved people were subject to the same harsh treatment as those in the rest of America.

In 1807, Congress voted to abolish the African slave trade. By that time, there were more than a million people living in slavery in the South. By the time this photograph was taken, that number had tripled.

Photo credit: Louisiana State Museum, New Orleans

FUGITIVE SLAVE LAW CONVENTION

Photograph by Ezra Greenleaf Weld

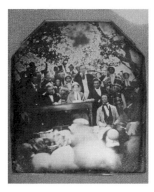

In August 1850, more than two thousand people came to the tiny town of Cazenovia to attend the Fugitive Slave Law Convention. The meeting brought together the famed orator Frederick Douglass, who had escaped from slavery fifteen years before and had been able to purchase his freedom; the abolitionist Gerrit Smith; and the Edmonson sisters, who had been freed from slavery in Washington, D.C., in 1848.

Nearly fifty men and women still being hunted by the people who had kept them in slavery were also there.

The meeting laid out the abolitionists' opposition to the proposed Fugitive Slave Act, which would allow the federal government to capture people who had escaped from slavery, even in free states, and *compel* free-state residents to cooperate with apprehension efforts.

The act passed that November as part of the Compromise of 1850—a group of bills that helped quiet early calls for southern secession.

Photo credit: J. Paul Getty Museum, Los Angeles, 84.XT.1582.5

HARVARD COLLEGE OBSERVATORY

Photograph by John Adams Whipple

In 1847, the Harvard College Observatory installed a mammoth telescope with a fifteen-inch-diameter lens. It was named "the Great Refractor" and was the largest telescope in the United States at the time. William Bond, the director of the observatory, was intrigued by the possibility of creating images by pairing the telescope with a camera and collaborated with the daguerreotypist John Adams Whipple. Four years later, Whipple stunned the world with his photographs of the moon.

However, Louis Daguerre had taken the *first* lunar photograph in January 1839. Sadly, a fire destroyed his studio two months later, and his entire archive was lost.

Whipple's daguerreotype is still the earliest-surviving image of the moon.

Photo credit: John G. Wolbach Library, Harvard College Observatory, olvwork 100163

ALICE MARY HAWES

Photograph by Josiah Hawes

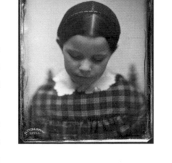

During their twenty years of collaboration, from 1843 to 1863, Sands Southworth and Josiah Hawes catered to Boston society and a clientele that included well-known figures of the day.

The two photographers made a distinction between the appropriate style for a personal portrait and a portrait intended for the public. "A likeness for an intimate acquaintance or one's own family should be marked by that amiability and cheerfulness, so appropriate to the social circle and the home fireside. Those for the public, of official dignitaries and celebrated characters, admit of more firmness, sternness, and soberness."

Among those who posed were Louisa May Alcott, Lyman Beecher, Ralph Waldo Emerson, William Lloyd Garrison, Oliver Wendell Holmes, Sam Houston, Henry Wadsworth Longfellow, Horace Mann, Harriet Beecher Stowe, Charles Sumner, Daniel Webster, and John Greenleaf Whittier—and Josiah Hawes's daughter Alice, shown here.

Photo credit: George Eastman Museum, 1974.0193.0193

LATTER-DAY SAINTS FAMILY

Photographer unknown

When a mob murdered their founder and prophet Joseph Smith in 1844, members of the Church of Jesus Christ of Latter-day Saints (also called Mormons) were forced to leave their settlement of Nauvoo, in Illinois.

After seventeen months of traveling 1,031 miles, Brigham Young led 148 pioneers into Utah's Valley of the Great Salt Lake. Gazing over the parched earth of the remote location, Young declared, "This is the place."

By the end of 1847, nearly two thousand Latter-day Saints had moved there.

By 1869, eighty thousand had made the trek to Deseret, their promised land.

Photo credit: Source undetermined

HENRY DAVID THOREAU

Photograph by the studio of Benjamin D. Maxham

Henry David Thoreau was described by a contemporary as "the apostle of individuality in an age of association and compromise."

When Calvin R. Greene, a Thoreau admirer, wrote from Michigan and asked for a photograph of the author, Thoreau replied, "You may rely on it that you have the best of me in my books, and that I am not worth seeing personally—the stuttering, blundering, clodhopper that I am." Greene was so eager for the portrait, however, that he wrote again, this time enclosing money for the sitting.

On a trip to Worcester, Thoreau had three daguerreotypes taken for 50 cents each.

He gave two of the prints to his friends in Worcester. The third, along with $1.70 in change, he sent to Calvin Greene in Michigan.

Photo credit: National Portrait Gallery, NPG.72.119

JOHN BROWN

Photographer unknown

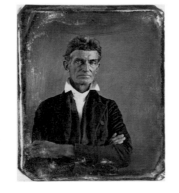

The abolitionist John Brown, a devout Calvinist, believed himself to be God's chosen instrument for ending slavery.

On May 24, 1856, Brown led a raiding party to Pottawatomie Creek in the Kansas Territory in retaliation for an attack on the antislavery settlers in Lawrence a few days before. The party interrogated several men, killing five of them with swords and knives.

Three and a half years later, on October 16, 1859, John Brown and eighteen men seized the U.S. arsenal at Harpers Ferry, Virginia. The plan was to use the arms to begin a guerrilla war against slavery.

Captured by U.S. Marines under Robert E. Lee, Brown was charged with treason against the Commonwealth of Virginia, murder, and inciting a slave insurrection.

He was hanged on December 2, 1859, the first person executed for treason in the history of the United States.

Photo credit: Boston Athenaeum, UTB-6 5.4 Bro.j.(no.1)

INSTITUTE HALL

Photographer unknown

On December 17, 1860, 169 South Carolina delegates to the state convention met in Columbia to decide if they would withdraw from the Union. However, when rumors of a smallpox outbreak reached the men, they moved to Charleston. Three days later, South Carolina became the first state to secede. The delegates wrote the decree in Institute Hall (pictured at an earlier date in the photograph above), and gathered before an enthusiastic crowd of hundreds to sign the document.

Their declaration stated that the primary reason behind South Carolina's secession was the "increasing hostility on the part of the non-slaveholding States to the Institution of Slavery."

One year later, a raging fire roared down Meeting Street in Charleston. General Robert E. Lee, staying with some of his staff at the Mills House Hotel, watched as Institute Hall burned to the ground.

Photo credit: Library of Congress, LC-DIG-ppmsca-19336

INAUGURATION OF JEFFERSON DAVIS

Photograph by Alexander Carson McIntyre

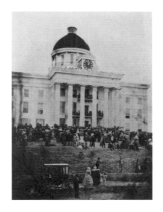

The inauguration ceremony for the newly elected president of the Confederate States of America was held in Montgomery, Alabama, on February 18, 1861. In his speech, which lasted only fifteen minutes, Jefferson Davis compared the Confederacy's fight to defend its way of life—including the institution of slavery—as a revolutionary act, similar to how the colonies rebelled against the control of Great Britain. He described how it is the right of the people to alter or abolish the government at will as was written in the Declaration of Independence:

> That whenever any Form of Government becomes destructive of these ends, it is the Right of the People to alter or to abolish it, and to institute new Government, laying its foundation on such principles and organizing its powers in such form, as to them shall seem most likely to effect their Safety and Happiness.

Photo credit: Boston Athenaeum, A B71M766 Hi.1861

CHARLESTON HARBOR,
SOUTH CAROLINA 1861

FORT SUMTER

Photograph attributed to Alma Alfred Pelot

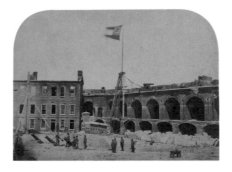

At 4:30 in the morning on April 12, 1861, a mortar shot exploded over the U.S. Government–held Fort Sumter in Charleston Harbor. It was a signal. From fortifications and floating batteries, Rebel guns roared to life, overwhelming the out-manned and undersupplied troops within the garrison. After thirty-six hours, Fort Sumter was surrendered to Confederate forces.

The following day at 2:30 p.m., the American flag was taken down and replaced by the Stars and Bars, the Confederate flag at that time.

The only casualties at Fort Sumter came during the Federal soldiers' one-hundred-gun salute to their flag, when a round exploded prematurely, killing one soldier and mortally wounding another.

The Civil War had begun.

Photo credit: Library of Congress Prints and Photographs, LC-DIG-ppmsca-32284

HESTONVILLE, PENNSYLVANIA 1862

FOURTH OF JULY PICNIC

Photograph by Coleman Sellers

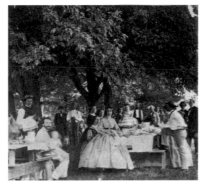

On July 4, 1862, a Seneca Falls, New York, newspaper wrote:

The recurrence of the birthday of our National Independence has heretofore been the occasion for universal congratulation and rejoicing. How different the scene in 1862! Instead of Peace, Union, and Prosperity, we have Civil War, Disunion and all their concomitant evils. Instead of National rejoicing, the land is filled with mourning. Upon every breeze is borne the sad, silent messenger of death. Hearts are bleeding all over the land at the loss of loved ones, stricken down in this most cruel and unnatural war. What a day for rejoicing! And for what can we rejoice? Our common interests are gone, sacrificed for the sake of our jealousies and passions. Fanaticism and madness rule the hour, and our beloved country seems to be fast drifting toward anarchy and ruin.

Photo credit: Library of Congress Prints and Photographs, LC-DIG-stereo-1501483

NEAR FREDERICKSBURG, VIRGINIA 1863

UNION SOLDIERS

Photographer unknown

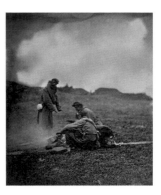

On December 13, 1862, General Ambrose Burnside sent six Union divisions across an open field in Fredericksburg, Virginia, to attack Robert E. Lee's line on the Rappahannock River. Lee's position was strong and well fortified, and it became one of the deadliest battles of the Civil War. The Union army suffered nearly thirteen thousand casualties, while the Confederates lost five thousand.

The battle is considered the Union army's worst defeat in the Civil War—so horrendous that, when it was over, Burnside wept openly.

Eight months later, when Union soldiers dealt a similar blow to the Confederate army at Gettysburg, victorious Union troops yelled out, "Fredericksburg! Fredericksburg!"

Photo credit: National Archives and Records Administration, 527550

BATON ROUGE, LOUISIANA 1863

GORDON

Photograph attributed to McPherson & Oliver

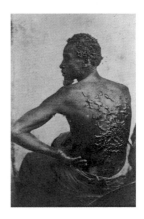

In 1863, a man known only as "Gordon" escaped from enslavement on a Mississippi plantation. Tracked by the owner's posse and a pack of bloodhounds, he rubbed his body with onions to throw off his scent and ran for ten days, over eighty miles, across the border into Louisiana and the safety of the Union army's XIX Corps in Baton Rouge.

The Union had authorized freed slaves to enlist, and Gordon joined the 2nd Louisiana Native Guard Infantry. He was one of twenty-five thousand Louisianan freedmen to fight with the Union army in critical battles at Port Hudson, the Siege of Petersburg, and Fort Wagner.

This photograph, taken by the itinerant photographers William D. McPherson and his partner, Mr. Oliver, first appeared in a story in the July 1863 issue of *Harper's Weekly*—alongside a picture of Gordon in uniform. Later that year it was published in the *New-York Daily Tribune* and became a powerful argument for the abolitionist cause.

Photo credit: National Portrait Gallery, NPG-A2000178C

MINING TOWN
Photograph by Carleton E. Watkins

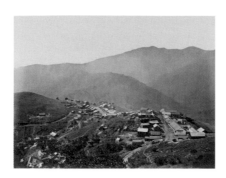

In the mid-nineteenth century, the most productive mercury (quicksilver) mine in North America was at the New Almaden settlement in the San Jose mountains.

Since mercury was used extensively to extract gold from ordinary rock, and the Union used gold to fund its army, these mercury deposits became critical to the war effort. Mercury was also used, at the time, to treat such a wide variety of ailments that some soldiers carried their own vials, not realizing how poisonous it could be.

So important was New Almaden, that when the title to the mine came into dispute in 1863, President Lincoln tried to seize it from its owners. Angry men armed with pickaxes, shotguns, and pistols met the federal agents at the mine gates. As news of the stand-off spread across the nation, many saw this as an abuse of executive authority. Westerners were alarmed that the president would start seizing other mines at will. Worried about the possibility of losing the loyalty of California to the Confederacy, Lincoln backed off.

Photo credit: The J. Paul Getty Museum, Los Angeles

"A HARVEST OF DEATH"
Photograph by Timothy O'Sullivan

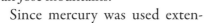

With more than fifty thousand casualties, the three-day conflict at Gettysburg was the bloodiest single battle of the Civil War.

Twenty-three-year-old photographer Timothy O'Sullivan took this photograph of the rotting dead awaiting burial, and in 1866 Alexander Gardner included it in *Gardner's Photographic Sketch Book of the War.* He wrote in his caption, "It was, indeed, a 'harvest of death.' . . . Such a picture conveys a useful moral: It shows the blank horror and reality of war, in opposition to its pageantry. Here are the dreadful details! Let them aid in preventing such another calamity falling upon the nation."

Photo credit: Library of Congress, LC-B8184-7964-A

NOTICE OF THE DEAD
Photographer unknown

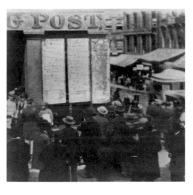

During the Civil War, the United States Department of War did not have a formal process for notifying casualties' next of kin. Families often found out from a letter sent home by a comrade or casualty lists published in newspapers and posted on the city streets.

In New York alone, more than 400,000 citizens served in the Union armed forces during the war, and 54,000 died in battle, from disease, or in enemy camps.

More than half of the Civil War dead were never identified. For many, their loss was the last straw. Grief over reading the lists of the dead after Gettysburg helped spur the violent draft riots in July 1863.

Photo credit: The Miriam and Ira D. Wallach Division of Art, Prints and Photographs: Photography Collection, New York Public Library, G91F211_028F

LINCOLN'S ADDRESS
Photograph by Isaac and Charles Tyson

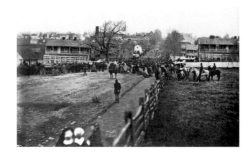

Following the Battle of Gettysburg, Union soldiers were removed from their makeshift graves and reburied in the new Soldiers' National Cemetery, which stood on part of the battlefield. On November 19, ceremonies to consecrate the cemetery began.

After music, prayers, and a two-hour speech by the politician Edward Everett, President Abraham Lincoln delivered his Gettysburg address. It lasted only two or three minutes.

Everett wrote Lincoln a brief note the next day, requesting a copy of the speech: "I should be glad, if I could flatter myself that I came as near to the central idea of the occasion, in two hours, as you did in two minutes."

Lincoln graciously replied, "In our respective parts yesterday, you could not have been excused to make a short address, nor I a long one. I am pleased to know that, in your judgment, the little I did say was not entirely a failure."

Photo credit: National Archives and Records Administration, 111-B-357

4TH U.S. COLORED INFANTRY

Photograph by William Morris Smith

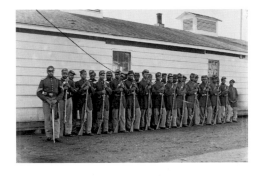

In January 1863, President Lincoln's Emancipation Proclamation opened the door for African Americans to enlist in the Union army and navy. Although many free Black men had wanted to join the war effort earlier, a federal law dating back to 1792—allowing the states to only conscript a "free able-bodied white male citizen"—prohibited them from enlisting.

In segregated troops commanded by white officers, these men were paid less than white soldiers, were given old and worn uniforms and poor equipment, and were relegated to the day-to-day tasks required to sustain the troops.

But despite the unfair treatment, Black men volunteered to take part in combat, and by the end of the war, nearly 200,000 African American soldiers had joined the forces.

Three-fifths of all Black troops were formerly enslaved.

Photo credit: Library of Congress Prints and Photographs, LC-DIG-cwpb-04294

PRISON CAMP

Photograph by Benjamin Franklin Upton

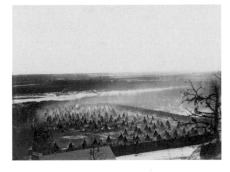

In 1862, the Dakota people in Minnesota rose in deadly attacks against white encroachment on their land. Treaty promises of food and money had been broken, and many were starving. Federal forces arrived, and after a five-week violent war the Dakota surrendered. A Minnesota military commission sentenced 303 Dakota to execution for the deaths of the white settlers. They were taken to a fort in Mankato to await trial.

After reviewing the cases, President Abraham Lincoln decided that there was evidence that 38 were guilty of murder or rape during the uprising and ordered their execution—the largest mass execution in U.S. history. Lincoln commuted the sentences of the remaining 265 Dakota, who were then forcibly removed to Fort McClellan in Davenport, Iowa, where they would stay interned for four years.

Another 1,600 Dakota—women, children, and the elderly, all innocent of any wrongdoing—were marched to a confinement camp set up by Fort Snelling in Minnesota. They were imprisoned there for the rest of the win-

ter. As many as three hundred would die. The rest were exiled to the Crow Creek Reservation in what is now South Dakota.

Photo credit: Minnesota Historical Society, E91.4S p53 Original c.1

YOSEMITE LAND GRANT

Photograph by Charles Weed

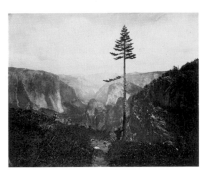

Climb the mountains and get their good tidings. Nature's peace will flow into you as sunshine into trees.

—JOHN MUIR

On June 30, 1864, while the Civil War still raged, President Abraham Lincoln signed a bill called the Yosemite Land Grant, establishing Yosemite Valley and the Mariposa Grove of Giant Sequoias as protected from settlement. It was given over to the care of the state of California. For the first time, a government declared that a place of exceptional natural value "shall be held for public use, resort, and recreation"—and that, crucially, it "shall be inalienable for all time."

Yosemite Valley became a popular vacation destination, and it soon became evident that California could not care for and protect the area. As a result, pressure grew to give management of a large portion of land around the park to the federal government. The campaign succeeded, largely thanks to the tireless efforts of the naturalist John Muir, and led to the establishment of the land around Yosemite Valley as the nation's third national park in 1890.

The majestic valley itself was included in 1903.

Photo credit: The Miriam and Ira D. Wallach Division of Art, Prints and Photographs: Photography Collection, New York Public Library, MFaZ (Weed) 06-6577, Plate 20

INDIAN ROCK, LOOKOUT MOUNTAIN

Photograph attributed to Mathew Brady

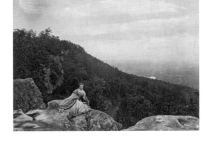

In November 1863, a decisive engagement was fought at Chattanooga on the Tennessee River. Sometime afterward, Mathew Brady, or one of his photographers, took this picture of a woman identified as "Miss Edwards" looking out over the battle scene.

Back in 1861, when it was clear that a civil war was imminent, Brady received permission from President Abraham Lincoln to photograph the

events, with the understanding that the government would not provide any financial help. With his own money, Brady equipped nearly twenty photographers with an assortment of cameras, tripods, chemicals, and glass plates. By the end of the war, they had produced more than ten thousand images.

Brady's photographs were not a commercial success, and he declared bankruptcy. His negatives sat neglected until Congress purchased the archive for $25,000 in 1875, estimated at a quarter of what he had spent.

Unfortunately, debts swallowed the entire sum, and unable to rescue his finances, Brady died penniless in 1896.

The Washington *Evening Star* wrote kindly of Brady, "News of his passing will be received with sorrow by hundreds and hundreds who knew this gentle photographer, whose name is today a household name all over the United States."

Photo credit: National Archives and Records Administration, III-B-2003

CITY POINT, VIRGINIA 1865

MAGAZINE WHARF
Photograph by Andrew J. Russell

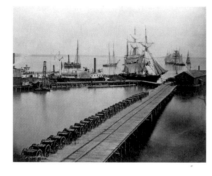

Until the Civil War, City Point was a small village, with only a few houses and businesses, located on a spit of land at the confluence of the Appomattox and James Rivers. However, during the Siege of Petersburg in 1864 and 1865, it became the headquarters of General Ulysses S. Grant and a crucial Union port.

In the spring of 1865, President Abraham Lincoln traveled to City Point with his wife, Mary, and son Todd. While there, aboard the steamboat the *River Queen*, Lincoln met with Generals Grant and William Tecumseh Sherman and Admiral David Dixon Porter to discuss the future surrender of Confederate forces.

That night, as recounted in a book by his friend Ward Hill Lamon, *Recollections of Abraham Lincoln,* the president woke up from a dream:

> Before me was a catafalque, on which rested a corpse wrapped in funeral vestments. Around it were stationed soldiers who were acting as guards; and there was a throng of people . . . "Who is dead in the White House?" I demanded of one of the soldiers. "The President," was his answer; "he was killed by an assassin!"

Photo credit: Library of Congress Prints and Photographs, LC-DIG-ppmsca-33298

WASHINGTON, D.C. 1865

ABRAHAM LINCOLN
Photograph by Alexander Gardner

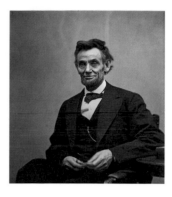

On February 5, 1865, Abraham Lincoln posed for a photograph in the Washington, D.C., studio of Alexander Gardner, a Scottish photographer who had immigrated to the United States in 1856. It would be the last formal portrait taken of the president. He was fifty-five years old.

Photo credit: Library of Congress Prints and Photographs, LC-B812- 9773-X

RICHMOND, VIRGINIA 1865

RUINS
Photograph by Alexander Gardner

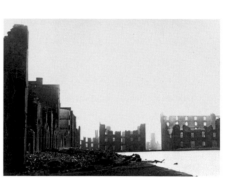

> With malice toward none; with charity for all . . . let us strive on to finish the work we are in; . . . to do all which may achieve and cherish a just and lasting peace among ourselves, and with all nations.
>
> —ABRAHAM LINCOLN, Second Inaugural Address, March 4, 1865

During the Civil War, Union forces tried several times to capture Richmond, the capital of the Confederate States. In 1864 and early 1865, General Ulysses S. Grant laid siege to nearby Petersburg. By the first days of April, the Confederate government realized that Richmond would fall and abandoned the city. The troops were ordered to set fire to bridges, the armory, and supply warehouses as they retreated, rather than let them fall into Union hands. Their actions reduced much of Richmond to rubble.

Afterward, President Abraham Lincoln visited the burned-out Confederate capital with General Godfrey Weitzel of the Union army as his guide. Weitzel asked the president for guidance on how he should treat the people of the city. Lincoln replied, "If I were in your place, I'd let 'em up easy."

Photo credit: Library of Congress Prints and Photographs, LC-DIG-ppmsca-34927

SPRINGFIELD, ILLINOIS 1865

OAK RIDGE CEMETERY

Photograph by Samuel Montague Fassett

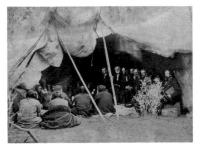

President Abraham Lincoln was shot on the night of Good Friday, April 14, 1865, at Ford's Theatre in Washington, D.C. After remaining in a coma for eight hours, he died the next day.

Services were held in D.C., and then in additional cities and state capitals as the funeral train made the sad twelve-day journey to carry his body for burial in his hometown of Springfield, Illinois.

A reporter noted that the train "moved slowly into the town, moved slowly through masses of 'plain people' who had come from all the country round about . . . The stillness among all the people is painful; but when the coffin is taken from the car, that stillness is broken, broken by sobs, and these are more painful than the stillness."

Photo credit: Courtesy of the Abraham Lincoln Presidential Library

ANDERSONVILLE, GEORGIA 1867

PRISON CEMETERY

Photograph by Engle & Furlong

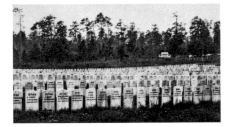

Andersonville was the largest of the 150 military prisons of the Civil War. It was also the deadliest. Of the 45,000 Union soldiers imprisoned there, nearly 13,000 died.

Almost 3 million men served during the Civil War. Between 620,000 and 750,000 soldiers died, along with an unknown number of civilians. It remains the deadliest military conflict in American history.

On July 14, 1861, Sullivan Ballou, a major in the 2nd Rhode Island Infantry Regiment, wrote to his wife:

> Sarah, my love for you is deathless . . . and yet, my love of country comes over me like a strong wind, and bears me irresistibly on with all those chains, to the battlefield . . .
>
> I know I have but few claims upon Divine Providence, but something whispers to me . . . that I shall return to my loved ones unharmed. If I do not, my dear Sarah, never forget how much I love you, nor that, when my last breath escapes me on the battle-field, it will whisper your name.

On July 21, 1861, Sullivan Ballou was critically wounded at the First Battle of Bull Run. He died five days later, a week before his thirty-second birthday.

Photo credit: Library of Congress Prints and Photographs, LC-DIG-stereo-1s04602

FORT LARAMIE, WYOMING TERRITORY 1868

INDIAN PEACE COMMISSION

Photograph by Alexander Gardner

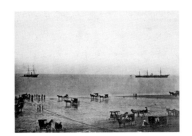

In 1865, a congressional committee began a study of the uprisings and clashes between settlers traveling west and the Native people who had lived on those lands for centuries. To address the issue, Congress passed an act in 1867 establishing the Indian Peace Commission.

The next year, a conference was held at Fort Laramie in the Wyoming Territory that resulted in a treaty in which the United States recognized the Black Hills—sacred to the Native Americans—as part of the Great Sioux Reservation and set aside for exclusive use by the Sioux (Lakota) people.

Following the discovery of gold in the Black Hills, however, the government failed to prevent white settlers from moving onto tribal lands. Rising tensions eventually led again to open conflict, in the Great Sioux War of 1876, where, most famously, General George Custer's troops and all his men were killed. Soon, though, the Sioux were forced to surrender, and the U.S. government unilaterally annexed land in the Black Hills once protected under the Treaty of 1868.

The sculpture of four U.S. presidents on Mount Rushmore, completed in 1941, sits on the land promised to the Sioux.

Photo credit: Missouri History Museum, N34237

DUXBURY, MASSACHUSETTS 1869

TRANSATLANTIC TELEGRAPH LINE

Photographer unknown

The Western Union Telegraph Company completed the first transcontinental telegraph line on October 24, 1861. Two days later, the Pony Express was out of business.

However, communication with the rest of the world still went by boat, until, in 1866, the Anglo-American Telegraph Company succeeded in laying two thousand miles of cable across the floor of the Atlantic Ocean from Ireland to Newfoundland—a British colony on the coast of Canada.

Determined to construct an independent line for France, the French-Atlantic Cable Company was established in 1869 and launched three vessels loaded with cable from Brest, France. In late July, the ships arrived on Duxbury Beach, thirty-five miles southeast of Boston.

A few years later, the British and French companies merged. In 1911, that company became part of Western Union, which was later taken over by the American Telephone and Telegraph Company (AT&T).

By 1918, AT&T had over 10 million telephones in the United States and monopolized telegraph communications to Europe.

The first transatlantic *phone call*, however, didn't happen until 1927 when the president of AT&T asked the head of the British General Post Office, "How's the weather over in London?"

Photo credit: Boston Public Library Special Collections

MILL WORKERS

Photographer unknown

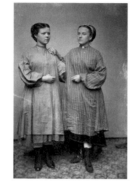

In 1834, one of the first strikes by the women working in the textile factories in this country took place in Lowell, Massachusetts, when the owners declared a 15 percent reduction in wages. The bosses won the showdown, and within a week the mills were operating nearly at total capacity.

But the long workday was still crucial in the grievances of the "mill girls," and they bravely lobbied to reduce it. In 1845, several workers testified before a state legislative committee about the harsh workplace conditions. Despite their accounts of sickness, injury, and lack of sleep and leisure time, the state refused to reduce working hours.

However, the "Ten-Hour Movement" spread to nearby states, and in many factories the mill girls succeeded. Massachusetts finally passed a law restricting hours in 1874. But by that time, mill owners had found a new source of labor: more recently arrived immigrants.

Photo credit: Center for Lowell History, University of Massachusetts Lowell Libraries, M6101 PN22

ALBEMARLE COUNTY, VIRGINIA
C. 1870

MONTICELLO

Photographer unknown

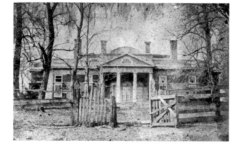

On July 4, 1826, Thomas Jefferson died at his beloved home, Monticello, and was buried there beneath a stone obelisk. To settle his debts, his daughter Martha put the entire property up for sale—including one hundred enslaved men, women, and children.

In 1831, an eccentric local druggist named James Barclay, who had despised Jefferson, bought Monticello. He had very little interest in the house itself. Instead, he had a scheme to turn the land into a silkworm farm. The project failed, and Barclay became a missionary and set off for the Holy Land after selling Monticello to Uriah Phillips Levy, the first Jewish commodore of the U.S. Navy. Levy admired Jefferson, and when he died in 1862, he willed Monticello to the federal government. However, during the Civil War, the Confederacy seized it and used it as a convalescent home for wounded Rebel soldiers.

In 1879, Uriah Levy's nephew, Jefferson Monroe Levy, gained title to the now run-down Monticello and repaired and restored the home and grounds over the next four decades.

In 1923, almost one hundred years after Jefferson died, Monticello was sold to the newly formed Thomas Jefferson Foundation.

Photo credit: Courtesy University of Virginia Library, 4x5-919-A

CANYON DE CHELLY, ARIZONA
1873

U.S. GEOLOGICAL SURVEY

Photograph by Timothy O'Sullivan

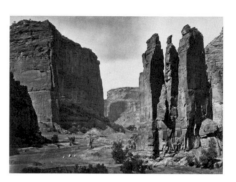

Canyon de Chelly was a sacred refuge to the Navajo for centuries.

Between 1863 and 1866, after a scorched-earth policy destroyed their crops, homes, and livestock, more than ten thousand Navajo were forced to surrender to U.S. soldiers and endure what was called "the Long Walk," a trip of more than three hundred miles to a reservation near Fort Sumner, New Mexico. Once there, they faced deprivation, disease, and death. With the signing of the Treaty of 1868, the Navajo Reservation was established, and the tribe was allowed to return to its homeland.

In 1871, Lieutenant George Wheeler led the U.S. Geological Survey west of the 100th Meridian. Within eight years, the Wheeler Survey had mapped, studied, and photographed an area covering 359,065 square miles. Wheeler's botanists, paleontologists, and zoologists had collected more than 100,000 specimens, while his ethnologists had documented the languages of many of the Native tribes in the American Southwest.

In 1931, President Herbert Hoover protected Canyon de Chelly and its thousands of artifacts and ruins by designating it a National Monument, managed by the National Park Service. The land, however, is still owned by the Navajo Nation.

Photo credit: Library of Congress Prints and Photographs, #LC-USZC4-8284

WASHINGTON, D.C. 1877

INAUGURATION OF RUTHERFORD B. HAYES

Photograph by Mathew Brady

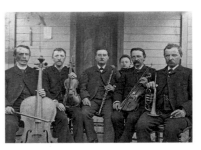

In 1876, Republican Rutherford B. Hayes of Ohio competed against New York Democrat Samuel Tilden in a bitterly contested presidential election.

Tilden won the popular vote by more than 250,000 votes but remained one electoral vote short of victory, and Florida, Louisiana, and South Carolina were all declared too close to call.

A commission set up to decide the election—consisting of members of the Senate and House of Representatives from both parties and five members of the Supreme Court—eventually awarded Hayes twenty of the contested electoral votes in what became known as the Compromise of 1877.

The compromise involved a backroom deal whereby southern Democrats agreed to Hayes's election on the condition that he immediately withdraw direct federal support for Reconstruction—including the U.S. Army's protection of newly freed enslaved people and their supporters from violence at the hands of ex-Confederates, and, particularly, the Ku Klux Klan.

Jim Crow at once came knocking on the door.

Photo credit: National Portrait Gallery, Smithsonian Institution, Gift of Frank and Anne Goodyear, NPG.2011.82

WALPOLE, NEW HAMPSHIRE C. 1880S

COUNTRY ROAD

Photographer unknown

From the *Gazetteer of Cheshire County, N.H., 1736–1885*:

WALPOLE is a beautiful village located . . . on a plain, high above the Connecticut River. It has three churches, a savings bank, hotel, two boarding houses, three stores, two blacksmith shops, harness shop, three meat markets, boot and shoe store, and a town hall. The main street is broad and beautifully shaded with grand old elms and maples. Many of the residences are elegant and costly, and ornamented with spacious and beautiful lawns, carpeted with green grass, and made fragrant by blooming flowers; while other dwellings have a rich, antique appearance, which are suggestive of the days of the past. There is a handsome common, neatly laid out and ornamented with beautiful shade trees. This common furnishes a delightful promenade for the quiet villagers, or their visitors, on the pleasant summer evenings, just as the sun settles below the horizon and reflects its golden beams on the western sky . . . the whole presenting

a picture far beyond the most splendid drapery of human imagination. The general neatness and quiet which prevails, together with the beautiful scenery of the surrounding community, render this one of the most beautiful and attractive villages in New Hampshire.

Photo credit: Walpole Historical Society, Walpole, New Hampshire

MARION COUNTY, OREGON C. 1877

AURORA COLONY BAND

Photographer unknown

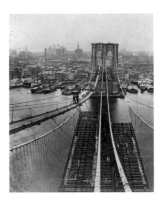

In 1839, William Keil, a Prussian-born pharmacist, became a preacher after attending a Methodist revival meeting. Dissatisfied with the traditional teachings of the Methodist Episcopal Church, he led his followers to Bethel, Missouri, where they established a German-speaking utopian community based on strict Christian beliefs.

In 1853, Keil sent a scouting party to the Pacific Northwest to find a "Second Eden." He purchased land and a mill south of Oregon City and named the colony Aurora Mills, after his daughter, Aurora, who died during a smallpox outbreak six years later.

The community built a town, planted an orchard, and crafted handmade goods. In 1870, the Oregon and California Railroad expanded and made Aurora a regular stop; four times a day, passengers left the trains to dine in the city's hotel. The colony's band became well known and traveled throughout the region to perform, many of the pieces written by Aurora musicians.

Keil died unexpectedly in 1877, and the six-hundred-member community broke up shortly after.

Photo credit: Willamette Heritage Center, Al Jones Collection, 2007.001.2006

BROOKLYN, NEW YORK 1881

BROOKLYN BRIDGE

Photographer unknown

In 1867, New York legislators approved John Augustus Roebling's plan for a suspension bridge over the East River between Manhattan and Brooklyn. Roebling wrote that his creation "will not only be the greatest bridge in existence, but it will be the great engineering work of the Continent and of the age."

At a little over a mile long, Roebling's bridge would be one and a half times the length of any existing suspension bridge. The towers would stand

295 feet above sea level, making them the tallest structure in the Western Hemisphere.

Just before construction began in 1869, Roebling was injured while surveying the bridge site. He died a month later. His son Washington took over the project, only to suffer from paralysis after getting the bends while trapped inside one of the bridge's underwater caissons. Confined to his bedroom, Washington would relay instructions through his wife, Emily, for the remainder of the bridge's construction.

Emily Roebling rode across the bridge on May 24, 1883, the first person to cross its entire span. Within twenty-four hours, more than 150,000 people had walked across the Brooklyn Bridge.

Photo credit: Museum of the City of New York Photo Archives, X2010.11.8453

HANOVER, NEW HAMPSHIRE
1882

DARTMOUTH BASEBALL
Photographer unknown

By 1880, baseball was such an important part of collegiate life that the American College Baseball Association was organized. Its members were Amherst, Brown, Princeton, Harvard, Yale, and Dartmouth—each of which played the other teams twice every season.

Two years later, Dartmouth was at the bottom of the league, having won only one game that year.

The other teams complained that the games with Dartmouth were too dull and did not attract enough spectators, and that the trip to New Hampshire was too arduous. Finally, at the close of the season, the association excluded Dartmouth from the league.

Consenting to play all games on the home fields of the other teams, Dartmouth was allowed back into the league for the season of 1884.

That year, they won two games.

Photo credit: Dennis Goldstein

ENFIELD, NEW HAMPSHIRE 1883

SHAKER VILLAGE SCHOOL
Photograph by W. G. C. Kimball

I will bow and be simple,
I will bow and be free,
I will bow and be humble,
Yea, bow like the willow tree.

—SHAKER HYMN

In 1774, a small group of a Protestant sect known as the United Society of Believers in Christ's Second Appearing (the Shakers) came to America from England.

When they settled on the site of their new home in Enfield, New Hampshire, among themselves they called it the "Chosen Vale." The ninth of nineteen Shaker communities established in the United States, more than three hundred adults and children lived, worked, and worshipped there at its peak in 1850.

The Shakers practiced equality of the sexes and races, celibacy, pacifism, communal ownership of property, and the worship of God through song and dance. They have also contributed to American culture with their inventions of the paper seed envelope, circular saw blade, flat broom, and more.

Photo credit: Communal Societies Collection, Hamilton College, Clinton, New York, enh-001

NIAGARA FALLS, NEW YORK C. 1883

WINTER TOURISTS
Photograph by George Barker

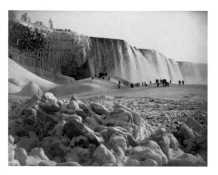

With the opening of the Erie Canal in 1825 and the development of the rail system, Niagara Falls, at the border between western New York and Ontario, Canada, became an accessible and popular destination for travelers from all over the world.

Soon unwary visitors were the victims of hustlers and hucksters. As early as 1831, the visiting French diplomat Alexis de Tocqueville urged a friend to "hasten" to Niagara if he wished "to see this place in its grandeur . . . If you delay your Niagara will have been spoiled for you."

To add to the spectacle, men and women performed death-defying stunts. A daredevil named "the Great Blondin" first crossed the river gorge on a tightrope in the summer of 1859. Over the years, he would go on to cross it while blindfolded, with a burlap sack pulled over his head, or with his feet secured in bushel baskets, carrying an iron stove—stopping to cook an omelet halfway across—and once with his manager, Harry Colcord, on his back before a crowd that included the Prince of Wales.

Photo credit: Library of Congress Prints and Photographs, LC-USZC4-2320

WASHINGTON MONUMENT
Photograph by Charles S. Cudlip

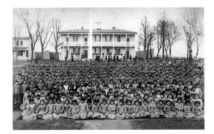

The Washington Monument was the idea of a private group calling themselves the National Monument Society, founded in 1833. Relying on private donations, the society began construction on July 4, 1848. Fund-raising was unsuccessful, however, and construction stopped six years later. The monument at this point was 154 feet tall.

In 1855, the Know-Nothings (whose name originated from the members instructed to reply, "I know nothing" when asked about their activities), a nativist, anti-immigration, and anti-Catholicism secretive society, took over the National Monument Society and promised to finish construction. After three years, they had added only three feet of inferior stone, which later had to be removed.

The Know-Nothings ceded control to the society in 1858, but a lack of funds again halted construction. Finally, in 1879, the U.S. government resumed construction, finishing the 555' 5⅛" tall obelisk in the winter of 1884.

At the dedication in February 1885, President Chester A. Arthur proclaimed, "I do now . . . in behalf of the people, receive this monument . . . and declare it dedicated from this time forth to the immortal name and memory of George Washington."

Photo credit: Henry Art Gallery, University of Washington, Seattle

CARLISLE, PENNSYLVANIA 1884

CARLISLE INDIAN SCHOOL
Photograph by John N. Choate

"Kill the Indian, save the man!"
—CAPTAIN RICHARD H. PRATT

In the late nineteenth century, "assimilation" was considered an alternative new policy for the "Indian problem" as settlers pushed further west. Instead of conquering Native Americans, the goal became to indoctrinate them into the white settlers' culture, especially the children.

Captain Richard H. Pratt, a soldier in the U.S. Army and a firm believer in assimilation, convinced the U.S. government to convert the Carlisle Barracks into a boarding school for Native American children—far from their families on reservations.

The Carlisle Indian Industrial School ran with unsparing strictness. School officials insisted that the students look, dress, behave, and speak like white Americans. Each child was assigned a new English name. To show politicians and the American public that cultural assimilation was working, "before and after" photos were taken and used as propaganda.

From 1879 until it closed in 1918, more than ten thousand Native American children, from 140 tribes, attended Carlisle.

There were more than 350 government-funded Native boarding schools across the United States in the nineteenth and twentieth centuries.

Photo credit: Archives & Special Collections, Waidner-Spahr Library, Dickinson College, PA-CH2-001

WYOMING TERRITORY 1884

YELLOWSTONE NATIONAL PARK
Photograph by F. J. Haynes

In 1869, when an expedition to the geothermal wonders at the headwaters of the Yellowstone River area tried to report what they saw to a newsmagazine, the editor responded, "Thank you, but we do not print fiction."

On March 1, 1872, President Ulysses S. Grant signed a bill setting aside a tract of land straddling the future states of Wyoming, Montana, and Idaho and creating the world's first national park at Yellowstone. The bill designated the region as a public "pleasuring-ground," which would be preserved "from injury or spoliation, of all timber, mineral deposits, natural curiosities, or wonders within."

Spanning nearly 2 million acres, Yellowstone sits on top of a forty-five-mile-wide caldera. With more than ten thousand thermal features, the park is home to more geysers and hot springs than any other place on Earth.

Photo credit: Haynes Foundation Photograph Collection, Montana Historical Society Photograph Archive, H-1371

BEDLOE'S ISLAND, NEW YORK 1885

THE STATUE OF LIBERTY
Photographer unknown

In hundreds of pieces packed in more than two hundred crates, the Statue of Liberty arrived at Bedloe's Island (owned by the federal government) in New York Harbor on June 17, 1885. A gift from the people of France, the statue was designed by Fréderic-Auguste Bartholdi. Gustave Eiffel provided the giant structure its internal stability.

However, the building of the pedestal for the statue was America's responsibility. A national committee went to the people and raised about

half of the funds, but both the state of New York and the U.S. Congress refused to cover the rest, and the pieces sat for over a year. During this time, Baltimore, Boston, San Francisco, and Philadelphia each offered to pay for the pedestal if the statue were relocated to their city.

Fed up, the Hungarian-born owner of the New York *World,* Joseph Pulitzer, declared that the statue "is not a gift from the millionaires of France to the millionaires of America" and promised to publish the name of every donor, no matter how small their contribution. Stories spread of children scraping together pennies, and soon donations came flooding in.

Photo credit: Alamy.com, #DA725A

into water and trees the recollection of some meditative ramble through the lonely seclusion of His own soul.

. . . sail, sail, sail, through the cypresses, through the vines, through the May day . . . and so shall you have revelations of rest, and so shall your heart forever afterwards interpret Ocklawaha to mean repose.

—SIDNEY LANIER, 1842–1881,
former Confederate soldier, musician, poet, and author

Photo credit: Library of Congress Prints and Photographs, LC-USZ62-97277

MOUNT McGREGOR, NEW YORK 1885

ULYSSES S. GRANT
Photograph by Howe, NY

Left destitute by bad investments and the dishonesty of his business partners, Ulysses S. Grant, Civil War hero and former two-term president of the United States, was urged to write the story of his life to raise badly needed income.

Shortly after he began, he discovered that he had cancer, and his health rapidly deteriorated. Sometimes writing more than ten thousand words a day, he finished his biography five days before his death on July 23, 1885. Toward the end of the book, Grant wrote, "Let us have peace." Those words would be engraved on his tomb.

The work was published as a two-volume set by his friend Mark Twain and was a huge success. Twain paid Grant's widow, Julia, almost half a million dollars in royalties, a small fortune at that time.

That same year, Twain published his own manuscript, *The Adventures of Huckleberry Finn.*

Photo credit: Library of Congress Prints and Photographs, LC-DIG-ppmsca-58230

NEW YORK HARBOR 1886

STATUE OF LIBERTY DEDICATION
Photograph by H. O'Neil

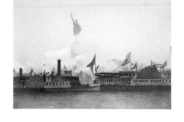

On a rainy October 28, 1886, more than a million people attended the celebrations for the unveiling of the Statue of Liberty. Brass bands played as soldiers and veterans, including the 20th Regiment of U.S. Colored Troops, marched down Broadway. On Bedloe's Island, prominent men joined President Grover Cleveland to praise her promise of liberty.

As the statue was revealed, cannons thundered, and steam whistles blew from hundreds of ships in the harbor.

But not all saw the Statue of Liberty as a beacon of freedom. African Americans, Chinese immigrants, and suffragists protested the hypocrisy when they still were barred or discouraged from the franchise in America.

The suffragist Matilda Joslyn Gage wrote, "It is the sarcasm of the 19th century to represent liberty as a woman, while not one single woman throughout the length and breadth of the land is as yet in possession of political liberty."

Photo credit: Library of Congress Prints and Photographs, LC-DIG-ds-04491

OCKLAWAHA RIVER, FLORIDA C. 1886

RIVER VIEW
Photograph by George Barker

Observations from the steamboat *Marion* traveling the Ocklawaha River, 1875.

. . . the sweetest water-lane in the world, a lane which runs for more than 150 miles of pure delight betwixt hedgerows of oaks and cypress and palms and bays and magnolias and mosses and manifold vine-growths . . . a lane which is as if . . . God had turned

BON AIR, VIRGINIA LATE 1880S

CHURCH PICNIC
Photograph by Huestis Cook

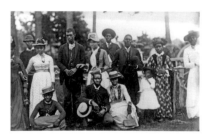

Several African American communities grew up after the Civil War around the small Victorian resort of Bon Air near Richmond, Virginia. People held in slavery were now free to make their own way. Some were laborers on farms or sharecroppers. Some had been sold land by those who had owned them. Others were new business owners. Teachers from the North came to work in new schools for Black children, and Black churches multiplied.

When Huestis Cook, the younger brother of the successful photogra-

pher George Cook, turned seventeen, he borrowed a camera and set out to chronicle the life of African Americans in that area. His photographs are some of the first photographs of former enslaved men and women and their descendants, and were taken to show dignity and respect.

Photo credit: "Picnic at Bon Air," Cook Collection, The Valentine, Cook 1384

CROOK COUNTY, WYOMING TERRITORY 1887

DEVILS TOWER

Photograph by John C. H. Grabill

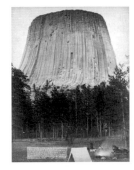

Devils Tower rises 1,267 feet from the Black Hills in northeastern Wyoming. Geologists are still studying how it was formed, but they agree that it began as magma (molten rock) buried beneath the Earth's surface.

Native American tribes, including the Arapahoe, Cheyenne, Crow, Kiowa, and Lakota, consider Devils Tower a sacred place and have legends about its creation. They call it many different names, including Bear Lodge, Mythic Owl Mountain, Gray Horn Butte, and Ghost Mountain. It was mistranslated from the Lakota language to Devils Tower during a gold rush expedition in 1875.

In the Kiowa legend, giant bears chased seven little girls out playing. The girls prayed to the Great Spirit, and the ground rose, lifting them toward the heavens. As the bears tried to reach them, they scored the rock with their sharp claws. Finally, the girls reached the sky and turned into the constellation Pleiades.

In 1906, Devils Tower became the first National Monument in the United States, granted that designation by President Theodore Roosevelt.

Photo credit: Library of Congress Prints and Photographs, LC-USZ62-78494

MCHENRY COUNTY, DAKOTA TERRITORY 1888

QUILTERS

Photographer unknown

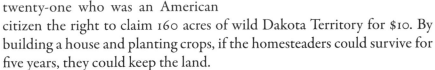

The Homestead Act of 1862 gave any man or woman over the age of twenty-one who was an American citizen the right to claim 160 acres of wild Dakota Territory for $10. By building a house and planting crops, if the homesteaders could survive for five years, they could keep the land.

Many of the homesteaders were women who came with their husbands, parents, friends, or by themselves, "proving up" and becoming landowners.

Communities formed on the prairie. Schools and churches were built.

And despite the endless hard work and often harsh weather, there were dances, baseball games, weddings, and other social gatherings.

For many women, quilting parties helped overcome the loneliness that was also part of pioneer life. Because they usually didn't have a big house with a parlor for hand quilting, the women would find a place outside their homes to work. In this photograph, the quilters are meeting in the local post office. They are stitching a double Irish chain quilt.

Throughout thirty states, nearly 4 million would settle land under the Homestead Act.

Photo credit: State Historical Society of North Dakota

INDIANAPOLIS, INDIANA 1888

BENJAMIN HARRISON

Photographer unknown

Nineteenth-century presidential candidates were not supposed to actively campaign by traveling around the country, because it was thought inappropriate and immodest. Instead, they were expected to look to the example of George Washington and remain above the fray.

In 1888, "Little Ben"—a moniker given to the Republican candidate Benjamin Harrison by his opponents, as he was only five feet six inches tall—followed that advice and opted for the "front porch" campaign, addressing more than 300,000 in more than eighty speeches from the small front vestibule of his home. He can be seen in this photograph sporting a long white beard.

Harrison received 100,000 fewer popular votes than his opponent, incumbent President Grover Cleveland, but ultimately won the election in the Electoral College.

Four years later, Cleveland ran again against Harrison, who was running for reelection. He defeated Harrison and became the only person in the country's history to be elected to a second, nonconsecutive presidential term.

Photo credit: Benjamin Harrison Presidential Site, 1675.15

MAUI, HAWAIIAN ISLANDS 1890

IAO VALLEY

Photograph by Brother Gabriel Bertram Bellinghausen

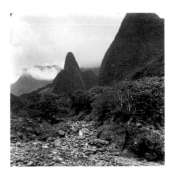

In September 1883, eight Marianist missionaries arrived in Honolulu. Among them was German-born Brother Gabriel Bertram Bellinghausen.

Brother Bertram was not only devoted to his faith and his students but also to the art of photography. He chronicled the days when his friend King Kalākaua occupied the newly built Iolani Palace, and in later years the funeral processions of Princess Likelike, Princess Kaiulani, and the king himself. His photographs show the islands before the onslaught of business and progress descended on the native culture.

Brother Bertram died in 1905, seven years after the annexation of the Hawaiian Islands by the United States. In 1964, a Marianist brother found hundreds of his glass plates in a Kalaepohaku trash can. They were packed away and forgotten until 1975, when they were brought to the public's eye.

Photo credit: National Archives, Marianist Province of the United States, Sec. 3, no. 331

NEZ PERCE RESERVATION
Photograph by Emma Jane Gay

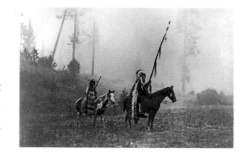

After the Dawes Allotment Act of 1887, 70 percent of the land on the Nez Perce Reservation passed into non-Native hands.

The act, which affected most reservations nationwide, assigned 160 acres of reservation land to each adult and up to eighty acres to each child, in exchange for abolishing their tribal governments and recognizing state and federal laws. The intent was to destroy traditional Native American life.

The unassigned lands were declared "surplus" and opened to white settlement.

The ethnologist and anthropologist Alice Cunningham Fletcher hoped that the Dawes Act would protect Native Americans' property rights and help them to assimilate into the white world. In 1889, the Department of the Interior appointed her to oversee the allotments to the Nez Perce in Idaho. Her friend Emma Jane Gay accompanied her as cook, maid, and secretary; having taught herself photography, Gay took more than four hundred photographs of the tribe.

Photo credit: "War Poles," Idaho State Archives, E. Jane Gay Collection, P1963-221-018

WALT WHITMAN
Photograph by Samuel Murray

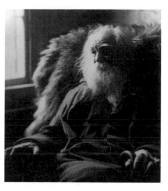

I am of old and young, of the foolish as
 much as the wise,
Regardless of others, ever regardful of
 others,
Maternal as well as paternal, a child as
 well as a man . . .
 —WALT WHITMAN, "Song of Myself"

On July 4, 1855, at the age of thirty-six, Walt Whitman published the first of nine editions of a book of poetry entitled *Leaves of Grass*. The poems reflected his belief in the ability of a person, and a nation, to contain contradictions and diversity and still be whole. A flyer written by himself for the book read, "An American Poet at last! . . . Through the poet's soul runs the perpetual spirit of union and equality."

During the Civil War, Whitman volunteered as a nurse tending to the wounded and dying. The war, he said, revealed to him "some pang of anguish—some tragedy, profounder than ever poet wrote." After witnessing so much bloodshed, the America Whitman would write about was a far less innocent nation.

His new poems were included in the following eight editions of *Leaves of Grass*, the last, a collection of almost four hundred poems, published after his death, in Camden, New Jersey, in 1892.

Photo credit: Library of Congress Prints and Photographs, LC-DIG-ppmsca-07547

CLIFF HOUSE
Photograph by Gustaf Nordenskiöld

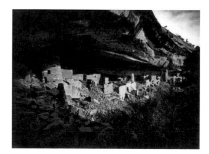

On June 29, 1906, to protect the area and "preserve the works of man," the U.S. Congress and President Theodore Roosevelt established Mesa Verde National Park.

More than five thousand ruins from the Ancestral Pueblo people are in the park. Six hundred are cliff dwellings.

The first evidence that ancient people had moved to Mesa Verde is from about the year 500. Those people lived in pit houses, which were large holes in the ground with roofs of wood and mud.

Around 750, the Ancestral Puebloans began building square structures of connected rooms on the tops of the mesas. Then, in about 1100, they

moved down the canyon walls and began building the cliff dwellings seen in this photograph.

In the late 1200s, the people of Mesa Verde migrated away for reasons that are still debated. However, they left behind thousands of relics of their daily life.

It would be almost six hundred years later that the dwellings were "discovered" by white expeditioners, and it would take the work of many men and women over the thirty years after that to protect the site and its valuable relics until it became a national park.

Photo credit: Mesa Verde National Park Archives

TUSKEGEE, ALABAMA C. 1890S

TUSKEGEE UNIVERSITY STUDENTS
Photograph by Frances Benjamin Johnston

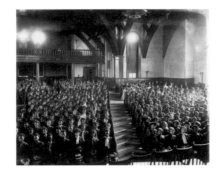

In 1880, Lewis Adams, freed by the Emancipation Proclamation, and George W. Campbell, a former enslaver, worked together to convince the Alabama legislature that it would be politically advantageous to fund a "Negro Normal School" in Tuskegee.

Adams then hired another man born into slavery, Booker T. Washington, to become the first principal. Washington implemented industrial and vocational education programs to teach his students to become self-sufficient American citizens.

At the time, there was a debate among Black intellectuals about the pros and cons of industrial versus liberal education. Washington's most vocal opponent was W. E. B. Du Bois, the first person from his family to graduate from high school and the first African American to receive a PhD from Harvard University. Du Bois believed that a broad liberal arts education would bring about full citizenship and equal rights for African Americans. "Education," he said, "must not simply teach work—it must teach life."

Photo credit: Library of Congress Prints and Photographs, LC-DIG-ppmscd-00083

CHADRON, NEBRASKA 1891

RED CLOUD
Photograph by Trager & Kuhn

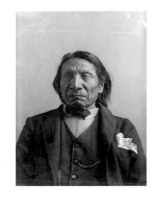

After a treaty signed at Fort Laramie in 1868 was broken, Red Cloud, a leader of the Oglala Lakota, made several trips to Washington, D.C., to lobby for Native American rights. "The object of the whites is to crush the Indians down to nothing," he said to Secretary of the Interior, Jacob Cox.

But he could do little to save his people's land from the onslaught of white settlers and the greed for gold.

Despite being betrayed by the government, and unlike younger leaders like Sitting Bull and Crazy Horse, who went back to war against the whites, Red Cloud kept the peace he had agreed to. In the late 1870s, he and his people moved to the Pine Ridge Reservation in South Dakota.

Twenty years later, at Wounded Knee Creek on the Pine Ridge Reservation, hundreds of Lakota were massacred by the United States 7th Cavalry.

Shortly before he died in 1909, Red Cloud said, "*Taku Shanskan* is familiar with my spirit, and when I die I will go with him. Then I will be with my forefathers. If this is not in the heaven of the white man I shall be satisfied."

Photo credit: Denver Public Library, Special Collections, X- 31322

HARRISON, MAINE C. 1890S

SUMMER COLONY
Photographer unknown

The 1890s were the heydays in much of Maine. Textile mills, lumber mills, paper mills, railroads, canneries, granite quarries, ice harvesters, lobstering, and shipbuilding flourished amid growing political clout and a thriving tourist industry with hotels and elegant homes built by the wealthy summer visitors.

In 1892, some 500,000 tourists came to the state.

Still, most of Maine's population lived quiet rural lives. In the state capital of Augusta, on February 12, 1891, legislators passed the following law:

Be it enacted by the Senate and House of Representatives in Legislature assembled as follows:

. . . It shall . . . be the duty of all teachers in the public schools of this state to devote not less than ten minutes of each week of the school term, to teach to the children under their charge, the principles of kindness to birds and the animals.

Photo credit: Source undetermined

GLACIER BAY, ALASKA 1891

MUIR GLACIER
Photograph by F. J. Haynes

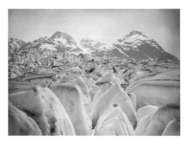

In 1879, the naturalist John Muir, intrigued by the new science of glaciology, embarked on a forty-day canoe journey

with fourteen members of the indigenous Tlingit people and a Presbyterian missionary to study the tidewater glaciers of Glacier Bay. He believed that ice had carved out his beloved Yosemite Valley long ago, and came to Alaska to see the glaciers in action and prove his theory.

He filled his journals with colorful writing about his canoe trips, the maritime currents, and the ice features, declaring the glaciers "God's Temples."

Muir's observations, published in a San Francisco newspaper, gave rise to new interest in the area, and Glacier Bay became a popular tourist attraction, as well as the focus of scientific research.

He would make five more trips to Alaska, where the Tlingit had given him the title "the Ice Chief."

Photo credit: "Crevasses on Top of Muir Glacier, Alaska," Haynes Foundation Photograph Collection, Montana Historical Society Photograph Archive, H-02594.

OUTSIDE PITTSBURGH, PENNSYLVANIA
1894

COXEY'S ARMY

Photographer unknown

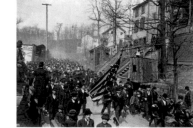

During the economic depression that followed the Panic of 1893, Jacob Coxey, a businessman and populist from Ohio, had an idea for the federal government to provide jobs through a public works program. He called it the "Good Roads Bill."

On Easter Sunday in 1894, Coxey and one hundred unemployed workers set out from Massillon, Ohio, to present his idea to the U.S. Congress. As their numbers grew, they became known as "Coxey's Army."

Four hundred marchers reached the Capitol grounds five weeks later. A melee ensued, and the police arrested Coxey along with some of his men. The rest of his ragtag soldiers were driven away.

On May 1, 1944, fifty years after his arrest, ninety-year-old Jacob Coxey was granted permission to read his original petition, "in behalf of millions of toilers," on the steps of the Capitol in honor of President Franklin D. Roosevelt's New Deal.

Photo credit: Getty Images, 640468509

WASHINGTON, D.C. C. 1894

THE SUPREME COURT

Photograph by C. M. Bell Studio

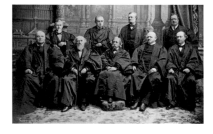

In 1892, Homer Plessy, a mixed-race resident of New Orleans, deliberately violated Louisiana's Separate Car Act of 1890, requiring "equal, but sepa-

rate" railroad accommodations for whites and nonwhites. As a result, he was arrested and charged with boarding a "whites-only" car. At trial, his lawyers claimed that the law was unconstitutional but lost, Judge John Howard Ferguson presiding.

In an appeal by Plessy in 1896, the Supreme Court issued a 7–1 decision, with one abstention, stating that although the Fourteenth Amendment established the legal equality of whites and Blacks, it did not and could not require the elimination of all "distinctions based upon color."

The Court ruled that states had the right to make laws regulating health, safety, and morals and rejected Plessy's arguments that those laws inherently implied that Black people were inferior. Their decision cemented the legality of "separate but equal" policies, making Jim Crow acceptable for the next sixty-two years.

The Court that heard *Plessy v. Ferguson* in 1896 never sat for a group photograph, but all but one of the justices (Justice Robert H. Jackson, holding a cane) in this 1894 photograph were on the bench for the decision. Justice John Marshall Harlan, seated second from the right, was the lone dissenter.

Photo credit: Collection of the Supreme Court of the United States

SEATTLE, WASHINGTON 1895

MARK TWAIN

Photograph by Major J. B. Pond

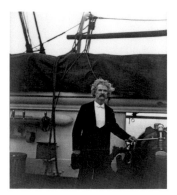

At nearly sixty years old, plagued by ill health, a fading career, and enormous debt, Samuel Clemens, known to the world as Mark Twain, set out on a year-long global speaking tour. His talks, delivered in deadpan fashion, included a humorous sermon on building up one's moral character by committing all 462 possible sins. The trip gave new life to Twain's celebrity, and he was able to settle his debts.

But tragic news reached him when he arrived in England. His twenty-four-year-old daughter, Susy, who had stayed behind in the family home in Hartford, had died of meningitis, with neither parent by her side. Twain blamed himself for not being there. For the rest of his life, despite financial success and involvement in everything from the struggle for racial justice and women's rights, politics, and a lively social circle, he would never regain his goodwill toward himself and to life itself.

William Dean Howells spoke at his friend's funeral, saying, "Emerson, Longfellow, Lowell, Holmes—I knew them all and all the rest of our sages, poets, seers, critics, humorists . . . but Clemens was sole, incomparable, the Lincoln of our literature."

Photo credit: Courtesy of the Center for Mark Twain Studies, Elmira College, Elmira, New York

AT THE BEACH

Photograph by W. B. Davidson

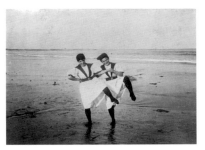

During the Victorian era in the nineteenth century, it was considered proper for women to keep their skin untouched by the sun. Ladies strolled on the beach in seaside walking dresses and were protected by bonnets, shawls, and gloves. So that a breeze would not reveal even a hint of flesh, weights were often sewn into the hems of their dresses.

Times changed, and near the turn of the century, women at the beach dressed less demurely, in knee-length, puffed-sleeve wool dresses that they wore over bloomers adorned with ribbons and bows. They further accessorized the costume with long black stockings, fancy bathing caps, and bathing slippers.

Still, despite the new bathing outfits, through the early decades of the twentieth century the only activity for women to "swim" in the ocean on a public beach involved jumping through the waves while holding on to a rope attached to an offshore buoy. Just to be safe.

Photo credit: Library of Congress Prints and Photographs, LC-USZ62-66488

THE KLONDIKE GOLD RUSH

Photograph by Sam C. Partridge

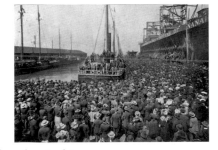

In August 1896, a Tlingit and Tagish man known as Skookum Jim Mason found gold near the Klondike River in Canada's Yukon Territory. The discovery set off one of the maddest gold rushes in history.

Nearby miners immediately headed to the Klondike to stake the good claims.

A year later, news spread to the outside world. Gold seekers called "stampeders" bought supplies and boarded ships in Seattle and other West Coast port cities. Within six months, more than 100,000 had set off for the Yukon. An arduous journey, violence, disease, and Mother Nature waited for them, and many would die before they even set foot in the goldfields. It is estimated that only 30,000 completed the trip.

The Klondike gold rush ended in 1899 with another discovery of gold, in Nome, Alaska.

Photo credit: University of Washington Libraries, Special Collections, PH Coll 290. Excelsior1 Ships

ARLINGTON NATIONAL CEMETERY

Photograph by Ernest C. Rost

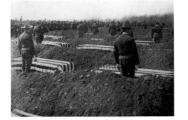

Washington—April 6, 1899—With full honors of war, upon the crest of the southern slope of Arlington Cemetery this afternoon, the nation, represented by President McKinley, his cabinet and other high dignitaries of the government, the commanding general of the army, and other distinguished officers, all the regular and militia organizations of the District of Columbia and a concourse of 15,000 people paid the last tribute of honor and respect to the 336 officers and men who gave their lives on distant battlefields for their country in the war with Spain, and who were today mustered into the silent army that sleeps in the last bivouac of the brave.

—*ST. JOHN DAILY SUN*, New Brunswick, Canada

On February 13, 1898, the USS *Maine* exploded off the coast of Havana, Cuba, killing close to 260 aboard. The United States blamed Spain, the country that controlled Cuba, and declared war. The conflict lasted for a little under four months and ended in a treaty that compelled Spain to relinquish its claims on Cuba and cede sovereignty of Guam, Puerto Rico, and the Philippines to the United States.

Fewer than four hundred Americans were killed in battle, but thousands more died from malaria, typhoid fever, and other tropical diseases.

Photo credit: Getty Images, 640507207

COTTON PICKERS

Photograph by Edward Warren Day

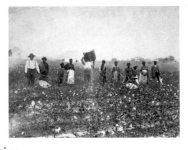

Cotton was the leading American export throughout the nineteenth century. In terms of the young nation's economy, the phrase "Cotton is king" wasn't an exaggeration.

By 1860, the country was producing more than 2 billion pounds of it a year—two-thirds of the world's supply—almost all of which was harvested by people living in slavery. While not the only cause of the Civil War, cotton's value to plantation owners made slavery worth fighting for.

The lucrative reign of King Cotton continued uninterrupted after the Civil War—a cruel irony for those who continued to be its subjects, as seen in this photograph almost forty years after the Emancipation Proclamation. Free Blacks, tenant farmers, and sharecroppers continued to pay a painful price in human terms for the meager sustenance it earned them.

Photo credit: Getty Images, 90000934

SAN FRANCISCO, CALIFORNIA C. 1900

CHINATOWN
Photograph by Arnold Genthe

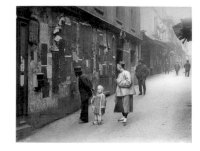

Chinese immigrants first came to the United States in the 1850s to escape war, famine, and a poor economy at home, and to mine for gold in California. When the gold rush ended, they found work as farmhands, gardeners, domestics, laundry workers, and railroad workers. In the 1860s, thousands of Chinese men helped build the Transcontinental Railroad, where, even though they were given the most dangerous jobs and longer hours than the other workers, they still earned much more money than they could in China.

As an economic depression in the 1870s led to a scarcity of jobs, resentment grew toward the Chinese and what some called the "yellow peril."

By 1882, these prejudices prompted Congress to pass the Chinese Exclusion Act, banning almost all Chinese immigration into the United States, with exceptions for some Chinese merchants, diplomats, and students as well as, for a time, their wives and families.

In 1943, when China became America's ally in World War II, Congress finally repealed the Exclusion Act, although Chinese immigration was limited to only 105 people a year.

In 1965, all restrictions were finally lifted.

Photo credit: Library of Congress Prints and Photographs, LC-G403- 0147-B

OMAHA, NEBRASKA 1900

TATANKA PTIEELA (SHORT BULL)
Photograph by Herman Heyn

Short Bull was a member of the Lakota tribe. Along with fellow Lakota Kicking Bear, he was instrumental in bringing the Ghost Dance movement to the Native Americans living on the reservations in South Dakota.

Beginning in 1890, Native Americans began practicing the Ghost Dance—Nanisśáanah—to unite living spirits with the dead to fight the white people stealing their lands and bring peace and unity to the tribes.

Federal agents saw the Ghost Dance as a threat. They held that Sitting Bull, the chief of the Lakota and a fierce enemy of the white people, was responsible for its spread and sent police to arrest him at his cabin on the Standing Rock Reservation in South Dakota. On December 15, 1890, they arrived at the reservation. A gunfight ensued, and Sitting Bull was killed.

Short Bull, Kicking Bear, and twenty-five other Ghost Dancers were arrested. They were released only after Buffalo Bill Cody arranged to take them to Europe with his Wild West show.

In his later years, Short Bull was known as Arnold Short Bull. In 1923, he died at the age of seventy-eight at his home on the Pine Ridge Reservation.

Photo credit: Alamy.com, 2A3RWDE

NEW YORK CITY 1900

JOHN PIERPONT MORGAN
Photographer unknown

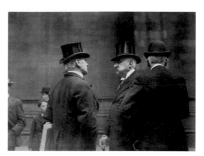

The term the "Gilded Age" describes the last quarter of the nineteenth century, when the rich grew richer and the poor became poorer still. It was taken from a book written by Mark Twain and Charles Dudley Warner, who took it from a line in a Shakespeare play: "To gild refined gold, to paint the lily . . . is wasteful and ridiculous excess."

During this time, a small group of men, often called "robber barons," amassed enormous wealth by controlling whole industries—creating monopolies and eliminating competition. The financier J. P. Morgan, railroad mogul Cornelius Vanderbilt, oil tycoon John D. Rockefeller, and steel magnate Andrew Carnegie became the titans of industry.

To avoid government regulations that might interfere with their businesses, Rockefeller and Morgan helped elect William McKinley to the presidency. However, in 1901 McKinley was assassinated. As soon as Vice President Theodore Roosevelt was inaugurated, he promptly began dissolving trusts if he thought their practices were unfair.

In his first message as president, Roosevelt said, "There is a widespread conviction in the minds of the American people that the great corporations known as trusts are in certain of their features and tendencies hurtful to the general welfare . . . and in my judgment this conviction is right."

Photo credit: Library of Congress Prints and Photographs, LC-USZ62-92327

PUTNEY, VERMONT C. 1900

TUG OF WAR
Photographer unknown

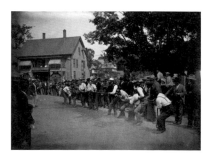

The land that became the town of Putney, Vermont, changed hands many times as British colonists rivaled the French, Native Americans, and each other. At various times, Putney came under the jurisdiction of Massachusetts, New Hampshire, and, finally, New York.

During the Revolutionary War, Vermont waged its own rebellion,

declaring independence from Great Britain *and* New York. In 1777, the new "republic" of Vermont adopted a constitution—the first on American soil to ban slavery. However, the Continental Congress refused to acknowledge Vermont's independence from New York and would not allow its statehood. Finally, in 1791, Vermont was admitted into the Union as the fourteenth state—after it agreed to pay New York $30,000 for its lost territory.

Despite all the upheaval, from the beginning, small-town rural life and a sense of community were Putney's hallmarks. When this photograph was taken, in 1900, the Putney general store had already been there for more than one hundred years.

It is worth noting that at the 1900 Olympic Games in Paris, the U.S. won the silver medal in the tug-of-war competition; at the 1904 Games in St. Louis, it won the gold. The event remained in the Olympics until 1920.

Photo credit: Putney Historical Society, Putney, Vermont

WASHINGTON, D.C. C. 1900

SUSAN B. ANTHONY
Photograph by Frances Benjamin Johnston

Forget conventionalisms; forget what the world thinks of you stepping out of your place; think your best thoughts, speak your best words, work your best works, looking to your own conscience for approval.

—SUSAN B. ANTHONY

Born in 1820 into a world ruled entirely by men, Susan Brownell Anthony fought to win the most basic civil rights for women for more than half a century.

Shortly before she died in 1906, Anthony wrote to her friend and fellow warrior Elizabeth Cady Stanton.

My Dear Mrs. Stanton:
. . . We little dreamed when we began this contest, optimistic with the hope and buoyancy of youth, that half a century later we would be compelled to leave the finish of the battle to another generation of women . . . There is an army of them, where we were but a handful.

. . . And we, dear old friend, shall move on to the next sphere of existence . . . where women will not be placed in an inferior position, but will be welcomed on a plane of perfect intellectual and spiritual equality.

Ever lovingly yours,
Susan B. Anthony

On August 26, 1920, the Nineteenth Amendment, granting women suffrage, was ratified by Congress with a margin of a single vote.

Photo credit: Library of Congress Prints and Photographs, LC-DIG-ppmsca-39001

HARTFORD, CONNECTICUT 1900

THE OLD STATE HOUSE
Photographer unknown

On New Year's Eve of 1900, the Old State House in Hartford was decorated with more than six hundred electric lights.

But the biggest topic of conversation before the celebrations began that year, argued by mathematicians, religious scholars, astronomers, and others around the world, was the question of whether the new century began on the eve of December 31, 1899, or December 31, 1900.

On December 15, 1899, *The New York Times* had reported, "Laboring apparently under the delusion that there is controversy as to when the twentieth century begins, *The Boston Herald* devotes the better part of a page to the publication of letters from college presidents to whom it had submitted inquiries on the subject." Of the fourteen who responded, eleven were in favor of 1901, two in favor of 1900, and one was "too enigmatic for the comprehension of ordinary mortals."

The Washington Post wrote, "This is a free country, and almost any citizen can assert, if he wants to, that 99 makes 100. What are we coming to, when our best people can be muzzled by the dry and stupid laws of mathematics?"

Photo credit: "Illumination of Old State House," Connecticut Historical Society, 2000.209.28

KITTY HAWK, NORTH CAROLINA 1902

THE WRIGHT BROTHERS
Photographer unknown

For some years I have been afflicted with the belief that flight is possible to man . . . I have been trying to arrange my affairs in such a way that I can devote my entire time for a few months to experiment in this field.

—WILBUR WRIGHT, May 13, 1900

In September 1902, Orville Wright completed a short flight on a glider weighing 117 pounds, with a wingspan of thirty-two feet. It was the third design that he and his brother Wilbur had tried. More than seven hundred test glides showed that the design was workable but still flawed.

After several modifications over the next year, the Wright brothers were satisfied that they had built the first working airplane. The *new* design included propellers and a simple four-cylinder engine.

On December 17, 1903, at Kill Devil Hills near Kitty Hawk, North Carolina, Orville Wright completed the first powered flight of a heavier-than-air aircraft. In twelve seconds, the plane traveled 120 feet, and reached a top speed of 6.8 miles per hour. One of the five people who witnessed the event took this photograph. The brothers completed three more flights that day, the longest traveling 852 feet in fifty-nine seconds. The highest altitude: about twenty feet.

Photo credit: Library of Congress Prints and Photographs, LC-DIG-ppprs-00602

SENORITO, TERRITORY OF
NEW MEXICO C. 1900

WEDDING PARTY
Photographer unknown

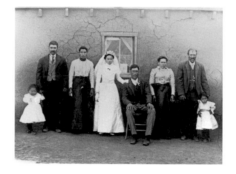

Signed on February 2, 1848, the Treaty of Guadalupe Hidalgo brought an official end to the Mexican-American War. By the treaty's terms, Mexico ceded 55 percent of its territory, including all or parts of present-day Arizona, California, New Mexico, Colorado, Nevada, Utah, and Texas, to the United States.

In turn, the United States paid Mexico $15 million. The government also agreed to accept former Mexican nationals' claims to their lands and accept them as full citizens of America with the right to vote.

From 1850 until 1912, the territory of New Mexico tried more than fifty times to become a state, but with no success. (As a territory, the residents of New Mexico could not vote in presidential elections and only had non-voting representation in Congress.) Instead, New Mexicans were cast as foreign and alien, lawless, and too Catholic.

It wasn't until 1912 that Congress admitted New Mexico as the forty-seventh state. President William Taft signed the proclamation, declaring somewhat enigmatically to the New Mexico delegation, "Well, it is all over. I am glad to give you life. I hope you will be healthy."

Photo credit: Special Collections and Center for Southwest Research, University of New Mexico Libraries, Henry A. Schmidt Collection, 000-179-0635

CHICAGO, ILLINOIS 1903

HORATIO NELSON
JACKSON AND BUD
Photographer unknown

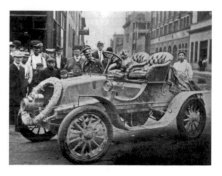

In the spring of 1903, on a whim and a $50 bet, Dr. Horatio Nelson Jackson set off from San Francisco in a twenty-horsepower Winton touring car named the *Vermont*, hoping to become the first person to cross the United States in the newfangled "horseless carriage."

At the time, there were only 150 miles of paved roads in the entire country. Traveling with his co-driver, Sewall K. Crocker, and a bulldog named Bud, relying on very few maps and the kindness of strangers for directions, Jackson arrived in New York City in sixty-three days, twelve hours, and thirty minutes, well within his bet of ninety days. He had lost twenty pounds and spent $8,000 of his own money—the price of the car, a salary for Crocker, food and lodging, the endless need for new tires and replacement parts, eight hundred gallons of gasoline, and $15 to purchase Bud.

That same year, at his home in Burlington, Vermont, Horatio Nelson Jackson was ticketed $5 plus court costs for driving over the speed limit of six miles an hour.

Photo credit: University of Vermont Special Collection

SAN FRANCISCO, CALIFORNIA
1903

FUJI ATHLETIC CLUB
Photographer unknown

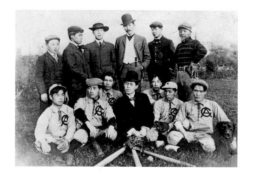

Chiura Obata arrived in the United States in 1903 at the age of seventeen, a young painter who only intended to stay briefly before going to Paris to continue his career. However, he soon set down roots in San Francisco, making a name for himself in the art community and cofounding the first Japanese American baseball team on the mainland—the Fuji Athletic Club. He is in the lower right of this team photograph.

In the 1920s, Obata visited Yosemite National Park, spending months tramping around "Great Nature." He would continue to visit Yosemite every summer with his wife, capturing the landscape that he loved, saying, "My paintings, created by the humble brush of a mediocre man, are nothing but expressions of my wholehearted praise and gratitude."

After the Japanese attack on Pearl Harbor in 1941, Obata and his family were forced to move to a detention camp in Topaz, Utah, for eleven

months. Years later, in remembrance of this ordeal, Obata painted *Glorious Struggle*—the image of a tree in Yosemite's High Sierra whose own struggle to survive had given him strength and hope.

Photo credit: Courtesy of Kerry Yo Nakagawa, Nisei Baseball Research Project, George Aratani Collection

BOSTON, MASSACHUSETTS 1903

ROYAL ROOTERS
Photographer unknown

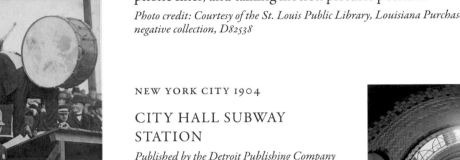

In 1903, the Boston Americans baseball team—which would later change its name to the Red Sox—made it to what is considered the first official World Series, pitting them against the Pittsburgh Pirates in a best of nine games match.

As thousands of hardcore Boston fans packed the Huntington Avenue Grounds, a raucous group called the "Royal Rooters" paraded around the field, cheering, chanting, and banging a big drum, and doing everything they could to distract their opponents.

Despite the antics of the Boston fans, the Pirates won three of the first four games. But the Americans came back to win the last four games in a row and took the championship five games to three.

The next day the victory was splashed across the front page of *The Boston Journal*, which claimed in a bold headline, "The Boston Americans Are Now the Champions of the World."

Photo credit: Boston Public Library, Special Collections, McGreevy Collection, 06_06_000012

ST. LOUIS, MISSOURI 1904

WORLD'S FAIR
Photographer unknown

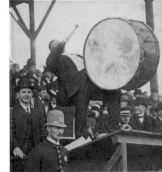

The inventor Lee de Forest—driven, self-promoting, and some say unscrupulous—is sometimes known as the "Father of Radio," an honorific he perpetuated in the title of his autobiography.

At the turn of the century, achieving the perfect wireless signal was the gold ring for inventors, and the governor of Missouri invited them to exhibit their latest creations at the St. Louis World's Fair in 1904.

While his respected competitor Guglielmo Marconi turned down the offer to participate in the fair, de Forest spent $10,000 to take down a three-hundred-foot sight-seeing tower from Niagara Falls, re-erecting it in St. Louis, with his name added in lights across the top. Then the high-

est structure in St. Louis, it included two electric elevators and a wireless telegraph station on the one-hundred-foot level. The uppermost platform was also a popular attraction, including for Violet E. Ingle and Alfred M. Landers, who were married there.

De Forest would go on to invent a vacuum tube called the "Audion," which could amplify an electrical signal. It would become a critical component in early electronics, making radio broadcasting, long-distance telephone lines, and talking motion pictures possible.

Photo credit: Courtesy of the St. Louis Public Library, Louisiana Purchase Exposition, glass plate negative collection, D82538

NEW YORK CITY 1904

CITY HALL SUBWAY STATION
Published by the Detroit Publishing Company

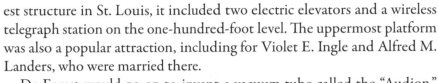

To great fanfare, the New York City subway system opened on October 27, 1904.

The City Hall station was the masterpiece of the Interborough Rapid Transit Company. Designed by the architects Heins & LaFarge, who were known for their work at the Cathedral of St. John the Divine, it was described as the most beautiful subway station in the world. It boasted colored glass tile work, brass chandeliers, cut amethyst glass skylights, and vaulted walls. *House & Garden* magazine called the station an "apotheosis of curves."

After the initial ride with the mayor, at 7 p.m., the subway opened for paying fares.

Two hundred policemen were ready, forming a line to hold back the crowd. Despite the police force, more than a few slipped by. *The New York Times* reported that "the two sections of the train were crowded uncomfortably . . . many passengers stood in every car," and the *Chicago Tribune* described the mob as utilizing "football tactics." An estimated 150,000 passengers rode the trains before they were shut down at midnight.

Photo credit: Library of Congress Prints and Photographs, LC-D401-17293

SAN FRANCISCO, CALIFORNIA EARLY 1900S

THE CLIFF HOUSE RESORT
Photographer unknown

After his first Cliff House resort burned to the ground in 1894, Adolph Sutro, a self-made millionaire and phi-

lanthropist, had plans for a second Cliff House. The new building was a grand, castle-like structure designed for elegant dining, dancing, and entertainment.

Sutro expanded his oceanfront complex with a massive public bathhouse offering six saltwater swimming tanks of varying sizes, shapes, and water temperatures spread over three acres.

In 1897, John Harris, an African American waiter, challenged Sutro Baths' "whites only" policy. He won his case due to newly enacted state laws that provided equal access to certain establishments, including restaurants, hotels, eating-houses, barbershops, bathhouses, theaters, skating rinks, and other places of public accommodation or amusement.

At the trial, the jury was so appalled that they asked the judge if they could simply ignore the law. Although the answer was no, Blacks were still not really welcome at the Sutro Baths. The superintendent of the establishment made it clear, stating, "Negroes, so long as they are sober and well-behaved, are allowed to enter the baths as spectators, but are not permitted to go in the water."

Photo credit: Dennis O'Rorke Collection

ELLIS ISLAND, NEW YORK 1905

RUSSIAN JEWISH IMMIGRANT
Photograph by Lewis Hine

> Give me your tired, your poor,
> Your huddled masses yearning to breathe
> free,
> The wretched refuse of your teeming shore.
> Send these, the homeless, tempest-tost to me,
> I lift my lamp beside the golden door!
>
> —EMMA LAZARUS, "The New Colossus"

In 1882, Emma Lazarus, the daughter of Jewish immigrants, wrote a poem entitled "The New Colossus" to raise money for the construction of the pedestal for the Statue of Liberty. The poem was cast onto a bronze plaque and mounted inside the pedestal in 1903.

Between 1905 and 1914, an average of a million immigrants per year landed on Ellis Island in New York City, the gateway to the United States. Among them were Jews escaping from political and economic oppression in czarist Russia and eastern Europe, and Italians fleeing poverty in their country. There were also Poles, Hungarians, Czechs, Serbs, Slovaks, Greeks, Swedes, Romanians, Dutch, Syrians, Turkish, Armenians, Lebanese, Algerians, and other people from all over the world.

In 1908, a popular play about immigrants—*The Melting Pot*—coined that phrase as a metaphor for America.

Photo credit: New York Public Library, Photography Collection, 212099

SAN FRANCISCO, CALIFORNIA 1906

EARTHQUAKE FROM LAFAYETTE SQUARE
Photograph by Bear Photo Company

At 5:12 a.m. on April 18, 1906, a tremendous earthquake shook San Francisco. The quake lasted less than a minute, but its impact was disastrous. A massive fire followed, burning for three days. Nearly five hundred blocks in the city were leveled, and the inferno destroyed more than twenty-five thousand buildings, leaving half the population of San Francisco homeless.

George Munson, the captain of the SS *Henley*, which was safely anchored offshore, watched the devastation with horror. Later he wrote home,

> My dearest Mother,
> . . . I have got a large number of homeless people aboard and the tales of woe are fit to break any human heart . . . the old and aged and young are all here, high born and low are all one class and I shame to say it, but the women are more cheerful in all their grief than the men . . . I have been condensing day and night and have supplied tens of thousands with water to drink. Fancy people walking miles and miles through blazing streets to get a drink of water and a bite to eat.

Photo credit: California State Library, California History Room, Bear Photo Co., no. 582, F869. S3.S24794, Vol. 3:119. Letter from collection of California Historical Society.

GILA RIVER VALLEY, ARIZONA C. 1907

MARICOPA
Photograph by Edward Curtis

Between 1907 and 1930, the photographer Edward Curtis published twenty volumes of *The North American Indian*. The series included 2,200 photogravures of Native Americans chosen from the 40,000 images Curtis had taken of more than eighty tribal groups—from the Inuit people of the far north to the Hopi people of the Southwest.

Some criticize his work as overly romanticized—arguing that the photographs don't reflect what everyday life had become for Native people after white culture had stripped them of many of their traditions. But Curtis's objective was to capture their culture as it *had* been, endeavoring to show its beauty, strength, honor, and dignity, and preserving it for generations to come.

At the time, fewer than three hundred sets of *The North American Indian* were sold, and Curtis spent the end of his life quietly, virtually unknown, and penniless.

In a 2012 auction, a complete edition of his work sold for almost a million dollars.

Photo credit: Library of Congress Prints and Photographs, LC-USZ62-101181

HOMESTEAD, PENNSYLVANIA 1907

STEEL MILLS
Photographer unknown

In June 1892, three thousand steelworkers at Andrew Carnegie's Homestead Mills voted to strike. To protect the nonunion workers he had hired in response, manager Henry Frick turned to the Pinkerton Detective Agency's private police force. Deadly violence by the strikers and union sympathizers against the Pinkertons and the "scabs" ensued, and the governor sent in the National Guard to protect them. By mid-August, the company had hired 1,700 strikebreakers, and the mills had resumed operations.

Eventually, the union conceded, and on November 18 Frick sent a one-word telegram to Carnegie: "Victory!" The strike leaders were blacklisted, and only three hundred strikers were rehired. Promptly, the company slashed wages and imposed a twelve-hour workday, seven days a week, with one single holiday—the Fourth of July.

Despite his triumph over the union, Carnegie wrote: "This is the trial of my life (death's hand excepted). Such a foolish step—contrary to my ideals.... Our firm offered all it could offer, even generous terms.... The pain I suffer increases daily. The Works are not worth one drop of human blood. I wish they had sunk."

At the time, Carnegie earned as much as nearly four thousand workers combined.

Photo credit: Library of Congress Prints and Photographs, LC-USZ62-34842

STANDING ROCK RESERVATION, NORTH DAKOTA 1908

SIOUX
Photographer unknown

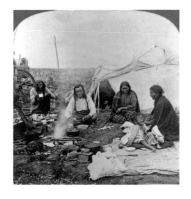

From the *Mandan Pioneer*, October 3, 1908:

> A bill passed by Congress during May 1908, provided for the opening within a short time, of approximately 1,800,000 acres of rich farming lands embraced in the Standing Rock and Cheyenne River reservations ...
>
> The great Sioux reservation is practically a thing of the past and the final breaking up of the magnificent empire which but thirty-three years ago was assured to the Teton Sioux forever, will take place when the white man takes possession of the great domain ... which is now being opened for settlement under the homestead laws ...
>
> The Indians have accepted the teaching of the government and have turned their attention to the arts of peace ... They have accepted the proposal of the government that they must live like white men ... It will be the breaking up of the home of the Indian romance on this continent ... All who have not used their homestead right should take advantage of the opening.

Photo credit: Getty Images, 640487819

CINCINNATI, OHIO 1908

OPEN AIR SCHOOL
Photographer unknown

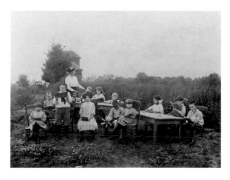

A century ago, many schoolchildren shivered in unheated classrooms open to the elements by giant windows or even in classes that met entirely outdoors. At the time, the "open air" concept in schools was used to combat a disease of the lungs, tuberculosis, one of the two leading causes of death in the early 1900s. Often killing slowly, the disease gradually destroyed the lungs and wasted the body.

Though it was transmitted through airborne germs and exacerbated by crowded conditions and poor hygiene, the disease did not spare the rich or famous. Over the centuries, tuberculosis is presumed to have killed—to name a few among many millions—King Edward VI, Catherine I of Russia, Louis XVII, John Keats, Napoleon II, Frederic Chopin, James Monroe, Franz Kafka, Andrew Jackson, Emily Brontë, Dred Scott, Henry David Thoreau, Stephen Crane, Doc Holliday, Anton Chekhov, Clara Barton, Christy Mathewson, D. H. Lawrence, Thomas Wolfe, and George Orwell.

Photo credit: Library of Congress Prints and Photographs, LC-USZ62-120428

HOMESTAKE GOLD MINE

Photograph by William Perkins Jr.

On land promised to the Lakota people in the Treaty of 1868, the Homestake Mining Company began operations in the Black Hills of Dakota Territory in 1877. In those early years, miners hammered the rock with picks, their way lit with candlelight, and drove mules pulling carts filled with ore.

In all, over 126 years, miners pulled more than 41 million ounces of gold and 9 million ounces of silver from 370 miles of tunnels in the 8,000-feet-deep underground mine, the largest in the Western Hemisphere.

In the year 2000, the mine closed, and its quiet depths are now used as a research lab for scientists studying subatomic particles called neutrinos and dark matter. The focus of the experiments is to answer the question: What is the origin of matter?

Photo credit: Getty Images, 640484533

ALLEY BASEBALL

Photograph by Lewis Hine

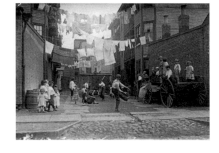

By the late 1800s, there were more than 1,600 laws in America regulating work conditions and limiting or forbidding child labor. The laws, however, were rarely enforced and often did not apply to immigrants, leaving those families, including the children, open to exploitation for the sake of profit.

In 1908, Lewis Hine became the photographer for the National Child Labor Committee to help in their effort to end child labor. He visited hundreds of mills and factories, meatpacking houses, canneries, immigrant neighborhoods, coal mines, and cotton fields, documenting the plight of children forced by poverty to work under dangerous and punishing conditions, only to return to crowded slums and tenement alleys. The photographs were used to enlighten the public and pressure Congress to change the laws.

After years of lobbying and public pressure, the Fair Labor Standards Act of 1938 eventually brought child labor in the United States to an end. As people became less interested in his work, Lewis Hine lost his house and applied for welfare. On November 3, 1940, he died at Dobbs Ferry, New York.

Photo credit: Courtesy of the George Eastman Museum, 1985.0174.0057

THREE GIRLS

Photograph by Hugh Mangum

Self-taught photographer Hugh Mangum was an itinerant portraitist working mainly in North Carolina and Virginia. Unlike many photographers during the Jim Crow era, Mangum welcomed a range of racially and economically diverse customers into his traveling studio.

"Black Codes" in many cities prohibited the patronage of the same business by Black and white citizens, even at different times. Barring no one, Mangum set up his studio tent near railroad depots to photograph circuses and vaudeville shows, stopped at roadsides to photograph workers in fields and caravans of nomadic travelers, and made photographs of congregations, students, veteran groups, and family reunions.

After his death in 1922 at the age of forty-four, Mangum's glass plate negatives remained stored and out of sight in a tobacco barn on his family farm for fifty years. About to be demolished in the 1970s, the barn was saved at the last moment and so too the sometimes playful and always respectful portraits of hundreds.

Photo credit: Duke University, David M. Rubenstein Rare Book & Manuscript Library, Hugh Mangum photographs, N576

ROAD TO THE CHAPEL

Photographer unknown, published by the Detroit Publishing Company

When Dr. Edward Livingston Trudeau was stricken with tuberculosis, he returned to the pristine lakes and forests of upstate New York, where he had hunted and fished in his youth. There, he expected to die, as his older brother had before him. Instead, he regained his health, thanks in large part, he felt, to the open air of the Adirondacks.

Using donations from wealthy friends, Trudeau founded a sanatorium in Saranac Lake to care for the urban poor who were sick with tuberculosis. Over the next sixty years, thousands of people traveled there to take "the cure," some staying for months and recovering, while an untold number died, brought out in coffins, sometimes in the dead of night.

The patients made friends and often formed new relationships, sheltered from the rest of the world. However, it was lonely for many, as one

patient wrote to a friend in Cazenovia: "I can't help but be a bit lonesome. Still, people are very kind to me. Be sure and write soon."

Photo credit: Library of Congress Prints and Photographs, LC-D4-71236

SUN RIVER, MONTANA 1910

SETTLERS FROM BENSON, MINNESOTA

Photograph by Walter Lubken

Only a rectangle of prairie sod, raw and untouched by the hands of man, but to us it was a kingdom.

—PEARL PRICE ROBERTSON, 1911

In the early 1900s, rains turned the dusty plains of Montana into fertile farmland. More than eighty thousand homesteaders, lured by the federal government's offer of free land, traveled there to stake their claims.

They came by car, truck, and train, from all over the United States and as far away as Europe. Some were experienced farmers, while many had never touched a plow. Some used their life's savings, and others arrived penniless. Many were single women, hoping to strike out on their own.

But the homesteaders were unprepared for Montana's cycles of rain and drought. By the 1930s, the plains had become dry and harsh again, destroying crops and the dreams of all but the most determined settlers.

Photo credit: National Archives and Records Administration, 115-JAD-224

DETROIT, MICHIGAN 1910

ITALIAN IMMIGRANTS

Photographer unknown

In the early twentieth century, Detroit was the thirteenth-largest city and fast becoming one of the nation's largest industrial metropolises. Its population was almost 300,000, a third of whom were foreign-born or first-generation Americans.

In 1910, *The Detroit News* began a photography project series called "Ethnic Types" to document this diversity of immigrants from all over Europe.

While only about a thousand were from Italy—including the two women in this photograph—within twenty years that number would grow to forty thousand as Italian Americans increasingly settled in the Detroit area, often to work in the burgeoning auto industry.

Many immigrants who came to America dreamed of a better life, if not

a "pot of gold." However, they often had to take demeaning jobs, where they faced prejudice, unfair employment practices, low wages, and long hours. For those who couldn't speak English, simply navigating the city was difficult. Some, disappointed, returned to their homelands, but others stayed, made their lives here, had families, built communities, and became part of the fabric of America.

Photo credit: Wayne State University, Walter P. Reuther Library, Detroit News Collection: Foreign Colonies, Italian, VMC21714_2

HOT SPRINGS, ARKANSAS 1910

ARKANSAS STATE FAIR

Photographer unknown

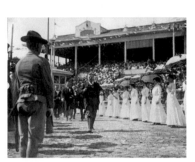

In the fall of 1910, the resort of Hot Springs was a mecca for the rich and famous. When the Hot Springs Country Club opened its new golf course, they invited President William Howard Taft—the first golfing president—to hit the ceremonial first ball. The event promised to be a welcome break for Taft, who was facing increasing criticism from his popular predecessor Theodore Roosevelt.

Then, to his dismay, he learned that Roosevelt had been invited to be the keynote speaker at the Arkansas State Fair on the same day. Taft canceled his appearance rather than risk being overshadowed by the larger-than-life Roosevelt.

In the Republican primary two years later, Roosevelt challenged Taft for the nomination but lost. He then formed a third party, the Bull Moose Party, with the motto "A square deal all around." Taft's slogan was "It is nothing but fair to leave Taft in the chair." On November 5, 1912, New Jersey governor Woodrow Wilson, who went with the slogan "The man of the eight-hour day," defeated them both, becoming the nation's twenty-eighth commander in chief.

Photo credit: Harvard University, Houghton Library, Theodore Roosevelt Collection, R560.6.C71

RENO, NEVADA 1910

JACK JOHNSON VS. JIM JEFFRIES

Photographer unknown

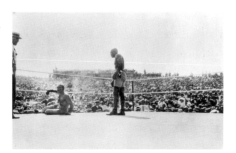

On the morning of July 4, 1910, fifteen special trains pulled into the desert town of Reno. Aboard were thousands of men who were there to see the former heavyweight champion Jim Jeffries, the "Great White Hope," take back the title from the first African American ever to hold

it, Jack Johnson—the most famous, and notorious, African American on Earth.

Before more than twenty thousand spectators, the referee called the bout in the fifteenth round, crowning Johnson the undisputed heavyweight champion of the world.

On July 5, 1910, the *Los Angeles Times* wrote a warning:

A word to the Black Man—

Do not point your nose too high. Do not swell your chest too much. Do not boast too loudly. Do not be puffed up. Let not your ambition be inordinate or take a wrong direction . . . Remember *you* have done nothing at all. You are just the same member of society you were last week . . . You are on no higher plane, deserve no new consideration, and will get none . . . No man will think a bit higher of you because your complexion is the same as that of the victor at Reno.

Photo credit: Getty Images, 11156344

SADORUS, ILLINOIS 1910

ICICLES
Photograph by Frank Sadorus

In the early twentieth century, amateur photographers were not only taking snapshots with their Kodak box cameras. Some were also interested in pursuing and studying photography as an art.

Frank Sadorus bought his large-format view camera in 1897, when he was seventeen. He mail-ordered his supplies, books, and magazines on the craft of picture taking from St. Louis to Sadorus, named after his family of homesteaders who had arrived there in 1824.

Experimenting, Sadorus photographed his family, and took self-portraits and still lifes of his favorite things, as well as landscapes—sometimes just a detail of a branch. He carefully recorded exposures, time of day, weather conditions, and often personal comments on the backs of prints signed by hand or with handmade stamps.

When his father died in 1911, the family sold the farm, and Sadorus moved to a small house on the outskirts of town. It was the first time he had lived alone, and shortly after, he became stricken with delusions and hallucinations. He was sent to an asylum, and died seventeen years later of tuberculosis.

His glass plate negatives, which had been stored away, were not discovered until 1973.

Photo credit: Collection of the Illinois State Museum, 1987.001.185

NEW YORK CITY 1910

PENN STATION
Photographer unknown

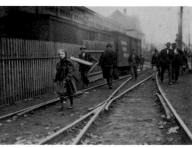

To compete with New York's Grand Central Terminal, the Pennsylvania Railroad began construction on Penn Station in 1904.

Many architects bid on the job, but the railroad chose McKim, Mead & White, a firm well known for McKim's Beaux-Arts style, in which elegance was equally as important as function. The design was influenced by classic structures, including ancient Roman baths and Bernini's piazza at the Vatican. Spanning 8 acres, it featured 27,000 tons of steel, 500,000 cubic feet of granite, 83,000 square feet of skylights, and 17 million bricks. *The New York Times* proclaimed that "it was the largest building in the world ever built at one time."

In 1911, 10 million people passed through the station. But as the decades passed, demand for rail travel declined. On a drizzly morning in October 1963, hard-hats and developers for the new Madison Square Garden, which would take the place of the soon-to-be-demolished building, smiled for photographers as the first stone eagle was lowered from the top of the old Penn Station, where it had perched for fifty-three years.

Photo credit: Library of Congress Prints and Photographs, #LC-D401-71937

KNOXVILLE, TENNESSEE 1910

BROOKSIDE COTTON MILLS
Photograph by Lewis Hine

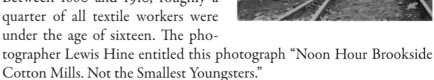

The southern textile industry relied largely on the labor of children. Between 1880 and 1910, roughly a quarter of all textile workers were under the age of sixteen. The photographer Lewis Hine entitled this photograph "Noon Hour Brookside Cotton Mills. Not the Smallest Youngsters."

The work was hot and dangerous. Lint floated through the air and stuck to workers' skin, hair, and throats as they put in twelve-hour days, seven days a week, for poor wages.

At the turn of the century, more than 90 percent of mill workers lived in company towns, where textile owners controlled everything from homes to churches and schools. Even their lives outside of the mills were often regulated by rules for moral conduct.

And although textile unions were beginning to organize at the turn of the century, at many mills talk of unions was forbidden. It would take decades before the unions could successfully bargain for the workers.

Photo credit: Library of Congress Prints and Photographs, LC-DIG-nclc-02027

GLACIER NATIONAL PARK, MONTANA
C. 1910

TOURISTS

Photograph by Lawrence Denny Lindsley

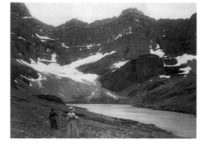

In the northern reaches of the Rockies, where glaciers could still be found sculpting mountains rising ten thousand feet into the sky and alpine cascades tumbled down to form more than 650 lakes, Glacier National Park was established by Congress in 1910.

For centuries, the Blackfeet claimed the land as their own, but with the eradication of the buffalo, increasing numbers of homesteaders, and the onset of a mining boom, they were pressured to sell to the government.

From the very beginnings of the National Park movement, railroad companies had been selling America's parks: more tourists riding the rails meant more money for them.

The Great Northern Railway promoted Glacier National Park as "America's Switzerland." On every Great Northern brochure and timetable, on every company press release and billboard, three words were always attached: "See America First." And to provide what they called an "authentic" western experience, an array of tepees was set up—50 cents a night.

Photo credit: University of Washington Special Collections, UW-PH548-Lindsley 20164, Folder GNP

OKEMAH, OKLAHOMA 1911

LYNCHING OF LAURA AND L. D. NELSON

Photograph by George Henry Farnum

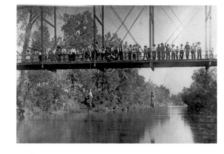

On May 2, 1911, after a member of the posse searching their farm for a stolen cow was shot and killed, Laura Nelson and her teenage son L.D. were taken to the Okfuskee County Jail.

On May 24, 1911, a mob of some forty men kidnapped them from their cells, raped Laura Nelson, then hanged her and her son from a railroad bridge over the North Canadian River.

The following morning, men, women, and children lined up on the bridge where the bodies hung. This photograph by George Henry Farnum was later turned into a postcard and sold under the title "The Lynching of Laura Nelson and Son."

No one was prosecuted for their deaths.

The lynching was one of thousands that occurred between 1880 to 1930. Many of the photographs of them were turned into postcards.

Photo credit: Courtesy of the Oklahoma Historical Society, 22076.44.

WASHINGTON, D.C. 1912

NEWSBOYS

Photograph by Lewis Hine

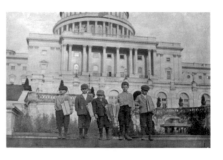

At the turn of the century, newsboys—often called "newsies"—were essential to newspaper distribution. Most came from poor immigrant families or were orphans living on the street. They bought papers at 50 cents per hundred and sold them at 1 cent each.

But despite their circumstances, the boys were resourceful. In 1899, several thousand newsboys called a strike, refusing to handle the newspapers of William Randolph Hearst and Joseph Pulitzer, the two most powerful publishers in the nation, until they were compensated for unsold papers.

Competing newspapers wrote about the strikers, depicting them as colorful characters with names like Race Track Higgens and Kid Fish. When Hearst and Pulitzer tried to recruit adults at lodging houses and flophouses who they knew needed work, one man responded, "I'm a Bowery bum . . . and one of about a hundred that's signed to take out *World*s and *Journal*s tomorrow. But . . . it's all a bluff . . . every one of us has decided to stick by the newsboys, and we won't sell no papers."

The newsboys took their grievances public by holding meetings and distributing circulars until they won their demands—a story that the publishers didn't find fit to print.

Photo credit: Library of Congress Prints and Photographs, LC-DIG-nclc-03755

NEW ORLEANS, LOUISIANA 1912

STORYVILLE

Photograph by Ernest J. Bellocq

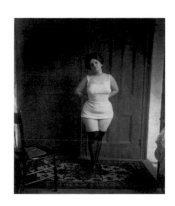

Following Reconstruction, sporting men came to New Orleans to frequent the saloons and honky-tonks in the French Quarter. But at the end of the nineteenth century, a reform movement began to grow under the leadership of an alderman named Sidney Story, a sworn enemy of iniquity and sin.

In 1897, Story crafted legislation that designated sixteen square blocks on the edge of the French Quarter where vice would be legal. Hundreds of prostitutes celebrated by staging a wild parade down Canal Street. Sidney Story was happy, too, until he learned that the district's sinners had named the area after him.

Storyville flourished for twenty-five years, but today there is little evidence that it ever existed—except for Ernest J. Bellocq's photographs of its prostitutes.

In 1949, Bellocq hit his head in a fall and died a week later. His brother, a Jesuit priest, discovered the negatives of the Storyville portraits in his apartment and stored them away.

In 1958, eighty-nine glass negatives were discovered in a chest in a junk shop, a part of old slave quarters. Nine years later, the photographer Lee Friedlander acquired the collection. They were exhibited at the Museum of Modern Art in 1970.

Photo credit: © Lee Friedlander, courtesy Fraenkel Gallery, San Francisco, and Luhring Augustine, New York

NEW YORK CITY 1912

PENN STATION

Photograph by Karl Struss

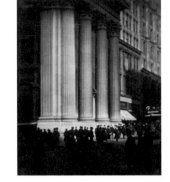

In 1908, having taken up photography in "self-defense" against the tedium of working in his father's bonnet factory, Karl Struss became a student of Clarence White, a famous pictorial photographer.

Pictorialism began in response to the idea that a photograph was nothing more than a record of reality and grew into a national movement to have photography seen as a true art form. With a dreamy soft focus, pictorial photographs were meant to elicit an emotional response from the imagination.

Struss drew the attention and patronage of the distinguished photographer Alfred Stieglitz. When several of his photographs were chosen for an exhibition at a prestigious art gallery, his reputation grew.

Photo credit: "Passing Throng," ca. 1912, platinum print, Amon Carter Museum of American Art, Fort Worth, Texas, P1983.23.91

PAWTUCKET, RHODE ISLAND 1912

WHITMAN STREET DUMP

Photograph by Lewis Hine

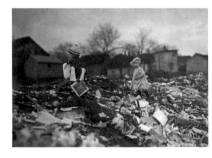

In one of his last acts as president, William Howard Taft created the Commission on Industrial Relations to investigate "the general condition of labor in the principal Industries."

For three years, the nine commissioners traveled the country asking capitalists, union organizers, reformers, and ordinary laborers what it was like for workers in America.

In 1916, they issued an eleven-volume report with tens of thousands of pages that included testimony from labor sympathizers such as Mary Har-ris "Mother" Jones and William "Big Bill" Haywood to capitalists such as Henry Ford and Andrew Carnegie.

They reported that the "Rich" (the top 2 percent) owned 60 percent of the nation's wealth and the "Poor" (the bottom 60 percent) owned just 5 percent.

"Have the workers received a fair share of the enormous increase in wealth which has taken place in this country . . . ?" the commissioners asked. "The answer—is emphatically No!"

Photo credit: Library of Congress Prints and Photographs, LC-DIG-nclc-04811

BALTIMORE, MARYLAND 1912

DEMOCRATIC NATIONAL CONVENTION

Photographer unknown

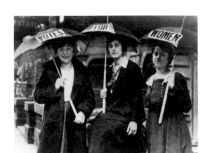

After winning the nomination at the 1912 Democratic National Convention, Woodrow Wilson went on to serve two terms as president. In September 1918, he gave a speech before Congress in support of guaranteeing women the right to vote, saying, "We have made partners of the women in this war . . . Shall we admit them only to a partnership of suffering and sacrifice and toil and not to a partnership of privilege and right?"

In 1919, the House and then the Senate finally passed the Nineteenth Amendment, stating, "The right of citizens of the United States to vote shall not be denied or abridged by the United States or by any State on account of sex."

On August 20, 1920, by one vote, Tennessee became the thirty-sixth state to ratify the amendment making it the law of the land. Seven states—Alabama, Georgia, Louisiana, Maryland, Mississippi, South Carolina, and Virginia—had rejected it.

On November 2, 1920, more than 8 million American women went to the polls for the first time in history and exercised their right to vote. It had taken them 144 years to finally achieve full citizenship in the United States.

Photo credit: The National Susan B. Anthony Museum & House, Rochester, New York

SKAGIT COUNTY, WASHINGTON 1913

LIMA LOCOMOTIVE WORKS

Photograph by Darius Kinsey

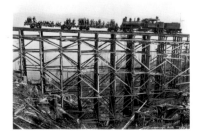

The arrival of transcontinental railroads to the Pacific Northwest during the 1880s marked one of the turning points in the region's history, increasing the

population in Idaho, Oregon, and Washington from 283,000 in 1880 to more than 2 million by 1910 and opening their natural resources to the rest of the country.

Many timber trestles were built, often hundreds of feet high. However, the bridges had drawbacks. Untreated lumber had a limited life span, and locomotives could easily cause the wood to catch fire. But initially, they were a quick way to get the rail route open. The railroad owners would eventually replace the structures with stone or steel bridges.

Early on, logging companies also used wooden trestles to transport timber from thickly forested regions. Over time, the heavy loads would weaken the bridges, and once the lumber was all out, they were left abandoned.

With few exceptions, these towering, massive marvels of engineering are all gone.

Photo credit: Darius & Tabitha Kinsey Collection, Whatcom Museum, Bellingham, Washington

GETTYSBURG, PENNSYLVANIA 1913

CIVIL WAR VETERANS
Photographer unknown

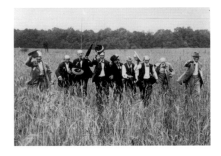

There were almost fifty thousand Union and Confederate casualties during the three days of fighting at Gettysburg in 1863. In 1913, fifty years later, tens of thousands of Civil War veterans returned to the town. But instead of traveling there to fight, they were there for an occasion of healing. It was called the "Grand Reunion."

Reporters were on the scene, and one remarked how small groups would wander through "the exact spots where they escaped death." Another recalled hearing, "This is where I lost my arm," and "My best friend fell here."

The high point of the reunion was a reenactment of Pickett's Charge. One onlooker recalled,

As the rebel yell rang out and the old Confederates started forward again across the fields, . . . the Yankees, unable to restrain themselves longer, burst from behind the stone wall and flung themselves on their former enemies, not in mortal combat, but embracing them in brotherly love and affection.

Photo credit: Pennsylvania State Archives

CRESCENT HOSIERY MILL
Photograph by Lewis Hine

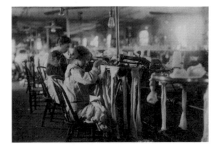

Lewis Hine traveled through the Northeast and the South, photographing children at work. Since most factory and mill owners were violently against social reform, often he would disguise himself to get in. He'd pose, for example, as a Bible salesman, a postcard salesman, or an industrial photographer who was there to document the latest developments in machinery. Once inside, fearful of being discovered, he would quickly note the child's age, job description, and personal information.

For this photograph, Hine noted,

Nannie Coleson, looper who said she was 11 years old, and has been working in the Crescent Hosiery Mill for some months. Makes about $3 a week. Has been through the 5th grade in school. She is bright, but unsophisticated. Told investigator, "There are other little girls in the mill too. One of them, says she's 13, but she doesn't look any older than me."

Nannie Coleson, 1902–1973. Bertie County, North Carolina. Wife, mother, grandmother. Favorite TV shows: Lawrence Welk, Ed Sullivan, and Julia Child. Favorite fragrance, Yardley. Loved music and could play the piano by ear.

Expert seamstress.

Photo credit: Library of Congress Prints and Photographs, LC-DIG-nclc-02949

MAMARONECK, NEW YORK 1914

EDNA ST. VINCENT MILLAY
Photograph by Arnold Genthe

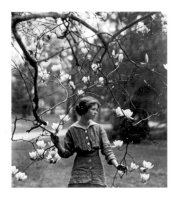

In 1923, thirty-year-old Edna St. Vincent Millay became the first woman to be awarded the Pulitzer Prize for Poetry, for "The Ballad of the Harp Weaver." Written in a narrative style, the poem is about a man looking back at his life of poverty with his mother. The mother sits before a harp— their only real possession—magically weaving her son a set of clothes with her singing. He awakens to find her dead.

. . . I saw my mother sitting on the one good chair
A light falling on her from I couldn't tell where
Looking nineteen and not a day older

And the harp with a woman's head leaned against her shoulder.
She sang as she worked and the harp strings spoke;
her voice never faltered and the thread never broke.
And when I awoke, there sat my mother
With the harp against her shoulder
looking nineteen and not a day older.

A smile about her lips and a light about her head
And her hands in the harp strings frozen dead
And piled up beside her, toppling to the skies
Were the clothes of a king's son just my size.

Photo credit: Alamy.com, 2A276GK

HANFORD, CALIFORNIA 1914

JAPANESE CHILDREN
Photographer unknown

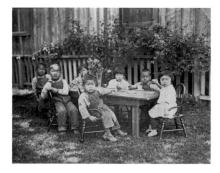

In the early 1900s, a young man named Sakutaro Tagawa came to America from the city of Kumamoto in Japan. To make a living, he got work on the railroads and began to raise chickens.

Soon he wrote to his brother in Japan to find him a bride. Tazu Nishiyama arrived in 1907, and the two were married in San Francisco.

Their daughter Susie Tagawa, shown here at the end of the tea table, was their first child.

The couple moved to Hanford and established a boarding house and a successful laundry business. They had two more daughters, Kikuya and Naomi. Inspired by the kindness of the Presbyterian women who taught them to speak English, the Tagawas converted from Buddhism and were baptized as Christians.

In 1942, the family was uprooted and sent to an internment camp in Arkansas. Three years later, they returned to their home in Hanford and reopened the Kings Hand Laundry.

Naomi, who kept this family photograph, lived in that family home until her death in 2021. She was one hundred years old.

Photo credit: Naomi Tagawa, courtesy Kings County Library, Hanford, California

SHREVEPORT, LOUISIANA 1915

BOOKER T. WASHINGTON
Photograph by Arthur P. Bedou

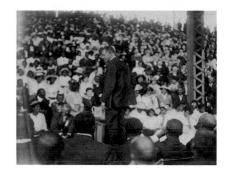

Born into slavery, Booker T. Washington came to the national stage on the opening day of the Atlanta Cotton States and International Exposition in 1895.

Speaking in front of an all-white audience, he urged African Americans to let go of the idea of social equality that had arisen during Reconstruction, and argued instead that southern Blacks gain self-improvement through service and labor. "No race can prosper till it learns that there is as much dignity in tilling a field as in writing a poem. It is at the bottom of life we must begin and not at the top. Nor should we permit our grievances to overshadow our opportunities."

Washington asked whites to recognize how valuable this workforce could be, concluding, "In all things that are purely social, we can be as separate as the fingers, yet one as the hand in all things essential to mutual progress."

For decades, his words would ignite a fierce debate over race relations. Should African Americans concentrate on learning skills and gradually gaining economic security to get the rights due them as citizens, or, as his philosophical rival W. E. B. Du Bois said, act: "Now is the accepted time, not tomorrow, not some more convenient season."

Photo credit: Arthur P. Bedou Photographs Collection, Xavier University of Louisiana Archives & Special Collections, New Orleans, Louisiana

LINCOLN, NEBRASKA 1915

WOMAN AND CHILD
Photograph by John Johnson

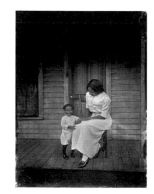

From the 1890s to the 1930s, the "New Negro Movement" encouraged African Americans throughout the United States to shape their own self-image. Photography gave them a powerful way to do so.

The photographer John Johnson was born in Lincoln in 1879 to Harrison Johnson, an escaped enslaved man and Civil War veteran, and his wife, Margaret. From 1912 through 1925, Johnson photographed African Americans in the small midwestern city of Lincoln, Nebraska, raising awareness of the role African Americans played in society.

In 1913, Nebraska's state law defined a person with one-quarter African American blood as legally "black." Throughout the country, laws were being enacted based on the "one-drop rule," which asserted that any

person with even one ancestor of Black ancestry—or "one drop" of Black blood—should be considered Negro, and therefore subject to any legal restrictions imposed on that race.

In an effort for others to see, as he did, the dignity and grace of the African American citizens of Lincoln, Johnson's photographs gave the lie to the belief that race should be a criterion for harsher treatment under the law.

Photo credit: McWilliams Family Collection at History Nebraska

HOLLYWOOD, CALIFORNIA 1916

CHARLIE CHAPLIN
Photographer unknown

Charles Spencer Chaplin was born in 1889 in England. He spent many of his early years in a London poorhouse and began working in vaudeville when he was just five years old. At twenty-one, Chaplin traveled to America. By 1914, he was making silent pictures for Keystone Studios, where he created his mustached, top-hatted, funny-walking, cane-carrying character, the "Little Tramp." This made him so popular that, by 1919, he was able to partner with famous actors such as Mary Pickford and Douglas Fairbanks, to create United Artists.

Chaplin believed that "one cannot do humor without great sympathy for one's fellow man." So the Little Tramp elegantly bumbled his way across the screen until Chaplin retired him in 1936 in the film *Modern Times*, which ended with the Tramp walking down an endless highway toward the horizon.

In 1952, Senator Joseph McCarthy branded Chaplin a Communist. After he left the country, he was told he could not come back.

When he finally returned in 1972, Charlie Chaplin was awarded a special Oscar at the Academy Awards and received what was then the longest-standing ovation ever from the audience.

Photo credit: The Daily Herald Collection at the National Media Museum, Bradford, England

NEW YORK CITY 1916

"WALL STREET"
Photograph by Paul Strand

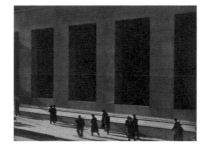

The decision as to when to photograph, the actual click of the shutter, is partly controlled from the outside, by the flow of life, but it also comes from the mind and the heart of the artist.

—PAUL STRAND

Paul Strand was born in 1890 in New York City and began to study photography with Lewis Hine when he was seventeen. At Hine's urging, Strand began to frequent 291, the gallery started by Alfred Stieglitz, the leader of the Photo-Secession group. There, Strand saw the paintings of Picasso, Cézanne, and Braque and was inspired to emphasize form and pattern in his photographs.

Strand relied on strict photographic methods, rejecting Pictorialism, where images were manipulated either with the camera or in the developing room to create the desired effect. His philosophy was known as Straight Photography, a style that simply used a large-format camera to faithfully reproduce reality and allowed the photographer to bring in new perspectives, thus making the ordinary abstract.

Stieglitz described Strand's work as "devoid of all flim-flam; devoid of trickery and of any 'ism.'" The Straight aesthetic would influence photographers for decades to come.

Photo credit: The J. Paul Getty Museum, Los Angeles, California, 93.XB.26.50.2

WASHINGTON, D.C. 1916

FORMER SLAVE CONVENTION
Photographer unknown

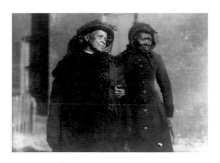

In 1916, Elizabeth Berkeley and Sadie Thompson traveled to Washington, D.C., for the fifty-fourth annual Former Slave Convention. Now propped on canes, these women had spent the first four to five decades of their lives in slavery.

At the turn of the century, a well-organized group advocating for reparations for those formerly enslaved, the National Ex-Slave Mutual Relief, Bounty and Pension Association, had advanced a bill that specified pension payments for them. Under their proposal, Berkeley and Thompson would have each received $15 a month.

A federal acting assistant attorney general wrote, "There has never been the remotest prospect that the bill would become a law."

The year before the 1916 convention, the MRB&PA filed a class-action lawsuit against the U.S. Treasury Department for $68 million, claiming that this sum, collected between 1862 and 1868 as a tax on cotton, was due the appellants because they and their ancestors had produced it as a result of their "involuntary servitude."

The U.S. Court of Appeals for the District of Columbia denied the claim based on governmental immunity, as did the U.S. Supreme Court, siding with the decision.

Photo credit: Alamy.com, WABYFT

EASTERN COLORADO 1917

"THE PRAIRIE"
Photograph by Laura Gilpin

Born in Austin Bluffs, Colorado, in 1891, Laura Gilpin began taking photographs with a Kodak Brownie camera when she was twelve. In 1916, she went to New York to study at the Clarence H. White School of Photography. After becoming seriously ill with influenza, Gilpin returned to Colorado Springs, where her mother hired a nurse, Elizabeth Forster.

After she recovered, Gilpin opened a portrait studio in Colorado Springs and began to photograph landscapes. These atmospheric pictures show the influence of her training with White, a leading pictorial photographer.

Gilpin and Forster became friends and, later, companions, and she frequently photographed Forster during their more than fifty years together.

Her work is divided into two periods. Between 1917 and 1935, Gilpin's subjects were in soft focus: western landscapes, Pueblo ruins, still lifes, and portraits, considered among the finest of the Photo-Secession movement started by Alfred Stieglitz. For the rest of her life, however, she turned to capturing clear, detailed images of the Southwest lands and Native tribes. Her most historically important work is her documentation of the daily lives of the Navajo.

Photo credit: Platinum print, Amon Carter Museum of American Art, Fort Worth, Texas, Bequest of the Artist, P1979.119.8

NEW YORK CITY 1917

WAKE UP, AMERICA PARADE
Photographer unknown

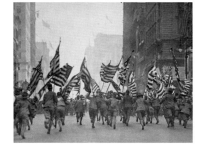

In 1914, the assassination of Archduke Franz Ferdinand of Austria triggered a series of conflicts that grew into World War I. The United States sought to remain neutral. President Woodrow Wilson's reelection slogan in 1916 was "He kept us out of war."

But in 1917, Germany began attacking American ships. Shortly after that, Great Britain shared a telegram with the United States revealing that Germany had promised to give Mexico territory in America in return for attacking the U.S. if it entered the war.

That was the final straw.

On April 6, 1917, Congress, at Wilson's request, declared war against the German Empire.

"Wake Up, America" parades to support recruitment were held across the country. In New York City, the day began with a reenactment of the famed ride of Paul Revere. At midnight, the chimes at Trinity Church rang, and a young suffragist, dressed as a Continental soldier, rode on horseback through Manhattan, beckoning men and women to "wake up" and fight.

At the parade, Boy Scouts charged down the avenue waving flags while Army and Navy planes dropped pamphlets into the crowd encouraging them to summon the "Spirit of 1776."

Photo credit: National Archives and Records Administration, PN 217710

NEW YORK CITY 1919

JEWISH IMMIGRANT
Photograph by E. O. Hoppé

In 1862, General Ulysses S. Grant initiated one of the most blatant official episodes of anti-Semitism up to that time. General Order No. 11 called for the expulsion of Jews from the portions of Tennessee, Kentucky, and Mississippi under his control as punishment for their cotton speculation, which raised prices for the badly needed commodity throughout the North.

President Abraham Lincoln quickly rescinded the order.

By the beginning of the twentieth century, a million Jews had immigrated to America, and another million and a half would follow in the next two decades. During this time, Jews were discriminated against in employment, residential areas, social clubs, and resort areas along with quotas on Jewish professors and students. Some restaurants and hotels barred Jews completely.

When America entered World War I, nearly 250,000 Jews enlisted. One draftee wrote, "I'm in a barracks with 270, and so far, I've found a half dozen men who could speak English without an accent."

Rabbi Stephen Wise, an immigrant from Budapest, spoke for many when he wrote in *The New York Times* that military service would "mark the burial, without the hope of resurrection, of hyphenism, and will token the birth of a united and indivisible country."

Photo credit: © EO Hoppé Estate Collection / Curatorial Inc

CHICAGO, ILLINOIS 1919

RACE RIOT
Photographer unknown

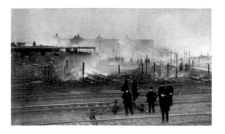

With the end of World War I, more than 300,000 Black soldiers returned home demanding an end

to second-class citizenship. White people saw them as a threat, and tensions grew. Between April and November 1919, there was mob violence in cities across America. The Ku Klux Klan experienced a resurgence, and by the fall had carried out almost one hundred lynchings. It would later be called the "Red Summer."

On Sunday, July 27, 1919, at the 29th Street Beach in Chicago, seventeen-year-old Eugene Williams crossed an invisible line in the water of Lake Michigan separating African Americans from whites. Williams was struck by a rock thrown by a white man and drowned. Angry Black and white Chicagoans stormed the beach.

White men and boys ransacked the city, some wearing blackface makeup. Black residents armed themselves with whatever weapons they could to protect themselves.

Over the next thirteen days, twenty-three Black people and fifteen whites were killed, hundreds were injured, and more than a thousand African Americans were left homeless.

The man who killed Eugene Williams was tried and acquitted.

Photo credit: Alamy.com, #KWD7TK

CASCADE MOUNTAINS, WASHINGTON 1919

MOUNTAINEERING GROUP

Photograph by Asahel Curtis

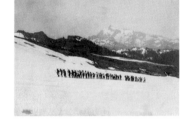

The brothers Edward and Asahel Curtis came to Seattle in 1888. Asahel worked in Edward's successful photography studio until a conflict between the two led to an estrangement, and he opened his own business documenting and promoting city development and recreation throughout Washington state.

In 1906, Curtis and two friends created the Mountaineers, a mountain-climbing group that also advocated for the preservation of wilderness areas. Toting his ten-pound camera box, Asahel helped lead climbing expeditions to Mounts Baker, Rainier, and Olympus. He said,

> It is on the untrodden mountain heights that the traveler receives a true reward for his toil. Here where vegetation makes its last stand amid a world of ice and snow, with the lower world stretching away to the horizon, nature unfolds in all her beauty.

He would continue fighting to protect the environment for the rest of his life.

After his death, his family set the burial urn in the forest west of the Cascades. After it was in place, a bolt of lightning struck the rock on which the urn sat, shattering the vessel and scattering the ashes. The family, it was reported, thought it was "the greatest compliment of all."

Photo credit: Source undetermined

BERGEN COUNTY, NEW JERSEY 1919

CHOCTAW SOLDIERS

Photographer unknown

For more than a century, Native Americans were forbidden by government agents to use their own languages.

In 1918 in northern France, during the fiercest battles of World War I, the army used a small core of Choctaw soldiers called "Code Talkers" to foil the enemy German troops by using their Indigenous language to transmit secure messages over the phone lines.

Ironically, these men, along with thousands of other Native Americans, had volunteered to fight for the same government that in 1838 had forced nearly fifteen thousand Choctaw to walk hundreds of miles along the so-called Trail of Tears, from their homeland in the southeastern states into what would be called Indian Territory and then later Oklahoma.

On June 2, 1924, Congress enacted the Indian Citizenship Act, which granted citizenship to all Native people born in the United States. However, state laws governed the right to vote. It wasn't until 1962, with the passage of a voting rights law in Utah, that Native Americans could vote in every state.

Photo credit: Indiana University Museum of Archaeology and Anthropology, 1962-08-6451

NEW YORK CITY 1920

CHICAGO WHITE SOX

Photograph by Charles Conlon

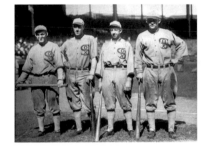

Fix these faces in your memory: These are the White Sox players who committed the astounding and contemptible crime of selling out the baseball world . . . they will be remembered from now on only for the depths of depravity to which they could sink.

—*THE SPORTING NEWS*, October 7, 1920

In 1919, eight Chicago White Sox players were accused of throwing the World Series against the Cincinnati Reds in exchange for money from a syndicate led by Arnold Rothstein, New York's notorious gambler.

First baseman Chick Gandil, a former hobo and onetime club fighter, was near the end of his career and wanted one last shot at something big. So he quietly let it be known that, for the right reward, he would be willing to talk some of his teammates into throwing the series.

The fix was in, and the Sox lost the series. Second baseman Eddie

Collins—second from the right—was the only player in this picture who didn't go along with the scheme.

In response to the scandal, Judge Kenesaw Mountain Landis was appointed the first commissioner of baseball and given absolute control to restore its integrity. Despite acquittals in a public trial in 1921, he permanently banned all eight men from professional baseball.

Photo credit: Dennis Goldstein

MERIDEN, CONNECTICUT 1920

JOHN BARLEYCORN TOMBSTONE
Photographer unknown

On December 10, 1913, several hundred women representing the Woman's Christian Temperance Union, and a thousand men, members of the Anti-Saloon League, marched to the U.S. Capitol. They were there to demand a prohibition amendment to the Constitution.

It was understood that if they succeeded, the prohibition of alcohol in the country would be enshrined in the Constitution forever, as no amendment had ever been repealed.

The Eighteenth Amendment, prohibiting the "manufacture, sale, or transportation of intoxicating liquors," was ratified in 1919 and one year later went into effect. After nearly a century of work by clergymen, women's groups, reformed alcoholics, and lobbyists, the United States of America was officially dry.

Millions were jubilant. "The slums will soon be a memory," the evangelist Billy Sunday said, "men will walk upright, women will smile, and the children will laugh."

However, speakeasy owners, bootleggers, and gangsters like Chicago's Al Capone got rich as crime grew around a new industry: illegal alcohol. Thirteen years later, the amendment was repealed.

Photo credit: Library of Congress Prints and Photographs, LC-USZ62-136527

NEW MEXICO C. 1920S

HOPIS ON THE TRAIL TO THE PLAZA
Photograph by Dorothea Lange

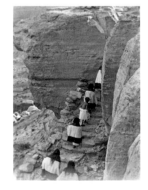

In 1919, at the age of twenty-three, Dorothea Lange opened a portrait studio in San Francisco. There she met the painter Maynard Dixon, who exposed her to the bohemian art world and encouraged her to visit the wild Southwest, including Hopi country—an area in northern Arizona and New Mexico.

The recorded history of the Hopis goes back more than two thousand years, but legends of their migrations north from what is now South America, Central America, and Mexico date back thousands of years before that.

They settled in and around the deep canyons in the area and arranged their houses into villages surrounding a central open space. This community space was called a "plaza." Each village was self-governing and autonomous, and members of the Hopi tribe often identified themselves by their village and clan affiliations.

According to their tradition, upon their arrival on Earth the Hopi made a sacred covenant with the deity Maasawu: to live a life of compassion, humility, respect, and stewardship of the Earth.

Photo credit: © The Dorothea Lange Collection, the Oakland Museum of California

HOUSTON, TEXAS 1921

KING & CARTER JAZZ ORCHESTRA
Photograph by Robert Runyon

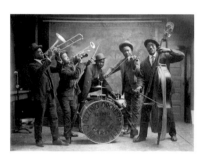

Jazz was born from the uniquely diverse mix of cultures in New Orleans. The music came from enslaved and freed African Americans, from Europeans, and from the multicultural Creole people. From the back-alley city streets and honky-tonks. From ragtime music, classical music, and the blues.

The twentieth century was not even two decades old when the first jazz record reached the public in 1917. Soon jazz bands sprang up all over America and the music became the soundtrack to the modern world. Thanks to the phonograph record, it was everywhere.

But the jazz most Americans were crazy about was still mainly novelty music—frenetic, funny, the perfect accompaniment for fast dancing and high times. It would take the genius of musicians like Louis Armstrong and Duke Ellington to broaden its message and turn it into art.

Photo credit: Robert Runyon Photographic Archive, RUN05018, Dolph Briscoe Center for American History, University of Texas at Austin

LA MESA, CALIFORNIA 1921

"STORM CLOUDS"
Photograph by Karl Struss

At the age of twenty-two, Karl Struss developed the Struss Pictorial Lens and introduced his soft-focus style to the film industry.

After World War I, he moved from New York to Hollywood and became a cinematographer for Cecil B. DeMille and D. W.

Griffith. In 1928, he received the first Academy Award for cinematography, for *Sunrise: A Song of Two Humans.*

While he was focused mainly on cinematography, Struss continued to devote time to fine art photography, as seen in the mysterious photograph "Storm Clouds."

Photo credit: Amon Carter Museum of American Art, Fort Worth, Texas, estate of the artist, P1980.3.14

LAKE GEORGE, NEW YORK 1922

FROM A SERIES ENTITLED
EQUIVALENTS
Photograph by Alfred Stieglitz

In the summer of 1922, Alfred Stieglitz began work on a photographic series of clouds at his Lake George retreat. He explained how the series came about in a letter to a friend:

> My mother was dying. Our estate was going to pieces . . . the world in a great mess, the human being a queer animal—not as dignified as our giant chestnut tree on the hill . . .
>
> So I made up my mind . . . I'd finally do something I had in mind for years. I'd make a series of Cloud pictures.
>
> I began to work with the clouds—daily for weeks . . . I wanted a series of photographs which, when seen by Ernest Bloch (the great composer), he would exclaim, "Music! Music!" . . . and would say he'd have to write a symphony called "Clouds."

Bloch did see the photographs, and although he did not write the symphony, he said those very words.

Photo credit: Gift of David A. Schulte, 1928 (28.127.6), © The Metropolitan Museum of Art, image source Art Resource

WASHINGTON, D.C. 1925

KU KLUX KLAN
DEMONSTRATION
Photographer unknown

During the Ku Klux Klan's heyday in the 1920s, its membership grew to 4 million.

Formed less than a year after the Civil War, the organization soon became known for its violent attacks on African Americans. After public denunciation during Reconstruction, the Klan faded away in the 1870s.

In the early twentieth century, the mass migration of African Americans from the South to the North, and an influx of Jewish and Catholic immigrants from Europe, led to a second coming of the Klan. It now emphasized an America-first nativist message, proclaiming itself to be "The World's Greatest Secret, Social, Patriotic, Fraternal, Beneficiary Order."

On August 8, 1925, close to thirty thousand members of the Ku Klux Klan paraded down Pennsylvania Avenue in front of thousands of onlookers.

One observer noted that "scores of the cars in the public parking places set aside for the visitors were covered with signs indicating the '100 percent Americanism' of their occupants."

The next day, an eighty-foot-high, thirty-foot-wide cross was set aflame in Arlington while a band played "Onward, Christian Soldiers."

Photo credit: Getty Images, 515360936

BRYCE CANYON, UTAH 1926

NATIONAL MONUMENT
Photograph by E. O. Hoppé

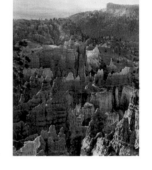

In 1868, at the age of seventeen, Ebenezer Bryce joined the Church of Jesus Christ of Latter-day Saints and headed for Utah.

Ebenezer and his family settled in the southwestern part of the state right below what is now called the Bryce Amphitheater—the largest collection in the world of long rock spires called "hoodoos." He grazed his cattle near the hoodoos and canyons, once writing that it was a "helluva place to lose a cow." Pioneers started calling the place Bryce's Canyon, and the name stuck.

In 1916, the Union Pacific Railroad and the Santa Fe Railroad published articles about Bryce Canyon in their magazines, and tourism grew. Then, on June 8, 1923, President Warren G. Harding declared the canyon a national monument. Later that month, he traveled west to visit Bryce Canyon National Monument and Zion National Park, remarking, "I have today viewed the greatest creations of the Almighty."

Photo credit: © E. O. Hoppé Estate Collection/Curatorial Inc. #17395-O

DEARBORN, MICHIGAN 1927

RIVER ROUGE COMPLEX
Photograph by Charles Sheeler

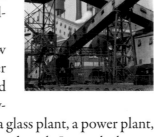

The first Model T left Henry Ford's factory in Detroit in September 1908. In 1927, the 15 millionth one rolled off the assembly line.

That same year, production began for a new Model A at Ford's recently completed River Rouge Complex. Built on nearly a thousand acres in Dearborn, Michigan, the site had ninety-three buildings, including blast furnaces, mills, a glass plant, a power plant, an assembly line, and one hundred miles of railroad track. It was the largest industrial complex in the world, employing tens of thousands of workers. In addition, the complex required a multi-station fire department, a modern police force, a fully staffed hospital, and a maintenance crew of five thousand. One new car came off the line every forty-nine seconds.

In 1927, an advertising agency for the Ford Motor Company commissioned Charles Sheeler to do a series of documentary photographs of River Rouge. In his series, Sheeler left out the human aspect of manufacturing work, focusing instead on the structure of the factory and machinery, which he considered the manifestation of the modern world. For Sheeler, American factories were the same as cathedrals, "our substitute," he said, "for religious experience."

Photo credit: "Criss-Crossed Conveyors—Ford Plant," © The Lane Collection, courtesy Museum of Fine Arts, Boston, hb_1987.1100.1

WEST ORANGE, NEW JERSEY 1927

THOMAS EDISON'S EIGHTIETH BIRTHDAY
Photographer unknown

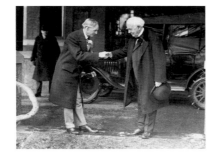

When he met Thomas Edison in 1896, Henry Ford did not know that he and his boyhood hero—inventor of the light bulb, the motion picture camera, and the phonograph—would become lifelong friends.

Between 1914 and 1924, Ford and Edison toured the eastern states for a series of camping trips. Joined by the tire maker Harvey Firestone and the essayist John Burroughs, they called themselves "the Vagabonds." Headlines like "Millions of Dollars' Worth of Brains Off on a Vacation" and "Genius to Sleep Under Stars" chronicled their journey.

In 1929, Ford established the Edison Institute in Dearborn, Michigan, for the purpose of assembling America's most important technological inventions.

His guest Thomas Edison stood up to speak at the festivities:

I would be embarrassed at the honors that are being heaped upon me this unforgettable night were it not for the fact that in honoring me, you are also honoring that vast army of thinkers and workers of the past. If I have helped spur men to greater effort . . . and given a measure of happiness in the world, I am content.

His last words were for Henry Ford: "I can only say that in the fullest meaning of the term, he is my friend."

Photo credit: Associated Press, APHS418283

COLUMBUS, KENTUCKY 1927

MAIN STREET
Photograph by Charles Phelps Cushing

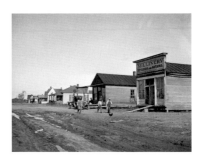

The town of Columbus was incorporated just before the beginning of the Civil War, with a population of 963, including 118 enslaved people. In 1862, it was seized by Union troops, who would remain there until the end of the war.

Located on the Mississippi River at the northern terminus of the Mobile and Ohio Railroad, Columbus was a busy transportation hub. The town flourished after the war until the mid-1880s. But due to a new terminus built by the railroad thirty-two miles away, in Cairo, Illinois, freight and passenger service declined at Columbus. In 1912, the railroad discontinued service altogether.

By 1920, the population of Columbus was 654.

In April 1927, the Mississippi River broke the town's levees, and the water stayed for almost three weeks. Then, in June, there was another flood. With the levee gone, the river swept across town, eroding 350 feet inland in just a few weeks. The entire business district sank into the river, and only about 13 of the town's 150 houses were saved.

In September 1927, the few salvageable homes were moved to a new location on higher ground—population, a little over 500.

In 2019, the town of Columbus was home to just 170.

Photo credit: Alamy.com, BRA955

NEW YORK CITY 1929

WALL STREET NEWSSTAND
Photograph by Martin McEvilly

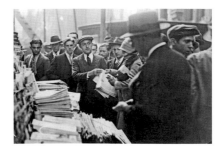

During the 1920s, a long boom took stock prices to heights never seen before. In one decade, stocks went up 600 percent. Investors specu-

lated that Wall Street was a sure thing and borrowed heavily to invest more money in the market.

But in September 1929, stock prices began to fall, and ominous headlines filled the newspapers. Investors became alarmed, and on Thursday, October 24, twenty-one-year-old Morris Bernstein's newsstand was swamped with men anxious to know what was happening.

It had been a rough day on Wall Street. A record 12,894,650 shares were traded. Investment companies and bankers tried to stabilize the markets, and there was a small rally on Friday.

Then, however, investors panicked again, and by Monday, the market went into free fall.

"Black Monday" was followed by "Black Tuesday"—October 29—when stock prices collapsed completely. More than 16 million shares were traded in a single day. Billions of dollars were lost, bankrupting thousands.

America sank into the Great Depression. By 1933, nearly half of the country's banks had failed, and almost 13 million people were unemployed.

Photo credit: New York Daily News via Getty Images, 5P100KIX

SOUTH CAROLINA C. 1930

GULLAH BAPTISM
Photograph by Doris Ulmann

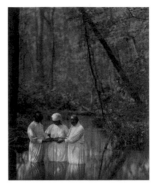

The Gullah people of South Carolina, who labored on the rice plantations along the coastal plain and Sea Islands, were direct descendants of the enslaved people brought over from the region in western Africa stretching from Senegal down to Sierra Leone and Liberia.

Even after emancipation, many chose to stay in the South Carolina Low Country. They claimed land from abandoned plantations, and as Jim Crow laws took hold, they increasingly isolated themselves in communities where their families had lived for generations.

Because of their relative separation from the rest of the world, the Gullah preserved much of their linguistic and cultural influences, developing a distinctive Creole language that mixes English and African languages. Similarly, their religious beliefs and practices are also a blend, coming from Christian, Islamic, and West African traditional practices.

Photo credit: Courtesy Phillips Auction House, with permission from the Doris Ulmann Foundation, Berea College

NORTH CAROLINA C. 1930

GREAT SMOKY MOUNTAINS
Photograph by George Masa

In 1881, Masahara Iizuka came to the United States, where his travels brought him to Asheville, North Carolina, at the edge of the Smoky Mountains.

Changing his name to George Masa, he took a position at the Grove Park Inn and began printing film from the guests' cameras to make extra money, a skill that grew into a business selling his own photographs. Though barely five feet tall, he lugged his heavy camera equipment everywhere, searching the Smokies for new vantage points.

In 1926, Congress authorized the creation of a national park in the Smokies, the only hitch being that the government would not pay a penny to buy the land.

Masa, and his dear friend and denizen of the Smokies, Horace Kephart, joined the effort to raise money. However, neither would live long enough to see their dream come true. After Kephart died in 1931, Masa roamed the mountains with a walking stick he called "Kep." He died two years later, penniless.

It would take seven more years, individual donors and community organizations, $5 million from John D. Rockefeller Jr., and a battle with the logging industry, but on September 2, 1940, President Franklin D. Roosevelt dedicated Great Smoky Mountains National Park.

Photo credit: Chandler Gordon, The Captain's Bookshelf, Inc., Asheville, North Carolina

NEW YORK CITY 1931

BREADLINE
Photographer unknown

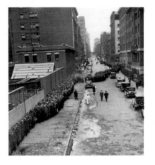

As the Depression in America deepened, millions of people across the country were in dire straits.

Herbert Hoover was president. Although he was inclined to give indirect aid to banks and local public works projects, he refused to use federal money for direct assistance to citizens, believing that the handout would weaken the public's morale. He cared too much for common Americans, he professed, to destroy the foundations of the country with deficits and socialist institutions.

Many New Yorkers were so poor they could not afford to buy food and found themselves on long breadlines and in soup kitchens around the city. The free food was distributed thanks to funds from charities and private individuals.

Thousands of people were fed in this Manhattan breadline on Christmas Day in 1931.

In a *New York Times* article from 1932, a man recalled looking back in line seeing "men in suits and hats, looking forward, and only forward, too proud to acknowledge the line they stood on, a line that stretched for blocks and blocks."

Photo credit: Getty Images, 515172162

HANAYE AND IWAO MATSUSHITA

Photographer unknown

Beyond these high valleys you can see the craggly white mountains, whose peaks are showing through a thick fog. It is a view worthy of a sumi-e painting. Looking to the north, you can see Mt. Rainier, appearing majestically—like our king of mountains, Mt. Fuji.

—IWAO MATSUSHITA

Iwao and Hanaye Matsushita came to Seattle from Japan in 1919. By the mid-1930s, they had visited Mount Rainier National Park more than a hundred times. Iwao loved the mountain so much he would fall asleep with maps and pictures of the park on his pillow.

When the industrial trading company he worked for ordered him back to Tokyo, Iwao resigned. He and Hanaye wanted to stay close to their "holy mountain."

In the first hours after the attack on Pearl Harbor, they were arrested and separated. Hanaye was put in a detention center near Seattle, where she wrote to her husband far away in an internment camp in western Montana:

> Dear Husband,
> . . . After severe rain, the sky became clear and we saw Mt. Rainier over the hill yesterday for the first time . . . Remember the times we hiked through the mountains together? It all seems like a dream.

Photo credit: University of Washington Libraries, Special Collections, UW17087

WEDDING OF ELLIOTT ROOSEVELT

Photographer unknown

In the summer of 1921, Franklin D. Roosevelt contracted poliomyelitis, and despite efforts to overcome the crippling illness, he never regained the use of his legs. His doctors fitted him with steel braces that weighed fourteen pounds and ran from above his waist to his heels.

Several years later, with the encouragement of his wife, Eleanor, and confidant Louis Howe, Roosevelt resumed his political career. He had been a New York state senator from 1911 to 1913 and then Secretary of the Navy under President Woodrow Wilson until 1920. In 1928, he became governor of New York.

After winning reelection for governor two years later, Roosevelt began to campaign for the presidency. As in this photograph at his son's wedding, he had learned to appear relaxed and smiling, even while tightly gripping something or someone to be able to remain standing.

In November 1932, Roosevelt defeated Herbert Hoover by 7 million votes.

During the four months between his election and assuming the presidency, the Depression worsened. After the inauguration, First Lady Eleanor Roosevelt reflected, "It was very, very solemn and a little terrifying . . . You felt [people] would do anything—if only someone would tell them what to do."

Photo credit: Franklin D. Roosevelt Presidential Library, Hyde Park, New York

SAN FRANCISCO DE ASSISI CHURCH

Photograph by Paul Strand

By the eighteenth century, Spain was at the height of its imperial power in North America, and Spanish and Mexican families had settled permanently in Ranchos de Taos. This Catholic agricultural village soon became home to the San Francisco de Assisi Mission.

In 1816, the large, sculpted church with massive adobe buttresses and two front-facing bell towers was completed—a blend of Pueblo and Spanish Colonial styles.

The photographer Paul Strand and his wife, Rebecca, traveled to New Mexico in the early 1930s, where Rebecca was spending time with the painter Georgia O'Keeffe at her studio near Santa Fe.

Strand was drawn to churches, struck by their longevity and connection with the land and sky. He tied them to universal spiritual mysteries, which he tried to express with his sense of form and geometry.

Rebecca reflected that his photographs showed "the grandeur and isolation of the New Mexican country—something he feels not only about that country—but about living itself."

Photo credit: The J. Paul Getty Museum, Los Angeles, © Aperture Foundation

LEESVILLE, LOUISIANA 1932

HUEY LONG

Photographer unknown

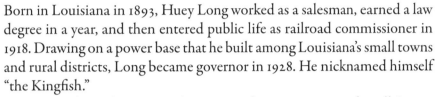

I'm for the poor man—all poor men, black and white, they all gotta have a chance. They gotta have a home, a job, and a decent education for their children. "Every man a king"—that's my slogan.

—HUEY LONG

Born in Louisiana in 1893, Huey Long worked as a salesman, earned a law degree in a year, and then entered public life as railroad commissioner in 1918. Drawing on a power base that he built among Louisiana's small towns and rural districts, Long became governor in 1928. He nicknamed himself "the Kingfish."

Long took on the moneyed interests of Baton Rouge and Wall Street, calling for a massive redistribution of wealth. In 1932, he was elected to the U.S. Senate, where he gained a national following with his populist "Share Our Wealth" plan and his "Every Man a King" philosophy.

Once described as the "most colorful, as well as the most dangerous man to engage in American politics," Long was autocratic and corrupt, but he kept the people on his side.

His ambitions soon turned to the White House, but in 1935, at the height of his popularity, Huey Long was assassinated by a young doctor named Carl Weiss (who may have been angered by Long's political and personal attacks on his in-laws) in the hallway of the Louisiana State Capitol in Baton Rouge.

Photo credit: Source undetermined

SEATTLE, WASHINGTON 1932

HOOVERVILLE

Photograph by the studio of Ira Webster and Nelson Stevens

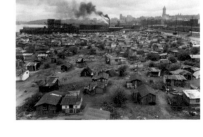

Three years after the stock market crash, there was no recovery in sight. Kansas farmers burned their wheat to keep warm. Kentucky coal miners survived on pokeweed and dandelion greens. In Pennsylvania, paroled prisoners asked to be locked up again because life outside was harder than on the inside.

From coast to coast, homeless men scrounged up materials to build shacks wherever they could. They had nowhere else to go. Hundreds of thousands of desperate people across the country named their temporary villages "Hooverville," after the president whom they had come to blame for everything that had happened to them.

Other expressions to deride Hoover were also coined, including a "Hoover blanket"—old newspaper used for bedding; "Hoover leather"—cardboard used to line a shoe when the sole had worn through; and a "Hoover flag"—an empty pocket turned inside out.

The largest Hooverville in Seattle, seen in this photograph, was built on the flats next to the port. After two attempts to remove the men and burn down the shacks, in 1932 the city surrendered and allowed the homeless to stay.

Photo credit: © PEMCO, Webster & Stevens Collection, Museum of History and Industry, Seattle, Washington

AMBRIDGE, PENNSYLVANIA 1932

LABOR STRIKE

Photographer unknown

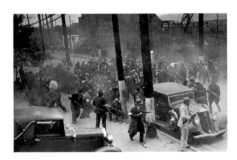

Following the Russian Revolution in 1917, many Americans began to equate unions with Bolshevism. Some believed that labor leaders wanted nothing less than to overthrow the capitalist system and branded union members anti-American.

Throughout the 1920s, courts regularly issued injunctions against striking, picketing, and other union activities. As a result, the labor movement weakened, union membership dropped from 5 million to 3 million, and business profits soared. By the early 1930s, as the nation slid toward the depths of the Depression, organized labor was in jeopardy.

On October 5, 1933, a violent anti-union face-off took place in Ambridge, Pennsylvania, when striking workers in front of the Spang-Chalfant factory were attacked by a large squad of hastily appointed sheriff's deputies armed with shotguns and tear gas. When the deputies started wildly shooting into the crowd, they didn't discriminate between picketers, news reporters, or the spectators who had gathered to support the strikers or simply watch the action. Scores of bystanders were injured in the melee, and twenty-one strikers were shot, one to his death.

The next day the *Pittsburgh Post-Gazette* described the scene as a "bloody battleground."

Photo credit: Edward Levinson Collection, Walter P. Reuther Library, Archives of Labor and Urban Affairs, Wayne State University

NRA PARADE
Photographer unknown

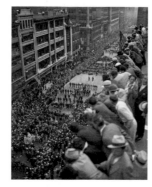

The country needs and ... the country demands bold, persistent experimentation. It is common sense to take a method and try it. If it fails, admit it frankly and try another. But above all, try something.

—FRANKLIN D. ROOSEVELT

Immediately after Roosevelt took office in 1933, he launched the most extensive public works program in American history and directed billions of federal dollars to fund relief for the unemployed.

Five days after the president's one hundredth day in office, Congress passed the National Industrial Recovery Act to end the cutthroat competition driving down wages and prices to disastrous levels. It encouraged businesses to create codes of "fair competition." The regulations set maximum hours and minimum wages, guaranteed union rights, and prohibited child labor. The National Recovery Administration was organized to implement the law.

Parades were organized across the country to celebrate and support the NRA.

On September 13, 1933, more than 250,000 men and women—employers and laborers from all occupations—marched down Fifth Avenue in New York. And even though the Supreme Court found the law unconstitutional two years later, to suffering Americans what mattered more was that someone was taking action.

Photo credit: Getty Images, #515571280

MEMPHIS, ARKANSAS 1935

BLIND FIDDLER
Photograph by Ben Shahn

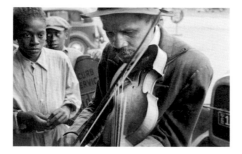

I crossed and recrossed many sections of the country, and had come to know well so many people of all kinds of belief and temperament, which they maintained with a transcendent indifference to their lot in life.

—BEN SHAHN

The Resettlement Administration was created in 1935 as part of President Roosevelt's "New Deal." The agency provided funds to resettle farmers living on marginal land to more productive areas. In addition, it imple-

mented soil conservation and reforestation programs and helped destitute farmers with low-interest loans to pay basic living and farming expenses. (In 1937, it was replaced by the Farm Security Administration, or FSA.)

The Resettlement Administration also organized groups to document its work, one of which was the Photography Project, headed by Roy Stryker.

Stryker hired photographers like Ben Shahn, Dorothea Lange, Walker Evans, Arthur Rothstein, Marion Post Wolcott, and Gordon Parks and sent them across the country to produce a "visual encyclopedia of American life."

The photographs and their stories were published in newspapers and magazines, raising sympathy for those who were suffering, and building support, both political and public, for the New Deal policies that were aiming to help them.

Photo credit: Library of Congress Prints and Photographs, LC-DIG-fsa-8a16135

CALIFORNIA 1935

SIERRA MADRES
Photograph by Margaret Bourke-White

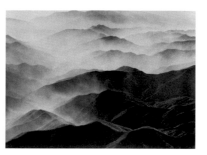

I want to do all the things that women never do. I want to become famous and I want to become wealthy ... I have opened my own studio ... and I have changed my name from Peggy White ... my father's last name ... to Margaret Bourke-White ... my mother's maiden name. Has more gravitas, don't you think?

—MARGARET BOURKE-WHITE

Margaret Bourke-White was the first photographer for *Fortune* magazine, the first female photographer for *LIFE* magazine, the first Western photographer permitted into the Soviet Union, and the first female correspondent to work in combat zones during World War II.

Bourke-White photographed the faces of the Depression, the rise of Nazism in Czechoslovakia and Hungary in 1938, and the liberation of the Buchenwald concentration camp and a Nazi work camp where Jews had been set on fire. She would spend two years in India photographing the struggle between Hindus and Muslims and would go on to South Africa to document the conditions of Blacks under apartheid.

Bourke-White continued photographing for *LIFE* even after being diagnosed with Parkinson's disease in early 1954.

When she wrote her autobiography, *Portrait of Myself*, in 1963, from among all her evocative photographs she chose this photograph of the Sierra Madres for the cover.

Photo credit: © 2014 Estate of Margaret Bourke-White/Licensed by VAGA, New York, New York

KIMBALL, WEST VIRGINIA 1935

MINING TOWN
Photograph by Ben Shahn

In the early years of the Great Depression, even those miners who managed to keep their jobs faced desperate circumstances. Below-ground, they withstood some of the worst working conditions in America. Aboveground, there were brutal mine guards and a system that controlled their lives and the politics and economy of the region. Coal wars—deadly conflicts between workers and guards—were common.

Before 1933, organizing efforts by the United Mine Workers of America in the West Virginia coalfields had failed. However, following the passage of the National Industrial Recovery Act—which affirmed labor's right to organize and bargain collectively—the UMWA conducted an organizing drive through the region. As a result, union and industry representatives signed an agreement that set the eight-hour workday as standard and ended the requirements that employees live in company houses and receive their wages in "scrip" that they could only use at company stores. Soon after that, West Virginia ended its practice of deputizing mine guards.

The UMWA became a power in the labor movement and the land, and that movement threw its support behind President Roosevelt.

Photo credit: Library of Congress Prints and Photographs, LC-DIG-fsa-8a16972

FLORIDA COAST 1935

PRESIDENT ROOSEVELT
Photographer unknown

When Franklin Delano Roosevelt was elected president, most people knew that he had had polio. What they did not know, however, was that he could not walk on his own.

On the campaign trail, Roosevelt could keep up the pretense that he could walk short distances by wearing steel braces and swiveling his torso while gripping the arm of one of his sons or a member of the Secret Service and supporting himself with a cane. In addition, specially reinforced podiums were built for him to lean on.

The Secret Service became expert at installing and removing special ramps to allow Roosevelt to enter a building without anyone seeing him being carried. When guests came into the formal dining room at the White House, they found the president already seated at the head of the table.

No images were allowed that showed FDR in his wheelchair or the arduous effort it took to get in or out of cars. Photographers who defied

the rules—including ordinary tourists—had their film confiscated by the Secret Service.

A few did slip through, but to this day, there are only a handful of amateur photographs of the president in his wheelchair.

Photo credit: Franklin D. Roosevelt Presidential Library, Hyde Park, New York

BACA COUNTY, COLORADO 1935

BLACK SUNDAY
Photographer unknown

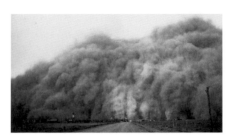

With the onset of drought in 1930, the overfarmed and overgrazed land on the Great Plains began to blow away.

Sunday, April 14, 1935, started with blue skies, but the temperature dropped by the afternoon, and an ominous black cloud was approaching. A giant storm came rolling along the plains, gathering speed and spreading huge black clouds of dust over farms and towns—a black blizzard. That day would later be called "Black Sunday." Some who were there thought the world was coming to an end.

A reporter from the Associated Press named Robert Geiger filed a story that began: "Three little words . . . rule life today in the dust bowl of the continent—if it rains."

People fastened onto the three words he used to describe the place that rain had forsaken: "the dust bowl."

With no chance of making a living, most farm families abandoned their homes and land, fleeing westward to become migrant laborers. Baca County in southeast Colorado lost nearly half of its residents.

Photo credit: Alamy.com, W5M6CR

NEAR NEW ORLEANS, LOUISIANA 1935

CHILDREN ON THE LEVEE
Photograph by Walker Evans

I was going around on my own very freely, wherever I pleased, just documenting the things that I saw, that I was interested in. I was all alone most of the time. I wasn't looking for anything, things were looking for me.

—WALKER EVANS

By the time the Depression had swept the country, Walker Evans had a growing reputation as a photographer. In 1935, he was hired by Roy Stryker, the head of the photographic division of the Resettlement Administra-

tion, a government-sponsored project that sent photographers into rural communities during the Great Depression to document conditions.

Many of the photographs Evans shot for the government are iconic—portraits of impoverished rural families and their hardships. Across the country, he took quiet studies of the unique character of small towns. When he was in New Orleans, Evans traveled outside of the city to photograph the crumbling plantation architecture and levee scenes upriver.

Stryker admired Evans's photographs, but the two men did not always agree, and they parted company in 1937.

The next year, the Museum of Modern Art gave Walker Evans its first one-man exhibition devoted to photography, entitled *American Photographs*.

Photo credit: © Walker Evans Archive (1994.254.879), Metropolitan Museum of Art, image source Art Resource

NEAR BAKERSFIELD, CALIFORNIA 1935

MIGRANT FAMILY

Photograph by Dorothea Lange

You know, so often it's just sticking around and being there . . . sitting down on the ground with people, letting children look at your camera with their dirty, grimy little hands, and putting their fingers on the lens,

and you just let them, because you know that if you will behave in a generous manner, you are apt to receive it.

—DOROTHEA LANGE

Driven by poverty, drought, and dust storms as the Depression wore on, farmers packed up their families and meager belongings and made the journey to California, where they hoped to find work.

The migrants were not welcome except to help with the crops, and harsh measures were taken to keep them out or to send them home. Lumped together as "Okies," they were accused of stealing jobs from Californians and branded troublemakers.

Families with hungry children settled in camps or by the roadside in their cars, fighting desperation, disease, and sometimes death.

In 1935, the photographer Dorothea Lange documented migrant farmworkers in the Imperial Valley for the California Emergency Relief Administration. Her photographs reached Roy Stryker, head of the National Resettlement Administration, and he offered Lange a job. Her images, packed with an emotional, heart-wrenching wallop, were picked up by newspapers across the country.

Photo credit: Library of Congress Prints and Photographs, LC-USF34-000961-E

GUYMON, OKLAHOMA 1935

ROBERT "BOOTS" McCOY

Photographer unknown

Boots McCoy's family lived in rural Texas County, in the panhandle of Oklahoma, when he saw his first dust storm. It was 1932. As the drought continued and the dust covered everything, hordes of jackrabbits, driven by hunger, invaded what pastures, crops, and gardens were left.

Amid the relentless storms, Boots's mother went into labor and had twins. They died hours later and were buried together in shoeboxes lined with cotton placed in a small handmade coffin.

The McCoy family moved to Guymon, the county seat. On April 14, 1935, Boots's parents dropped him and his sister, Ruby Pauline, off for Sunday school. A monstrous dust storm started rolling in, and the pastor, with a prayer, excused everybody. The children blindly made their way home through the black darkness, covering their noses and mouths with handkerchiefs.

A month later, Boots and his sister came down with dust pneumonia. He would suffer lung ailments for the rest of his life. Ruby died before summer arrived.

Photo credit: From the collection of Boots McCoy

NEAR EXETER, CALIFORNIA 1936

COTTON CAMP

Photograph by Dorothea Lange

In 1936, with Americans still struggling to survive, 20 million people were receiving some form of assistance from the government. Although his critics demagogued during the campaign that he was merely a president and not a king, Roosevelt won a second term in a landslide victory and continued the New Deal programs.

The Public Works Administration put several hundred thousand people to work in construction. The Works Progress Administration employed millions of artists, musicians, writers, actors, teachers, historians, blacksmiths, basket weavers, and others. The Civilian Conservation Corps put 2.7 million young men to work. The National Youth Administration helped more than 2 million high school and college students stay in school by paying them for part-time work. And the Tennessee Valley Authority brought electricity to some of the poorest regions in America.

Notably, women influenced all these programs—Secretary of Labor

Frances Perkins, the first woman to hold a cabinet post; First Lady Eleanor Roosevelt, who ensured that women were hired for many projects; and the New Deal administrator and FDR advisor Mary McLeod Bethune, who ensured the hiring of African Americans.

Photo credit: Library of Congress Prints and Photographs, LC-USF34- 009866-C

WHITE SANDS NATIONAL
MONUMENT, NEW MEXICO 1936

TOURISTS
Photograph by George A. Grant

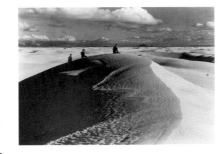

At the northmost end of the Chihuahuan Desert, which stretches from northern Mexico to the southwestern United States, sits a field of white sand dunes that sprawls over some 275 miles of south-central New Mexico. Almost half of that area is designated as the White Sands National Monument.

A soft mineral called gypsum formed the sands there. Gypsum, like salt, dissolves readily in water. So, in most cases, when subjected to rain or snowmelt, the mineral will dissolve and eventually flow into the sea.

But thousands of years ago, rivers with gypsum flowed from the San Andres and Sacramento Mountains into a large basin that is now the White Sands National Monument. With no outlet, the water evaporated and left the gypsum behind. Then freezing and thawing cycles broke it into tiny grains, and strong winds formed the dunes.

The dunes appear white because the gypsum grains, which are actually clear, are constantly banging into each other. The scratches that occur reflect the sun's rays, making the grains appear white.

Finally, unlike silica sand, gypsum doesn't absorb heat from the sun. So even on the hottest day of the year, the dunes are cool.

Photo credit: Harpers Ferry Center, Historic Photo Collection, Hpc-000526/Wa.110

NEW YORK CITY 1936

NAACP HEADQUARTERS
Photographer unknown

On May 15, 1916, a seventeen-year-old African American farmworker named Jesse Washington was found guilty of murdering and raping a white woman in Waco, Texas.

Chained by his neck, he was taken out of the courthouse by a mob that proceeded to stab and beat him as they dragged him down the street. Then he was castrated and lynched in front of the town hall.

Thousands of men, women, and children, city officials and police, gathered to watch the attack. The mob poured kerosene over Washington's body and hung him over a bonfire, raising and lowering his charred body for hours. A photographer took pictures throughout the brutal attack. Eventually, they were printed and sold as postcards.

The NAACP stepped up its anti-lynching campaign and used a portion of their funds to purchase a flag announcing "A MAN WAS LYNCHED YESTERDAY," which they hung outside their headquarters at 69 Fifth Avenue in New York City.

Estimates are that between 1870 and 1950, more than four thousand African Americans were lynched. Some now say that number is low.

Photo credit: Library of Congress Prints and Photographs, LC-DIG-ppmsca-39304

DOS PALOS, CALIFORNIA 1938

SUNDAY MORNING REVIVAL
Photograph by Dorothea Lange

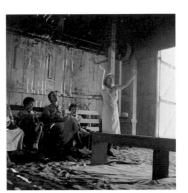

For many during the Great Depression, churches remained the center of community life.

Some religious leaders blamed the awful misery of the country on a cruel and competitive society and called for a change in the social order.

Conversely, more conservative church members believed that they needed to concentrate on preaching God's commandments and preparing for the afterlife.

Dorothea Lange titled this photograph "Victory through Christ society holding its Sunday Morning Revival in a garage."

She went on to document the testimony being given: "Glory to God. I'm so glad I came home. Praise God. His love is so wonderful."

Photo credit: Library of Congress Prints and Photographs, LC-USF34-T01-018216-E

DOVER, DELAWARE 1938

MAIN STREET
Photograph by John Vachon

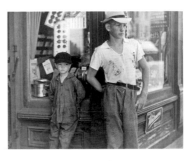

In the six months between August 1937 and January 1938, the U.S. economy dropped as sharply as it had during the thirteen months following the stock market crash of 1929.

This recession came in the middle of Roosevelt's second term, after an extended period of slow but definite recovery.

The New Dealers had carefully constructed a public image as Depres-

sion busters—in contrast with their political rivals, Herbert Hoover and the Republicans. Now it appeared that the Roosevelt administration might have a Depression of its own.

However, by the summer of 1938, when this photograph was taken, the decline had ended, and the economy was back on track. Still, these boys' troubled faces and tattered clothing tell a different story.

Photo credit: Library of Congress Prints and Photographs, LC-USF34-008493-D

CADDO, OKLAHOMA 1938

MAIN STREET
Photograph by Dorothea Lange

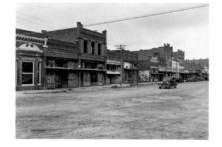

In 1938, the country was slowly recovering but still reeling from the Depression, and Americans were consumed with their own problems—not with the German expansion in Europe. A few months after this photograph of a quiet Oklahoma town was taken, President Roosevelt received this telegram:

Telegram BERLIN, September 27, 1938

To His Excellency the President of the United States of America, Mr. Franklin Roosevelt, Washington.

In your telegram received by me on September 26 Your Excellency addressed an appeal to me in the name of the American people, in the interest of the maintenance of peace, not to break off negotiations in the dispute which has arisen in Europe, and to strive for a peaceful, honorable, and constructive settlement of this question. Be assured that I can fully appreciate the lofty intention on which your remarks are based and that I share in every respect your opinion regarding the unforeseeable consequences of a European war. Precisely for this reason, however, I can and must decline all responsibility of the German people and their leaders, if the further development, contrary to all my efforts up to the present, should actually lead to the outbreak of hostilities . . .
—Adolf Hitler

Photo credit: Library of Congress Prints and Photographs, LC-USF34-T01-018258-C

CROWLEY, LOUISIANA 1938

DIXIE BELLES
Photograph by Theodore Fonville Winans

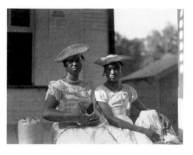

In 1928, Theodore Fonville Winans, a seventeen-year-old construction worker and amateur photographer, moved to Louisiana from Texas. Fascinated by the area, he began taking photographs of both well-known Louisiana personalities, such as Huey Long, and the people and landscapes of the rural towns and bayous. "Louisiana was my Africa, my South America," he later said.

In the small town of Crowley, Louisiana, the schools were segregated. African American children went to all-Black schools, taught by Black teachers using secondhand books handed down from the white schools.

But it was also a town where, despite Jim Crow, the children were taught about their own history, sometimes in school but also by their family elders. They learned about Booker T. Washington, George Washington Carver, Frederick Douglass, Harriet Tubman, and other early Black civil rights activists.

Winans opened his photography studio in his home in Baton Rouge sometime around 1940. It was rudimentary, with a jerry-rigged darkroom and "studio" in his dining room, but his work gained respect that continued to grow even after his death in 1992.

Photo credit: Courtesy of the Ogden Museum of Southern Art and Bob Winans, Crowley, Louisiana

NEW YORK CITY 1939

LOU GEHRIG DAY
Photographer unknown

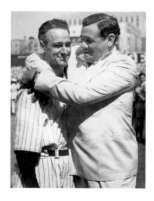

On July 4, 1939, Lou Gehrig, head bowed and fighting back tears, stood at a microphone set up on the field of Yankee Stadium, and said goodbye to his fans. He had been diagnosed with amyotrophic lateral sclerosis, an incurable neuromuscular illness, and after 2,130 consecutive games could no longer play baseball.

Fans, for the past two weeks, you have been reading about the bad break I got. Yet today, I consider myself the luckiest man on the face of the earth. I have been in ballparks for 17 years and have never received anything but kindness and encouragement from you fans.

After his speech, his old teammate Babe Ruth—"the Bambino"— fighting back tears himself, came over to shake Gehrig's hand. After a fall-

ing out, the two had not spoken to each other in years. But instead of a handshake, the Bambino gave his old teammate a big hug and a smile like only he could give. In return, Gehrig smiled for the first time that day. The past unfriendliness fell away, and the cameras captured the moment.

Gehrig died two years later.

Photo credit: Getty Images, 517213158

WASHINGTON, D.C. 1939

MARIAN ANDERSON
Photograph by Thomas D. McAvoy

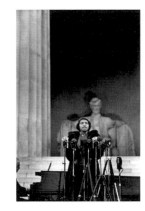

In 1939, Washington, D.C., was still a racially seg-regated city.

When the organizers of opera contralto Marian Anderson's singing tour petitioned the Daughters of the American Revolution to use their Constitution Hall auditorium for a con-cert, they were denied. The hall had an unwritten white-performers-only policy.

In protest, Eleanor Roosevelt, who had recently become a member of the DAR, left the organization. As word of her resignation spread, Mrs. Roosevelt and others worked behind the scenes promoting the idea for an outdoor concert at the Lincoln Memorial, overseen by the Department of the Interior. Interior Secretary Harold Ickes got permission from President Roosevelt, and the concert was scheduled for Easter Sunday.

Fearing that she might upstage Anderson's moment of triumph, Eleanor Roosevelt did not attend. However, she and others lobbied the various radio networks to broadcast the concert nationwide.

On April 9, seventy-five thousand people attended the concert. It was a diverse crowd, all dressed in their Sunday finest. Hundreds of thousands more listened over the radio. After being introduced by Ickes, who declared, "Genius draws no color line," Anderson opened her concert with "America."

Photo credit: Thomas D. McAvoy/The LIFE Picture Collection/Shutterstock, 50590871_10

BLACK HILLS, SOUTH DAKOTA 1939

MOUNT RUSHMORE
Photograph by Edwin L. Wisherd

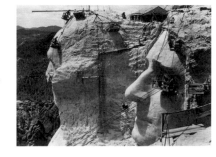

Carved into the granite face of Mount Rushmore in the Black Hills of South Dakota, on land stolen from the Sioux, are the faces of four U.S. presidents: George Washington, Thomas Jefferson, Abraham Lincoln, and Theodore Roosevelt.

The South Dakota state historian Doane Robinson had conceived the idea in 1923 to help promote tourism. Robinson persuaded the sculptor Gutzon Borglum to design the monument and brought him out to the Black Hills to review the site. Robinson had wanted to salute the old West with carvings of historical figures such as Lewis and Clark and the Lakota leader Red Cloud. But Borglum—who had in the past had ties with the Ku Klux Klan—had a different idea. He wanted the monument to be a shrine to American exceptionalism, saying, "America will march along that skyline."

The sculpture, which took sixteen years to finish, was completed in 1942.

In 1980, the U.S. Supreme Court awarded the Sioux Nation $105 million as compensation for their loss of the Black Hills. The offer was rejected. The sacred land, the Sioux said, was never for sale.

Photo credit: Source undetermined

NEW YORK CITY 1939

WORLD'S FAIR
Photographer unknown

On April 30, 1939, "The World of Tomorrow" world's fair opened with a televised dedication by President Roosevelt. Later, Albert Einstein gave a speech that discussed cosmic rays, after which the fair's lights were ceremonially lit.

All the major countries had contributed to the exhibition, except for Germany.

One of the most notable events was the burial of a time capsule built by Westinghouse Corporation, not to be opened until 6939. Among the more than a hundred items included were writings by Thomas Mann, *LIFE* magazines, a Mickey Mouse watch, a Gillette safety razor, a pack of Camel cigarettes, and a roll of microfilm with an essay of more than twenty-two thousand pages describing the arts, sciences, industries, and other information about the time. They also put in a microfilm reader, just in case.

As the war in Europe escalated in 1940, the theme of the fair was changed to "For Peace and Freedom." On an advertising poster created by Borden's Milk, Elsie the Cow proclaimed, "Makes you proud to be an American."

When the fair closed in the fall of that year, more than 44 million people had attended.

Photo credit: Source undetermined

NEW YORK CITY 1940

TIMES SQUARE
Photographer unknown

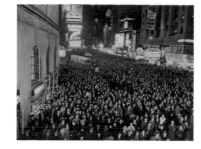

On November 5, 1940, a massive crowd waited for election news in Times Square. At 9:40 p.m. they found out that Roosevelt had defeated the Republican businessman Wendell Willkie and was reelected for an unprecedented third term in office.

War abroad was escalating. In Europe, the Axis Powers had overtaken Albania, Belgium, Denmark, Finland, France, Greece, Hungary, the Netherlands, Norway, Poland, and most of North Africa. The Japanese controlled large portions of China and were expanding their empire in Southeast Asia and the Pacific. And the Nazis were dropping bombs on London and building concentration camps.

In a radio "Fireside Chat" two months before the election, the president had promised an increasingly alarmed and isolationist American people that they would not go to war—but insisted that the nation still had to support its allies.

> The people of Europe who are defending themselves do not ask us to do their fighting. They ask us for the implements of war . . . which will enable them to fight for their liberty and for our security . . . we must get these weapons to them . . . so that we and our children will be saved the agony and suffering of war which others have had to endure.

Photo credit: Franklin D. Roosevelt Presidential Library, Hyde Park, New York

NATCHEZ, MISSISSIPPI 1940

BACKROAD
Photograph by Marion Post Wolcott

In 1940, Marion Post, soon to become Marion Post Wolcott, found herself on the Mississippi Delta. Like other FSA photographers, she had traveled thousands of miles through the United States with her camera. During her time with the agency, she produced more than nine thousand photographs.

Before the Civil War, with trade made possible by river traffic and when cotton was king, Natchez, Mississippi, had the most millionaires per capita of any city in the United States.

After the war, the grand antebellum homes managed to be spared, sitting high on the bluffs—above the freed Black people below.

During the Depression, to attract tourists, the city of Natchez sold itself as a place "Where the Old South Still Lives," and people flocked to view the town's decaying antebellum mansions.

Marion Post Wolcott photographed a different side of life in Natchez. Her photographs of African American life do not necessarily recall a dark past or even the struggle of the Depression, as seen in this beautiful portrait of two young women walking down a dusty southern road.

Photo credit: Library of Congress Prints and Photographs, LC-DIG-fsa-8c30742

NEW YORK CITY C. 1940

FOUR BOYS
Photograph by Helen Levitt

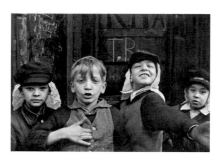

Helen Levitt was born in Brooklyn in 1913 to Russian immigrant parents. Dropping out of high school in her senior year, she went to work for a commercial photographer. When she had saved up enough money, Levitt bought a used Austrian Voigtländer camera and began learning the craft.

The spontaneous style of the French photographer Henri Cartier-Bresson most inspired her. As Levitt recalled later, "I decided I should take pictures of working-class people . . . And then I saw pictures of Henri Cartier-Bresson and realized that photography could be an art."

She started shooting men, women, and children on the sidewalks and stoops of the Lower East Side and Harlem, capturing the passing moments of street life.

Levitt remained a very private person throughout her life, giving few interviews. In her fourth-floor walk-up apartment, she had boxes containing her photos. One was labeled "nothing good." Another, marked "Here and There," became the title of a book of her unpublished photographs in 2004. Levitt described the ability that allowed her to make her pictures: "I can feel what people feel."

Photo credit: © Film Documents LLC, courtesy Galerie Thomas Zander, Cologne

SUN VALLEY, IDAHO 1940

ERNEST HEMINGWAY
Photograph by Robert Capa

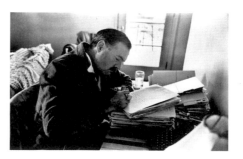

Ernest Hemingway completed *For Whom the Bell Tolls* in his cramped writing studio in Sun Valley, Idaho. The novel explores the devastating effects of war on all sides and the complex moral issues involved in killing another human being.

For Whom the Bell Tolls was published in October 1940, when Europe and Asia were engulfed in war. Nearly half a million copies were sold in less than six months.

In 1954, Hemingway was awarded the Nobel Prize in Literature for his lifetime of influence in the literary world. He was unable to attend the ceremony, but the ambassador to Sweden read his thank-you speech at the Nobel banquet in Stockholm.

> Writing, at its best, is a lonely life. Organizations for writers palliate the writer's loneliness but I doubt if they improve his writing. He grows in public stature as he sheds his loneliness and often his work deteriorates. For he does his work alone and if he is a good enough writer he must face eternity, or the lack of it, each day.

Photo credit: Robert Capa, © International Center of Photography/Magnum Photos, PAR99845/W00010/33C

NEW YORK CITY 1941

AMERICA FIRST RALLY
Photograph by Ralph Morse

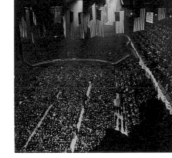

In 1927, Charles Lindbergh flew his plane, the *Spirit of St. Louis*, from New York to Paris and became the first to fly solo non-stop across the Atlantic Ocean. Congress awarded him the Medal of Honor.

After the kidnapping and murder of his baby son, Lindbergh moved with his wife, Anne, to London. In 1936, they traveled to Germany, where they were guests of the Third Reich. Lindbergh would make several trips to Germany over the next two years.

In 1939, Lindbergh returned to the safety of the United States and became the voice for the isolationist America First Committee, a group that based its philosophy on white supremacy. The might of Germany alone, Lindbergh argued, could "dam the Asiatic hordes" and prevent the overrunning of Europe with undesirables.

Lindbergh claimed that "the British, the Jewish, and the Roosevelt administration" were "war agitators" who had fed propaganda to frightened Americans. And at a rally at Madison Square Garden on October 30, 1941, underneath an army of American flags, the crowd waved symbols in support of the Nazis.

Photo credit: Ralph Morse/The LIFE Picture Collection/Shutterstock, 12515728a

GRAND CANYON NATIONAL PARK, ARIZONA C. 1941

FROM POINT IMPERIAL
Photograph by Ansel Adams

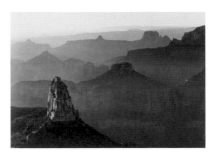

> I believe in beauty. I believe in stones and water, air and soil, people and their future and their fate.
>
> —ANSEL ADAMS

In 1941, at the height of World War II but before the bombing of Pearl Harbor, Secretary of the Interior Harold Ickes put the photographer Ansel Adams on the department's payroll. In exchange for film, paper, darkroom chemicals, and a day rate of $22, Ickes asked Adams to bring back photographs of all the national parks for a prominent mural display in the Department of the Interior building.

Adams said it was "one of the best ideas ever to come out of Washington."

In all, he took some 225 photographs for the Department of the Interior, including this image of the Grand Canyon. But when America went to war, the project came to an end.

In 1980, Adams received the Presidential Medal of Freedom from President Jimmy Carter. The accompanying citation read,

> At one with the power of the American landscape, and renowned for the patient skill and timeless beauty of his work, photographer Ansel Adams has been visionary in his efforts to preserve this country's wild and scenic areas, both on film and on earth.

Photo credit: Getty Images, 519416472

SIMPSON COUNTY, MISSISSIPPI 1941

BOTTLE TREES
Photograph by Eudora Welty

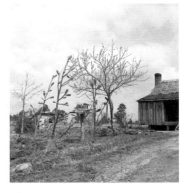

During the 1930s, the Works Progress Administration created the Federal Writers' Project to support writers and artists and record the country's culture. The *American Guide* series consisted of individual booklets for each state, showcasing their uniqueness. Little-known authors— many of whom would later become celebrated—were commissioned to help with the guides. Saul Bellow, Zora Neale Hurston, Ralph Ellison, and Eudora Welty were among them.

Born in Jackson, Mississippi in 1909, Eudora Welty took a job with the

Works Progress Administration in 1933, and, two years later, would begin traveling throughout Mississippi to document daily life.

One of the photographs Welty took is of this run-down house with a bottle tree in front of it. An African custom that dates back centuries, bottle trees made their way into the yards of both Black and white people in the South in the belief that the colored bottles would lure evil spirits, entrapping them and protecting the home.

After working for the WPA, Welty became a noted author whose stories called upon her observations of life in the South. One of her short stories, "Livvie," was inspired by the bottle trees. In 1973, Welty received the Pulitzer Prize in Fiction.

Photo credit: Eudora Welty Collection, Mississippi Department of Archives and History, and Russell & Volkening as agents for the author's estate, © 1941 by Eudora Welty, from Z/0301, Series 26, Sysid 0710

OAHU, HAWAII 1941

PEARL HARBOR
Photographer unknown

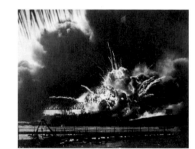

> I fear all we have done is to have awoken a sleeping giant and fill him with a terrible resolve.

—ADMIRAL ISOROKU YAMAMOTO,
Commander in Chief, Japan's Combined Fleet

On December 7, 1941, shortly before eight in the morning, 183 planes of the Imperial Japanese Navy attacked the United States Navy base at Pearl Harbor on the island of Oahu. In only minutes, four battleships were hit, including the USS *Arizona*. Almost immediately after, a bomber hit the gunpowder stores in the *Arizona*. The explosion killed 1,177 of its crew.

A little over an hour later, 170 Japanese aircraft attacked again in a second wave.

Eighteen warships, including the USS *Shaw*, shown in this photograph, were damaged or sunk; 188 aircraft were destroyed; and more than 2,400 American servicemen and servicewomen died in the attack.

The following day, the United States declared war against Japan. Three days later, Germany and Italy declared war against the United States. In response, that same day, Congress responded with a declaration of war against Germany and Italy.

> With confidence in our armed forces—with the unbounding determination of our people—we will gain the inevitable triumph so help us God.

—PRESIDENT FRANKLIN ROOSEVELT,
Commander in Chief, U.S. Armed Forces

Photo credit: National Archives and Records Administration, 80-G-16871

CENTERVILLE, CALIFORNIA 1942

RELOCATION CENTER
Photograph by Dorothea Lange

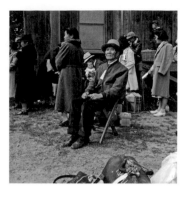

On February 19, 1942, two months after the bombing of Pearl Harbor, President Roosevelt issued Executive Order 9066, authorizing the secretary of war and military commanders to evacuate to internment camps all persons on the West Coast deemed a security threat. They called the camps "relocation centers."

Around 120,000 men, women, and children of Japanese descent, the majority of whom were American citizens, were forced to leave their homes, businesses, and most of their worldly goods.

While interned at the Minidoka Relocation Center in Idaho, twenty-three-year-old Kimi Tambara wrote an open letter to her friend Jan in the *Minidoka Irrigator*, the camp newsletter:

> I can now understand how an eagle feels when his wings are clipped and caged. Beyond the bars of his prison lies the wide expanse of the boundless skies, flocked with soft clouds, the wide, wide, fields of brush and woods—limitless space for the pursuit of Life itself.

On December 14, 1944, a unanimous Supreme Court decision ruled that the government "has no authority to subject citizens who are concededly loyal to its leave procedure." The last of the camps, the high-security one at Tule Lake, California, was closed in March 1946.

Photo credit: National Archives and Records Administration, 210-G-C219

OAK RIDGE, TENNESSEE 1942

MANHATTAN PROJECT
Photograph by Ed Westcott

On August 2, 1939, President Roosevelt received a letter, cosigned by Albert Einstein, stating that Germany might be trying to develop an atomic bomb and that the United States should start its own research.

Roosevelt decided that the letter called for action and authorized the creation of the Advisory Committee on Uranium. Progress was slow until, in 1942, the U.S. Army Corps of Engineers directed an all-out bomb development program known as the Manhattan Project.

Facilities were set up in remote locations in New Mexico, Washington, and East Tennessee, where, on fifty-nine thousand acres at the foothills

of the Appalachians, the Corps built four plants for enriching uranium, along with an entire town for the forty-five thousand men and women who would work there in secret. While the city is now called Oak Ridge, during the war it was known simply as "Site X."

A pacifist at heart, Einstein never worked on the Manhattan Project and later told *Newsweek* magazine, "Had I known that the Germans would not succeed in developing an atomic bomb, I would have done nothing."
Photo credit: DOE/Ed Westcott

MANSFIELD, OHIO 1942

BOYS PLAYING SOLDIERS
Photograph by John Phillips

On September 16, 1940, President Roosevelt signed into law the Selective Training and Service Act, which required all men between the ages of twenty-one and forty-five to register for the draft. It was the nation's first peacetime draft.

After the attack on Pearl Harbor in 1941, Congress amended the act to require all nondisabled men ages eighteen to sixty-four to register for military service from that day until six months after the end of the war. In practice, however, only men eighteen to forty-five were drafted.

More than 10 million men were inducted into the U.S. Army, Navy, Air Force, and Marines through the draft over the course of the war.

Eight million more people volunteered, 400,000 of them women.
Photo credit: John Phillips/The LIFE Picture Collection/Shutterstock, 12143237b

NEW YORK CITY 1942

PENN STATION
Photograph by Alfred Eisenstaedt

During World War II, so many GIs shipped out overseas from the New York Port of Embarkation that it became known as "Last Stop, USA." There, the photographer Alfred Eisenstaedt captured the men and their wives or girlfriends saying tearful goodbyes.

As thousands of soldiers traveled to the port by rail, civilians began to complain about the overcrowded trains.

In response, the New York, New Haven and Hartford Railroad took out an ad in the *New York Herald Tribune*. It pictured a young man in an upper berth with his helmet beside him and the words:

Next time you are on the train, remember the kid in Upper 4. If you have to stand en route, it is so he may have a seat. If there is no berth for you, it is so that he may sleep. If you have to wait for a seat in the diner, it is so he . . . and thousands like him . . . may have a meal they won't forget in the days to come.

The railroad received eight thousand grateful letters in response. Eisenstaedt's photos were printed in *LIFE* magazine on Valentine's Day, 1943.
Photo credit: Alfred Eisenstaedt/The LIFE Picture Collection/Shutterstock, 12257765a

BALTIMORE, MARYLAND 1943

BETHLEHEM-FAIRFIELD SHIPYARD
Photograph by Arthur S. Siegel

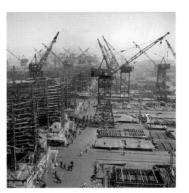

In 1941, President Roosevelt announced a $350 million emergency shipbuilding program to provide Great Britain with armaments and supplies. The ships were called the "Liberty Fleet."

The Bethlehem-Fairfield yard in Baltimore was one of several new shipyards. On September 27, 1941, the first Liberty ship, the SS *Patrick Henry*, was launched, followed by thirteen more at other shipyards across the country. It was called "Victory Fleet Day," and Roosevelt was in Baltimore to christen the ship:

The *Patrick Henry*, as one of the Liberty ships launched today, renews that great patriot's stirring demand: "Give me liberty or give me death." There shall be no death for America, for democracy, for freedom! There must be liberty, worldwide and eternal. That is our prayer—our pledge to all mankind.

At its peak in late 1943, Bethlehem-Fairfield employed 46,700 men and women, who worked around the clock.

When its last ship, the *Atlantic City Victory*, slid into the water in the fall of 1945, the yard had built more vessels than any other American shipyard: 5,187,600 tons of shipping vessel—more than five hundred cargo ships.
Photo credit: Library of Congress Prints and Photographs, LC-DIG-fsa-8d29175

FORT HUACHUCA, ARIZONA 1943

93RD COMBAT DIVISION
Photograph by Charles E. Steinheimer

As the war escalated in Europe, President Roosevelt decided that African American men could register for the draft. However, the military determined how many were called up, and Jim Crow dictated how they served.

Black troops were segregated from white troops. Barracks, hospitals, and even blood banks were segregated on the bases. The men were demeaned in coarse terms, not only by many of their fellow soldiers but also by many commanders who believed they were not suited for combat. Those very few who made it to the rank of officer were only allowed to lead other Black men.

One soldier wrote to Roosevelt describing how, in his camp, the buildings in the sections for the Black soldiers were covered in tar paper, while all the other barracks and buildings were painted white.

And, in 1944, a Black officer named Lieutenant Jack Roosevelt Robinson was brought to a court-martial trial for refusing to move to the back of the bus.

Photo credit: Charles E. Steinheimer/The LIFE Picture Collection/Shutterstock, 12149276b

DETROIT, MICHIGAN 1943

RACE RIOT
Photographer unknown

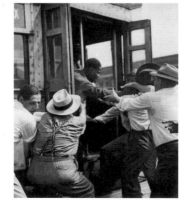

In a city where the growing Black population was crowded into a small segregated area sixty blocks wide known as "Black Bottom," tensions were running high. Many whites refused to work alongside African Americans in the wartime factories, and they didn't want them moving next to their white neighborhoods, either. Resentments built up on both sides.

On June 20, 1943, African Americans at a social club were falsely told that whites had thrown a Black woman and her baby off the Belle Isle Bridge. Violence erupted as a furious mob looted white businesses and attacked white people.

Close by, a group of angry whites who had heard an equally false rumor that Black men had raped a white woman turned their rage against the African Americans.

The violence grew as word spread about both instances.

Cars owned by African Americans were overturned and set on fire.

White mobs beat Black men as white police officers watched. A white doctor was beaten to death while making a house call in a Black neighborhood.

It took six thousand Army troops in tanks and armed with automatic weapons to stop the rioting. Nine whites and twenty-five African Americans died over those three summer days.

Photo credit: Associated Press, 4306210370

WARM SPRINGS, GEORGIA 1945

THE DEATH OF PRESIDENT ROOSEVELT
Photograph by Ed Clark

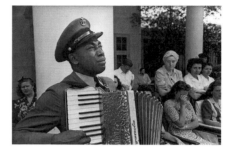

Despite being noticeably weakened, on November 7, 1944, Franklin D. Roosevelt won a fourth term in office.

The war finally seemed to be coming to a close, and in February 1945 Roosevelt traveled to Yalta to meet with Winston Churchill and Joseph Stalin to discuss the progress of the conflict and the postwar world. He had lost weight, and his exhaustion showed in his gaunt face.

Two months later, the president returned to the house he had built in Warm Springs, Georgia, where, in 1926, he had established a treatment center for other people stricken with polio. It was his retreat and had been dubbed "the Little White House."

On April 12, while sitting for a portrait, Roosevelt collapsed and died of a cerebral hemorrhage. The next day, Navy musician Graham Washington Jackson Sr. played "Goin' Home" on his accordion as the flag-draped coffin of his friend left Warm Springs for the last time.

Photo credit: Ed Clark/The LIFE Picture Collection/Shutterstock, 12152638a

WASHINGTON, D.C. 1945

MOURNERS
Photograph by Thomas McAvoy

On April 12, 1945, two hours after Franklin Roosevelt's death, Vice President Harry S. Truman was sworn in, becoming the thirty-third president of the United States.

Two days later, mourners gathered outside the portico of the White House. The world was in shock. Tearful people had lined the streets as the funeral procession carrying Roosevelt's body made the trip from Warm Springs, Georgia, to Washington, D.C. It would soon go on to his home in Hyde Park, New York.

German armed forces surrendered a month later, on May 7, 1945, and Victory in Europe Day was proclaimed amid celebrations in Washington, London, Moscow, and Paris.

Three months later, two atomic bombs leveled the cities of Hiroshima and Nagasaki, and Japan surrendered.

The war was over.

Millions upon millions of people had died, including not only soldiers but many civilians caught in the fighting, killed by famine and disease, or victims of crimes against humanity.

Photo credit: Thomas D. McAvoy/The LIFE Picture Collection/Shutterstock, 12149276b

HARLAN COUNTY, VIRGINIA 1946

BLAINE SERGENT, COAL LOADER
Photograph by Russell Lee

In 1946, Russell Lee took more than four thousand photographs in the Appalachian coalfields. He had been hired by the Department of the Interior, in collaboration with the United Mine Workers, to document working and living conditions.

After the war, when thousands of returning service members were available to enter the workforce and industries were transitioning from war to peacetime manufacturing, companies began to lower wages and cut employment. What followed became known as the "Great Strike Wave of 1946," which involved more than 5 million American workers in labor disputes. Three hundred and forty thousand of them were coal miners.

In response, in 1947, Congress enacted—over President Harry Truman's veto—the Taft-Hartley Act.

The legislation outlawed closed shops in which only union members could work, permitted union shops only if a majority of employees voted for them, and required unions to give sixty days' advance notice of a strike.

It also allowed the attorney general to issue an injunction against any strike that might imperil national health or safety.

In addition, it placed restrictions on political contributions by unions and required union leaders to testify that they were not affiliated with any Communist party or organization.

Photo credit: National Archives and Records Administration, 541286

NEW YORK CITY 1947

CARNEGIE HALL
Photograph by William Gottlieb

We all do "do, re, mi," but you have got to find the other notes yourself.
—LOUIS ARMSTRONG

Louis Armstrong was born in New Orleans in 1901 in a neighborhood so poor it was called "the Battlefield." In 1912, after firing a gun in the air at a New Year's Eve celebration, he was sent to the Colored Waif's Home for Boys. While there, he learned how to play the cornet.

When he stepped onto the stage at Carnegie Hall in 1947, Armstrong had been performing for almost thirty years and had become a star.

In his raspy voice, he sang with white performers like Bing Crosby and Black singers like Billie Holiday. He had appeared in fifteen movies, starred in a Broadway show, and performed all over Europe.

The world knew him as "Satchmo." Many say he is the most influential person in the history of jazz. The conductor Leonard Bernstein described Armstrong like this: "What he does is real, and true, and honest, and simple, and even noble. Every time this man puts his trumpet to his lips, even if only to practice three notes, he does it with his whole soul."

Photo credit: Library of Congress Prints and Photographs, LC-GLB23-0021 DLC

WASHINGTON, D.C. 1948

DEPARTMENT OF THE INTERIOR
Photograph by William Chaplis

We will sign this contract with a heavy heart . . . With a few scratches of the pen, we will sell the best part of our reservation.
—GEORGE GILLETTE

On May 20, 1948, George Gillette, chairman of the business council at the Fort Berthold Reservation in North Dakota, wept as he watched Secretary of the Interior Julius Krug authorize the forced sale of reservation lands to make way for the construction of the Garrison Dam. The reservation was home to the Mandan, Hidatsa, and Arikara tribes, given to them in a treaty with the government in 1851.

More than three hundred families were forced out of their homes to

make way for the dam, losing not only their fertile farmland along the Missouri River but also their schools, churches, and a medical clinic.

President Dwight Eisenhower spoke at the dedication of the still-uncompleted dam in 1953: "Garrison Dam was built with the people's money, and its benefits shall go to the people."

In 1956, the government flooded 156,000 acres of the land they had taken from the tribes.

Photo credit: Associated Press/William Chaplis, 480520014

NEW YORK CITY 1949

BOY ON THE STREET
Photograph by Jerome Liebling

There are no superiors, I think we all are about the same. But there certainly are advantages in life—money, who writes the history and who says who's good. The rich control the history. So, I suppose I'm saying these people are valuable. You have to look again.

—JEROME LIEBLING

Jerome Liebling grew up in Brooklyn. When he was a young teenager, he bought a Kodak Brownie box camera and began photographing the people on the streets of New York. He wanted to bring attention to social injustice and would show his photographs to his father to prove a point when they were arguing politics.

Throughout his career, Liebling would not demand, but invite, the viewer to take a closer look. He asked that of his students as well.

There is a saying that "God is in the details." The name of the boy in this photograph is unknown, but Liebling saw him, standing on a bit of broken pavement with an untied shoelace, his improbable hockey shirt, his irrepressible hat, and a look much older than his years.

There's an unmistakable honesty in the exchange between subject and artist, the subtle subtexts of race and money and power, all carefully balanced and if not reconciled, *seen*.

Photo credit: "Boy and Car," Jerome Liebling, New York City, 1949

LEVITTOWN, NEW YORK, 1949

HOUSING DEVELOPMENT
Photographer unknown

In 1947, Abraham Levitt bought four thousand acres of potato fields in the town of Hempstead on western Long Island.

Thousands of soldiers who had returned from the war needed a place to live and raise a family, and Levitt had the idea to build a development of modest houses. All the homes were identical, which made construction cheaper and the cost of the homes more affordable. With low-cost loans provided by the government, young families flocked to the new community.

Named Levittown, it was a place where Jews, Italians, Irish, and Poles—working people—lived side by side.

African Americans, however, were explicitly barred from Levittown.

Initially, every lease and homeowner's contract stated that no person who was not a member of the Caucasian race would be allowed in. Further, owners were prohibited from selling to anyone who was not white.

In 1948, when the Supreme Court ruled that racial covenants were unconstitutional, Levitt replied that eliminating the clause in his contracts changed "absolutely nothing."

Photo credit: GRANGER Historical Picture Archive, 0259481

NORTH CAROLINA 1950

JIM CROW WATER FOUNTAIN
Photograph by Elliott Erwitt

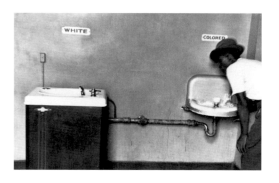

Around 1828, a minstrel show performer named Thomas "Daddy" Rice created a routine in which he blacked his face and sang and danced in a caricature of an old Black man in raggedy clothes. Rice's character, Jim Crow, eventually gave its name to a negative stereotype of African Americans.

By the 1880s, "Jim Crow" was used as shorthand for practices and laws that dictated the physical separation of Black people from white people.

When the photographer Elliott Erwitt took this photograph, Jim Crow segregation was still legal, as it had been since the Supreme Court supported the doctrine of "separate but equal" in its 1896 decision in *Plessy v. Ferguson*.

By state law in most of the South, schools, restaurants, parks, playgrounds, hotels, train cars, waiting rooms, elevators, public bathrooms, colleges, hospitals, cemeteries, swimming pools, prisons, and drinking fountains had separate areas for whites and African Americans. It was forbidden to pass books from Black schools to white schools. In movie theaters that did allow Black people, they were forced to sit in balconies known as "Crow's Nests." And, on buses, even if seats were available in the white section, African Americans stood in the back.

Photo credit: Elliott Erwitt/Magnum Photos, PAR41687/W00N76/26

ANN ARBOR, MICHIGAN 1950

DRUM MAJOR

Photograph by Alfred Eisenstaedt

"It was early in the morning," the photographer Alfred Eisenstaedt said about this photograph, which was shot while he was in Ann Arbor covering the University of Michigan's famous marching band. After taking the usual pictures of the band rehearsing, he spotted the school's drum major—Dick Smith—practicing by himself. And then, as Eisenstaedt recalled, "I saw a little boy running after him, and all the faculty children on the playing field ran after the boy. And I ran after them."

Time magazine called it "the happiest photo ever made."

Photo credit: Alfred Eisenstaedt/The LIFE Picture Collection/Shutterstock, 12121991a

IOWA 1954

FARMER

Photograph by Gordon Parks

At the turn of the nineteenth century, almost half the population of the United States lived on farms. By the time the *LIFE* photographer Gordon Parks took this picture in the mid-1950s, that number had dropped to 16 percent.

The transformation of agriculture in America began after World War II, when new technology and modern mechanization, new fertilizers, and pesticides changed the way America farmed and made it increasingly difficult for small farms to remain competitive.

Many rural workers left for more lucrative urban jobs, and larger farms swallowed up the small family farms. Before the war, there were more than 6 million farms in America, with an average size of 150 acres. Today there are only about 2 million farms, and their average size is 444 acres.

And while 96 percent of them are considered family farms, they represent only 20 percent of the acreage under cultivation. Large-scale farming corporations own the other 80 percent.

Photo credit: Gordon Parks/The LIFE Picture Collection/Shutterstock, 12257736a

WASHINGTON, D.C. 1954

SENATE COMMITTEE HEARING

Photographer unknown

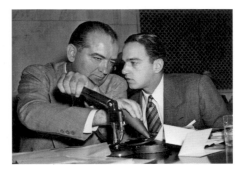

In February 1950, at the height of the Cold War, Senator Joseph McCarthy gave a speech to the Republican Women's Club in Wheeling, Virginia, during which he pulled out a piece of paper with a list of more than two hundred employees at the State Department whom he accused of being Communists.

The Senate committee formed to investigate McCarthy's allegations declared them unfounded, saying that his actions were an attempt to "confuse and divide the American people . . . to a degree far beyond the hopes of the Communists themselves."

McCarthy continued his campaign, relentlessly conducting dozens of hearings, calling hundreds of witnesses, and ruining countless lives. His chief counsel, shown in this photograph, was Roy Cohn.

After McCarthy debased a general during an interrogation—and a Wyoming senator committed suicide due to McCarthy's attack against the senator's son's homosexuality—his support began to wane.

In 1954, a Senate committee held televised hearings, which McCarthy called a "lynch party," to debate whether to censure him. They did, calling his behavior "inexcusable," "reprehensible," and "vulgar and insulting." While the penalty for censure wasn't expulsion from the Senate, McCarthy's power was thoroughly diminished. He died while still in office in 1957.

Photo credit: Associated Press, 5404260142

CALIFORNIA 1954

BRACERO PROCESSING CENTER

Photograph by J. R. Eyerman

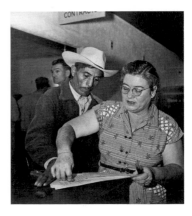

In 1942, in response to a farm labor shortage, Congress enacted the Emergency Labor Program. The legislation allowed Mexican citizens to temporarily enter and remain in the United States to work in the fields. The workers were called "braceros," which in Spanish refers to "one who works using his arms."

As they entered the United States, the men were told to strip and were fumigated with the pesticide DDT. Then, after being examined to make

sure they were healthy enough to work, they were fingerprinted, given identification cards, and packed tightly together to travel to their place of work.

Although the program guaranteed the workers fair wages and decent living quarters, the braceros suffered inhumane conditions and practices. The men were crowded into small rooms without water. They were underpaid—sometimes having part of their wages tithed to accounts in Mexico that they would never see. They had no health care. And the back-breaking labor in the fields was made even more so when they were only provided with short-handled tools that forced them to bend perpendicular to the ground.

Photo credit: J. R. Eyerman/The LIFE Picture Collection/Shutterstock, 12106666b

PATAGONIA, ARIZONA 1955

THE WALLS
Photograph by Bruce Davidson

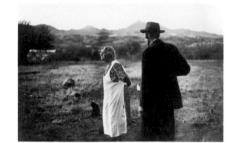

We were sending rockets to the moon. I felt the need to photograph inner space.

—BRUCE DAVIDSON

Bruce Davidson was sixteen when he won the Kodak High School Snapshot Contest for his picture of a baby owl.

In 1958, he was drafted into the Army and sent to Fort Huachuca, Arizona, for training. One day, hitchhiking to Nogales, a city on the Mexican border, Davidson got a ride from an elderly couple in a Model T Ford—John and Kate Wall.

For months, he visited with the Walls on weekends, and they allowed him to photograph every aspect of their lives.

Later, Davidson would become known for several landmark projects, including a collection of some of the most iconic and influential photographs of the civil rights movement in the 1960s and an unparalleled photographic biography of the people of his hometown, New York City.

Photo credit: Bruce Davidson/Magnum Photos, NYC64448/W00027/28

NEW YORK CITY 1955

BROOKLYN DODGERS
Photograph by Grey Villet

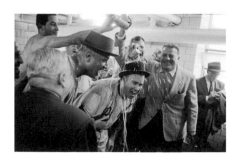

In 1955, the Brooklyn Dodgers won the National League pennant for the eighth time. They had played in a World Series seven

times, and were defeated each time. Once again, they faced their hated rivals, the New York Yankees—who had already beaten them five times in past series.

Brooklyn fans braced themselves for another disappointment when New York took the first two games, but the Dodgers came back and tied the series at 3–3.

The seventh game was played in Yankee Stadium, enemy turf for Brooklyn fans.

In the sixth inning, the Dodgers went ahead 2–0. They held the lead and won the series. Brooklyn fans went wild. Telephone circuits collapsed from overload. Western Union sent and received the greatest flood of telegrams since VJ Day, and honking cars blared up and down Flatbush Avenue. The skies over Brooklyn filled with fireworks, while Joseph Saden, owner of a delicatessen on Utica Avenue, handed out free hot dogs—a gesture, one reporter said, that "for a Brooklyn merchant is but one step from total numbness."

It was the only series the Brooklyn Dodgers would ever win. In 1958, the team's owner, Walter O'Malley, moved the franchise to Los Angeles.

Photo credit: Grey Villet/The LIFE Picture Collection/Shutterstock, 12151441a

NEW ORLEANS, LOUISIANA 1955

"TROLLEY—NEW ORLEANS"
Photograph by Robert Frank

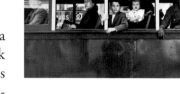

In 1955, a few months before Rosa Parks refused to move to the back of the bus, Robert Frank took this photograph of the segregated passengers in a trolley car in New Orleans. One click of the camera shutter captured the whole of the consequences of race in America.

For two years, Frank traveled across the United States, taking photographs of all aspects of American life with unblinking honesty, capturing not only what was before him but somehow, without any contrivance, what was beneath the surface.

In 1958 Frank wrote, in the same quiet manner and with the same direct import of his images, "With these photographs, I have attempted to show a cross-section of the American population. My effort was to express it simply and without confusion."

A year later, eighty-three of Frank's photographs were published in a landmark book, *The Americans.* "Trolley—New Orleans" was on the cover.

Photo credit: © Andrea Frank Foundation, from The Americans

ATCHISON, KANSAS 1955

ST. BENEDICT'S ABBEY
Photograph by Gordon Parks

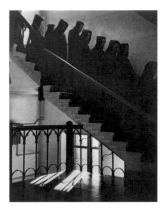

On the day after Christmas in 1955, *LIFE* magazine published a special edition on Christianity in the United States. Staff photographer Gordon Parks went back to the state where he was born to take pictures of the monks at a Benedictine monastery near Atchison, Kansas.

Born in 1901, the youngest of fifteen children, Parks became interested in photography during the Depression when he saw Dorothea Lange's photographs of migrant workers. He bought a secondhand camera, taught himself how to use it, and earned a position with the Farm Security Administration and later with the Office of War Information.

In 1946, Parks moved to Harlem and got work as a freelance fashion photographer for *Vogue*. Then, in 1948, he became the first African American staff photographer for *LIFE*. In both cases, he was breaking racial barriers.

For the rest of his career, Parks used his camera to document those who were victims of poverty, racism, and injustice—or, as he put it, anyone who was "getting a bad shake." But he also defended his decision to use the camera to show beauty. "You know," he said, "the camera is not meant just to show misery."

Photo credit: Gordon Parks/The LIFE Picture Collection/Shutterstock, 12141793b

MONEY, MISSISSIPPI 1955

EMMETT TILL MURDER TRIAL
Photograph by Ed Clark

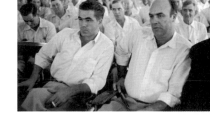

In a unanimous decision in May 1954, the Supreme Court overturned the "separate but equal" legal doctrine that the court had established in 1896 in *Plessy v. Ferguson*.

This time, in *Brown v. Board of Education*, the Court determined that "separate educational facilities are inherently unequal." However, the decision did not spell out any method for ending segregation in schools except to say that it should be done with "deliberate speed."

The states where segregation was a way of life delayed action or simply ignored the decision. They didn't like the Court telling them what to do. Jim Crow wasn't going anywhere.

On August 20, 1955, Emmett Till, a fourteen-year-old African Ameri-can teenager from Chicago, boarded a train to visit his great-uncle, who lived near Money, Mississippi.

Three days later, after allegedly whistling at a white woman in a local grocery store, Till was kidnapped, brutally beaten, and shot to death. His corpse, with a seventy-five-pound cotton gin fan tied to the neck, was pulled from the Tallahatchie River.

His assailants—the woman's husband and his brother—were acquitted at trial a month later by an all-white jury who deliberated for less than an hour.

Photo credit: Ed Clark/The LIFE Picture Collection/Shutterstock, 12065832g

BROOKLYN, NEW YORK 1956

JACKIE ROBINSON
Photograph by George Silk

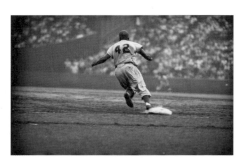

On April 15, 1947, Jackie Robinson walked onto Ebbets Field in Brooklyn in a Dodgers uniform. Since 1887, there had been a so-called gentlemen's agreement in major-league baseball: no Blacks.

In his first season, Robinson was cursed at and received death threats. An opposing player spiked him in the leg. Pitches were thrown at his head. He was forced to shower separately from the rest of the team. Despite all the abuse, Robinson kept his promise to manager Branch Rickey that he would turn the other cheek for his first two seasons.

That year, Robinson was named National League Rookie of the Year.

At the start of his third season, he was free from his obligation to Rickey, and Robinson did fight back, like any other ballplayer would—refusing to take abuse from other players and arguing with umpires. Some then called him "uppity."

Over his career, Robinson led the Brooklyn Dodgers to six league championships and their only World Series victory. He retired from baseball in 1957.

Photo credit: George Silk/The LIFE Picture Collection/Shutterstock, 12146597a

RICHMOND, VIRGINIA 1956

ELVIS PRESLEY
Photograph by Alfred Wertheimer

I'm not trying to be sexy. It's just my way of expressing myself when I move around.
—ELVIS PRESLEY

My only deep sorrow is the unrelenting insistence of recording and motion picture companies upon purveying the most brutal, ugly, degenerate, vicious form of expression it has been my displeasure to hear—Naturally I refer to the bulk of rock 'n' roll.

—FRANK SINATRA

In 1956, twenty-one-year-old Elvis Presley became a star. He worked hard that year, appearing in concert 143 times in seventy-nine different cities, was on prime-time network variety shows eleven times, including *The Ed Sullivan Show*, and starred in his first Hollywood film, *Love Me Tender*. He had seventeen songs on Billboard's Top 100 singles chart, including three that reached No. 1: *Heartbreak Hotel*, *Don't Be Cruel*, and *Love Me Tender*.

Rock and roll spread across America in the 1950s. A generation of teenagers rebelled against the music their parents loved and against the parents themselves. They had their own identity now.

When Marlon Brando's character was asked what he was rebelling against in *The Wild One* a few years earlier, he casually replied, "Whaddaya got?" Teens in the 1950s took that to heart.

Photo credit: Alfred Wertheimer/MUUS Collection via Getty Images, 505679735

LITTLE ROCK, ARKANSAS 1957

LITTLE ROCK CENTRAL HIGH SCHOOL
Photograph by George Silk

In 1957, nine African American students put the 1954 decision of *Brown v. Board of Education* to the test when they enrolled at Little Rock High School.

On September 2, the governor of Arkansas, Orval Faubus, threatened to call in the National Guard to block the students' entry, "to preserve the public peace."

A federal judge ordered that the students be allowed in.

When the students arrived on September 4, the governor ordered the National Guard to prevent them from entering the school.

On September 20, after negotiations with the governor failed, a federal judge ordered the National Guard removed. Little Rock police and state troopers, armed with riot guns and tear gas, escorted the students into the school. However, growing violence became so great that they had to remove them three and a half hours later.

The following day, President Dwight Eisenhower federalized the Arkansas National Guard (thus removing it from Faubus's authority) and sent in 1,200 of the U.S. Army's 101st Airborne Division, seen in this pho-

tograph, to enforce *Brown*. The "Little Rock Nine" attended their first full day of classes.

In September 1958, Governor Faubus closed all Little Rock public high schools for the entire school year rather than allowing any further integration.

Photo credit: George Silk/The LIFE Picture Collection/Shutterstock, 11921359f

MARTHA'S VINEYARD, MASSACHUSETTS 1957

THOMAS HART BENTON
Photograph by Alfred Eisenstaedt

Thomas Hart Benton was at the forefront of the Regionalist art movement in America, which rose during the Depression as some artists moved away from European modernist art to embrace the unique identity of the country's heartland. The Regionalists' art told a story accessible to everyday people instead of an intellectual few.

During the late 1930s, Benton completed large murals and individual works for institutions across the country. His stylized approach and outspokenness got him *Time* magazine's first cover story on an artist, featuring a self-portrait and entitled "Thomas Benton's Thomas Benton."

By the close of World War II, interest in Regionalism had waned, and Benton's work fell out of favor. Abstract Expressionism was now on the vanguard in the American art world. A populist, Benton was outspoken in his criticism of the elitism in the art world and defended his own aesthetic.

The *LIFE* magazine photographer Alfred Eisenstaedt took this portrait of Benton in the studio at his summer home on Martha's Vineyard. Eisenstaedt also spent the summers on the Vineyard. "I photographed Benton every year . . . He was my friend, and he is the only person who's ever called me 'Alfie.'"

Photo credit: Alfred Eisenstaedt/The LIFE Picture Collection/Shutterstock, 12474243a

NEW YORK CITY 1959

THE GUGGENHEIM MUSEUM
Photograph by Dennis Stock

The architect must be a prophet . . . a prophet in the true sense of the term . . . if he can't see at least ten years ahead, don't call him an architect.

—FRANK LLOYD WRIGHT

In 1943, Solomon R. Guggenheim commissioned

the architect Frank Lloyd Wright to design a museum to display his unique art collection.

Guggenheim died at the age of eighty-eight in 1949. Although his death delayed construction of the museum, work finally began in 1956. Three years later, ninety-one-year-old Frank Lloyd Wright visited the building site for the last time. He died just two months before the museum opened on October 21, 1959. The Guggenheim Museum defied all preconceptions of architectural design and was as controversial as the architect himself had been. Inside, instead of having separate floors, patrons moved along a spiral ramp that continued for a quarter of a mile around the central rotunda topped by an intricate glass dome. Critics ridiculed the concrete building, calling it "an inverted oatmeal dish" and a "washing machine." The writer Norman Mailer said it "shattered the mood of the neighborhood"—"wantonly" and "barbarically."

But to Wright's admirers, the Guggenheim building was, and remains, a work of art in itself.

Photo credit: Dennis Stock/Magnum Photos, NYC11828/W00005/71-72

VICCO, KENTUCKY 1959

COAL MINING TOWN
Photograph by John Cohen

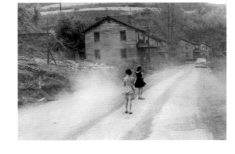

There's a side of ourselves that goes out trying to change the world into our own image. And there's another side of ourselves that goes out trying to find our image in the outside world. And I think it's that second one that's kind of forced me to become who I am.

—JOHN COHEN

John Cohen was a photographer, filmmaker, and founder of the folk revival group the New Lost City Ramblers.

In the spring of 1959, Cohen traveled from his home in New York to eastern Kentucky, searching for traditional musicians. He brought his camera with him to record and better understand what never-ending hard times had brought to the people in Appalachia's backwater coal and timber towns and how that influenced their music.

Five years later, President Lyndon Johnson declared a war on poverty in his State of the Union address. His new programs included Medicaid, Medicare, Head Start, food stamps, more spending on education, and tax cuts to help create jobs.

To show the rest of America the effects of poverty and gather support for his programs, the president, as Cohen had before him, traveled to rural Kentucky to talk with the people.

Photo credit: John Cohen Trust

SAN ANTONIO, TEXAS 1959

JOHNNY CASH
Photograph by Don Hunstein

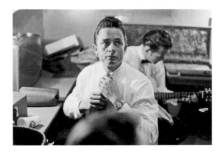

By 1959, Johnny Cash was a star. Only five years earlier, he had been making $50 a week as an appliance salesman; now he was appearing on the shows of Ed Sullivan, Dinah Shore, and Jimmie Rodgers and on track to earn $250,000 a year.

The year before, Cash had moved with his wife Vivian and their two daughters from Memphis to a sprawling house in Southern California. That same summer, he left Sun Records to sign with Columbia, a bigger label that gave him a $50,000 bonus, a better royalty rate, and greater creative freedom in choosing what songs to record.

One of his first albums for Columbia was a collection of gospel songs, *Hymns by Johnny Cash*, followed by *Songs of Our Soil*, filled with stories about hardship and death.

The year before this picture was taken, Cash had performed to a wildly appreciative crowd at San Quentin Prison. Sitting in the audience was a young inmate who had already busted out of juvenile detention centers seventeen times, Merle Haggard.

Haggard later recalled, "He identified with us. And he, he was the kind of guy that might have been in there with us had things gone the wrong way for him."

Photo credit: Sony Music Archives

ATLANTA, GEORGIA 1960

STUDENT NONVIOLENT COORDINATING COMMITTEE
Photograph by James Karales

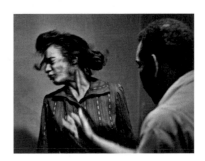

In 1960, Black students in southern college towns began staging sit-ins at restaurants where they were denied service because of their race. These nonviolent protests caught the attention of civil rights advocates around the country and led to the founding of the Student Nonviolent Coordinating Committee in Raleigh, North Carolina. Inspired by this new movement, both Black and white young people volunteered to participate in SNCC protests.

The students met and were taught the philosophy of nonviolence. They were also trained not to react when violence came to them. This photograph—one of James Karales's first assignments for *Look* magazine—is from a training session.

During the sit-ins, the students were brutally verbally attacked and spit

on, had milk, ketchup, sugar, and whatever their tormentor could grab poured over their heads, and had cigarette smoke blown in their faces. They were shoved, slapped, pushed off their stools, and arrested. They were told that God is white.

It was almost impossible to change the minds of the people who believed in segregation, but because the SNCC protests were not violent, the cruelty of Jim Crow stood out all the more sharply.

Photo credit: Amon Carter Museum of American Art, Fort Worth, Texas, P2008.18, "Passive Resistance Training, SNCC, 1960," © 2002 Monica Karales

QUEENS, NEW YORK C. 1960

TWA TERMINAL
Photograph by Balthazar Korab

When Frank Sinatra crooned "Come Fly with Me" in 1958, air travel in America was beginning its heyday, stylish and glamorous, the dawn of the jet age.

Eero Saarinen, the architect of the Trans World Airlines (TWA) terminal in Queens, New York, captured this feeling in his design for the building. Using swooping curves and organically shaped forms, Saarinen created a sculptural vision of the freedom of flight.

Like the country at the beginning of the 1960s, Saarinen's work was hopeful, pointing toward the future. And though purists criticized him on the arbitrariness of some of his designs, Saarinen could not tamp down his own creativity, even admitting about one of his designs, for a water tower at General Motors, that it was "a departure from the completely rational."

Another of Saarinen's most famous projects is the Gateway Arch in St. Louis, constructed out of a slender steel frame standing 630 feet above the Mississippi River.

Saarinen didn't live to see the arch's completion, dying unexpectedly in 1961.

Photo credit: Library of Congress Prints and Photographs, LC-DIG-krb-00604

NEW ORLEANS, LOUISIANA 1960

WILLIAM FRANTZ ELEMENTARY SCHOOL
Photographer unknown

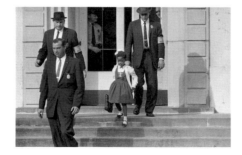

After four years of resistance to the *Brown v. Board of Education* decision, a federal court demanded that Louisiana integrate its schools.

On November 14, six-year-old Ruby Bridges bravely walked into the William Frantz Elementary School. She and her mother Lucille would be escorted by four federal marshals every day that year. In retaliation, white parents withdrew her classmates; her father, Abon, was fired from his job; and the local grocery store refused to sell to her mother. Her grandparents, who were sharecroppers, were evicted from the farm they had lived on for twenty-five years.

On her walks to school, one woman threatened to poison Bridges, and another held out a coffin holding a Black baby doll.

Barbara Henry, a white Boston native, was the only teacher who would have Ruby in her class. For the rest of the year, it was a class of one.

The Harvard professor and child psychiatrist Robert Coles met with Bridges every week to provide emotional support. A relative of Coles sent her the clothes she wore in this photograph. Her family could not have afforded them.

Photo credit: Associated Press, 63611230376

PEMAQUID POINT, MAINE 1960

OCEAN SHORE
Photograph by Erich Hartmann

A large portion of my work is concerned with people, because people are the most inventive and news-making part of our lives . . . Yet I am as much attracted to the evidence of their presence and efforts, whether good or evil, as I am to the people themselves.

—ERICH HARTMANN

In 1938, when he was sixteen, Erich Hartmann and his family escaped from Nazi Germany and emigrated to the United States. He enlisted in the U.S. Army three years later, married, and began his professional photography career. From then on, he carried a camera everywhere he went.

In the water that rushes onto the rocks at Pemaquid Point in Maine, there are echoes of history that go back centuries—from the Abenaki who fished and hunted there, to the first English ship that landed there in 1605, to the lighthouse keepers and captains whose wives and families looked out over the ocean waiting, and to the remains of shipwrecks washed up onto the shore.

About 100,000 people visit Pemaquid Point every year.

Photo credit: Erich Hartmann/Magnum Photos, NYC16496/W00026/09

LOS ANGELES, CALIFORNIA 1960

JOHN F. KENNEDY AND ROBERT
KENNEDY

Photograph by Hank Walker

At the Democratic National Convention in Los Angeles on July 13, 1960, Senator John F. Kennedy won his party's nomination for president.

He chose Texas senator Lyndon B. Johnson as his running mate. Their Republican opponents were forty-seven-year-old Vice President Richard Nixon and his running mate, Henry Cabot Lodge Jr.

The issue that dominated the election was the rising Cold War tensions between the United States and the Soviet Union. Communism and nuclear arms were daily threats in the minds of Americans. And, in 1957, the Soviets had launched Sputnik, the first man-made satellite to orbit Earth, setting off the "space race" and ramping up fears of ballistic missiles. Then Fidel Castro was sworn in as prime minister of Cuba in 1959, bringing the Communist revolution to Latin America.

On November 8, 1960, forty-three-year-old John F. Kennedy was elected president, the youngest in the country's history, in one of the closest contests in U.S. history. In the popular vote, his margin over Nixon was only 118,550 out of a total of nearly 69 million.

Photo Credit: Hank Walker/The LIFE Picture Collection/Shutterstock, 12108114a

WASHINGTON, D.C. 1961

NATION OF ISLAM RALLY

Photograph by Eve Arnold

If you turn the other cheek, you can be enslaved for a thousand years.

—MALCOLM X

Malcolm Little was born in 1925 in Omaha, Nebraska. His mother and father were involved with organizations that fostered African American advancement. Because of that association, the Ku Klux Klan and the Black Legion, a white racist group, targeted the family. When Malcolm was six, his father died in a streetcar "accident." Rumors spread that the Black Legion had killed him.

When he was twelve, his mother suffered a breakdown and was institutionalized, and he and his siblings went into foster homes. Malcolm

dropped out of high school and, after being arrested for several burglaries and firearms charges, ended up with a ten-year prison sentence in 1946.

In prison, Malcolm Little joined the Nation of Islam and changed his name to Malcolm X, explaining that "Little" had been given to him by his ancestors' enslavers.

Paroled in 1952, he became an important minister of the Nation of Islam, preaching Black nationalism—the separation, *not* the integration, of the races. He was uncompromising and radical in his resistance to white oppression, scaring whites and also dividing African Americans. He was eventually expelled by the Nation of Islam for his popularity and politics.

At age thirty-nine, Malcolm X was assassinated by members of the sect, but his influence only grew after his death.

Photo credit: Magnum Photos, LON47143/W00003/13

BIRMINGHAM, ALABAMA 1963

KELLY INGRAM PARK

Photograph by Bob Adelman

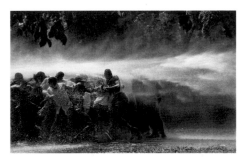

In 1957, the Southern Christian Leadership Conference was founded by civil rights leaders, including Dr. Martin Luther King Jr. and Reverend Fred Shuttlesworth. Its purpose was to coordinate civil rights protest activities across the South.

During the first week of May 1963, the SCLC organized sit-ins, boycotts, and marches in Birmingham, Alabama.

When the adult demonstrators were arrested, the SCLC called on Black children to join the protests. On May 2, police arrested six hundred children. By the next day, one thousand children were jailed.

Images aired on television and in newspapers of children being blasted by high-pressure fire hoses, clubbed by police officers, and attacked by dogs. The world was outraged. The White House and local business owners urged the city's officials to end the violence.

On May 10, 1963, King and Shuttlesworth announced an agreement with the city to desegregate lunch counters, restrooms, drinking fountains, and department store fitting rooms within ninety days, to hire African Americans as salesmen and clerks in stores, and to release hundreds of jailed protestors on bond.

In retaliation, the KKK began its bombing campaign against the Black community in Birmingham.

Photo credit: © Bob Adelman

NEWPORT, RHODE ISLAND 1963

NEWPORT FOLK FESTIVAL
Photograph by Rowland Scherman

Someone's singing, Lord,
 kumbaya.
Someone's crying, Lord,
 kumbaya.
Someone's praying, Lord, kumbaya.
Oh, Lord, kumbaya.

—AFRICAN AMERICAN SPIRITUAL

"Surfin' USA," by the Beach Boys, was the No. 1 hit in 1963. Skeeter Davis followed at No. 2 with "The End of the World." But while pop music may have been at the top of the charts, folk music was having a revival.

Young people, who had listened eagerly to Pete Seeger and Woody Guthrie sing traditional songs, were now hearing songs by musicians like Joan Baez, Arlo Guthrie, Dave Van Ronk, Joni Mitchell, Judy Collins, and Bob Dylan. Some were story songs and old ballads, but others were new songs about the people of America. They were protest songs about race, politics, oppression, and inequality. And they were songs of hope.

The folk revival music bonded young people and gave them a powerful new tool for fighting injustice . . . peacefully.

A month after this photograph was taken at the Newport Folk Festival, Joan Baez sang "We Shall Overcome" with 250,000 people in front of the Lincoln Memorial.

Photo credit: © Rowland Scherman

WASHINGTON, D.C. 1963

MARCH ON WASHINGTON FOR JOBS AND FREEDOM
Photograph by James K. Atherton

Martin Luther King Jr. became pastor of the Dexter Avenue Baptist Church of Montgomery, Alabama, in 1954. He was now the *Reverend* Martin Luther King Jr. and preached nonviolence and civil disobedience as the way to equality.

Starting in 1955, a 382-day bus boycott in Montgomery, Alabama, revealed King as one of the most influential leaders in the civil rights movement. He was arrested, his home was bombed, and he suffered personal abuse. But in November 1956, the Supreme Court ruled that the laws requiring segregation on buses were unconstitutional.

In 1962, FBI Director J. Edgar Hoover created a file on King, marking him a Communist and a threat to American society. It began a six-year campaign of character assassination.

On August 28, 1963, in a well-coordinated effort by civil rights organizers, people came from all across the country to Washington, D.C., to hear King tell them of his dream for equality between the races. He was thirty-four years old.

That year he was named Man of the Year by *Time* magazine.

The following year, King received the Nobel Peace Prize. He donated the award money to the civil rights movement.

Photo credit: Library of Congress Prints and Photographs, LC-DIG-ppmsca-08109

NEW YORK CITY 1963

LEW ALCINDOR
Photograph by Richard Avedon

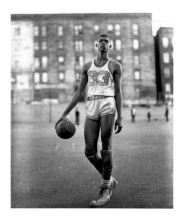

And if a day goes by without my doing something related to photography, it's as though I've neglected something essential to my existence, as though I had forgotten to wake up.

—RICHARD AVEDON

At twelve years old, Richard Avedon joined a Young Men's Hebrew Association camera club in New York City. Using a Kodak Brownie camera, he began taking photographs.

After serving for two years in the Merchant Marines, Avedon stepped into the world of fashion in 1944 and soon became the lead photographer for *Harper's Bazaar*. In 1966, he moved to *Vogue*. From then on, his revolutionary portraits were on the cover of almost every issue.

When sixteen-year-old Lew Alcindor posed for Avedon in May 1963, he was the star center at the all-boys Power Memorial Academy in New York City. The photograph appeared in a special 1965 issue of *Harper's*, simultaneously reflecting the elegance and talent of both the photographer and the subject.

Lew Alcindor converted to Islam, and in 1971 changed his name. He described his decision this way: "I used to be Lew Alcindor, the pale reflection of what white America expected of me. Now I'm Kareem Abdul-Jabbar, the manifestation of my African history, culture, and beliefs."

Photo credit: © The Richard Avedon Foundation

GREENWOOD, MISSISSIPPI 1963

VOTER REGISTRATION RALLY

Photograph by Danny Lyon

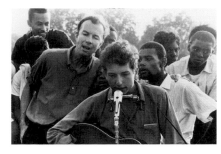

In July 1963, Bob Dylan and Pete Seeger traveled to Greenwood, Mississippi, and gathered with civil rights workers at a Student Nonviolent Coordinating Committee voter registration rally on Silas McGee's farm. They sang Dylan's new song about the murder of civil rights leader and activist Medgar Evers, "Only a Pawn in Their Game."

One month before, Evers parked his car in his driveway and walked toward the front door. He was shot in the back by a member of the Ku Klux Klan. It was only a few hours after President Kennedy finished his nationally televised speech on the rights of African Americans:

> One hundred years of delay have passed since President Lincoln freed the slaves, yet their heirs, their grandsons, are not fully free. They are not yet freed from the bonds of injustice. They are not yet freed from social and economic oppression. And this Nation, for all its hopes and all its boasts, will not be fully free until all its citizens are free . . . Those who do nothing are inviting shame as well as violence. Those who act boldly are recognizing right as well as reality.

Photo credit: Magnum Photos, NYC10617/W00002/13

BIRMINGHAM, ALABAMA 1963

16TH STREET BAPTIST CHURCH

Photograph by Burton McNeely

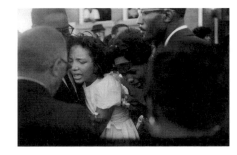

It was a quiet Sunday morning in Birmingham, Alabama—10:24 on September 15, 1963—when a bomb exploded in the back stairwell of the 16th Street Baptist Church. On their way downstairs to closing prayers, four African American girls were killed, and twenty more people were injured.

The church had been a rallying point for civil rights activists throughout the spring and summer. However, when they reached an agreement with local officials to begin integrating schools after the protests in Kelly Ingram Park, it outraged segregationists and led to the bombing.

More than eight thousand people attended the public funeral for three of the girls. Not a single city or state official attended. A month later, no one had been arrested for the bombing, although police arrested twenty-three African Americans near the church for disorderly conduct and other charges. After throwing rocks at passing cars with white passengers, one Black youth was shot and killed by a policeman who claimed he had only meant to fire a warning shot.

Despite years of investigation by the FBI, the four KKK members responsible for the murders were not charged until forty-five years later. All but one, who had died earlier, were eventually found guilty and sentenced to life in prison.

Photo credit: Burton McNeely—LIFE magazine

ARLINGTON COUNTY, VIRGINIA 1963

ARLINGTON NATIONAL CEMETERY

Photograph by Eddie Adams

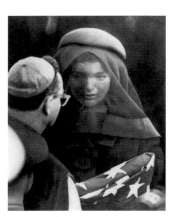

> Mrs. Kennedy, this flag is presented to you in the name of a most mournful nation.
>
> —JACK METZLER, Superintendent of Arlington National Cemetery

John F. Kennedy was assassinated in Dallas, Texas, on November 22, 1963. Later that day, Vice President Lyndon B. Johnson took the oath of office aboard Air Force One and assumed the presidency.

Three days of solemn ceremonies followed.

On Saturday, the president's casket lay in the East Room of the White House, where nearly one hundred years earlier the body of Abraham Lincoln had rested. A private mass was held.

The following day, a black gelding with an empty saddle and boots reversed in the stirrups followed the caisson bearing the casket in the funeral procession from the White House to the Capitol Rotunda. There, hundreds of thousands of mourners said final goodbyes.

Then, on Monday, as the funeral procession carried Kennedy to St. Matthew's Cathedral and Arlington National Cemetery, a million mourners lined the streets to pay their respects.

Shortly after three in the afternoon, a bugler in the U.S. Army played taps before the casket, and Jacqueline Kennedy lit the eternal flame at the gravesite of her husband.

Photo credit: Associated Press, 6311250200

GREENWOOD, MISSISSIPPI 1964

LEFLORE COUNTY COURTHOUSE

Photographer unknown

It took courage for this unknown woman to walk into the LeFlore County Courthouse in Greenwood, Mississippi, to register to vote.

The story of another woman, named Fannie Lou Hamer, shows just how harrowing that journey to the ballot box could be. In 1962, forty-four-year-old Hamer attended a meeting of the Student Nonviolent Coordinating Committee and learned that she had the right to vote.

She drove with seventeen activists from Ruleville, Mississippi, to Indianola to register but failed the literacy test, which involved interpreting a portion of the state constitution.

Back home, the owner of the plantation where she and her husband were sharecroppers told her to withdraw her registration or be fired. Hamer left, and three days later, white supremacists shot up the home where she was staying.

Continuing to work with SNCC to register Black voters, she was beaten and threatened.

In 1964, Hamer, representing the Mississippi Freedom Party, spoke at the Democratic National Convention. That same year she ran for Congress, and although the Democratic Party did not allow her on the official ballot, her name was written on an unofficial ballot, and Hamer voted for the first time.

She continued to speak for the civil rights movement until her death in 1977.

Photo credit: Amistad Research Center at Tulane University, New Orleans, Louisiana/John O'Neal Papers, Box 14, Folder 14x

PORTLAND, OREGON 1964

IVY

Photograph by Minor White

Minor White was born in Minneapolis in 1908. He earned degrees in botany and English literature at the University of Minnesota and served in the South Pacific during World War II.

After the war, White traveled the country, meeting and learning from photographers, including Ansel Adams, Paul Strand, Edward Weston, Edward Steichen, Alfred Stieglitz, Imogen Cunningham, and Dorothea Lange.

He would go on to inspire and teach a generation of young photographers. A poet and a student of mystical religions, White wrote,

The first "visions" are given to us to let us know that they are possible . . . I seek out places where it can happen more readily, such as deserts or mountains or solitary areas, or by myself with a seashell, and while I'm there get into states of mind where I'm more open than usual. I'm waiting, I'm listening. I go to those places and get myself ready through meditation. Through being quiet and willing to wait, I can begin to see the inner man and the essence of the subject in front of me . . . Watching the way the current moves a blade of grass—sometimes I've seen that happen and it has just turned me inside out.

Photo credit: The Minor White Archive, Princeton University Art Museum, bequest of Minor White (x1980-5667), © Trustees of Princeton University

PHILADELPHIA, PENNSYLVANIA 1964

SANDY KOUFAX

Photograph by Walter Iooss

Sandy Koufax was raised in a Jewish neighborhood in Brooklyn. He hadn't planned on being a ballplayer. In his first year of college, he was studying to be an architect and playing basketball.

But it was the speed with which Koufax threw a *baseball* that attracted the attention of scouts for the Brooklyn Dodgers. They signed him at nineteen and sent him directly to the majors.

His career did not get off to a promising start: he threw the ball with demon speed but little control for six years, losing more games than he won.

In 1961, Norm Sherry, a veteran catcher, quietly told him he didn't need to throw so hard to get men out.

For five years, Koufax dominated the National League, winning five ERA titles, pitching four no-hitters, and winning the Cy Young Award three times—despite excruciating pain from an elbow damaged before he had learned to pace himself.

He pitched a no-hitter every year from 1962 to 1965. In 1965 alone, he struck out 382 batters, 33 more than the record set by Rube Waddell in 1904.

Koufax did not argue with umpires, did not throw at batters, engaged in no theatrics. "He'll strike you out," an opposing batter said. "But he won't embarrass you."

Photo credit: Getty Images, Sports Illustrated Classic, 452573350

GLEN CANYON, UTAH 1964

CATHEDRAL IN THE DESERT
Photograph by Philip Hyde

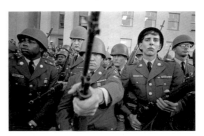

Cathedral in the Desert was the ulti-
mate magical place in Glen Canyon . . .
when you walked into that, it was so
much like a cathedral that you felt you
better be quiet there—and we were.

—DAVID BROWER

In 1963, the U.S. Department of Reclamation finished the construction of
the Glen Canyon Dam. The 710-foot-high concrete structure spans the
sandstone cliffs carved out by the Colorado River in northern Arizona. A
reservoir 186 miles long and stretching to southern Utah was created when
the dam was completed.

David Brower, executive director of the Sierra Club, tried to convince
President Kennedy to halt the project. But Floyd Dominy, the commis-
sioner of the Bureau of Reclamation, called a Colorado River without
dams "useless to anyone," adding, "I've seen all the wild rivers I ever want
to see."

As the water slowly rose over seventeen years, it covered thousands of
years of natural and Native American history.

One of the most spectacular caverns along the river is called the "Cathe-
dral in the Desert," shown before it was flooded in this photograph by
the influential landscape photographer and lifelong conservationist Philip
Hyde.

Photo credit: Courtesy of the Estate of Philip Hyde

QUEEN COUNTY, VIRGINIA 1965

RICHARD AND MILDRED LOVING
Photograph by Grey Villet

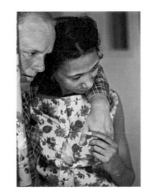

Almighty God created the races white, black, yel-
low, malay and red, and he placed them on sepa-
rate continents. The fact that he separated the
races shows that he did not intend for the races
to mix.

—JUDGE LEON M. BAZILE,
U.S. District Court of the Eastern District of Virginia

When Richard Loving and Mildred Jeter married in Washington, D.C., in
1958, interracial marriage was a crime in their home state of Virginia. But
Mildred was unhappy in the city, and the couple moved back to Virginia,

where they were discovered and arrested. Richard got out, but Mildred
spent three days in jail until she was finally released. They were brought
to trial and charged with violating Virginia's Racial Integrity Act. The
judge, Leon Bazile, told them to leave Virginia for twenty-five years or go
to prison.

In 1964, Mildred wrote to Attorney General Robert Kennedy, who
referred her to the ACLU. Two lawyers took their case. Then, the *LIFE*
magazine photographer Grey Villet met and photographed the Loving
family, and their story reached the public in 1966.

Loving v. Virginia made its way to the Supreme Court in 1967. In a
unanimous decision, the Court declared Virginia's law against interracial
marriage unconstitutional.

Photo credit: Grey Villet Photography

WASHINGTON, D.C. 1967

MARCH ON THE PENTAGON
Photograph by Leonard Freed

Hey, hey LBJ, how many kids did you
kill today?

—ANTI-VIETNAM WAR CHANT

In 1954, a treaty was signed in Geneva, splitting the country of Vietnam
in two. In the north was a Communist regime, and in the south, an anti-
Communist government supported with aid and military advisors, but
not combat troops, by the United States.

In 1965, President Lyndon B. Johnson sent the first ground troops—
3,500 Marines—to fight alongside the South Vietnamese.

By 1967, almost half a million American troops were stationed there.
Although the government insisted that the war was being won, Americans
were watching horrific images of battle on television, and casualties were
growing.

On October 21, 1967, an estimated thirty-five thousand to fifty thou-
sand antiwar activists, most under the age of thirty, marched to the Penta-
gon, where they were met by an equally young force of U.S. Marshals and
military police. What started as civil disobedience turned into a melee.
Over six hundred protestors were arrested. Dozens of people on both sides
were hurt.

The Washington Post reported, "They came, and they confronted . . .
and nothing changed. The war goes on." But things had changed. A cul-
ture war had begun at home.

Photo credit: Leonard Freed/Magnum Photos, NYC26089/W00016/25

MARINE CORPS RECRUIT DEPOT

Photograph by Master Gunnery Sergeant Mosier

Between 1963 and 1973, more than 200,000 Marine Corps recruits trained at Parris Island in South Carolina.

When they arrived at the training center, they had their heads shaved and were given green utility uniforms. With the drill instructors yelling in their faces, they were forced to keep their eyes averted—never make eye contact, never speak unless to scream, "Yes, sir!"

They ran for miles, did squats, jumping jacks, and push-ups, crawled under barbed wire, swam, and treaded water for what might have seemed like an eternity. They learned to use knives, pistols, rifles, and explosives.

They were broken down in order to be built up, trained to kill and to protect their fellow corps members and their country with their lives if necessary.

And they were taught the Marine motto, "Semper fidelis"—always faithful—to which the reply was often "Oorah"—ready for battle.

Nearly one of every four Marines serving in Vietnam would be killed or wounded.

Photo credit: National Archives and Records Administration, 127-GG-921-A602348

DELANO, CALIFORNIA 1968

"MASS OF THANKSGIVING"

Photograph by George Ballis

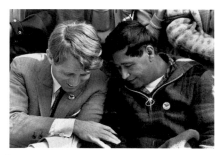

And though you may be old and bent from many years of labor, no man will stand taller than you when you say, "I marched with César."

—ROBERT KENNEDY

By 1968, grape workers in California had been on strike, and organizing boycotts of products from grape growers, for more than two years. But with no success, the younger strikers started talking about resorting to violence.

The leader of the United Farm Workers, César Chávez, following in the footsteps of Mahatma Gandhi and Martin Luther King Jr., announced that he was fasting to rededicate the movement to nonviolence. He went without food for twenty-five days.

Sitting beside Senator Robert Kennedy, Chávez ended his fast. Weak from hunger, his speech was read for him: "It is how we use our lives that determines what kind of men we are."

Inspired, activists traveled across the U.S. and Canada. They showed people that they could help the migrant workers, who had lost so much, by simply not eating grapes. Finally, grape growers signed their first union contracts with the workers in 1970.

Less than three months after this photograph was taken, Kennedy was mortally wounded in the Ambassador Hotel in Los Angeles.

Photo credit: George Ballis, Take Stock/TopFoto, TKS3670613

MEMPHIS, TENNESSEE 1968

SANITATION WORKERS STRIKE

Photograph by Ernest C. Withers

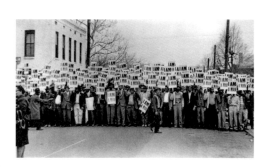

On February 1, 1968, it was raining in Memphis. Echol Cole and Robert Walker took shelter in the back of their garbage truck and were crushed to death when a switch malfunctioned. Eleven days later, 1,300 city sanitation workers went on strike for safer working conditions. The mayor of Memphis, Henry Loeb III, refused their demands.

Martin Luther King Jr. came to Memphis on March 16. In a demonstration that included African Americans and whites, some activists grew violent. King removed himself from the violence but was blamed for it, nonetheless. Loeb declared martial law and called in nearly four thousand National Guards.

The following day, after King had gone back to Atlanta, the sanitation workers continued to march—at gunpoint—carrying signs that read "I Am a Man."

King returned to Memphis on April 3 to support the strike once again. He spoke at the Mason Temple and told the people that *they* would reach the promised land, even if he didn't get there with them.

The next evening, King was shot and killed on the balcony of the Lorraine Motel.

Photo credit: © Dr. Ernest C. Withers Sr., courtesy of the WITHERS FAMILY TRUST

ATLANTA, GEORGIA 1968

MARTIN LUTHER KING JR. FUNERAL

Photographer unknown

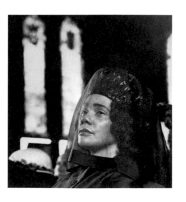

On April 8, 1968, four days after her husband was assassinated, Coretta Scott King, dressed in black, led a silent march through downtown Memphis with three

of her children and some forty-two thousand people in support of striking sanitation workers.

The next day, at the private service held for King at the Ebenezer Baptist Church in Atlanta, excerpts from a speech that he had given in February in the same church were played for the mourners. He had imagined his funeral and asked the people to remember him simply—as a servant for justice.

A slow procession carried King's body from the church to Morehouse College for a public service.

The streets were so full that people climbed trees and light posts and sat on rooftops to be there. As the casket passed the Georgia Capitol, marchers sang a civil rights song adapted from an old African American spiritual.

Ain't gonna let nobody turn me around
Turn me around, turn me around
Ain't gonna let nobody turn me around
I'm gonna keep on a-walkin', keep on a-talkin'
Marchin' down to freedom land.

Photo credit: Getty Images, 517481426

SONOMA COUNTY, CALIFORNIA 1968

POMO TRIBAL BURIAL
Photograph by Hansel Mieth

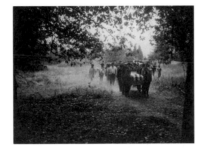

On May 23, 1968, Specialist Four Rodney Elmer Marrufo Jr., the son of the chief of the Kashia Band of Pomo Indians in California, was killed in the Vietnam War.

His tour of duty had begun just six months before when he'd joined the 25th Infantry Division, 38th Infantry Platoon. There, he'd learned to train and work with Vietnam "Scout Dogs." Thousands of these specially trained dogs served as sentries, guarding airfields and base camps. Others went directly into combat with troops to help them detect snipers, booby traps, ambushes, and underground tunnels.

Specialist Four Marrufo was killed when he was struck by rocket fragments during a firefight. He was just nineteen years old. Posthumously, he was awarded a Silver Star for his bravery in action.

Seven years later, on April 30, 1975, Saigon fell to the North Vietnamese, and the last Americans were airlifted out of the country. The conflict that had started twenty years before was over.

More than 3 million soldiers and civilians had lost their lives.

Photo credit: © Center for Creative Photography, the University of Arizona Foundation, photograph by Hansel Mieth, 98.122.50

PINE RIDGE INDIAN RESERVATION, SOUTH DAKOTA 1969

SACRED HEART CATHOLIC CHURCH
Photograph by Elliott Erwitt

On December 29, 1890, near Wounded Knee Creek on the Pine Ridge Indian Reservation, the U.S. Army's 7th Cavalry surrounded a band of Native American Ghost Dancers. The Ghost Dance was a spiritual ritual—a call to their ancestors for protection from the whites. The soldiers demanded that they surrender their weapons. One of the Lakota men fired a shot, and the cavalry, in turn, fired at will, killing several hundred, including women and children.

We followed down along the dry gulch, and what we saw was terrible. Dead and wounded women and children and little babies were scattered all along there where they had been trying to run away . . . but I was not sorry for the women and children. It was better for them to be happy in the other world. And I wanted to be there too.

—HEȞÁKA SÁPA (BLACK ELK)

Photo credit: Magnum Photos, NYC103711/W00139/11

BETHEL, NEW YORK 1969

WOODSTOCK
Photograph by Baron Wolman

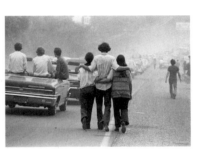

The summer of 1969 was wet in Bethel, New York, and farmer Max Yasgur could not put in his crop for hay. Then, in August, four young men came and asked him if they could lease his field for a concert, and he said yes.

A political conservative himself, fifty-five-year-old Yasgur still believed in the right of expression.

But when the town got wind of who was coming to the concert, they were not so accommodating. Signs went up along the road reading, "Don't buy Yasgur's milk. He loves the hippies."

Days before the concert began, crowds of young people descended on Bethel. The roads were so clogged that most just parked where they could and walked to Yasgur's farm. The promoters finally tore down the fence, and it became a free concert.

From Friday night to Monday morning, jammed together on a hillside of mud, in conditions that were very far from ideal, almost 500,000 "hippies" and dozens of musicians were part of what *Time* magazine called the "greatest peaceful event in history."

Photo credit: © Baron Wolman Collection, Rock and Roll Hall of Fame

PALATINE, ILLINOIS 1970

FOREST PATH
Photograph by Judson Hofmann

The road we have long been traveling is deceptively easy, a smooth superhighway on which we progress with great speed, but at its end lies disaster. The other fork of the road—the one less traveled by—offers our last, our only chance to reach a destination that assures the preservation of the earth.

—RACHEL CARSON, *Silent Spring*, 1962

Pioneers first came to Palatine, Illinois, on the outskirts of the new city of Chicago, in the early nineteenth century. They settled in forest groves known as Deer Grove, Plum Grove, Englishman's Grove, and Highwaymen's Grove.

Between 1966 and 1974, Palatine developed fifteen parks on land that had escaped settlement. Today, 127 trails are protected for its citizens to enjoy.

The same year this photograph was taken, Wisconsin senator Gaylord Nelson, inspired by nationwide anti-Vietnam peaceful protests, sit-ins, and teach-ins, proposed a day to celebrate the planet and learn how to protect it—Earth Day. On April 22, 1970, an estimated 20 million people attended events at thousands of sites, including schools, universities, parks, and community areas across the country. Public pressure to clean up the planet grew.

In 1972, over President Richard Nixon's veto, Congress passed the Clean Water Act.

Photo credit: Judson Hofmann

NEW YORK CITY 1971

WORLD TRADE CENTER
Photograph by Jean-Pierre Laffont

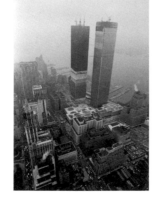

As an architect, if I had no economic or social limitations, I'd solve all my problems with one-story buildings. Imagine how pleasant it would be to always work and plan spaces overlooking lovely gardens filled with flowers.

—MINORU YAMASAKI

The architect Minoru Yamasaki was born in Seattle in 1912 to Japanese immigrants.

In 1962, the Port Authority of New York, responsible for constructing the proposed World Trade Center complex in Lower Manhattan, chose Yamasaki's design for twin towers surrounded by five other buildings. The architect called the center "a monument to peace."

The design of the towers was revolutionary, from the outer shell construction to the innovative elevator system, both of which allowed for a maximum amount of space for offices.

Completed in 1973, the World Trade Center became home to more than 430 companies. Eventually, an estimated fifty thousand people worked and tens of thousands visited there on any given day. The entire complex was so large that it had its own zip code.

Not many outside the world of architecture know the name Minoru Yamasaki. He died in 1986, fifteen years before his towers came down.

Photo credit: Photo © JP Laffont

WASHINGTON, D.C. 1973

WATERGATE HEARINGS
Photographed by Gjon Miliv

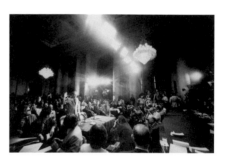

I don't know if a tape exists, but if it does exist . . . I think this Committee should have that tape.

—JOHN DEAN

On the night of June 17, 1972, Frank Wills, a security guard at the Watergate complex in Washington, D.C., noticed that someone had tampered with the locks. He called the police, who arrested five men inside the headquarters of the Democratic National Committee.

Although investigations into the burglary implicated several people close to President Nixon, he won a second term in November. The following April, White House Counsel John Dean began cooperating with federal prosecutors, and the Senate created a special committee to investigate the president's involvement. On June 25, 1973, Dean, in front of a live television audience, revealed that there might be secret tapes that would verify suspicions that Nixon was involved in planning the burglary and trying to cover up the investigations. Several weeks later, on July 13, Alexander Butterfield, the Deputy Assistant to Nixon, confirmed that the tapes did indeed exist.

After a Supreme Court ruled against Nixon's claim of executive privilege, the committee was able to obtain the tapes, which justified drawing up formal impeachment charges. On August 9, 1974, Nixon bowed to pressure and became the only president in U.S. history to resign from office.

Photo credit: Getty Images, 50602846

NEAR SODOM, NORTH CAROLINA 1976

ERNEST FRANKLIN
Photograph by Harvey Wang

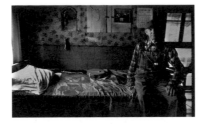

Life was hard for Scottish and Irish settlers in the hills of Appalachia. But throughout the years, they found time to gather with family and neighbors to share the ballads and fiddle tunes they had brought with them from home. That music was passed down through the generations and is a tradition in Madison County, North Carolina.

In 1976, Harvey Wang, a photography and anthropology student at Purchase College in New York, traveled through Madison County to document the culture of the isolated Appalachian communities. There, in Sodom, he met and photographed Ernie Franklin.

Franklin lived with his mother in a small house located off a dirt track in a remote holler. There was no electricity or plumbing. Oil lamps provided light, and a coal stove kept it warm.

An accomplished musician, Franklin made fiddles, like his grandfather before him. But his specialty was the fretless banjo, a craft learned from his father. He made his first banjo from a wooden cigar box. The next he made with a wooden top, rather than using hide, and many more followed. All the instruments were crafted using hand tools, some that Franklin made himself, and others that had been passed down through the generations.

Photo credit: Harvey Wang

NEW YORK CITY 1977

MUHAMMAD ALI
Photograph by Marty Lederhandler

Cassius Clay was born in 1942 in Louisville, Kentucky.

Four years after winning the light-heavyweight gold medal at the Olympic Games in Rome in 1960, he became the world heavyweight champion in 1964, defeating Sonny Liston in six rounds. Over the course of twenty-one years, he lost only five bouts out of sixty-one. Full of bravado, often taunting his opponents, he proclaimed himself "the Greatest."

In 1964, Clay joined the Nation of Islam and later changed his name to Muhammad Ali. On the grounds of religious beliefs, in 1967 he refused to be inducted for the war in Vietnam and was charged with draft evasion and stripped of his world title and boxing license. After a series of appeals, the Supreme Court overturned his conviction in 1971, and he returned to the ring.

Deeply religious, a symbol of Black pride, and some say the best boxer of all time, Ali was also a goodwill emissary, philanthropist, and social activist.

After he was diagnosed with Parkinson's disease he retired from boxing in 1981.

At Ali's death in 2016, President Barack Obama reflected, "Muhammad Ali shook up the world. And the world was better for it."

Photo credit: AP Images, 7709290121

WASHINGTON, D.C. 1982

MAYA LIN, VIETNAM VETERANS MEMORIAL
Photograph by John McDonnell

In April 1981, a panel of eight architects and sculptors gathered in an airplane hangar at Andrews Air Force Base to choose the winning design for a Vietnam War memorial. They chose the design of Maya Lin, a twenty-two-year-old senior at Yale University.

Some who believed that the war had been unjust and immoral feared the monument was somehow meant to glorify it. *The New York Times* wrote,

> Ideas about heroism, or art, for that matter, are no longer what they were before Vietnam. And there is certainly no consensus yet about what cause might have been served by the Vietnam War.
>
> But perhaps that is why the V-shaped, black granite lines merging gently with the sloping earth make the winning design seem a lasting and appropriate image of dignity and sadness. It conveys the only point about the war on which people may agree: that those who died should be remembered.

Photo credit: The Washington Post, Getty Images, 145339667

CANNON BEACH, OREGON 1986

BASALT ROCKS
Photograph by William Turner

The grandest and most pleasing prospects which my eyes ever surveyed, inoumerable rocks of emence Sise out at a great distance from the Shore and against which the Seas brak with great force gives this Coast a most romantic appearance.

—FROM THE JOURNAL OF WILLIAM CLARK

In January 1806, the Corps of Discovery, led by Meriwether Lewis and William Clark, were low on food. They were wintering over at the fort

they had built at the mouth of the Columbia River in Oregon before they began the long journey back East.

Having received a report that a whale had washed ashore south of them, Clark took a band of men and their Shoshone guide Sacagawea to get some blubber and replenish their provisions. Finally, after a two-day, thirty-five-mile trip, they arrived at what is now known as Cannon Beach, seen in this photograph taken almost two hundred years later.

After reaching the whale, however, they discovered that the Tillamook natives had stripped the carcass bare. All that was left was a skeleton—105 feet long.

Clark bargained for three hundred pounds of blubber and a few gallons of whale oil from the Tillamook and headed back to Fort Clatsop.

Photo credit: William E. Turner

EAST WINDSOR, CONNECTICUT 1986

KU KLUX KLAN
Photographer unknown

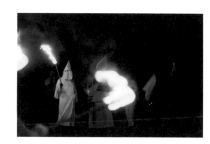

In 1979, twenty-nine-year-old David Duke, the "Grand Dragon" of the Ku Klux Klan, began a recruiting drive for new members in Connecticut.

He proclaimed that the Klan was not anti-Black or anti-Jewish, but "simply pro-white and pro-Christian."

In December of that year, Duke held a meeting at the Grange Hall in Danbury, where they watched *The Birth of a Nation*, a movie from 1915 in which white-robed Klansmen play the heroes. When Klansmen tossed the corpse of a "Black" man (a white actor in blackface) with a KKK sign around his neck onto the porch of a politician as a warning, Duke applauded—and others in the room joined in.

That Christmas, Duke sent out Christmas cards. They read, "May you have a meaningful and merry Christmas, and may they forever be White."

Throughout the mid-1980s, the Klan held rallies in Connecticut. Although its influence began to wane, as of 2014, according to the Southern Poverty Law Center, there was still a faction of the Klan in the state—the Loyal White Knights.

Photo credit: Getty Images, 514678112

NEW YORK CITY 1989

KOREY WISE
Photograph by John Pedin

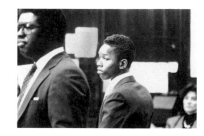

On the night of April 19, 1989, a jogger was brutally beaten and raped in New York City's Central Park. Five teenag-

ers, Antron McCray, Kevin Richardson, Yusef Salaam, Raymond Santana, and Korey Wise were convicted of the crime.

Peter Jennings (ABC): "Some of the young men told police that they were just out 'Wilding.'"

Jeanne Moos (CNN): "'Wilding' is a word you won't find in Webster's . . ."

Tom Brokaw (NBC): "'Wilding.' New York City police say that's new teenage slang for rampaging in wolfpacks, attacking people just for the fun of it."

A *New York Post* columnist wrote that the teens were "from a world of crack, welfare, guns, knives, indifference and ignorance . . . a land with no fathers . . . to smash, hurt, rob, stomp, rape. The enemies were rich. The enemies were white."

New York City mayor Ed Koch called it "the crime of the century."

In 2002, after serving sentences that ranged from six to thirteen years, new DNA evidence and a confession from another man proved that the five men were innocent.

Photo credit: John Pedin, New York Daily News Archive, Getty Images, 97258131

DETROIT, MICHIGAN 1993

ROSA PARKS
Photograph by Donna Terek

In 1993 in New York City, at the Essence Awards honoring outstanding African American women, eighty-year-old Rosa Parks, dressed in a long gown, made her way slowly to the stage. Everyone in the packed auditorium stood and applauded.

"Thank you," she said. "It's a long way from the suffering that we endured in Alabama."

Four decades before, Montgomery, Alabama, was one of the most segregated cities in the South. On the city's buses, a Black person had to pay the fare, get out, and reenter the bus through the back door, where signs and lines indicated the divide between African Americans and whites. However, if the bus got full, the driver could move those lines to provide more room for white passengers, and the Black passengers would have to crowd into the back of the bus.

On December 1, 1955, a bus driver ordered Parks to give up her seat to a white passenger. She refused and was arrested.

The civil rights movement as we know it began four days later with a bus boycott. African Americans who didn't have a ride walked to work for 382 days. On December 20, 1956, the Supreme Court ordered Montgomery to integrate its buses.

Photo credit: Library of Congress Prints and Photographs, LC-DIG-ppmsca-47113

MASHANTUCKET PEQUOT RESERVATION,
CONNECTICUT 1996

TOMMY CHRISTIAN, SCHEMITZEN POWWOW

Photograph by Lauren Grabelle

> I wasn't doing it for show. I was doing it for the process of continuing this journey that I am on, this red road of healing.
>
> —TOMMY CHRISTIAN

In 1996, Tommy Christian, an Assiniboine Sioux, danced and won the championship at the Schemitzen Powwow on the Mashantucket Pequot Reservation in Connecticut. Schemitzen (pronounced *ski-met-zun*) means "Festival of the Green Corn" and comes from a practice that had existed for more than a thousand years of braiding corn husks and storing them in underground pits.

Powwows began in the mid-1870s as a way of helping tribes hold on to their traditional culture. Over time, they have become intertribal celebrations where Native Americans from across the country compete in dance, sing, and share other customs. It is a time to make sure that the young can hold on to their ancestors' ways and a time to share that culture with non-native people.

A former social worker for the Bureau of Indian Affairs, champion dancer, and powwow MC, Tommy Christian has said that he sees things from the perspective of a Native American: "I just choose to be with Indians, and that is how I balance. I stay Indian."

Photo credit: "Tommy in His Car," Lauren Grabelle

CLAIBORNE COUNTY, MISSISSIPPI 1998

WINDSOR MANSION PLANTATION

Photograph by Sally Mann

In 1996, the photographer Sally Mann received a commission from the High Museum of Art in Atlanta to take photographs for their ongoing project "Picturing the South." Her "awestruck, heartbreaking trips down South" led her through Georgia, Alabama, Louisiana, and Mississippi. She photographed swamplands, fields, plantation ruins, and even the Tallahatchie Bridge, with its sad story. Mann described the landscape of the South as "terrible in its beauty, in its indifference."

Windsor Mansion was located on a plantation covering 2,600 acres. Enslaved African Americans built it between 1859 and 1861 for Smith Cof-

fee Daniell II, a cotton planter, and his family. It burned to the ground in 1890, leaving only twenty-three Corinthian columns.

Photo credit: © Sally Mann, courtesy Gagosian, "Deep South, Untitled (Valentine Windsor)," 1998

NAVAJO RESERVATION, ARIZONA 1989

ANTELOPE CANYON

Photograph by Bruce Barnbaum

There are many canyons in the dry, rocky landscape of Southwest America. One unique type is the slot canyon, which has high vertical walls carved from red sandstone by seasonal flooding rains. The water, full of stones and hard minerals, washes through the dry land and creates narrow openings through the softer rock layers.

Antelope Canyon is a slot canyon located on the Navajo reservation, east of Page, Arizona. In some places, the canyon is more than eighty feet deep and only a few feet wide, just enough to walk through. At different times of the day, shafts of sunlight filter through the rock formations.

When the photographer Bruce Barnbaum took this photograph of a branch of Antelope Canyon, which lies between Lower Antelope Canyon and Upper Antelope, tourism for these natural wonders was growing. He had been photographing the canyons for eighteen years, and where once he had time to appreciate their swoops and curls, tourists had become too much of a distraction. This photograph was taken on his last trip there.

Photo credit: Bruce Barnbaum

NEAR MENDOCINO, CALIFORNIA 2005

BOWLING BALL BEACH

Photograph by William Scott

In a country with one of the most diverse landscapes on Earth, the state of California alone has a wealth of natural wonders: twisted Joshua "trees" (actually giant yucca plants) that can live for five hundred years; Death Valley, the hottest place on Earth; giant sequoia trees with names like General Grant and General Sherman that are 2,200 to 2,700 years old; Moro Rock, 576 feet tall, formed around 23 million years ago by cooling lava in volcanoes; Yosemite's granite Half Dome, which soars more than eight thousand feet into the sky; Crystal Cave, where some of the crystals measure up to thirty-six feet long and weigh up to fifty-five tons; and a petrified forest where, over 225 million years, fallen trees have turned entirely into stone.

One smaller wonder is on Schooner Gulf Beach near Mendocino in Northern California. There, almost identical round boulders line the shore like an army of stone. They were formed by a geological phenomenon called "concretion," a process lasting millions of years, during which minerals bind sand and stone together in the mudstone cliffs. Gradually, erosion washed away the softer material, and the hard round rocks—two to three feet in diameter—tumbled onto the beach, appearing only at low tide.

Photo credit: William Scott, courtesy of Photography West Gallery, Carmel-by-the-Sea, California

CLAPBOARD HOUSE WITH FLAG

Photograph by Keith Dotson

The village of Friendship was founded in 1857 by settlers from New York. By 1876, they had four general stores, a hotel, a post office, two blacksmiths, a carpenter, a wagon maker, and three lawyers. The leading citizen, a Civil War veteran, also ran the newspaper.

The population stayed around 250 for the rest of the nineteenth century. In 1912, Dr. Glenn F. Treadwell came to Friendship. He married the schoolteacher Nell Daly and, after a brief leave, spent the next forty years there, answering his own phone and making house calls.

After World War I, Friendship buried its dead, as did the rest of the country. Private McKinley W. Cole, who had perished at the age of twenty-two, less than five months after enlisting, was buried in Mount Repose Cemetery.

In the 1930s, with the help of the New Deal, Friendship built a water and sewer system. And in the 1940s, they again sent their sons and daughters to war. In the 1950s, Friendship built its first hospital.

Vietnam claimed one from Friendship—Army Sergeant William Wayne Van Mater, killed in action on September 22, 1968.

The village continued to grow for the rest of the twentieth century and into the next. In 2020, there were 625 men, women, and children who called Friendship home.

Photo credit: Keith Dotson

MURFREESBORO, TENNESSEE 2014

RAINDROPS

Photograph by Keith Dotson

The grand sweep of a lifetime is made up of countless vague impressions, forgotten moments, and unnoticed instances of beauty. The miracle of photography is that it can preserve a fraction of a second forever . . . the little spaces in between the big moments.

—KEITH DOTSON

Photo credit: Keith Dotson

CAPITOL HILL, WASHINGTON, D.C. 2016

CONGRESSMAN JOHN LEWIS

Photograph by Michael Avedon

People always ask us: "What was it like to work for Congressman Lewis? What was he like up close? What was he like in real life?" . . . My answer was always the same: "He's just as you may imagine, but better."

—JAMILA THOMPSON, Deputy Chief of Staff

On the day before he died on July 17, 2020, at the age of eighty, Georgia Representative John Lewis wrote an open letter to Americans entitled "Together, You Can Redeem the Soul of Our Nation." It was published in *The New York Times* after his death.

"Democracy is not a state," he wrote. "It is an act, and each generation must do its part to help build what we called the Beloved Community, a nation and world society at peace with itself."

Throughout his lifetime of activism and advocacy, Lewis believed in making "good trouble": at lunch counter sit-ins in 1960; on a Greyhound bus with Freedom Riders in 1961; at the March on Washington in 1963; on "Bloody Sunday" in Selma in 1965; and, ultimately, for seventeen years in the House of Representatives, where he was nicknamed "the conscience of Congress."

John Lewis was a civil rights icon in the real sense of the word—a representation of his belief that there is a moral mandate to "be a blessing to our fellow human beings."

Photo credit: Michael Avedon

ACKNOWLEDGMENTS

I have always admired the bravery of the writer and the photographer who daily labor mostly alone, courageously facing the blank page or the random chaos of the visible world. But that is not the case in my day job—making films—nor with this project; it is wholly a joyously collaborative project.

Besides the two men central to my life and my life's work to whom this book is dedicated, I am indebted to so many talented colleagues who helped at every juncture.

I am indebted first to my editor, Andrew Miller at Alfred A. Knopf, who has always, for years, been a steady guiding hand. Looming over both of us is the ghost of the incomparable Sonny Mehta, Andrew's boss, and my old editor and publisher and friend for decades. Though he has been gone for far too long, he was alive to see and encourage the first iterations of this book, and his wisdom and thoughtfulness still influence us—Andrew as well as me—at every turn. The entire team at Knopf has been professional in the extreme, including the light but exquisite hand of designer Maggie Hinders and Andrew's assistant, Maris Dyer.

At Florentine Films, our film production company, two writers, Geoffrey C. Ward and Dayton Duncan, offered encouragement and helpful advice, and the echoes of the stories we've told together over the decades resound in this decidedly different work.

My colleagues Stephanie Jenkins, Jen Fabis, Elle Carrière, Chris Darling, and Jillian Hempstead aided this unusual production in myriad ways, offering assistance that went way beyond their job descriptions. I am so grateful.

The photographs themselves, from scores of sources, have been saved and restored by countless archivists who make this book project, indeed all of our films, possible with their loving and scholarly stewardship.

But I am indebted most of all to three people without whom this project would remain just a handful of enthusiastic ideas.

David Blistein, my dearest friend of fifty years, helped write many of the descriptions and backstories of the photographs.

Brian Lee, for years, assembled and reassembled the ever-changing array of photographs, patiently showing and reshowing the emerging image selection on his computer. He printed it out as well so that I could go with him to New York and share our vision with Sonny Mehta and Andrew Miller, fellow Luddites, so the three of us (maybe Brian would admit the four of us) could hold the baby in our hands.

But most of all, this book owes its existence to the tireless work—in all phases of searching, collecting, arranging, and researching the hidden narratives behind the photographs—of Susanna Steisel. I may have conceived this project, but she is its midwife. She has worked with me on many films over the decades and for this project she would retrieve the cherished images of long-finished documentaries, find new ones along the way, and set off on entirely new quests for images we didn't know we needed until they arrived and miraculously fit into our impossibly complex jigsaw puzzle. She championed dozens of images, persistently reminding me each instant what I had missed the first time I rejected that one or this one. I'm sure she has in her mind and heart a "shadow book" of all the images I left out. She argued, lobbied, cajoled, and fought for her favorites, but was accepting and acquiescent in the face of my "certainty." Susanna dove deep into the story behind each photograph, reveling in the complexities and contradictions these "representatives" of the United States embody. Without her year-in-and-year-out attention, this book would not exist. No her, no it. I cannot adequately express my profound thanks for all her efforts.

A NOTE ABOUT THE AUTHOR

Ken Burns, the producer and director of numerous film series, including *Vietnam, The Roosevelts,* and *The War,* founded his own documentary film company, Florentine Films, in 1976. His landmark film *The Civil War* was the highest-rated series in the history of American public television, and his work has won numerous prizes, including the Emmy and Peabody Awards, and two Academy Award nominations. He lives in Walpole, New Hampshire.

A NOTE ON THE TYPE

This book was set in Adobe Garamond. Designed for the Adobe Corporation by Robert Slimbach, the fonts are based on types first cut by Claude Garamond (c. 1480–1561). Garamond was a pupil of Geoffroy Tory's and is believed to have followed the Venetian models, although he introduced a number of important differences, and it is to him that we owe the letter we now know as "old style." He gave to his letters a certain elegance and feeling of movement that won their creator an immediate reputation and the patronage of Francis I of France.

Composed by North Market Street Graphics, Lancaster, Pennsylvania

Printed and bound by Mohn Media Mohndruck GmbH, Gutersloh, Germany

Designed by Maggie Hinders